2393 00013 8637

D1397339

B VAN GOGH C.1
Hammacher, Abraham Marie
Van Gogh, a documentary
biography
 16.98

GRINNELL LIBRARY
WAPPINGERS FALLS, N. Y.

A.M. HAMMACHER
RENILDE HAMMACHER

VAN GOGH

A DOCUMENTARY
BIOGRAPHY

MACMILLAN PUBLISHING CO., INC.
New York

GRINNELL LIBRARY
WAPPINGERS FALLS, N. Y.

Introduction, linking texts and new documents translated from
the Dutch by Mary Charles

Numbered letters and texts marked CLVG are taken from *The
Complete Letters of Vincent van Gogh*, London and New York 1958

New matter, new translations and editorial arrangement
Copyright © 1982 by Thames and Hudson Ltd, London

All rights reserved. No part of this book may be reproduced or
transmitted in any form or by any means, electronic or
mechanical, including photocopying, recording or by any
information storage and retrieval system, without permission in
writing from the Publisher.

Macmillan Publishing Co., Inc.
866 Third Avenue, New York, N.Y. 10022
Collier Macmillan Canada, Inc.

Library of Congress Cataloging in Publication Data

Hammacher, Abraham Marie. 1897–
 Van Gogh, a documentary biography.

 Includes index.
 1. Gogh, Vincent van, 1853–1890.
 2. Painters—Netherlands—Biography.
 I. Hammacher, Renilde. II. Title.
ND653. G7H255 1982 759.9492 (B) 82-7224
 AACR2

ISBN 0-02-547710-2

First American Edition 1982

10 9 8 7 6 5 4 3 2 1

Printed in The Netherlands

CONTENTS

FOREWORD 6

INTRODUCTION 7
1853–1864 Zundert
1864–1866 Zevenbergen
1866–1868 Tilburg

I THE ART TRADE AND RELIGION 15
1869–1873 The Hague 16
1873–1874 London 16
1874–1876 Paris 21
1876 Ramsgate and Isleworth 24
1877 Dordrecht 30–33
1877–1878 Amsterdam 33
1878 Laeken 39
1878–1880 Wasmes 40
1880 Cuesmes and Brussels 44

II THE DUTCH PERIOD 65
1881 Etten 66
1881–1883 The Hague 69
1883 Drenthe 82
1883–1885 Nuenen 86

III ANTWERP AND PARIS 117
1885–1886 Antwerp 118
1886–1888 Paris 122

IV ARLES 153
1888–1889 Arles 154

V SAINT-RÉMY AND AUVERS 193
1889–1890 Saint-Rémy-de-Provence 194
1890 Auvers-sur-Oise 202

Bibliographical note 233
List of Illustrations 235
Index 239

FOREWORD

The composition of this book has necessitated a fresh re-reading of well-known documents, as well as research in less familiar fields: among others, the artistic affinities of the period when Van Gogh was not yet a painter. The material is so rich that our initial selection, already much reduced, has had to be subjected for practical reasons to a further process of cutting. This delicate operation was done, in collaboration with the authors, by Thames and Hudson, the book's originating publishers, who also undertook the task of collecting picture material – a matter of increasing difficulty since the owners of works of art have become more and more anonymous.

We have to thank the director of the Rijksmuseum Vincent van Gogh, Amsterdam, Johan van der Woek, and his staff members Han van Krimpen and Miss Fieke Pabst, for opening the archives to us and facilitating an investigation of numerous photographic negatives, and the three children of the late Engineer Dr V.W. van Gogh, now trustees of the Van Gogh Foundation, who gave permission for investigation of the Foundation's archives and reproduction of works. Another main source of works by Van Gogh, the Rijksmuseum Kröller-Müller at Otterlo, has also been highly co-operative. Our thanks are due also to the many other museums and private collections whose contributions have enriched the illustration sections of this book.

We feel a debt of special gratitude to Dr P.J.J. van Thiel, director of the Department of Paintings at the Rijksmuseum, Amsterdam, who unhesitatingly furnished us with unpublished information on the famous Trippenhuis, so dear to Van Gogh and a main source of his knowledge of seventeenth-century Dutch painting. Dr van Thiel has made a special study of the subject, and has been preparing a publication on the function of the Trippenhuis as museum before the Rijksmuseum was constructed. Mr J.M. van der Hock-Ostende of the Gemeentearchief in Amsterdam, Madame Claudine Lemaire of the Bibliothèque Royale in Brussels, and Mr Carlos van Hasselt, Curator of the Frits Lugt Collection (Custodia) in Paris, all gave their assistance in the search for a number of rare, or even untraceable, illustrations.

A.M. HAMMACHER
RENILDE HAMMACHER–VAN DEN BRANDE

All the quoted documents, except where there is an indication to the contrary, are letters from Vincent van Gogh (1853–90) to his brother Theo (1857–91). The original language is Dutch except in those documents marked F. (French) or E. (English).

INTRODUCTION

Just before Vincent van Gogh died, young Albert Aurier – man of letters, poet and philosopher – wrote an article in which he set out to explore the essence of the artist's work, still at that time known only within a small circle. After Vincent's death Aurier wanted to write a biography using the correspondence with Theo which he had borrowed. He had difficulty in finding a publisher, and the book remained unwritten. Nowadays, more than ninety years later, it would be hard to find a publisher who did not aspire to publish a book about Van Gogh, despite the flood of publications which have been attracting readers all over the world for several generations. The number of specialized art-historical and psychological studies of the Van Gogh phenomenon is very much smaller, although some most welcome and detailed research has been carried out, mainly in recent years, and mostly dealing with specific, limited areas. The purpose of the present book, however, is to study the artist's entire personality. It concentrates, more than previous work has done, on the area where art merges into life and vice versa.

Although the reader will find here a large number of fragments from the letters, and from family and other sources, this book should not be seen as an anthology. It is meant rather as an invitation to return to the sources themselves, and as a reading of those sources. Fragmentation is always painful – even if, as in this instance, its purpose is to find the key to an important whole.

Perhaps the most extraordinary thing about Van Gogh's life is the fact that he did not discover his artistic vocation until his twenty-eighth year. Little is known of his childhood and adolescence; but the experiences of the eight years between the ages of nineteen and twenty-seven are vividly reported by Vincent himself, and his interests and obsessions carry clues to the origins of his later work, and above all to the nature of the tensions and inhibitions that gave his adult life its curious and fascinating combination of frustration, achievement and self-destructiveness.

I am convinced that the early part of Van Gogh's adult life – his life as a non-artist – is of fundamental importance in relation to his work, and deserves as close study as the later, creative phase of his career. All this is a problem area, but it is one Vincent himself was always aware of, and one which never ceased to haunt him.

Those eight years of preparation brought a series of failures and much tentative searching. They provided the tilth, the reservoir for a life which was lived with intensity and devoted to a pictorial incarnation of one man's world. The vehemence with which Vincent always rejected anything that, in his family's eyes, represented a socially acceptable means of earning a living, was for many years a blind force; activated by suffering, it eventually developed into a force that was clear-sighted. In this study, full attention is devoted to that process. The letters not only reflect the origins of an artistic output, but constitute an enthralling source in which we can discover the structure of a personality, still unaware of a hesitant and dormant creative power which was not yet ready to become a will to create.

For most of the time, Vincent was prey to an inner tension that he himself did not know how to interpret. His reading, for example, was never for relaxation; it was always purposeful, even compulsive, although there is evidence of a strong affinity to certain writers rather than of any premeditated

system of selection. His reactions to external impressions were strong and idiosyncratic. Object and subject constantly merged. Conscious and unconscious reactions to stimuli can be traced in his actions, his habits – such as that of studying his reflection in a mirror, the child's first form of self-examination – and eccentricities of behaviour. Problems with clothes started early; he never ate or drank sensibly; he showed great delicacy, as well as sensitivity, in conversation and in making small gestures and gifts; his reactions were violent when the power of passion began to make itself felt, long before he was able to come to terms with that of love. The contradictions of those eight crucial years are the marks of a period of artistic gestation. Trying to find one's way in all this has meant discovering a number of basic motifs so deeply rooted that they played a part in his work until the very end.

Psychoanalytical opinion has held that the still-birth of his namesake one year before his own birth had some influence on Vincent's earliest emotions. No information has been produced to make me consider this in any way likely. The earliest letters known to us were written in 1872. Information about his youth is inadequate. Even the reminiscences published by his sister, Elisabeth H. du Quesne-van Gogh, twenty years after his death (1910), fail to rise above the customary awe and lack of comprehension for a temperament that seemed merely 'strange' to those around him.

'Strange' was the only word relatives, acquaintances, schoolfellows and teachers could find to describe a child who for obscure reasons held aloof from his environment. We possess no clues to suggest a motive for this isolation. One thing that seems clear is that it does not conform to any of the familiar stereotypes of the 'gifted child'; it was not accompanied by an early and seemingly effortless mastery of technique in one discipline or another, as was observed in such individuals as Mozart, Pascal, Flaubert or Picasso. His early drawings are unremarkable. Nor, in consequence, did Vincent have the fragile support of the gifted child's characteristic self-confidence or self-conceit. He manifested only the negative aspects of a potential but deeply hidden creativity.

Vincent showed no signs of maladjustment in his school work. Why his education was broken off in March 1868 remains a mystery. It was the first of a series of enterprises in his life that were abruptly left unfinished, in this case presumably through no fault of his own. The most likely explanation is that there was simply not enough money for the parson's family, with its ever-present financial anxieties, to continue this somewhat expensive undertaking, which included the cost of full board and lodging. It was more than a year *9, 10* (July 1869) before his uncle Vincent, a prominent member of Goupil & Cie, an international firm of art dealers, was able to take on the sixteen-year-old youth as a trainee at the organization's branch at The Hague. Nothing is known about how Vincent spent his time between leaving Tilburg and joining his uncle at The Hague.

It was to be another three years before Vincent provided a record, and a reticent one at that, of how he had fared in his first job at Goupil's. And it was only then, at the age of nineteen, that a penetrating spiritual awareness of painting and literature became apparent: childishly, conventionally formulated at first, and then becoming ever stronger, like a slowly rising tide. He did not have to reach far back into the past. The seventeenth century was close to him, the eighteenth century less so; but he had a thorough knowledge of the art of his own time, in so far as the 1860s and 1870s contained elements to which he felt attracted. This knowledge was in fact so thorough that once his

creative instinct, with inflexible psychic force, had overcome all resistance, its content was largely determined by this absorption with the art of the nineteenth century. Literature, painting and drawing – all seen in relationship to the Bible – were the disciplines that we shall be able to follow through a gradually changing appreciation based on inward struggle.

During the years before becoming a painter, Vincent developed a notable predilection for twilight and night, which became even more apparent during the last phases of his life as a painter, at Arles and Saint-Rémy. The first and last light of day promoted a state of mind in which his emotions, thoughts and bodily senses were absorbed in what he saw, intensifying his experience and giving him the ecstatic sense of being absorbed in the macrocosm. Often he rose at four a.m. or walked to meet the dusk late in the evening. Many a time he sat without shelter by a pond, or in a churchyard or a field, waiting for the dawn and listening to the first bird song.

Superficially, such a tendency might be considered a mere romantic inclination, had it not also been a specific symptom of an ecstatic disposition (see, inter alia, Marghanita Laski on *Ecstasy*, London 1961, 1980). Ecstatic experience takes a wide range of possible forms, from the erotic to the abstract, from a visionary transformation of everyday life to states of sensitivity that can culminate in visual and auditory paranormal experiences. In Van Gogh's case, the two states of mind – losing himself in the twilight and awakening – whereby his spiritual existence was released from both the past and the present, came to have a fundamental and long-lasting effect on his existence and subsequently on his creativity. Through such profound experiences of Nature, in its most elemental and universal manifestation, his inwardly lonely life was transformed and united with a greater whole.

Fascinated by the Montagne Sainte-Victoire, Cézanne for many years felt the need to go there before five o'clock in the morning to witness the awakening of light and nature in complete solitude. There is no record of what sensations he actually experienced there. We know more about a similar compulsion on the part of Charles Baudelaire (1820–67) and Arthur Rimbaud (1854–91), the latter a contemporary of Van Gogh, to experience the eternal repetition of the awakening and death of light and the world. Georges Poulet has written a profound analysis of this psychic condition (*La Poésie éclatée*, Paris 1980). The work of both poets manifests profound reactions to the awakening of the world or the transition to night. However, the inspiring power of these ecstatic moments allows for differences in the way they are assimilated and in their effect. This applies to Vincent, whose world was unlike that of Baudelaire with his devotion to night and artificial light. Vincent, like Rimbaud, was as sensitive to the victory of the rising sun as to that of the night.

It was above all during those eight years before Vincent became a painter that he wrote the descriptions of exhausting nocturnal or evening walks which recur like a refrain in the text of his letters. These experiences, seen with hindsight, were probably the best of his tormented life. Later, particularly after his year of painting at The Hague, in 1881–82, Vincent's predisposition for ecstatic experiences acquired an active aspect, both in Holland and the South of France, where colour sometimes escalated to paroxysm.

His sense of affinity to night and twilight continued to make itself felt even in Provence, where – stimulated by Impressionism and by his body's craving for warmth – his love of the sun appeared, superficially at least, to cast out all northern gloom and even gave him a false reputation of being a 'sunlight' artist. Star-filled night skies at Arles inspired several drawings and paintings *156*

9

which are among his finest works. At Auvers in 1890, in his last few months of life, the blue of the sky acquires a value which eliminates from scenes such as the view of the little church and the background of Dr Gachet's portrait any definition of day, evening or night. It is true that most of the harvest scenes with the high note of yellow, with which he himself characterized Arles, constitute a maximum and exhaustive realization of his endeavours to express the effect of the sun; but this was never free from 'the shadow of death' seen in the figures of reapers, or 'the shadow of evil' in the cypresses.

In the years before he was an artist, his whole attitude towards the dark, towards dusk, towards mourning for what is lost, towards the romantic and psychoanalytical linking of Eros and Thanatos, love and death, became concentrated, with obsessional persistence, in the figure of the 'woman in black'. This figure then appeared in his early Hague drawings and paintings, and later in those produced in Brabant – in autumnal landscapes or as an individual worn down by cares and sorrows (the woman Christine with whom he lived at The Hague); but it had germinated and developed in his mind from 1873 onwards, before there was any question of his starting to paint.

Its origin lay in a complex interaction of factors. Among these were the 'heavy blow' of his first unsuccessful infatuation, in London, with Eugenia Loyer, and the rise of his great admiration for Jules Michelet, whose *L'Amour* was one of his favourite books. Michelet – more than Carlyle or Longfellow, whom he also read at this time – meant to him the crystallization of his awakening feelings for women, not only as mothers of children, but also as stimulators of psychic energy and imagination. In his letters, we shall find the details of his fluctuating feelings for Michelet and the latter's evocations and imaginings of the 'woman in black'. Other writers were also having an effect on him in those same years, 1873–76. There was John Bunyan's seventeenth-century allegory *The Pilgrim's Progress*, with its fascinating character, the attractive vampire-like female who features as the Temptress on the Pilgrimage; H.W. Longfellow, the American with many readers in Europe, who wrote the history of the legend of the Plymouth colony (*The Courtship of Miles Standish*, 1858) and *Evangeline*, a rhyming tale of Anglo-French tensions, sealing the fate of Acadia; George Eliot (*Janet's Repentance*); and Charlotte Brontë (*Shirley*). There was in Vincent's imagination a strange mixture of puritanism and adventurousness. Passionate females in difficult circumstances fascinated him. At the same time, the cold fire of fanatical piety was developing in him as a substitute for his extinguished passion for Eugenia.

From the time of his employment at Goupil, Vincent had on the walls of his small rooms in Paris, London, Dordrecht and Amsterdam, two pictures of women whom he admired, or who at all events occupied his mind to a remarkable degree. They were the portrait in the Louvre of the *Woman in Mourning* which had inspired Michelet, and a drawing from the tomb effigy of Anne of Brittany, whose name reminded him of rocks and the sea (the link with landscape), and who responded to his admiration for a strong, combative, loving image of womanhood.

The religious feeling which held him prisoner, through obsessive passion rather than through the warmth of genuine love, has nevertheless been rather caricatured by his biographers. The suggestion that he lived for no other purpose for three years in the late 1870s is contradicted by his passion for literature and art, which, far from weakening after his days in London, Paris and Amsterdam, was asserting itself with increasing vigour. Yet he was aware

205, 216

141
207

70, 71, 76
56

18
19

that he was 'imprisoned in something'. I call that having a psychological block. He remained his own prisoner until he had come to accept the consequences of not wanting to become a biblical scholar, as would have been required of him had he sought entry to the ministry. The questions requiring an answer were 'What is it that I might be?' and 'What purpose might I serve?' He could answer them only by eliminating the block. Instead, he tried to adapt in behaviour and clothing, thereby holding back whatever might be struggling for release.

It was in his clothing that Vincent sought to show the outside world to what category of people he felt it was his calling to belong: the poor. He had arguments to provide a motive for neglecting his clothes when, after leaving Goupil, he no longer possessed the means to dress like the class to which his family belonged. But his family, and Theo in particular, had observed that even during his final year at Goupil in 1875, after his spell of depression in London and the onset of his fanatical piety, some measure of neglect was already noticeable. Theo understood this to be one of the reasons why Goupil wanted to get rid of him – although Vincent denied this, advancing the deeper reason of his aversion to the practices of the world of art dealers. In London in 1873 he had conformed to some extent to the conventions of his environment by acquiring the top hat he then continued to wear at Dordrecht in the Netherlands, three years later – where it did deviate from local custom. (It was also, by this time, noticeably decrepit.)

It was in the Borinage, where he preached among the miners in 1879–80, that he tried hardest to achieve his aim, not to be distinguishable – inwardly, but above all outwardly – from those among whom he had to perform his mission. He did all he could to avoid standing out among them by loaning his good clothes if help was needed at the time of accidents, as well as by neglecting himself physically, and by reducing his food requirements to the barest necessities. He managed to achieve the very opposite of what he had hoped for, and drew attention to himself, not only because people had seen him arrive looking *Hollands proper* – well-dressed and clean as it behoved a Dutchman – but also because of his social role and manners, which clearly reflected his different origins. Local tradition suggests that it was the very artificiality of his attempted adaptation which aroused notice. It was not expected of him. His goodness and commitment were remembered with deep respect, but as a deviation, as something special. There were memories of his old military coat, his shabby cap, and how he slept in a small hut without furniture even though not driven to it through lack of money.

His longing for primeval purity, his Adamistic, ecstatic character, remained apparent in his clothing even when he became an artist, and so continued to be a challenge to his family. They, in fact, did their best on several occasions to smarten Vincent up a little, as may be seen in some rather touching letters from his parents. In his defence, he pointed to his occupation rather than bringing forward any social or political arguments. Painting was a messy job, and he had to work unobtrusively in slum streets, in the rain and mud. He went on to air his objections to the bourgeois life indulged in by some painters who were prospering in a material sense.

In Antwerp, however, on his way to Paris after leaving the Netherlands for good, his attitude was modified to some extent. He found it necessary to do something about his clothes. His Paris self-portraits of 1885–88 show him *115–117* conforming to an astonishing degree to the environment where Theo had to carry on his business as an art dealer. It is obvious that the hat, collar and tie, and respectable suit which we see in his self-portraits would not have been

specially assumed for the purpose of self-examination in a mirror. (Although the fur hat and paint-smeared smock were still obviously essential for his work out of doors in all weathers at Asnières.)

He was working with Paul Signac and Emile Bernard, and even had a number of acquaintances of aristocratic descent. Toulouse-Lautrec's unrivalled profile portrait in pastels must reflect Van Gogh's image as it appeared in Paris, without any extravagances in dress and with the appearance of a gentleman. It is remarkable that it was Lautrec who saw him like this, whereas he was always out to stress the elements in a person's appearance whereby he might turn them, with barely suppressed irony or malice, into caricatures stressing decay, vice and the exhaustion of passion. To him Vincent looked impassioned but controlled, vehement and quick to react, but neither unrestrained nor confused.

114

Vincent was not wholly uninterested in politics, but such interest as he had did not affect either his bearing or his behaviour. On one occasion, in an unusual mood, he was tempted to apply the divisions of the 1848 barricades to himself and his brother, assigning Theo to the side of Guizot and himself to Michelet's. He once spoke of his own 'socialism', and referred to an ideal 'revolution'. But he never showed any signs of a commitment other than one based on sentiment and on his own psychological make-up. Not once in his letters did he mention the name of Marx or that of Bakunin, who had a considerable reputation among artists in France. In Belgium in the late 1870s, Vincent hardly mentions the negligence on the part of the mine-owners, or the social unrest among the population which was to lead to revolt in 1885; he speaks of strikes in one letter (130) which was written in 1879, the year in which Bakunin (more popular in France and in anarchist Wallonia than Marx) broke with Marx at the International. But his preoccupations at the time when he was living among the industrial poor were markedly religious rather than political. He wrote in praise of Courbet, but failed to respond to his political action, with its well-known and unhappy end. Vincent's compassion was fundamentally directed towards individuals.

More, perhaps, than he would admit to himself, Vincent remained deeply inspired by the figure of Christ, even after he had come to place the Bible and the Church alongside and not above other matters. He was congenitally better at giving than at receiving, although he set out to correct this in himself after he had experienced the adverse consequences of giving alone.

There is no evidence that his life's sufferings ever caused him to rebel, either in the Borinage, or in London or Brabant. He wanted to do good, to give personal help. In this context, his repetition, in Provence, of an inscription quoted in an old newspaper as having been found on an ancient tombstone between Arles and Carpentras, acquires a profound significance. It expressed something he knew only too well. 'Thebe, daughter of Thelhui, priestess of Osiris, who never complained of anyone.' 'Never complained' implies a great deal. It means an acknowledgment and understanding, if not total acceptance, of the basic truth that suffering is constant and there is no complaining.

Vincent's sole, but absolute, act of revolt was directed against himself – his suicide. All manner of speculations have been made, referring to rational as well as irrational impulses. However, from an early age there were slight, and subsequently more serious, signs of his predisposition, of his reactions to happenings frequently initiated by himself. There is coherence in these signs. Gradually, the realization grew of an end dimly perceived earlier on. He became more and more aware of his existence in the service of a specific task, imposed from within. His ecstatic disposition laid him open to the absorbing,

totally possessive power of an idea which overcomes all opposition. Pulling the trigger was the final deed brought about by what, ten years earlier on, he had termed his 'active melancholy'.

The mystery of his sickness, and the series of crises, can no longer be solved by medical science. It has remained nameless, since it cannot be identified by that final deed alone. The final deed was an actual, but not an inevitable, consequence of the syndrome. It went beyond this and was closely linked with creative power and creative instinct. The presumed syndrome and subsequent suicide have caused a great deal of misunderstanding in writings about Van Gogh. An art historian is clearly in no way competent to define the syndrome itself, but he cannot ignore the possibility of a link existing between Vincent's sickness or predisposition and his artistic output. Conversely, psychiatric studies have rarely had a sufficiently aesthetic slant to do justice to the problem. The symbolic explanation of Vincent van Gogh along psychoanalytical lines (Graetz) suffers from the same defect, i.e. that the aesthetic and art-historical aspect cannot be ignored with impunity. Not only because of his link with Roger Fry, Charles Mauron inspires confidence in this respect, displaying a discipline that is aesthetically well orientated.

In a book like this it would be an omission to dispose of Vincent's sickness with a few generalities. The reader will find the details in the Arles and Saint-Rémy/Auvers sections. It is appropriate to recall here that the now obsolete and schematic routine data noted by the doctors at the institutions at Arles and Saint-Rémy do not constitute the only information available for contemporary psychiatrists to work on. The dates of pre-crisis exaltation as well as the crisis situations in his life – including, it should be remembered, his pre-painting years – can be worked out with some accuracy. There were periods of being out of humour; there was insomnia. We know very little about his dreams, but a great deal about his eating and drinking habits; smoking (he several times quoted Dickens on smoking as an antidote to suicidal thoughts); fears; hallucinations, both auditory and visual; his sense, not of persecution, but certainly of isolation; statements about his sexuality in certain circumstances; evidence of possibly faulty treatment of venereal disease. When leaving Paris, Vincent feared total paralysis.

The information given to the psychiatrist at Arles about epileptics in his family was provided by Vincent himself. As far as we know, it was not refuted by Theo. At Saint-Rémy, Dr Rey gave epilepsy as his own diagnosis, with some reservations. Family records on the Van Gogh side provide no record of epilepsy; and the Van Goghs – the uncles at least – were mostly clear-sighted, realistic people earning good money. On the Carbentus side of his mother's family the evidence is different: artistic and musical talent occurred, but also nervousness, depressions and neuroses. It seems it is too late now to devote more attention to this neglected area of Vincent's ancestry; but there is some information concerning the generation to which Vincent himself belonged. After working as a teacher for some years, his favourite sister Willemien was admitted to a psychiatric institution; she died in one, after many years (undated letter from Mrs van Gogh, Van Gogh Archive). Without any knowledge of her symptoms, and relying solely on his own powers of observation, Vincent himself had, in a photograph, seen signs of madness in the eyes of his sober and quiet sister.

The epilepsy hypothesis appears to have been rejected by most modern psychiatrists because of the absence of convulsive conditions; yet the idea of epilepsy occasionally turns up again. Fernand Destaing (*La Souffrance et le génie*, Paris 1980) refers to the modern change in the concept of epilepsy, in

that convulsions are not invariably present; despite many errors in Destaing's summary of Van Gogh's life, the possibility of epilepsy is once again a live issue.

The aspect of interest to us – however inconclusive the diagnosis must remain – is the question of how his predisposition helped to determine the form and quality of his art. Ignoring his sickness is a misjudgment of its character; trying to show that the sickness was the cause of some of the aesthetic phenomena in Vincent's art is turning the matter back to front. The known facts are too numerous for one not to agree with Van Gogh himself, who said that the output which, after years of preparation, he finally produced at speed in the space of ten years meant exhausting his physical and psychic strength and destroying his health. His psychological disposition – including his unconscious – possessed a reservoir of energy comparable to the fertile soil which has to be ploughed, sown, manured, and rained on, before its latent forces can be realized. Such forces included the sickness which could not fail to make itself felt after Vincent had whipped up all his nerves into a paroxysm in order to produce his work. Tensed beyond the limits, he could not be saved by any relaxation of tension. Relaxation became disorientation.

Without such transgression of the limits, many a work by Van Gogh would never have acquired the quality which causes it to affect people who remain totally unconscious of what is enacted within it. Van Gogh was aware of this. He remembered – or rather continued to feel – the impression made on him in *17* 1873 by the wild-eyed portrait of the mad Hugo van der Goes in a painting by Wauters. And in 1888 that same image of Van der Goes returned to him as he was drawing up his own balance-sheet. He always had occasional lucid moments, of such existential power that at the age of thirty (1883) he was able to state, 'I must complete a certain amount of work in just a few years' (309), knowing it would depend on the first ten years and reckoning on having between six and ten. In the event, he had seven. In the same year, 1883, he knew that the wound caused by rejected and forbidden love 'cannot heal', that it goes too deep and '*after years and years* will be as it was on the first day' (312). The decisions were taken then, and it is there, in his sense of obligation towards his work and the wound caused by love, that the two sources of his art lie linked; sources which determined all that was to follow.

A.M. HAMMACHER

I

THE ART TRADE
AND RELIGION

'Homesick for the land of pictures'

1869–1873 The Hague
1873–1874 London
1874–1876 Paris
1876 Ramsgate and Isleworth
1877 Dordrecht
1877–1878 Amsterdam
1878 Laeken
1878–1880 Wasmes
1880 Cuesmes and Brussels

GRINNELL LIBRARY
WAPPINGERS FALLS, N. Y.

Vincent wrote the earliest of his extant letters in August 1872, when he was nineteen and Theo a fifteen-year-old schoolboy. He wrote from The Hague, where he had been working for the art dealers Goupil & Cie since the age of sixteen (1869).

Thanks for your letter. I was glad to hear you arrived home safely. I missed you the first few days; it was strange not to find you when I came home in the evening. We have had pleasant days together, and between times have taken many a nice walk and done some sightseeing.

What terrible weather! You must have suffered from the heat on your walks to Oisterwijk. Yesterday there were races to celebrate the Exhibition; but the illumination and the fireworks were put off because of the bad weather, so it is just as well that you did not stay to see them. Compliments from the Haanebeek and Roos families. (1, Aug. 1872.)

9
10
Goupil & Cie, founded in Paris by Adolphe Goupil in 1827, now incorporated the Hague business founded by Vincent's uncle, another Vincent Willem van Gogh, who was still active as a partner in the parent company. Centres of the art trade such as this should not be underestimated as sources of knowledge and connoisseurship. Both Vincent and Theo made their first contact with art through 'Uncle Cent''s collection, and met their first artists through working for Goupil. Business at The Hague bore a mixed character at this time and consisted of the production and sale of engravings, etchings, lithographs, and photographs of works of art as well as the sale of paintings.

Art dealers made considerable profits at that time out of reproductions; and they were gradually beginning to deal in contemporary art. Goupil in The Hague was already selling works by artists who belonged to contemporary groups, the French Barbizon School (Théodore Rousseau, Charles-François Daubigny, Narcisse-Virgile Diaz, Jules Dupré, Constant Troyon) and the Dutch Hague School (Anton Mauve, Jozef Israëls, Thijs and Jacob Maris, H.W. Mesdag, Johannes Bosboom, H.J. Weissenbruch).

62, 63
59, 64, 90
25, 61

Vincent has left little record of the kind of work he did for the firm at The Hague. When he left he took with him a reference signed by H.C. Tersteeg, who managed the branch on behalf of Vincent's uncle. The letters of this period, immature though they are, show signs of regular visits to the major art galleries and pronounced, if conventionally expressed, preferences.

The young Vincent was intensely attached to his parental home and his family, so that his transfer to London in 1873, although intended as promotion, immediately aroused his fears of homesickness. Theo, meanwhile, started working for Goupil in Brussels.

... Be sure to tell me more about the pictures you see. A fortnight ago I was in Amsterdam to see an exhibition of the pictures that are going from here to Vienna. It was very interesting, and I am curious to know what impression the Dutch artists will make in Vienna. I am also curious to see the English painters; we see so little of them because almost everything remains in England. ... (5, 17 Mar. 1873.)

It is easy to overlook the postscript:

Theo, I strongly advise you to smoke a pipe; it is a good remedy for the blues, which I happen to have had now and then lately. ... (5, 17 Mar. 1873.)

Vincent was to remain inseparable from his pipe all his life; and not long before the end he was to refer to its value as an antidote to thoughts of suicide:

Every day I take the remedy which the incomparable Dickens prescribes against suicide. It

consists of a glass of wine, a piece of bread and cheese, and a pipe of tobacco. (Vincent to Wil van Gogh, WII, 10 Apr. 1889, F.)

In London, Vincent's first impressions of English art were not altogether favourable. He was still unfamiliar with the artists who were to be his enduring love, the draughtsmen who produced the illustrations for weeklies and other publications. Soon however, he began to take considerable interest in the competent, if mediocre, painter George Henry Boughton, whom he long continued to mention in his letters. It was characteristic of Vincent that even at an early age he was not only impressed by famous names and great masters, but also had an eye for lesser artists provided they gave evidence of genuine sentiments and something that went beyond modish competence. Boughton attracted him because of his serious understanding of landscape and because he occasionally chose pilgrims and particularly Puritans as his subjects. Boughton also inspired Vincent to reread Longfellow's *Evangeline* and *The Courtship of Miles Standish*. From an early age Vincent had been aware of the interaction between literature and painting.

20–22

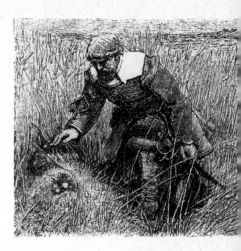

G.H. Boughton. *'On the hill by the sea lies buried Rose Standish'*. From H.W. Longfellow, *The Courtship of Miles Standish*.

... At first English art did not appeal to me; one must get used to it. But there are here, among other, Millais, who has painted *The Huguenot, Ophelia*, etc., of which I think you know the engravings; his things are beautiful. Then there is Boughton, whose *Puritans Going to Church* is in our Galerie Photographique; I have seen wonderful things by him. Among the old painters, Constable was a landscape painter who lived about thirty years ago [*sic*]; he is splendid – his work reminds me of Diaz and Daubigny. Then there are Reynolds and Gainsborough, whose forte was very beautiful ladies' portraits, and Turner, whose engravings you must have seen. ...

Sometime you must write me if there are any photographs of Wauters's work besides *Hugo Van der Goes* and *Mary of Burgundy*; and if you know about any photographs of pictures by Lagye and De Braekeleer. I don't mean the elder Braekeleer, but, I think, a son of his who had three beautiful pictures called *Antwerp, The School* and *The Atlas* at the last exhibition in Brussels. (10, 20 July 1873.)

97

It is remarkable that he was collecting photographs of paintings and specifically mentioned Emile Wauters' painting of *Hugo van der Goes in the Red Monastery*, where the artist is shown, wild-eyed and staring, as a small choir endeavours to calm his mind with music. This image of Hugo van der Goes was to remain with Vincent until his dying day. He clearly identified with him; such thinking was fundamental to his way of reading, seeing and hearing.

17

Vincent walked a great deal and became familiar with London and the surrounding countryside.

... I walk as much as I can, but I am very busy. It is very beautiful here (though it is in the city). The lilacs and hawthorn and laburnums are in bloom in every garden, and the chestnut trees are beautiful. If one really loves nature, one can find beauty everywhere. But still I sometimes long for Holland and especially for home. ... (16, 13 Apr. 1874.)

Such walks were to become an indispensable element in his experience of nature, as well as in the activation of his inner life. They were true wanderings and pilgrimages, and reflect an intense inner life, which long remained in a receptive, passive state.

He visited the museums, but seems to have despised the traditional London sights and failed to visit the Tower, Crystal Palace and Madame Tussaud's. He was fascinated by the people, their way of life, and the scenes he encountered in the streets. In spite of permanent homesickness, his nationalism weakened.

... I live a rich life here, 'having nothing, yet possessing all'. At times I am inclined to believe that I am gradually turning into a cosmopolite; that is, neither a Dutchman, nor an Englishman, nor yet a Frenchman, but simply a *man*. And as a homeland, the whole world, *i.e.* a small spot in the world where we are sent to stay. We have not got there yet, though I am straining after it, and perhaps may grasp it. And as my ideal, what Mauve called, 'That is *it*.' (Vincent to Carolien van Stockum-Hannebeek, 13a, 1874.)

The Mauve whom Vincent here and afterwards approvingly quotes was the distinguished Hague painter Anton Mauve, who was married to Vincent's maternal aunt Jet. His most significant allegiance, however, was to the philosophical historian Jules Michelet; and a letter from London quotes the following fragment from the chapter 'Les Aspirations de l'automne' in Michelet's *L'Amour*:

'From here I see a lady, I see her walk pensively in a not very large garden, bereft of its flowers early in the season, but sheltered, as you see them behind our cliffs in France or the dunes of Holland. The exotic shrubs have already been put back into the conservatory. The fallen leaves reveal a number of statues. An artistic luxury which contrasts a little with the lady's very simple, modest, dignified dress, of which the black (or grey) silk is almost imperceptibly brightened by a lilac ribbon.

'But haven't I seen her already in the museums of Amsterdam or The Hague? She reminds me of a lady by Philippe de Champaigne [*n.b.* in the Louvre – V. v. G.], who took my heart, so candid, so honest, sufficiently intelligent, yet simple, without the cunning to extricate herself from the ruses of the world. This woman has remained in my mind for thirty years, persistently coming back to me, making me say: 'But what was she called? What happened to her? Did she know some happiness? And how did she cope with life?' (Vincent to Carolien and Willem van Stockum, 11, Oct. 1873.)

Vincent was a solitary, and an intensely religious, youth. His imagination was captured by the image of womanhood he found above all in Michelet. In London in 1873, he was humiliated by the rejection of his love for Eugenia, the daughter of his widowed landlady Ursula Loyer. Eugenia proved to be secretly engaged to be married. Vincent apparently failed to respect the fact, nor had he any sympathy with Eugenia's boyfriend whom he wished to supplant. His forceful nature, and what he later considered to have been half imagination and half genuine love, brought about a sense of injury and a state of introversion which distracted his mind from the harsh reality of having to earn a living. Much later, he gave an acute analysis of his state of mind at this time.

... What kind of love did I feel, when I was twenty? It is difficult to define – my physical passions were very weak then, perhaps because of a few years of great poverty and hard work. But my intellectual passions were very strong, meaning that without asking anything in return, without wanting any pity, I wanted only to give, not to receive. Foolish, wrong, exaggerated, proud, rash – for in love one must not only give, but also take; and, reversing it, one must not only take but also give. Whoever deviates either to the right or to the left fails, there is no help for it. So I fell, but it was a wonder that I got up again. ... (157, 12 Nov. 1881.)

In 1873, Vincent was unable to put these feelings into words in his letters; we know of the episode with Eugenia only because Theo later told his wife Johanna, who tells the story in her introduction to the *Complete Letters* (erroneously calling the daughter by the mother's name). Theo mentioned it also in letters to his parents (unfortunately not all preserved in the Van Gogh Archive).

In the summer of 1874 Vincent visited his parents at Helvoirt (they had moved there from nearby Zundert in 1871) in order to escort his sister Anna to

England, where she was to seek employment. His parents were disappointed to find him 'silent and depressed, and also more and more religious'.

I am glad you have read Michelet and that you understand him so well. Such a book [*L'Amour*] teaches us that there is much more in love than people generally suppose.

To me that book has been both a revelation and a Gospel at the same time: 'There is no such thing as an old woman.' (That does not mean that there are no old women, but that a woman is not old as long as she loves and is loved.) And then such a chapter as 'The Aspirations of Autumn' – how beautiful it is.

That a woman is quite a different being from a man, and a being that we do not yet know – at least, only quite superficially, as you said – yes, I am sure of it. And that man and wife can be one, that is to say, one whole and not two halves, yes, I believe that too.

Anna is in good spirits; we take beautiful walks together. It is so beautiful here, if only one has an open and simple eye, without many beams in it. But if one has that, it is beautiful everywhere.

That picture by Thijs Maris which Mr Tersteeg has bought must be beautiful. I have already heard about it, and I myself have bought and sold one quite similar.

Since I have been back in England, my love for drawing has stopped, but perhaps I will take it up again some day or other. I am reading a great deal just now. ... (20, 31 July 1874.)

Only in his musings about man and wife is there evidence of his passion for womanhood and its mysterious force, a passion governed by the impelling power of Michelet's writing. Ever in search of self-understanding, Vincent seems to have been intuitively attracted to Michelet's intensely emotional personality and way of thinking, so aptly described by Georges Poulet:

Michelet is a creature who starts off by refusing ever to unburden himself, to open his heart to others, to the outside world; and who furthermore cannot concentrate his thoughts on any single object without a deliberate expenditure of energy. There is nothing spontaneous in his conduct. Self-isolation and restriction are in this instance the consequences of a considered decision. Michelet starts his life by forcing his nature. Or rather, in his explicit acts of will he is obeying one of the essential characteristics of that nature. He does violence to himself because there is violence in his temperament. (Georges Poulet, *Etudes sur le temps humain*, Paris 1968.)

Vincent now left the Loyers and their infants' school and went to lodge without board at Ivy Cottage, 395 Kennington Road. He attached no importance to his drawings; and since creativity in the true sense of the word hardly comes into them at all, it would be wrong to attach importance to them.

... With the money I gave you, you must buy Alphonse Karr's *Voyage autour de mon jardin*. Be sure to do that – I want you to read it.

Anna and I walk every evening. Autumn is coming fast and that makes nature more serious and more intimate still. We are going to move to a house quite covered with ivy; I will soon write more from there. Compliments to anybody who may inquire after me. (21, 10 Aug. 1874.)

Ivy and moss appealed to him wherever he found them, and ivy became a symbol, one of the underlying themes in his work. In Christian symbolism it represents death, immortality and affection. In 1876, visiting his sister Anna at another Ivy Cottage, at Welwyn, he found a *Mater Dolorosa* in her room, framed in ivy (letter 69). At Isleworth, one autumn evening that same year, he was moved by the sight of 'the church with the ivy, and the churchyard with the weeping willows on the banks of the Thames' (letter 76). At Dordrecht he quoted Dickens (from memory): *172*

... The window of my room looks out on a garden with pine trees and poplars, and the backs

of old houses covered with ivy. 'A strange old plant is the ivy green,' says Dickens. The view from my window can be solemn and more or less gloomy, but you ought to see it in the morning sun – how different it is then. When I look at it, I am often reminded of a letter from you in which you speak of such a house covered with ivy – do you remember? . . . (84, 21 Jan. 1877.)

Later still, struggling with his Latin and Greek in Amsterdam in 1878, he was to reflect that 'patience will help me through. I hope to remember the ivy, "which stealeth on though he wears no wings"; as the ivy creeps along the walls, so the pen must crawl over the paper' (letter 95). At Arles, years later, he wrote, in a curious attempt to comfort his sister Willemien, who was nursing a sick relative:

. . . The ivy loves the old branchless willow – every spring the ivy loves the trunk of the old oak tree – and in the same way cancer, that mysterious plant, so often fastens on people whose lives were nothing but love and devotion. However terrible the mystery of these sufferings may be, yet there is in reality something sweet and pathetically touching about it, which has the same effect as seeing the abundant growth of green moss on the old thatched roof. . . . (Vincent to Wil, w11, 10 Apr. 1889, f.)

One of the last letters written during Vincent's first spell at Goupil's in London includes a remarkable description of one of Thijs Maris' most popular works, *Souvenir of Amsterdam*, painted in Paris with the aid of a stereoscopic photograph. Vincent has clearly studied the painting; he describes it with uncommon precision, and makes a telling assessment of its quality.

Thanks for your letter. I copied in your little book 'Meeresstille' [Calm Sea] by Heine, didn't I? Some time ago I saw a picture by Thijs Maris that reminded me of it. It represents an old Dutch town with rows of brownish-red houses with stepped gables and high stoops; grey roofs; and white or yellow doors, window frames and cornices. There are canals with ships and a large white drawbridge under which a barge with a man at the tiller passes the little house of the bridgekeeper, who is seen through the window, sitting alone in his little office. Farther on is a stone bridge across the canal, over which some people and a cart with white horses are passing.

And there is life everywhere: a porter with his wheelbarrow; a man leaning against the railing of the bridge and looking into the water; women in black with white bonnets.

In the foreground is a brick-paved quay with a black rail; in the distance a church spire rises above the houses. A greyish white sky is above.

It is a small picture, and the artist was looking down on the scene. The subject is almost the same as that of the big J. Maris, *Amsterdam*, which you probably know; but this is talent and the other, genius. . . . (24, 6 Apr. 1875.)

His final letter briefly but unmistakably reflects a sombre mood. His art dealer uncle C.M. van Gogh had visited London, together with Tersteeg.

. . . Aye, boy, 'What shall we say?' C.M. and Mr Tersteeg have been here and left again last Saturday. In my opinion they went too often to the Crystal Palace and other places where they had nothing particular to do. I think they might just as well have come to see the place where I live. I hope and believe that I am not what many people think I am just now. We shall see, some time must pass; probably they will say the same of you a few years hence, at least if you remain what you are: my brother in both senses of the word. . . .

[PS.] 'If one is to act in this world, one must be dead to oneself. The nation that makes itself the missionary of a religious idea no longer has any fatherland but that idea.

'A man does not exist here below simply in order to be happy, or even in order to be honest. He is here to achieve great things for society, to attain nobility, and to rise above the common round in which almost every individual drags out his existence.' (Renan.) (26, 8 May 1875.)

Vincent had developed a new awareness of his own personality, and at the same time a sense of estrangement. Being different meant – and this was to prove fundamental over a long period of inner growth – the detachment of his social ego from his family tradition. This tradition decided, with authority based on the desire for status rather than money, what kind of career the children of the Reverend Theodorus van Gogh and his wife Anna van Gogh-Carbentus should have.

The members of his family were seriously worried by Vincent's sombre mood. He was clearly suffering from dissatisfaction with life and the world, although the nature of his dissatisfaction was as incomprehensible to himself as it was to them. They put their heads together, in 1874, and Uncle Vincent, who had more understanding of his nephew's psychological problems than the others, had him transferred to Paris for a while (October–December). When the experiment failed, Vincent was sent back to London. Nevertheless, Paris was to bring matters to a head.

Vincent now clearly began to subordinate his social ego to the undefined being which contained his true self and its psychic structure. He was unable to write about this. For those who can read there are ample indications in views on painting and literature which are far from commonplace, as well as an obsessive and constrained (or unfree) religious life which had an increasingly disruptive effect on his relations with his family and their traditional bourgeois values.

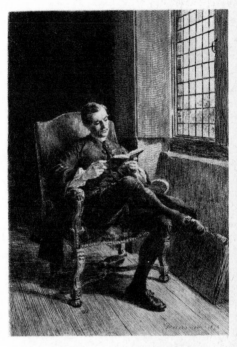

Ernest Meissonier. *The Reader* (see also *pl. 11*).

In May 1875 Vincent was transferred permanently to Paris. He knew he would be under special observation after the doubts felt about him in London.

Uncle Vincent has been here again. I have been with him pretty often and have talked things over. I asked him if there was any chance of getting you here in Paris. At first he wouldn't hear of it and said it was much better for you to stay in The Hague. I persisted, however, and you may be sure he will keep it in mind. When he comes to The Hague he probably will talk to you about it. Be as calm as you can and let him say whatever he likes: it will do you no harm, and probably you will want his help later on. You must not speak about me if you can avoid it.

He is enormously clever. When I was here last winter, one of the things he said to me was, 'Supernatural things I may not know, but I know everything about natural things.' I do not know if those were the exact words, but that was the meaning.

I can also tell you that one of his favourite pictures is *Lost Illusions* by Gleyre.

Sainte-Beuve said, 'In most men there exists a poet who died young, whom the man survived.' And Musset said, 'Know that often a dormant poet is hidden within us, always young and alive.' I think Uncle Vincent belongs to the first group. So you know whom you are dealing with. You can ask him straight out if he can have you transferred here or to London.

Thank you for the letter I got this morning and for the poem by Rückert. Have you a copy of his poems? I should like to know him better. As soon as there is a chance I shall send you a French Bible and the *Imitation of Christ*. The latter was probably the favourite book of the lady painted by Ph. de Champaigne. At the Louvre there is a portrait of her daughter, a nun, also by Ph. de Ch.; she has the *Imitation* on the chair beside her. . . .

[PS.] Do you have the photographs after Meissonier in the gallery? Look at them often; he has painted *men*. Probably you know his *Smoker at the Window* and *Young Man at Breakfast*. (31, 15 July 1875.)

His reading now centred on the Bible (in French) and Thomas à Kempis' *Imitation of Christ*; which had a significant influence on his convictions and even on his style of writing. He soon became an ardent visitor to the Louvre and the Luxembourg museum. Two contemporary painters that Vincent

mentioned at this time were to be of lasting importance to him: Ernest Meissonier and the painter-poet from Northern France, Jules Breton.

... Yesterday I saw the Corot exhibition. In it was the picture, *The Garden of Olives*; I am glad he painted that. To the right, a group of olive trees, dark against the glimmering blue sky; in the background, hills covered with shrubs and a few large ivy-grown trees over which the evening star shines.

At the Salon there are three very fine Corots; the best of them, painted shortly before his death, *Female Woodcutters*, will probably be reproduced as a woodcut in *L'Illustration* or *Le Monde Illustré*.

Of course I have also been to the Louvre and the Luxembourg. The Ruysdaels at the Louvre are splendid, especially *The Copse*, *The Stockade*, and *The Shaft of Sunlight*. I wish you could see the little Rembrandts there; *The Men of Emmaus* and its counterpart, *The Philosophers*.

Some time ago I saw Jules Breton with his wife and two daughters. His figure reminded me of J. Maris, but he has dark hair. As soon as there is an opportunity I will send you a book of his, *Les Champs et la mer*, which contains all his poems. He has a beautiful picture at the Salon, *St John's Eve*. Peasant girls dancing on a summer evening around a St John's fire; in the background, the village with a church and the moon over it. ...

[PS.] I have taken a little room in Montmartre which I am sure you would like. It is small, but it overlooks a little garden full of ivy and wild vines.

I will tell you what engravings I have on the wall. ... (27, 31 May 1875.)

His letters make no mention of his own work at the Goupil gallery, but include a remarkably detailed description – reminiscent of that of Thijs Maris' *Souvenir of Amsterdam* – of the striking Adriaan van Ostade group portrait in the Louvre, which is unusual for this painter in its choice of subject.

... Last Sunday I was at the Louvre (on Sundays I generally go there or to the Luxembourg). I wish you could see Van Ostade, his own family – himself, his wife and, I think, eight children. They are all in black – the wife and daughters with white caps and kerchiefs – in a stately old-Dutch room with a fireplace, large oak panels and ceiling, and whitewashed walls with pictures in black frames. In the corner of the room is a large bed with blue curtains and quilt.

The Rembrandt, *The Men of Emmaus*, which I wrote you about, has been engraved; Messrs. Goupil & Co. will publish the engraving next autumn. ... (35, 2 Sept. 1875.)

... Theo, I want to make a suggestion that may perhaps surprise you. Do not read Michelet any longer or *any* other book (except the Bible), until we have seen each other at Christmas, and do as I told you: go out in the evening often, dropping in on Van Stockum, Borchers and the like. I don't think you will regret it; you will feel much freer once you start this regimen.

Beware of the words I underlined in your letter [*still sadness*]. ... (36a, 8 Sept. 1875.)

The tone of Vincent's letters to his younger brother was becoming peremptory, and, with the zeal of a youthful Savonarola, he even went so far as to check later whether Theo had destroyed his copy of Michelet. Michelet had become an admired but dangerous writer. The text Vincent had quoted in London about the 'woman in black' continued to stir his imagination, although he urged its destruction. In July 1875 the picture was still on the wall of his room in Montmartre (letter 30).

With their frequently highflown, sermonizing tone and their profusion of Biblical texts (necessarily omitted here), conjoined with Thomas à Kempis' intense style of argument, his letters at this time do not make easy reading. He was unable as yet to formulate his ideas, and therefore borrowed much from other writers, although his sentiments were genuine and personal. This permeation of Vincent's feelings and thoughts with the spirit of the medieval lay religious movement of the *Devotio moderna*, from which Thomas à Kempis stemmed, was to be of importance all his life. Appealing directly to the individual, it preached a pure and humble way of life and the need to fight

27
26
29, 58

28

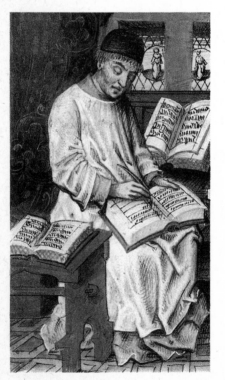

Thomas à Kempis (1379/80–1471). From a medieval ms. of the *Imitation of Christ*.

temptation. Both in Paris and on his return to England, Vincent had a picture of Thomas à Kempis on his wall (letter 33). It was a lithograph, untraceable today, of a painting by a now forgotten Spanish artist called Luis Ruyperez or Ruipérez (1833–67), a pupil of Meissonier, who at one time had a considerable reputation as a portrait and genre painter.

During the same period in Paris Vincent also quoted (from memory) the following lines from Christina Rossetti's poem 'Uphill':

> *Does the road wind uphill all the way?*
> *Yes to the very end.*
> *Will the day's journey take the whole long day?*
> *From morn to night, my friend.* (41, 6 Oct. 1875.)

(In writings about Van Gogh, reference is always made to his 'misquoting', although in this instance it consisted merely of 'go' instead of 'wind', 'the journey' instead of 'the day's journey' and 'till' instead of 'to'. This seems quite excusable in someone who seems to have been able to jot down from memory anything he had found deeply moving.)

He did not reflect to any great extent on his visual impressions of paintings, since their impact was mainly emotional. This provides a clue to what was passing through his mind at this time. Since leaving London Vincent had arrived in a zone of pain and suffering, and his thinking was dominated by a desire to know the meaning of the sorrow and what it had to convey to him, rather than by a wish to complain. He failed to assimilate the outer world, but let himself be permeated with whatever his unconscious self made him select. He digested it, but his religious life was not creative; hence its forced aspect, which he carried to the utmost extreme before discovering that it was doing violence to his nature.

In December 1875 he decided to go home to Holland for Christmas. His employer, the new proprietor of Goupil in Paris, Boussod, did not approve, but Vincent seemed oblivious of his displeasure. He had become a man overwhelmingly absorbed in his own problems, seeking dawn and dusk rather than the light of day. Back in Paris after Christmas, he wrote laconically to Theo:

I have not written to you since we saw each other; in the meantime something has happened that did not come altogether unexpectedly. When I saw M. Boussod again, I asked him if he approved of my being employed in the house for another year, and said that I hoped he had no serious complaints against me. But the latter was indeed the case, and in the end he forced me, as it were, to say that I would leave on the first of April, thanking the gentlemen for all that I might have learned in their house.

When the apple is ripe, a soft breeze makes it fall from the tree; such was the case here; in a sense I have done things that have been very wrong, and therefore I have but little to say. . . . (30, 10 Jan. 1876.)

Meanwhile his real, that is to say his inner, life – that of seeing, reading and evaluating – continued. All this seems to have counted for far more with him than the loss of prospects in the art trade.

. . . I have just read a very fine book by [George] Eliot, *Scenes from Clerical Life*; three tales, especially the last one, 'Janet's Repentance', struck me very much. It is the story of a clergyman who lived chiefly among the inhabitants of the squalid streets of a town; his study looked out on gardens with cabbage stalks, etc., and on the red roofs and smoking chimneys of poor tenements. For his dinner he usually had nothing but underdone mutton and watery potatoes. He died at the age of thirty-four. During his long illness he was nursed by a woman

who had been a drunkard, but by his teaching, and leaning as it were on him, had conquered her weakness and found rest for her soul. ... (55, 19 Feb. 1876.)

It would be hard to avoid the impression that there was a psychic link between Vincent's experiences and intentions later on in The Hague, relating to the alcoholic prostitute Christine, and the story he had read in Paris in 1876. He read with so much intensity that it seems as if, whenever his reading had activated his still unconscious desires and driving force, it could years later, totally detached from the actual moment, occasionally make itself felt not as a memory, but as something new and contemporary or resurgent.

To his parents, with their constant financial anxieties and obsessive concern for social appearances, Vincent's dismissal naturally came as a severe blow. They could hardly be expected to come anywhere near comprehending a problem which Vincent himself was still engaged in elucidating. His father wrote to Theo:

He leaves Paris at eight o'clock this evening. What will be passing through his mind – and through ours! You will understand something of all this. It is a bitter blow. And yet I have always continued to write and encourage him, and I also pointed out to him the possibility of starting up on his own if he was still keen on his occupation. Uncle Cent started up with a miniature business, and he went so far in the world, and Uncle Cor ditto. *If only he could gain some life and energy!* and fight his way through with fresh vigour – whatever he does and wishes to do, it will have to come from himself. (Father to Theo, 31 Mar. 1876.)

Vincent's father had had no sign that the 'life and energy' that his son had failed to devote to business were abundantly present in his inner life. His parents complained that the letter they received from him on 31 March was

... only about paintings ... without a word about his birthday or anything else ... How he loves art, and how deeply he will feel having to take leave of it all. I need not tell you how sad we are, and it must be a great disappointment to you as well ... (Mother to Theo, Apr. 1876.)

Arriving at Etten on 1 April 1876, one day after his twenty-third birthday, Vincent came face to face with the hard reality of needing to find another job. Naturally drawn to the religious tradition in the family, more so than to the world of commerce, and devoted as he was to the Bible and the works of Thomas à Kempis and John Bunyan (*A Pilgrim's Progress*), he felt a strong desire to preach the Gospel to the poor. His sense of reality, however, was still far from strong.

He decided to try to teach and preach, although unqualified for either, and took up a post, in return for board and lodging only, as assistant master at the small private school run by a minister, the Rev. William Port Stokes, at Ramsgate in south-eastern England.

And now Vincent has left us. We have had such pleasant days with him. His impending departure gave us all a difficult day; we took communion together at De Hoeven, and Father found it hard to have to preach a sermon at five o'clock after Vincent had left at four. (Mother to Theo, 16 Apr. 1876.)

Vincent felt impelled to tell his parents about his crossing to Ramsgate and his never-ending difficulty in saying farewell, always experiencing his departures in symbolic depth. It is possible to observe a fundamental fusion of inner and external worlds, which existed long before the revelation of his will to create, and which ever afterwards gave his vision of reality a quality of its own.

You have probably received my telegram, but you will be glad to hear some more particulars. On the train I wrote down a few things, and I am sending them to you, so that you will know all about my journey.

Friday.

In thought we will stay together today. Which do you think is better . . . the joy of meeting or the sorrow of parting? We have often parted before; this time there was more sorrow in it than there used to be, but also more courage because of the firmer hope, the stronger desire, for God's blessing. And didn't nature seem to share our feelings, everything looked so grey and dull a few hours ago.

Now I am looking across the vast expanse of meadows, and everything is very quiet; the sun is disappearing again behind the grey clouds, but sheds a golden light over the fields.

These first hours after our parting – which you are spending in church, and I at the station and on the train – how we are longing for each other and how we think of the others, of Theo and Anna and the other little sisters and the brother. Just now we passed Zevenbergen; I thought of the day you took me there, and I stood on the steps at Mr Provily's, looking after your carriage on the wet road; and then of that evening when my father came to visit me for the first time. And of that first homecoming at Christmas!

Saturday and Sunday.

On the steamer I thought often of Anna – everything reminded me of our journey together.

The weather was clear, and the river was especially beautiful, and also the view, seen from the sea, of the dunes, dazzling white in the sun. The last I saw of Holland was a little grey church spire. I stayed on deck until sunset, but then it became too cold and rough.

At dawn the next morning on the train from Harwich to London it was beautiful to see the black fields and green meadows with sheep and lambs and an occasional thornbush and a few large oak trees with dark twigs and grey moss-covered trunks; the shimmering blue sky with a few stars still, and a bank of grey clouds at the horizon. Before sunrise I had already heard the lark. When we were near the last station before London, the sun rose. The bank of grey clouds had disappeared and there was the sun, as simple and grand as ever I saw it, a real Easter sun. The grass sparkled with dew and night frost. But I still prefer that grey hour when we parted.

Saturday afternoon I stayed on deck till the sun had set. The water was fairly dark blue with rather high white-crested waves as far as one could see. The coast had already disappeared from sight. The sky was one vast light blue, without a single little cloud. And the sunset cast a streak of glittering light on the water. It was indeed a grand and majestic sight, but still the simpler, quieter things touch one so much more deeply. . . .

At one o'clock I arrived at Mr Stokes's; he was not home but will be back tonight. During his absence his place was taken by his son (twenty-three years old, I think), a teacher in London. I saw Mrs Stokes at dinner. There are twenty-four boys from ten to fourteen years old. (It is a pleasant sight to see them at their dinner.) So the school is not large. The window looks out on the sea. . . . Yesterday everything was grey. In the evening we went with the boys to church. On the wall of the church was written: 'Lo, I am with you always, even unto the end of the world.'

The boys go to bed at eight o'clock, and they rise at six.

There is another assistant teacher, seventeen years old. He, four boys and myself sleep in another house near by, where I have a little room that is waiting for some prints on the wall. (Vincent to parents, 60, 17 Apr. 1876.)

In the nine months he now spent in England, at Ramsgate and Isleworth, Vincent occupied lowly and ill-rewarded posts at private schools, living in a constant state of self-scrutiny. In this he was aided by his explorations of nature, in the external world of earth and sky. A sense of darkness and confinement often yielded to moments of religious ecstasy. Periods of desolation were transformed into tense, devout moods in which he could scale the heights of ecstatic experience. Those nine months passed in an inner twilight.

It is not enough to select just one of the wonderful descriptions of his remarkable walks. Apparent repetitions in fact never do repeat, but reflect a

renewed penetration to the source, an absorbing, an ecstatic experience, clearly nourished by powerful driving forces from his unconscious self. Walking, for him as for Wordsworth and Coleridge, was a passion: the finest condition for engendering the required state of loneliness in which he could scrutinize his inner life and at the same time lose himself in the external world of nature familiar to him since his childhood in Brabant. He loved the nights, rose early, and did not mind spending the night out of doors. In Arles he was to say that 'night is even more richly coloured than day'.

Vincent's sense of affinity with anything gnarled or thorny, or anything which clings like ivy or moss, is already apparent in a few lines from a letter written soon after he arrived at Ramsgate.

... Now I am going to tell you about a walk we took yesterday. It was to an inlet of the sea, and the road there led through fields of young corn and along hedges of hawthorn, etc. Once there, we saw to our left a steep two-storey-high ridge of sand and stone. On top of it were old gnarled hawthorn bushes – their black and grey moss-covered stems and branches were all bent to one side by the wind; there were also a few elder bushes.

The ground we walked on was all covered with big grey stones, chalk and shells. To the right lay the sea as calm as a pond, reflecting the light of the transparent grey sky where the sun was setting. The tide was out and the water very low. ... (63, 28 Apr. 1876.)

One of Vincent's last Ramsgate letters conveys much of his state of mind, and his perennial fascination with the 'poetry of parting'. The precise phraseology, more mature now than during his first stay in London, and the ecstatic, stilled tone with which he experienced and reported the appearance of first light, birdsong, the sight of the sea at night, and his evening wanderings, either in the country or in the streets of London, are signs that his walks were the great moments, the profound experiences of those nine months.

... Did I tell you about the storm I watched recently? The sea was yellowish, especially near the shore; on the horizon a strip of light, and above it immense dark grey clouds from which the rain poured down in slanting streaks. The wind blew the dust from the little white path on the rocks into the sea and bent the blooming hawthorn bushes and wallflowers that grow on the rocks. To the right were fields of young green corn, and in the distance the town looked like the towns that Albrecht Dürer used to etch. A town with its turrets, mills, slate roofs and houses built in Gothic style, and below, the harbour between two jetties which project far into the sea.

I also saw the sea last Sunday night. Everything was dark and grey, but in the horizon the day began to dawn. It was still very early, but a lark was already singing. So were the nightingales in the gardens near the sea. In the distance shone the light from the lighthouse, the guard ship, etc.

From the window of my room that same night I looked on the roofs of the houses that can be seen from there and on the tops of the elm trees, dark against the night sky. Over those roofs one single star, but a beautiful, large, friendly one. And I thought of you all and of my own past years and of our home, and in me arose the words and the emotion: 'Keep me from being a son that maketh ashamed; give my Thy blessing, not because I deserve it, but for my mother's sake. Thou art love, cover all things. Without Thy continued blessings we succeed in nothing.'

Enclosed is a little drawing of the view from the school window through which the boys wave good-bye to their parents when they are going back to the station after a visit. None of us will ever forget the view from the window. *You ought to have seen* it this week when it rained, especially in the twilight when the lamps were lit and their light was reflected in the wet street.

On such days Mr Stokes is sometimes in a bad temper, and when the boys make more noise than he likes, they occasionally have to go without their supper. I wish you could see them looking from the window then, it is rather melancholy: they have so little else except their meals to look forward to and to help them pass their days. ... (67, 31 May 1876.)

Drawing from letter 67.

Stokes closed his school at Ramsgate in the summer of 1876 and moved it to Isleworth, a few miles up the Thames from London. On 12 June Vincent followed, taking the opportunity to visit his sister Anna at Welwyn in Hertfordshire, north of the city.

Last Monday I started from Ramsgate to London. It is a long walk; when I left it was very hot, and it stayed so until the evening, when I arrived in Canterbury. I went still a little farther that same evening, till I arrived at a few large beech and elm trees near a little pond; there I rested for a while. At half past three in the morning the birds began to sing at sight of dawn and I set off again. It was fine to walk then.

In the afternoon I arrived at Chatham. There one can see in the distance between partly flooded low-lying meadows, with elm trees here and there, the Thames full of ships. I believe the weather is always grey. I met a cart which took me a few miles farther, but then the driver went into an inn and I thought that he would stay a long time, so I continued on my way.

But to continue. One night I stayed at Mr Reid's and the next day at Mr Gladwell's, where they were very, very kind. Mr Gladwell kissed me good night that evening and it did me good; may it be given to me in the future to prove my friendship for his son now and then.

I wanted to go on to Welwyn that very evening, but they kept me back literally by force because of the pouring rain. However, when it began to let up about four o'clock in the morning, I set off for Welwyn. First a long walk from one end of the city to the other. In the afternoon at five o'clock I was with our sister and was very glad to see her. She is looking well, and you would like her little room as much as I do, with the *Good Friday, Christ in the Garden of Olives, Mater Dolorosa* framed in ivy. . . . (69, 17 June 1876.)

Professionally, Vincent's prospects remained dim. He wrote to Theo from Isleworth:

The time may come when I shall look back with a certain melancholy on the 'fleshpots of Egypt' connected with other situations – that is, the bigger salaries and the higher worldly esteem – this I foresee.

Mr Stokes says that he definitely cannot give me any salary because he can get teachers enough for just board and lodging, and that is true. But will it be possible for me to continue this way? I am afraid not; it will be decided soon enough.

But, boy, however this may be, one thing I can repeat: these few months have bound me so strongly to the sphere that extends from schoolmaster to clergyman, as much by the pleasures connected with those professions as by the thorns which have pricked me, that I cannot draw back any more. So I have to go on! . . .

Last week I was at Hampton Court to see the beautiful gardens and long avenues of chestnut and lime trees, where many crows and rooks have their nests, and also to see the palace and the pictures. Among other things there are many portraits by Holbein which are very beautiful; two splendid Rembrandts (the portrait of his wife, and of a rabbi); beautiful Italian portraits by Bellini, Titian; a picture by Leonardo da Vinci; cartoons by Mantegna; a beautiful picture by S. Ruysdael; a still life of fruit by Cuyp, etc. I wish you had been there with me; it was a pleasure to see pictures again.

And involuntarily I thought of the persons who had lived there at Hampton Court, of Charles I and his wife (it was she who said, 'I thank Thee, my God, for having made me queen, but an unhappy queen') at whose grave Bossuet spoke from the fullness of his heart. Do you have Bossuet's *Oraisons funèbres*? In it you will find that speech (there is a very cheap edition, I think for 50 centimes); and I thought also of Lord and Lady Russell, who must have been there very often too (Guizot described their lives in *L'Amour dans le mariage* – you must read that when you can lay your hands on it).

Enclosed, a feather from one of the rooks there. . . . (70, 5 July 1876.)

Early in July, Vincent moved to another private school in Isleworth, kept by a Methodist minister, the Rev. T. Slade Jones, who not only paid him a salary (unlike Stokes) but was to remain a friend.

It is Saturday again and I am writing once more. How I long to see you all again. Oh! my longing is sometimes so strong. Drop me a line soon, to tell me how things are.

Last Wednesday we took a long walk to a village an hour from here. The road led through meadows and fields, along hedges of hawthorn, full of blackberries and traveller's joy, and an occasional large elm tree. It was so beautiful when the sun set behind the grey clouds and the shadows were long. By chance we came upon Mr Stokes's school; several of the boys I knew are still there. The clouds stayed red long after the sun had set and the dusk had settled over the fields; and in the distance we saw the lamps lit in the village.

While I was writing to you, I was called to Mr Jones, who asked if I would walk to London to collect some money for him. And when I came home in the evening, hurrah! there was a letter from Father with news of you. How I should like to be with you both, my boy. And thank God there is some improvement, though you are still weak. And you will be longing to see Mother, and now that I hear that you are going home with her, I think of Conscience's words:

'I was ill. My mind was fatigued, my soul disillusioned, my body suffering. I, whom God has endowed at least with mental energy, and with a vast instinct for affection, I was sinking into the depths of the bitterest discouragement, and I felt with horror the deadly poison that was entering my withered heart. I spent three months on the Heath – you know that fair land where the soul returns to itself and enjoys a delectable repose, where all is calm and peace; where the soul, in the presence of God's immaculate creation, shakes off the yoke of convention, forgets society and frees itself from its fetters with the vigour of youth reborn; where every thought forms a prayer, where all that is out of harmony with the freshness and freedom of nature departs from the heart. Oh! there the tired soul finds tranquillity, there the exhausted man regains his youthful strength. So passed my days of sickness. . . . And the evenings? To sit beneath the wide canopy of the fireplace, feet in the ashes, gazing up at a star which sends down its ray through the opening of the chimney, as if to send me an appeal; or deep in a vague reverie, watching the flames as they are born, rise, pant, flicker, succeed each other, as if out of desire to lick the pot with their fiery tongues, and reflecting that this is human life: we are born, we work, we love, we grow, and we vanish!' [Henri Conscience, *Le Conscrit*, preface.]

Mr Jones has promised me that I shall not have to teach so much in future, but may work more in his parish, visiting the people, talking with them, etc. May God give it His blessing.

Now I am going to tell you about my walk to London. I left here at twelve o'clock in the morning and reached my destination between five and six. When I came into the part of town where most of the picture galleries are, around the Strand, I met many acquaintances: it was dinnertime, so many were in the street, leaving the office or going back there. First I met a young clergyman with whom I became acquainted when he preached here once. After that, Mr Wallis's employee and then one of the Messrs. Wallis, whose house I visited occasionally; now he has two children. Then I met Mr Reid and Mr Richardson, who are already old friends. Last year about this time Mr Richardson was in Paris and we walked together to Père Lachaise.

After that I went to Van Wisselingh, where I saw sketches for two church windows. In the middle of one window was a portrait of a middle-aged lady – oh, such a noble face – with the words 'Thy will be done' over it; and in the other window, a portrait of her daughter with the words, 'Faith is the substance of things hoped for, the evidence of things not seen.' There, and in Messrs. Goupil & Co.'s gallery, I saw beautiful pictures and drawings. It is such an intense delight to be so often reminded of Holland by art. . . . Then to the place where I had to collect the money for Mr Jones. The suburbs of London have a peculiar charm; between the little houses and gardens there are open spots covered with grass and generally with a church or school or workhouse in the middle among the trees and shrubs. It can be so beautiful there when the sun is setting red in the thin evening mist.

Yesterday evening it was like that, and afterward I wished you could have seen those London streets when the twilight began to fall and the lamps were lit and everybody went home. Everything showed that it was Saturday night, and in all that bustle there was peace, one felt the need of and the excitement at the approaching Sunday. Oh, those Sundays, and all that is done and accomplished on those Sundays, it is such a comfort for those poor districts and crowded streets.

In the City it was dark, but it was a beautiful walk along the row of churches one has to pass. Near the Strand I caught a bus which took me quite a long way; it was already pretty late. I passed Mr Jones's little church and saw another one in the distance, with a light still burning at that hour; I entered and found it to be a very beautiful little Catholic church where a few women were praying. Then I came to that dark park which I have already written you about; from it I saw far away the lights of Isleworth and the church with the ivy, and the churchyard with the weeping willows on the banks of the Thames.

Tomorrow for the second time I shall get some small salary for my new work, and with it buy a pair of new boots and a new hat. And then, God willing, I shall gird myself up again.

Everywhere in the London streets they sell scented violets, which bloom here twice a year. I bought some for Mrs Jones to make her forget the pipe I smoke now and then, especially late in the evening in the playground, but the tobacco here is rather a gloomy weed. . . . (76, 7/8 Oct. 1876.)

The sermon Vincent preached at Richmond, towards the end of his final nine months in England, was a great moment for him. It is a mixture of personal experience and borrowed formulations – quoted, as usual, from memory. It shows how powerful and workable a synthesis he had developed between literature and the Bible, as well as between literature and his sentiments about painting and nature. An irresistible fusion of painting, narrative and landscape had taken place in his imagination, and he included all three elements in his conception of a 'picture'.

The entire sermon is permeated with the spirit of Puritanism, and in particular with that of Methodism, which, at this time more than later, was in tune with Vincent's own character. Since 1875 he had been a passionate reader of Bunyan, of whom it is said that in England there are more editions of his work than of any other writer except Shakespeare. After a dramatic experience of conversion, Bunyan had taken to preaching among the ordinary, poor people whom the established Church neglected. For this and his non-conformist views he spent years in prison. His personal style of devotion, and his simple, measured style of writing, in which allegory alternated with realism, were highly congenial to Vincent.

In composing his sermon, Vincent used symbolic images made up of elements such as the pilgrim's journey to the Heavenly City through the Valley of the Shadow of Death, his meeting with the woman in black (which for Vincent had become an almost obsessive image since his encounter with Michelet's description of the portrait by Champaigne); the constant question, 'Is there far still to go?' (frequently quoted from Christina Rossetti's 'Uphill'), and, lastly, Boughton's lost painting which Vincent called *The Pilgrim's Progress*. Here he followed his own imagination, and provided the only genuine section of the sermon. The confusion of elements makes it typical of his later work.

18

. . . Our life is a pilgrim's progress. I once saw a very beautiful picture: it was a landscape at evening. In the distance on the right-hand side a row of hills appeared blue in the evening mist. Above those hills the splendour of the sunset, the grey clouds with their linings of silver and gold and purple. The landscape is a plain or heath covered with grass and its yellow leaves, for it was in autumn. Through the landscape a road leads to a high mountain far, far away, on the top of that mountain is a city whereon the setting sun casts a glory. On the road walks a pilgrim, staff in hand. He has been walking for a good long while already and he is very tired. And now he meets a woman, a figure in black, that makes one think of St Paul's word: As being sorrowful yet always rejoicing. That Angel of God has been placed there to encourage the pilgrims and to answer their questions and the pilgrim asks her: 'Does the road go uphill then all the way?'

And the answer is: 'Yes to the very end.'
And he asks again: 'And will the journey take all day long?'
And the answer is: 'From morn till night my friend.'
And the pilgrim goes on sorrowful yet always rejoicing – sorrowful because it is so far off and the road so long. Hopeful as he looks up to the eternal city far away, resplendent in the evening glow. ... (CLVG, I, 90.)

... Theo, your brother has preached for the first time, last Sunday, in God's dwelling, of which is written 'In this place, I will give peace.' Enclosed a copy of what I said. My it be the first of many.

It was a clear autumn day and a beautiful walk from here to Richmond along the Thames, in which the great chestnut trees with their load of yellow leaves and the clear blue sky were mirrored. Through the tops of the trees one could see that part of Richmond which lies on the hill: the houses with their red roofs, uncurtained windows and green gardens; and the grey spire high above them; and below, the long grey bridge with the tall poplars on either side, over which the people passed like little black figures.

When I was standing in the pulpit, I felt like somebody who, emerging from a dark cave underground, comes back to the friendly daylight. It is a delightful thought that in the future wherever I go, I shall preach the Gospel; to do that *well*, one must have the Gospel in one's heart. May the Lord give it to me. ...

Yesterday evening I was again at Richmond, and walked through a large grassy field surrounded by trees and houses, over which the church spire rises. The dew was lying on the grass and the twilight was falling: on one side the sky was still aglow from the setting sun, on the other, the moon was rising. Under the trees an old lady with beautiful grey hair was walking, dressed in black. In the middle of the grass plot the boys had lit a bonfire which one could see flickering from afar. I thought of the lines: 'Once at the evening of my life, tired from care and strife, I'll bring Thee praise more loud and fair, for each day given to me here.' (79, 7 Oct. 1876.)

Vincent went home for Christmas in December 1876, and never returned to England. His prospects there appeared non-existent, and it was decided that he would try something new.

... A few days ago Mr Braat from Dordrecht came to visit Uncle Vincent, and they talked about me; Uncle asked Mr Braat if he had a place for me in his business, should I want one. Mr Braat thought so, and said that I should just come and talk it over. So I went there early yesterday morning; I thought I could not let it go by without seeing what it was. We arranged that I should come for a week after New Year's to try it out, and after that we will see. There are many things that make it desirable; being back in Holland near Father and Mother, and also near you and all the others. Then the salary would certainly be better than at Mr Jones's, and it is one's duty to think of that because later in life a man needs more.

As to the religious work, I still do not give it up. Father has so many interests and he is so versatile, I hope that in whatever circumstances I may be, something similar will develop in me. The change will be that, instead of teaching the boys, I shall work in a bookshop. ...

So it is quite possible that I shall go there.

Yesterday evening I was at Uncle Vincent's to tell him that I had gone to Dordrecht at once. It was a stormy night; you can imagine how beautiful the road to Prinsenhage was with the dark clouds and their silver linings.

I just entered for a minute the Catholic church where evening service was being held. It was a beautiful sight, all those peasants and peasant women in their black dresses and white caps, and the church looked so cheerful in the evening light. ... (83, 31 Dec. 1876.)

Vincent spent just over three months (14 January–2 May 1877) working for the Blussé & Van Braam bookshop. Thirty-seven years later, when Vincent was famous, a Rotterdam journalist made some enquiries at Dordrecht, and talked to one of Braat's sons (whose brother Frans had been a colleague of Theo's at Goupil).

In theory Vincent had the show goods, and now and then the delivery goods, under his care – but whenever anyone looked at what he was doing, it was found that instead of working, he was translating the Bible into French, German and English, in four columns, with the Dutch text in addition.

He was puttering at this mostly. At other times when you happened to look, you caught him making little sketches, such silly pen-and-ink drawings, a little tree with a lot of branches and side branches and twigs – nobody ever saw anything else in it. (Although it turned out that afterward, when this work had come so much into vogue, Mr Braat had taken a good look through Vincent's little desk from top to bottom! – But not the slightest vestige of his handiwork was to be found, neither outside nor in.) . . .

'Well, shortly afterward Vincent went to Amsterdam and was taken in by his uncle, the rear admiral, in whose house he started studying Latin and Greek in an attic. Since then I have lost sight of him – I cannot say I was particularly interested. No, he was not an attractive boy, with those small, narrowed, peering eyes of his, and, in fact, he was always a bit unsociable.

'And then I remember well that he always preferred to wear a top hat, a bit of respectability he had brought back from England; but such a hat – you were afraid you might tear its brim off if you took hold of it. I have often puzzled over his exact age, but I cannot work out, for instance, whether he was old enough to be called up for the militia.'

But he was certainly obliging, and physically very strong, though he did not look it. During one of those frequent floods Mr Braat had admired his physical strength and good nature. At the time he lived in Tolbrugstraatje – in a room with whitewashed walls, my informant believed, on which he had made all kinds of sketches and crude drawings. But his landlord, who did not like this at all, had repainted them later on. However this may have been – that particular night everything was flooded. Without hesitating for a moment, Van Gogh rushed out of the house and waded through the water to his employer's house in order to warn him. For Blussé & Van Braam's storehouse was next door to his boarding-house. All the next morning he was lifting those heavy wet sacks of paper and carrying them upstairs. After all these years Mr Braat still spoke with admiration of so much physical strength.

Also, Van Gogh was always as compliant as possible. For all that, he now and then could irritate the old gentleman into peevishness: 'Good heavens! that boy's standing there translating the Bible again.' But he could not be trusted to serve the public and such, except perhaps to sell a quire of letter paper or a halfpenny print once in a while. For he had not the slightest knowledge of the book trade, and he did not make any attempt to learn.

On the contrary, he was excessively interested in religion. 'On Sunday he always went to church, preferably an orthodox one. – And during the week, well, we started work here at eight o'clock in the morning; at one o'clock he went home to lunch until three; and then he came back in the evening for a few hours. For the rest, he had no intercourse with anybody; he led an absolutely solitary life. He took many walks all over the island, but always alone. In the shop he hardly spoke a word. In short, he was something of a recluse.' . . . (M.J. Brusse, 'Onder de mensen', *Nieuwe Rotterdamse Courant*, 26 May, 2 June 1914, CLVG, I, 108–09.)

At Dordrecht he continued with even greater intensity the twilit life of his days in Isleworth, went to church, including the Eglise Wallonne, and did some drawing. The thirteen letters dating from this period also refer to frequent visits to museums and art galleries. Once again he continued to go for a great many walks, insisted that Theo and his father accompanied him to the museum, and extolled Ary Scheffer, chiefly because of the subject matter of paintings such as *Christ in Gethsemane, Portrait of The Artist's Mother, Christ the Comforter*. His predilection for ivy was a continuation of his English love of Dickens' 'strange old plant'.

38
39

. . . The two prints, *Christus Consolator* and *Remunerator*, which you gave me are hanging in my little room – I saw the pictures at the museum, as well as Scheffer's *Christ in Gethsemane*, which is unforgettable. Then there is a sketch of *Les Douleurs de la Terre* and several drawings, a sketch of his studio, and, as you know, the portrait of his mother. There are still other fine pictures, for instance, Achenbach and Schelfhout and Koekkoek and also a fine Allebé – an old man near the stove. Shall we look at them together someday? . . .

The window of my room looks out on a garden with pine trees and poplars, and the backs of old houses covered with ivy. 'A strange old plant is the ivy green,' says Dickens. The view from my window can be solemn and more or less gloomy, but you ought to see it in the morning sun – how different it is then. When I look at it, I am often reminded of a letter from you in which you speak of such a house covered with ivy – do you remember? ...

30 If you can afford it – if I can, I will do the same – you must subscribe to the Catholic *Illustration* of this year; there are prints in it from London by Doré – the wharves on the Thames, Westminster, Whitechapel, the underground railway, etc. ... (84, 21 Jan. 1877.)

... Oh, that I may be shown the way to devote my life more fully to the service of God and the Gospel. I keep praying for it and, in all humility, I think I shall be heard. Humanly speaking, one would say it cannot happen; but when I think seriously about it and penetrate the surface of what is impossible to man, then my soul is in communion with God, for it is possible to Him Who speaketh, and it is, Who commandeth, and it stands firmly.

Oh! Theo, Theo boy, if I might only succeed in this! If that heavy depression because everything I have undertaken has failed, and that torrent of reproaches which I have heard and felt, might be taken from me; and if there might be given to me both the necessary opportunity and the strength to develop fully and to persevere in that course for which my father and I would thank the Lord so fervently. ... (92, 15 Apr. 1877.)

This letter shows how his family's reproaches had wounded him. However, his proposal to study for admission to university at Amsterdam, after giving up his job at the bookshop, was approved by all the family except his Uncle Vincent, who lacked confidence in it. His final letter from Dordrecht mentions three separate church attendances. After a morning service at the French church he quoted the text of the sermon, taken from I Corinthians 13.12, which had deeply impressed him: 'For now we see through a glass, darkly; but then face to face: now I know in part, but then shall I know even as also I am known.'

In letter 641a, written shortly before his death in 1890, he quoted it, following his mother's departure from Nuenen, to allude to the ultimate farewell. This text, quoted in its Dutch form ('in a mirror, by a dark reason'), obsessed him for years.

... In the afternoon I was in the Great Church to hear the Reverend Mr Keller van Hoorn; his text was, 'Our Father.' In the evening I heard the Reverend Mr Greeff, whom I also heard the first Sunday night I was here in Dordrecht. May the Lord bless thee and keep thee. The Lord make His face to shine upon thee, and give thee peace. The Lord make thee pray high prayers and think high thoughts. The Lord be thy keeper and the shade upon thy right hand. May He be with thee always until the end of the world.

After church I walked along the path behind the station where we walked together; my thoughts were full of you, and I wished we might be together. I walked on to the churchyard at the end of a black cinder track through the meadows – they looked so beautiful in the twilight. The churchyard reminds me of that drawing by Apol in *Eigen Haard*; a moat surrounds it, and there is a house circled by pine trees – last night a light was shining kindly through the windows – it is an old house, and looks like a parsonage. ...

Much good may be in store for us in the future; let us learn to repeat with Father, 'I never despair'; and with Uncle Jan, 'The devil is never so black but you can look him in the face.' ...

Between times I have worked through the whole story of Christ from a catechism book of Uncle Stricker's and copied the texts; they reminded me of so many pictures by Rembrandt and others. I hope and believe I will not repent my choosing to try to become a Christian and a Christian worker. Yes, everything in my past experience may contribute to it: through the acquaintance with cities such as London and Paris and life in schools like those at Ramsgate and Isleworth, one is strongly drawn and attached to many things and books from the Bible – for instance, the Acts of the Apostles. Knowledge of and love for the work and life of men like Jules Breton, Millet, Jacque, Rembrandt, Bosboom and so many others may become a source

of new thoughts. What a resemblance there is between the work and life of Father and that of those men; I value Father's higher still. ... (94, 30 April 1877.)

The twenty-six letters Vincent wrote as a theological student in Amsterdam between May 1877 and July 1878 reflect the same two driving forces within him: religion and art. His devotion to art and to literature was increasing rather than diminishing, and it was further stimulated by the paintings then exhibited by the State in the Trippenhuis (Cuypers' Rijksmuseum was not yet *12–14* built). This interest was in fact gaining ground on his obligation to learn Latin, Greek and other subjects so as to be admitted to the University. He still remained firmly tied to the family circle, and had a room in an official residence in the Amsterdam naval dockyard, where his Uncle Jan was officer *42* commanding. He called regularly on his aunt Catrina Gerardina Carbentus and her husband J.P. Stricker, a prominent clergyman. One of the Strickers' *43* daughters was married to a clergyman by the name of Vos, and Vincent enjoyed visiting the young couple as well. After she was widowed a few years later, this cousin, Cornelia Adriana (Kee), born 21 March 1846, was to *49* become the object of Vincent's great and unrequited love.

 Outside the family circle his tutor Dr M.B. Mendes da Costa was the only person with whom he was able to talk freely without fear of offending the authoritarian sensibilities of clerics like his Uncle Stricker – for whom Vincent, however, had considerable affection. Mendes da Costa wrote a frank memoir many years later.

... Our first meeting, of so much importance to the relationship between master and pupil, was very pleasant indeed. The seemingly reticent young man – our ages differed but little, for I was twenty-six then, and he was undoubtedly over twenty – immediately felt at home, and notwithstanding his lank reddish hair and his many freckles, his appearance was far from unattractive to me. In passing, let me say that it is not very clear to me why his sister [Lies] speaks of his 'more or less rough exterior'; it is possible that, after the time when I knew him, because of his untidiness and his growing a beard, his outward appearance lost something of its charming quaintness; but most decidedly it can never have been rough, neither his nervous hands, nor his countenance, which might have been considered homely, but which expressed so much and hid so much more.

I succeeded in winning his confidence and friendship very soon, which was so essential in this case; and as his studies were prompted by the best of intentions, we made comparatively good progress in the beginning – I was soon able to let him translate an easy Latin author. Needless to say, he, who was so fanatically devout in those days, at once started using this little bit of Latin knowledge to read Thomas à Kempis in the original.

So far everything went well, including mathematics, which he had begun studying with another master in the meantime; but after a short time the Greek verbs became too much for him. However I might set about it, whatever trick I might invent to enliven the lessons, it was no use. 'Mendes,' he would say – we did not 'mister' each other any more – 'Mendes, do you seriously believe that such horrors are indispensable to a man who wants to do what I want to do: give peace to poor creatures and reconcile them to their existence here on earth?'

And I, who as his master naturally could not agree, but who felt in my heart of hearts that he – mind, I say *he*, Vincent van Gogh! – was quite right, I put up the most formidable defence I was capable of; but it was no use.

'John Bunyan's *Pilgrim's Progress* is of much more use to me, and Thomas à Kempis and a translation of the Bible; and I don't want anything more.' I really do not know how many times he told me this, nor how many times I went to the Reverend Mr Stricker to discuss the matter, after which it was decided again and again that Vincent ought to have another try.

But before long the trouble would start afresh, and then he would come to me in the morning with an announcement I knew so well, 'Mendes, last night I used the cudgel again,' or, 'Mendes, last night I got myself locked out again.' It should be observed that this was some

sort of self-chastisement resorted to whenever he thought he had neglected a duty. . . . (M.B. Mendes da Costa, *Het Algemeen Handelsblad* (Amsterdam), 2 Dec. 1910, CLVG, I, 169–70.)

Vincent's parents showed touching solicitude for the neglected appearance of their twenty-four-year-old son.

We have smartened him up a little by putting him in the hands of the best tailor in Breda. Would you care to perform an act of mercy and have his *chevelure* metamorphosed by a clever barber? Here in Etten there is no one suitable, but I think a Hague *friseur* would be able to make something of it. (Mother to Theo, 7 May 1877.)

His first letter from Amsterdam to Theo in The Hague proves once more that art, painting, and the pictures he wanted to hang on his own wall, were taking precedence over his studies.

. . . I am sending you something for your collection by the same mail, namely a lithograph after J. Maris which might be called *A Poor Man in the Kingdom of God* and a lithograph after Mollinger – I never saw it before, did you?

A Jewish bookseller who gets me the Latin and Greek books I want had a large number of prints, and I could choose from them very cheaply, thirteen for 70 cents. I took some for my little room to give it the right atmosphere, for that is necessary to get new thoughts and ideas. I will tell you what they are, then you will know how my room looks and what is hanging there: one after Jamin (it also hangs in your room); one after M. Maris, the little boy going to school; five after Bosboom, Van der Maaten's *Funeral Procession through the Cornfields*; Israëls, poor man on a snowy winter road; and Ostade, studio. Then there is still an Allebé, a little old woman carrying her hot water and live coals on a winter morning along a snow-covered street. I sent the last one to Cor for his birthday. The Jew had a lot more fine things, but I could not afford any more, and though I like to put some up in my room, I am not going to make a collection.

Yesterday Uncle Cor sent me a lot of old paper, like the sheet on which I am writing now; isn't it delightful for writing my exercises on?

I have a lot of work to do and it is not very easy, but patience will help me through. I hope to remember the ivy 'which stealeth on though he wears no wings'; as the ivy creeps along the walls, so the pen must crawl over the paper.

Every day I take a long walk. Lately I came through a very nice part of town; I went along the Buitenkant to the Dutch Railway station, where I saw men working with sand carts near the IJ, and I passed through many narrow streets with gardens full of ivy. Somehow it reminded me of Ramsgate. Near the station I turned to the left, where all the windmills are, along a canal with elm trees; everything there reminds one of Rembrandt's etchings.

How is Mrs Tersteeg, and have you been to see Mauve? Keep courage, there may be good days in store for us, if God will grant us life and bless what we undertake. Will you ever hear me preach in some little church? May God grant it – I believe that He will. . . .

[PS.] Yesterday I saw a portrait of Michelet; I looked at it carefully and thought of 'his life of ink and paper'. At night I am tired and I cannot get up as early as I wish, but I will get over that, and hope to force myself to it. (95, 19 May 1877.)

Michelet was now fully restored to Vincent's affections. His letters give a lively impression of insuperable distaste for his studies and a conflicting desire to complete them so as to confound those who would otherwise condemn him.

The idea, a central one in the minds of many nineteenth-century artists and writers, of a 'wasted life' – *une vie, une existence, manquée* – here makes its first appearance in Vincent's letters, long before the related idea of sacrificing all human happiness in the cause of art. Vincent was ultimately to make that

Thomas Couture. *Jules Michelet* (detail).

sacrifice, but would never cease to be tormented by the sense of the life he had missed.

... A phrase in your letter struck me: 'I wish I were far away from everything; I am the cause of all, and bring only sorrow to everybody; I alone have brought all this misery on myself and others.' These words struck me because that same feeling, exactly the same, neither more nor less, is also on my conscience.

When I think of the past; when I think of the future of almost invincible difficulties, of much and difficult work which I do not like – which I, or rather my evil self, would like to shirk; when I think of the many watching me who will know where the fault is if I do not succeed, who will not make trivial reproaches, but as they are well tried and trained in everything that is right and virtuous and pure gold, the expression on their faces will seem to say, We have helped you and have been a light unto you, we have done for you what we could – have you honestly tried? What is our reward and the fruit of our labour now? See! when I think of all this and of so many other things like it too numerous to mention, of all the difficulties and cares that do not lessen as we advance in life – of sorrow, of disappointment, of the fear of failure, of disgrace – then I also know the longing, I wish I were far away from everything!

And yet I go on, but prudently and hoping to have the strength to resist those things, so that I shall know how to answer the reproaches that threaten me, and believing that, notwithstanding everything that seems against me, I yet shall reach the aim I am striving for, and if God wills it, find favour in the eyes of some I love and of those who will come after me. . . . (98, 30 May 1877.)

His anxieties were counterbalanced, as they had been in England, by his profound sensitivity to all he observed and enjoyed in the way of light, sky and especially people, in and around Amsterdam.

You remember that night at Dordrecht when we walked together through the town, around the Great Church and through so many streets, and along the canals – in which the old houses and the lights from the windows were reflected? You spoke then about the description of a day in London by Théophile Gautier, the coachman for a wedding party in front of the door of a church on a stormy foggy day: I saw it all before me. If that struck you, you will also appreciate the pages I enclose. I read them on a very stormy day last week: it was in the evening, and the sunset threw a ruddy glow on the grey evening clouds, against which the masts of the ships and the row of old houses and trees stood out; and everything was reflected in the water, and the sky threw a strange light on the black earth, on the green grass with daisies and buttercups, and on the bushes of white and purple lilacs, and on the elderberry bushes of the garden in the yard.

In London I had read that book of Lamartine's, and I was very much struck by it; the last pages especially made a deep impression on me again. Tell me what you think of it. These places mentioned in it – Hampton Court with its avenues of linden trees full of rookeries; Whitehall overgrown with ivy at the back; and the square bordering St James's Park where one can see Westminster Abbey – they are all before me, and the weather and the gloomy atmosphere: it keeps me from sleeping. . . .

[PS.] Today when I passed the flower market on the Singel, I saw something very pretty. A peasant was standing selling a whole bunch of pots with all kinds of flowers and plants; ivy was behind it, and his little girl was sitting between it all, such a child as Maris would have painted, so simple in her black bonnet, and with a pair of bright, smiling eyes. She was knitting; the man praised his wares – and if I could have spared the money I should have liked only too well to buy some – and he said, pointing unintentionally at his little daughter also, 'Doesn't it look pretty?'

(5 June)

Yesterday evening I was at Stricker's ... We walked along the Buitenkant and the embankment near the East railway. I cannot describe to you how beautiful it was there in the twilight. Rembrandt, Michel and others have sometimes painted it: the ground dark, the sky still lit by the glow of the setting sun, the row of houses and steeples against it, lights in the windows everywhere, and the whole mirrored in the water. And the people and the carriages

35

like little black figures, such as one sees sometimes in a Rembrandt. We were so struck by the beauty of it that we began to talk about many things.

I sat up writing late last night and was up again early this morning, it was such beautiful weather. At night there is also a beautiful view of the yard; everything is dead quiet then, and the lamps are burning and the starlit sky is over it all.

'When all sounds cease, God's voice is heard under the stars.'

Write me soon and tell me if that part about Cromwell isn't taken from the very heart of London.

Youth of Cromwell [Lamartine, *Cromwell*]

'The family soon lost its wealth. He retired to a small estate he possessed amidst the marshes of Huntingdon. The barren, rough and morose character of this shore district, the monotonous horizon, the muddy river, the clouded skies, the meagre trees, the infrequent cottages, the rude habits of the inhabitants, were such as to make the young man's nature concentrated and gloomy. The soul of a land seems to enter into that of man. Often a lively, ardent and profound faith seems to emanate from a poor and dismal country; like country, like man. The soul is a mirror before it becomes a home. . . .' (100, 5 June 1877.)

Vincent now began to teach a Sunday-school class, and enjoyed it, because he felt he could achieve something positive and of use to the children. His father thought otherwise, and felt he should not allow matters of secondary importance to distract him from his studies. Vincent persevered, and his letters home became infrequent.

He really takes no pleasure in life, always walking around with head bent, although we have done all we could to bring him to some honourable goal in life. It is as if he deliberately chooses whatever leads to trouble. (Parents to Theo, 1877.)

At home they clearly felt that another disaster was imminent. This impression was not false; but his parents remained totally unaware of what lay behind his actions in 'deliberately choosing' the hard way: the pressure from his unconscious self which held him back from a path which was ultimately the wrong one, even though he was still unaware of the power of his own artistic genius.

In the summer of 1877 he wrote, as he had done before, of Dickens' frugal remedy for suicidal thoughts:

. . . I got up early and saw the workmen arrive in the yard while the sun was shining brightly. You would be intrigued by the sight – that long line of black figures, big and small, first in the narrow street where the sun just peeps in, and later in the yard. Then I breakfasted on a piece of dry bread and a glass of beer – that is what Dickens advises for those who are on the point of committing suicide, as being a good way to keep them, at least for some time, from their purpose. And even if one is not in such a mood, it is right to do it occasionally, while thinking, for instance, of Rembrandt's picture, *The Men of Emmaus*. . . . (106, 18 Aug. 1877.)

His tendency to view matters ecstatically was now well developed. After a frightening sensation he had experienced when looking into a dark cellar, he managed to express with great clarity how ordinary things can be transfigured.

. . . This morning I saw a big dark wine cellar and warehouse, with the doors standing open; for a moment I had an awful vision in my mind's eye – you know what I mean – men with lights were running back and forth in the dark vault. It is true you can see this daily, but there are moments when the common everyday things make an extraordinary impression and have a

deep significance and a different aspect. De Groux knew so well how to put it in his pictures *96*
and especially in his lithographs. . . . (108, 4 Sept. 1877.)

Vincent's ecstatic disposition was also manifest in the obsessional persistence
with which he continued to dwell on the *Imitation of Christ*. He even began to
observe a resemblance to Thomas à Kempis (as portrayed by Ruiperez) in his
tutor Mendes.

. . . This morning I had a talk with Mendes about M. Maris, and showed him that lithograph
of those three children, and also *A Baptism*, and he understood them very well. Mendes
reminds me now and then of the *Imitation of Jesus Christ*, by Ruyperez. . . . (106, 18 Aug. 1877.)

. . . How would a man like Father, who so often goes long distances, even in the night with a
lantern, to visit a sick or dying man, to speak with him about One whose word is a light even
in the night of suffering and agony – how would he feel about Rembrandt's etchings, for
instance, *The Flight into Egypt in the Night* or the *Burial of Jesus*? The collection in the
Trippenhuis is splendid, I saw many I had never seen before; they also told me there about
drawings by Rembrandt at the Fodor Museum. . . .

But I am up to my ears in my work, for it is becoming clear to me what I really must know
what *they* know and what inspires *those* whom I should like to follow. 'Search the scriptures' is
not written in vain, but is a good guide; I should like to become the kind of scribe who brings
forth old and new things from his treasure.

I spent Monday evening with Vos and Kee; they love each other truly, and one can easily
perceive that where love dwells, God commands His blessing. It is a nice home, though it is a
great pity that he could not remain a preacher. When one sees them sitting side by side in the
evening, in the kindly lamplight of the little living room, quite close to the bedroom of their
boy, who wakes up every now and then and asks his mother for something, it is an idyll.
On the other hand, they have known days of anxiety and sleepless nights and fears and
troubles. . . .

Twilight is falling – 'blessed twilight', Dickens called it, and indeed he was right. Blessed
twilight, especially when two or three are together in harmony of mind and, like scribes, bring
forth old and new things from their treasure. Blessed twilight, when two or three are gathered
in His name and He is in the midst of them, and blessed is he who knows these things and
follows them, too.

Rembrandt knew that, for from the rich treasure of his heart he produced, among other
things, that drawing in sepia, charcoal, ink, etc., which is in the British Museum, representing
the house in Bethany. In that room twilight has fallen; the figure of our Lord, noble and *40*
impressive, stands out serious and dark against the window, which the evening twilight is
filtering through. At Jesus's feet sits Mary who has chosen the good part, which shall not be
taken away from her; Martha is in the room busy with something or other – if I remember
correctly, she is stoking the fire, or something like that. I hope I forget neither that drawing
nor what it seems to say to me: 'I am the light of the world: he that followeth me shall not walk
in darkness, but shall have the light of life.' . . .

Such are the things twilight tells to those who have ears to hear and a heart to understand
and believe in God – blessed twilight! And it is also twilight in that picture by Ruyperez, the
Imitation of Jesus Christ, as well as in another etching by Rembrandt, *David Praying to God.*

But it is not always blessed twilight, as you can see from my handwriting; I am sitting
upstairs by the lamp, for there are visitors downstairs and I cannot sit there with my books. . . .
(110, 18 Sept. 1877.)

Akin to this twilight obsession were his romantic dreams and imagined love
of Anne of Brittany, whose image (from a Goupil drawing course) had hung *19*
on his wall of his room since his early days in London, together with
Michelet's 'woman in black'. The last independent Duchess of Brittany in the
late fifteenth and early sixteenth centuries, Anne was twice Queen of France,
married first to Charles VIII and then to Louis XII. This brave woman
defended the lost Breton cause, and died at the age of thirty-seven.

... I have walked a great deal this week; there is no harm in knowing the city well.

Today while I was working I had in front of me a page from the *Cours de Dessin Bargue* (the drawing examples) part 1, No. 39, 'Anne of Brittany'. It was hanging in my room in London with No. 53; 'A Young Citizen' was hanging in between. What I liked and admired in the beginning, I like and admire still. The expression on Anne of Brittany's face is noble, and reminds one of the sea and the rocky coasts. I should like to know her history someday. She is a real king's daughter. De Lemud would have drawn her figure well. ... (115, 4 Dec. 1877.)

Vincent owned Flemish, Dutch, Latin and French editions of the *Imitation of Christ* and read them critically, noting that they had sometimes been unduly 'adapted' by clerical editors. He presented his tutor Mendes with a Latin edition and discussed with him the principle of 'hating one's own life' for the sake of the universal.

... This week I had a conversation with Mendes about 'the man who hates not his own life, cannot be my disciple'. Mendes asserted that that expression was too strong, but I held that it was the simple truth; and doesn't Thomas à Kempis say the same thing when he speaks about knowing and hating oneself? When we look at others who have done more than we and are better than we, we very soon begin to hate our own life because it is not as good as others'. Look at a man like Thomas à Kempis, who wrote his little book with a simplicity and sincerity unequalled by any other writer, either before or since; or, in another sphere, look at Millet's work or Jules Dupré's *The Large Oaks* – that is *it*. ... (116, 9 Dec. 1877.)

60
62

Vincent must also have found this line of reasoning in Michelet, who continued to influence his ideas on women.

... Uncle Cor asked me today if I didn't like *Phryne* by Gérôme. I told him that I would rather see a homely woman by Israëls or Millet, or an old woman by Edouard Frère: for what's the use of a beautiful body such as Phryne's? Animals have it too, perhaps even more than men; but the soul, as it lives in the people painted by Israëls or Millet or Frère, that is what animals never have. Is not life given us to become richer in spirit, even though the outward appearance may suffer? I feel very little sympathy for the figure by Gérôme. I can find no sign of spirituality in it, and a pair of hands which show they have worked are more beautiful than those of this figure. The difference is greater still between such a beautiful girl and a man like Parker or Thomas à Kempis or those Meissonier painted; one can no more love and have sympathy for two such disparate things than one can serve two masters.

90

Uncle Cor then asked me if I should feel no attraction for a beautiful woman or girl. I answered that I would feel more attraction for, and would rather come into contact with, one who was ugly or old or poor or in some way unhappy, but who, through experience and sorrow, had gained a mind and a soul. ... (117, 9 Jan. 1878.)

36

159, 160

Vincent first wrote about Fildes' *The Empty Chair* when he was still in London. We have also observed how oversensitive were his reactions to saying farewell. The famous empty chairs belonging to himself and Gauguin which he painted in Arles have given rise to both matter-of-fact and symbolic interpretations. In view of his account of bursting into tears at the sight of his father's empty chair after a visit, and his continuing emotional reactions to partings, the appearance of the image of the empty chair, particularly when his nerves were in an overwrought state as they were at Arles, seems wholly in keeping with a character abnormally sensitive to symbols.

... As you know, Father has been here, and I am so glad he came. Together we went to see Mendes, Uncle Stricker and Uncle Cor and the two Meyes families, and the most pleasant recollection of Father's visit is of a morning we spent together in my little room, correcting some work and talking over several things. You can imagine how the days flew by. After I had seen Father off at the station and had watched the train go out of sight, even the smoke of it, I came home to my room and saw Father's chair standing near the little table on which the

books and copybooks of the day before were still lying; and though I know that we shall see each other again pretty soon, I cried like a child. ... (118, 10 Feb. 1878.)

The profoundly significant moment had now arrived when Vincent could unhesitatingly accept art as a main source of inspiration alongside the Bible. He had doubts about taking 'the wrong road', but not about the value of opposition or difficulties as long as there was an ultimate goal to which one could devote oneself totally. In June 1878 he took the decision to abandon his academic studies, and to train in Belgium as a lay evangelist. His mother wrote to Theo, now in Paris:

... Pa has written to him so firmly that he should continue with his lessons for another three months so as to allow himself time to think matters over clearly and calmly. Pa has also written to Belgium, and there comes the reply, just as I have got this far. ... 'Decent, clever people should be able to manage there, even without examinations.' I am always so concerned that wherever Vincent goes and whatever he does, he will always give up everywhere, because of his strangeness and odd ideas and notions about life. ... (Mother to Theo, 7 June 1878.)

Vincent arrived home at Etten on 8 July, and in the following week went with his father to see 'Master' Bokma, the principal of the school of evangelism at Laeken, near Brussels. His former headmaster, Mr Jones, came from England specially to be present, a remarkable proof of the impression Vincent must have made during his short time at Isleworth.

I suppose Father has written to you that we went to Brussels last week, along with the Rev. Mr Jones from Isleworth, who stayed here over Sunday. The impression of that journey was satisfactory, in that I think I shall find my work there sometime – the course certainly is shorter and less expensive than in Holland. ... And they do not even require that you quite finish the course, before you can apply for a place as evangelist. What is wanted is the talent to give popular and attractive lectures to people, more short and interesting than long and learned. So they require less knowledge of ancient languages and less theological study (though everything one knows is an asset), but they value more highly fitness for practical work and the faith that comes from the heart.

Still, there are many obstacles to overcome. First, one does not acquire at once, but only by long practice, a talent for speaking to people with seriousness and feeling, fluency and ease; what one says must have meaning and purpose and some persuasiveness to rouse one's listeners so that they will try to root their convictions in truth. In short, one must be a popular orator to succeed there. *Ces messieurs* in Brussels wanted me to come for three months to become better acquainted, but that would again cause too much expense, and this must be avoided as much as possible. Therefore I am staying in Etten for the present, doing some preparatory work; from here I can occasionally visit both the Reverend Mr Pietersen in Mechlin and the Reverend Mr de Jong in Brussels, and in that way become mutually better acquainted. How long this will take depends entirely on what they say over there. Father and I have just written them again.

Now I will try to write as well as I can some compositions which will prove useful to me later: I am writing one now on Rembrandt's picture, *The House of the Carpenter*, in the Louvre. ... (123, 22 July 1878.)

... I wonder if the exhibition of pictures there [in Brussels] will still be open then – I should like very much to see it. I am eager to hear from you. I hope to write you more as soon as I am in Brussels; also about the exhibition – at least if it isn't already closed. ... (125, 15 Aug. 1878.)

Once at Laeken, he immediately started sketching, but realized that it would probably distract him from his work. A single underlined paragraph shows how strong the power and significance of art had become to him, and how little regard he had for his assessment by the Training School for Evangelists. He was to stay at Laeken only for the probationary period.

Drawing from letter 126.

I enclose that hasty little sketch, *Au Charbonnage*. I should like to begin making rough sketches of some of the many things that I meet on my way, but as it would probably keep me from my real work, it is better not to start. As soon as I came home, I began a sermon about the barren fig tree, Luke 13: 6–9. The little drawing *Au Charbonnage* is not particularly remarkable, but I made it because one sees here so many people who work in the coal mines, and they are a rather distinctive type. This little house stands not far from the road; it is a small inn which adjoins the big coal shed, and the workmen come to eat their bread and drink their glass of beer there during the lunch hour. . . .

How rich art is; if one can only remember what one has seen, one is never without food for thought or truly lonely, never alone. . . . (126, dated 15 Nov. 1878.)

He left Brussels for a six months' probationary period as a lay evangelist at Wasmes, near Mons, in the Borinage mining district in the south of Belgium. There he soon became, in the phrase he later used, 'homesick for the land of pictures'.

. . . As for me, I am sure you realize that here in the Borinage there are no pictures; generally speaking, they do not even know what a picture is. So of course I have not seen anything in the way of art since I left Brussels. Notwithstanding, the country is very picturesque and very unique here: everything *speaks*, as it were, and is full of character. Lately, during the dark days before Christmas, the ground was covered with snow; then everything reminded one of the medieval pictures by Peasant Brueghel, for instance, and of those by the many who have known how to express so remarkably well that peculiar effect of red and green, black and white. At every moment I am reminded here of the work of Thijs Maris or of Albrecht Dürer. There are sunken roads, overgrown with thornbushes, and old, gnarled trees with their fantastic roots, which perfectly resemble that road on the etching by Dürer, *Death and the Knight*. So, a few days ago, it was an intriguing sight to see the miners going home in the white snow in the evening at twilight. Those people are quite black. When they come out of the dark mines into daylight, they look exactly like chimney sweeps. Their houses are very small, and might better be called huts; they are scattered along the sunken roads, and in the wood, and on the slopes of the hills. Here and there one can see moss-covered roofs, and in the evening the light shines kindly through the small-paned windows. . . . (127, 26 Dec. 1878.)

It is not the purpose of this book to recount in detail Vincent's sufferings during his period as an evangelist in the Borinage; but it is necessary to point out his extraordinary capacity for using suffering, both to gain access to the most profound knowledge and to activate his creative powers. The letters recount Vincent's experiences amidst the ordinary working people, whom he had first observed in artists' drawings for *The Graphic* and other magazines when he was in England, and among whom he had dreamed of working. Influenced partly by what he had read and partly by the English Methodists, he saw opportunities ahead of him which would satisfy his Adamistic longing for primeval simplicity and justice, his Thomas à Kempis-like humility and distaste for the rich, as well as his sense of fellowship with the poor.

With a certain logic, this English image of Christianity led at last to a direct confrontation with reality when he reached the Borinage. Alongside this, a creative power had been developing in his psychical make-up which then became an urge to create. Initially he ignored the urge, but he could no longer do so when his evangelical work had to come to an end. Not only the qualities later censured by the ecclesiastical assessors in Brussels, but also the effect, no doubt unconscious, of the powerful growth of his creativity, must have contributed to his failure to rise above a fanatical and immoderate display of compassion which surprised and sometimes touched people but did not convince them. In the same way, his style of preaching, violent in emotion but intolerably laden with borrowed formulations, failed to impress.

30–37

In the Borinage, deliberately avoiding contact with Theo or his parents, Vincent now came face to face with real poverty for the first time. The 'dry bread', the diet of which he constantly spoke in England, Paris and Amsterdam, had been his by choice; it had never been necessary. He had always stayed in or near the homes of relatives or friends who were solvent. Announced with so much emphasis, such self-mortification struck a forced and not wholly genuine note. It was genuinely willed, and yet there was an undercurrent of self-pity, of mixed motives. In the Borinage things were different. In this respect too, the experience marked a turning-point and proved a test of endurance.

Because he now seldom wrote to anyone, even Theo, Vincent was totally on his own. He forwent the therapy of letter-writing which except for this period and one or two others, helped him all his life to bear both the strain of his sense of vacuity and the pressure of a rich and emotional world of images, as well as the condition of his body, through putting them into words. His relations with the miners were good, and he gave an almost dispassionate, realistic account of going down the Marcasse mine, one of the most dangerous. *47*

... Most of the miners are thin and pale from fever; they look tired and emaciated, weather-beaten and aged before their time. On the whole the women are faded and worn. Around the mine are poor miners' huts, a few dead trees black from smoke, thorn hedges, dunghills, ash dumps, heaps of useless coal, etc. Maris could make a wonderful picture of it.

I will try to make a little sketch of it presently to give you an idea of how it looks.

I had a good guide, a man who has already worked there for thirty-three years; kind and patient, he explained everything well and tried to make it clear to me.

So together we went down 700 metres and explored the most hidden corners of that underworld. The *maintenages* or *gredins* [cells where the miners work] which are situated farthest from the exit are called *caches*.

This mine has five levels, but the three upper ones have been exhausted and abandoned; they are no longer worked because there is no more coal. A picture of the *maintenages* would be something new and unheard of – or rather, never before seen. Imagine a row of cells in a rather narrow, low passage, shored up with rough timber. In each of those cells a miner in a coarse linen suit, filthy and black as a chimney sweep, is busy hewing coal by the pale light of a small lamp. The miner can stand erect in some cells; in others, he lies on the ground (⊞⊞⊞⊞ *tailles à droit*, ⊞⊞⊞ *tailles à plat*). The arrangement is more or less like the cells in a beehive, or like a dark, gloomy passage in an underground prison, or like a row of small weaving looms, or rather more like a row of baking ovens such as the peasants have, or like the partitions in a crypt. The tunnels themselves are like the big chimneys of the Brabant farms.

The water leaks through in some, and the light of the miner's lamp makes a curious effect, reflected as in a stalactite cave. Some of the miners work in the *maintenages*, others load the cut coal into small carts that run on rails, like a tramcar. This is mostly done by children, boys as well as girls. There is also a stable yard down there, 700 metres underground, with about seven old horses which pull a great many of those carts to the so-called *accrochage*, the place from which they are pulled up to the surface. Other miners repair the old galleries to prevent their collapse or make new galleries in the coal vein. As the mariners ashore are homesick for the sea, notwithstanding all the dangers and hardships which threaten them, so the miner would rather be under the ground than above it. The villages here look desolate and dead and forsaken; life goes on underground instead of above. One might live here for years and never know the real state of things unless one went down in the mines.

People here are very ignorant and untaught – most of them cannot read – but at the same time they are intelligent and quick at their difficult work; brave and frank, they are short but square-shouldered, with melancholy deep-set eyes. They are skilful at many things, and work terribly hard. They have a nervous temperament – I do not mean weak, but very sensitive. They have an innate, deep-rooted hatred and a strong mistrust of anyone who is domineering. With miners one must have a miner's character and temperament, and no pretentious pride or mastery, or one will never get along with them or gain their confidence.

Did I tell you at the time about the miner who was so badly hurt by a firedamp explosion? Thank God, he has recovered and is going out again, and is beginning to walk some distance just for exercise; his hands are still weak and it will be some time before he can use them for his work, but he is out of danger. Since that time there have been many cases of typhoid and malignant fever, of what they call *la sotte fièvre*, which gives them bad dreams like nightmares and makes them delirious. So again there are many sickly and bedridden people – emaciated, weak, and miserable. . . . (129, April 1879.)

Vincent's official time as an evangelist in the Borinage lasted only from January to July 1879. His appointment was not renewed, on the grounds of his inaptitude for preaching. He stayed in the area for another year, continuing his work in spite of lack of means and the distress of his family. There was even a rift between the two brothers; no letter from Vincent survives from the period between April, when he wrote his account of the coalmine, and October, when Theo paid him a visit and the first steps to reconciliation were taken.

. . . While I am remembering your visit gratefully, I of course think over our discussions too. I have heard them before, even a great many of them, and often. Plans for improvement and change and gathering energy; do not be annoyed, but I am a little afraid – because I sometimes followed them, and the result was poor. How many things have been discussed that later proved to be impracticable.

How fresh my memory of that time in Amsterdam is. You were there yourself, so you know how things were planned and discussed, argued and considered, talked over with wisdom, with the best intentions, and yet how miserable the result was, how ridiculous the whole undertaking, how utterly foolish. I still shudder when I think of it.

It was the worst time I have ever lived through. How desirable and attractive have become the difficult days, full of care, here in this poor country, in these uncivilized surroundings, compared to that. I fear a similar result if I follow wise advice given with the best intentions.

Such experiences are too dreadful – the harm, the sorrow, the affliction is too great – not to try on both sides to become wiser by this dearly bought experience. . . .

And now if you should conclude from what I say that I wanted to call you a quack because of your advice, you would have quite misunderstood me, as I do not think this of you at all. On the other hand, you would also be mistaken if you thought that I would do well to follow your advice literally to become an engraver of bill headings and visiting cards, or a bookkeeper or a carpenter's apprentice – or else to devote myself to being a baker – or many similar things (curiously different and hard to combine) that other people advise me.

But, you say, I do not expect you to take that advice literally; I was just afraid you were too fond of spending your days in idleness, and I thought you had to put an end to it.

May I observe that this is a rather strange sort of 'idleness'. It is somewhat difficult for me to defend myself, but I should be very sorry if, sooner or later, you could not see it differently. I am not sure it would be right to combat such an accusation by becoming a baker, for instance. It would indeed be a decisive answer (always supposing that it were possible to assume, quick as lightning, the form of a baker, a barber or a librarian); but at the same time it would be a foolish answer, more or less like the action of the man who, when reproached with cruelty for riding a donkey, immediately dismounted and continued his way with the donkey on his shoulders.

Now, all jesting aside, I really think it would be better if the relation between us became more friendly on both sides. If I had to believe that I were troublesome to you or to the people at home, or were in your way, of no good to anyone, and if I should be obliged to feel like an intruder or an outcast, so that I were better off dead, and if I should have to try to keep out of your way more and more – if I thought this were really the case, a feeling of anguish would overwhelm me, and I should have to struggle against despair. . . . (132, 15 Oct. 1879.)

Vincent's moment of truth came with a grim journey on foot, early in 1880, to Courrières, about 70 kilometres or 45 miles to the west, over the French *29, 58* border, the home of the painter-poet Jules Breton. The journey is related in a (later) letter, which represents Vincent's *De Profundis*, with all the details of its

martyrdom. This experience saw the awakening of that power which had been blocked for years but was now in process of transformation, as if by miracle, into a will to create.

... I had undertaken a walking tour mostly in Pas-de-Calais, not the Channel [coast], but the department or province. I had undertaken the trip hoping to find some kind of work there if possible. I would have accepted anything. But after all, perhaps I went involuntarily, I can't exactly say why.

I had said to myself, You must see Courrières. I had only 10 fr. in my pocket, and having started by train, I was soon out of money; I was on the road for a week, I had a long, weary walk of it. Anyhow, I saw Courrières, and the outside of M. Jules Breton's studio. The outside of the studio was rather disappointing: it was quite newly built of brick, with a Methodist regularity, an inhospitable, chilly and irritating aspect. If I could only have seen the interior, I would certainly not have given a thought to the exterior, I am sure of that. But what shall I say of the interior? I was not able to catch a glimpse, for I lacked the courage to enter and introduce myself. ...

But I have at least seen the country around Courrières, the haystacks, the brown earth or almost coffee-coloured clay, with whitish spots here and there where the marl appears, which seems very unusual to those of us who are accustomed to black earth. And the French sky seemed to me very much clearer and more limpid than the smoky, foggy sky of the Borinage. Besides, there were farms and sheds which, the Lord be praised, still retained their moss-covered thatched roofs. I also saw flocks of crows made famous by the pictures of Daubigny and Millet. Not to mention, as I ought to have in the first place, the characteristic and picturesque figures of the different travellers, diggers, woodcutters, peasants driving horses, and here and there the silhouette of a woman in a white cap. Even in Courrières there was a *charbonnage* or mine. I saw the day shift coming up in the twilight: there were no women in men's clothes as in the Borinage, only miners with tired and miserable faces, blackened by the coal dust, clad in tattered miners' clothes, and one of them in an old soldier's cape.

Though the journey was almost too much for me, and I came back overcome by fatigue, with sore feet, and quite melancholy, I do not regret it, for I had seen interesting things, and one learns to take a different but correct view of the hardships of real misery. Occasionally I earned some crusts of bread along the road in exchange for some drawings which I had in my valise. But when the 10 fr. were all gone, I had to spend the last nights in the open air, once in an abandoned wagon, which was white with frost the next morning – rather a bad resting place; once in a pile of faggots; and one time that was a little better, in a haystack, where I succeeded in making a rather more comfortable berth – but then a drizzling rain did not exactly further my well-being.

Well, even in that deep misery I felt my energy revive, and I said to myself, In spite of everything I shall rise again: I will take up my pencil, which I have forsaken in my great discouragement, and I will go on with my drawing. From that moment everything has seemed transformed for me; and now I have started and my pencil has become somewhat docile, becoming more so every day. The too long and too great poverty had discouraged me so much that I could not do anything.

Another thing which I saw during that excursion was the villages of the weavers.

The miners and the weavers still constitute a race apart from other labourers and artisans, and I feel a great sympathy for them. I should be very happy if someday I could draw them, so that those unknown or little-known types would be brought before the eyes of the people. The man from the depth of the abyss, *de profundis* – that is the miner; the other, with his dreamy air, somewhat absent-minded, almost a somnambulist – that is the weaver. I have been living among them for two years, and have learned a little of their unique character, at least that of the miners especially. And increasingly I find something touching and almost sad in these poor, obscure labourers – of the lowest order, so to speak, and the most despised – who are generally represented as a race of criminals and thieves by a perhaps vivid but very false and unjust imagination. (136, 24 Sept. 1880, F.)

At this time, between October 1879 and July 1880, there was silence once more between Vincent and Theo. Only a gift of fifty francs from Theo

compelled Vincent to write again, which he did with reluctance, and (for the first time) in French. Amid an apparent welter of disparate ideas, this letter contains an evaluation of his own past, and an analysis of his true self, which was to form the driving force for his future actions. It does not mention the decision to 'take up my pencil', which with hindsight he was to consider the most significant result of the journey to Courrières.

I am writing to you with some reluctance, not having done so in such a long time, for many reasons.

To a certain degree you have become a stranger to me, and I have become the same to you, more than you may think; perhaps it would be better for us not to continue in this way. Probably I would not have written you even now if I were not under the obligation and necessity of doing so, if you yourself had not given me cause. At Etten I learned that you had sent 50 francs for me; well, I have accepted them. Certainly with reluctance, certainly with a rather melancholy feeling, but I am up against a stone wall and in a sort of mess. How can I do otherwise? So I am writing to thank you.

Perhaps you know I am back in the Borinage. Father would rather I stay in the neighbourhood of Etten; I refused, and in this I think I acted for the best. Involuntarily, I have become more or less a kind of impossible and suspect personage in the family, at least somebody whom they do not trust, so how could I in any way be of any use to anybody? Therefore, above all, I think the best and most reasonable thing for me to do is to go away and keep at a convenient distance, so that I cease to exist for you all.

As moulting time – when they change their feathers – is for birds, so adversity or misfortune is the difficult time for us human beings. One can stay in it – in that time of moulting – one can also emerge renewed; but anyhow it must not be done in public and it is not at all amusing, therefore the only thing to do is to hide oneself. Well, so be it.

Now, though it is very difficult, almost impossible, to regain the confidence of a whole family, which is not quite free from prejudices and other qualities equally fashionable and honourable, I do not quite despair that by and by, slowly but surely, a cordial understanding may be renewed between some of us. And in the very first place, I should like to see that *entente cordiale*, not to put it stronger, re-established between Father and me; and I desire no less to see it re-established between us two. An *entente cordiale* is infinitely better than misunderstandings.

Now I must bore you with certain abstract things, but I hope you will listen to them patiently. I am a man of passions, capable of and subject to doing more or less foolish things, which I happen to repent, more or less, afterward. Now and then I speak and act too hastily, when it would have been better to wait patiently. I think other people sometimes make the same mistakes. Well, this being the case, what's to be done? Must I consider myself a dangerous man, incapable of anything? I don't think so. But the problem is to try every means to put those selfsame passions to good use. For instance, to name one of the passions, I have a more or less irresistible passion for books, and I continually want to instruct myself, to study if you like, just as much as I want to eat my bread. *You* certainly will be able to understand this. When I was in other surroundings, in the surroundings of pictures and works of art, you know how I had a violent passion for them, reaching the highest pitch of enthusiasm. And I am not sorry about it, for even now, *far from that land, I am often homesick for the land of pictures.*

You remember perhaps that I knew well (and perhaps I know still) who Rembrandt was, or Millet, or Jules Dupré or Delacroix or Millais or M. Maris. Well, now I do not have those surroundings any more – yet that thing called soul, they say it never dies, but lives on and continues to search forever and ever and ever. So instead of giving way to this homesickness, I said to myself: That land, or the fatherland, is everywhere. So instead of giving in to despair, I chose the part of active melancholy – in so far as I possessed the power of activity – in other words, I preferred the melancholy which hopes and aspires and seeks to that which despairs in stagnation and woe. So I studied somewhat seriously the books within my reach like the Bible, and the *Révolution française* by Michelet, and last winter, Shakespeare and a few by Victor Hugo and Dickens, and Beecher Stowe, and lately Aeschylus, and then several others, less classical, several great 'minor masters'. You know, those 'minor masters' include people like Fabritius or Bida.

Now he who is absorbed in all this is sometimes *choquant*, shocking, to others, and

sometimes unwittingly sins against certain forms and customs and social conventions. It is a pity, however, when this is taken in bad part. For instance, you know that I have often neglected my appearance; I admit it, and I admit that it is shocking. But look here, poverty and want have their share in the cause, and also profound discouragement; and then, it is sometimes a good way to assure the solitude necessary for concentrating on whatever study preoccupies one. A very necessary study is that of medicine; there is scarcely anybody who does not try to know a little of it, who does not try to understand what it is about, and you see I do not yet know one word about it. All this absorbs and preoccupies one – all this gives one something to dream about, to reflect on and to think about.

Now for more than five years – I do not know exactly how long – I have been more or less without employment, wandering here and there. You say, Since a certain time you have gone down, you have deteriorated, you have not done anything. Is this quite true?

It is true that occasionally I have earned my crust of bread, occasionally a friend has given it to me in charity. I have lived as I could, as luck would have it, haphazardly. It is true that I have lost the confidence of many; it is true that my financial affairs are in a sad state; it is true that the future is only too gloomy; it is true that I might have done better; it is true that I've lost time in terms of earning my bread; it is true that even my studies are in a rather sad and hopeless condition, and that my needs are greater – infinitely greater – than my possessions. But is this what you call 'going down', is that what you call 'doing nothing'?

You will perhaps say, But why didn't you continue as they wanted you to – they wanted you to go through the university?

My only answer is, the expenses were too heavy, and besides, that future was not much better than the one on the road now before me.

But I must continue on the path I have taken now. If I don't do anything, if I don't study, if I don't go on seeking any longer, I am lost. Then woe is me. That is how I look at it: to continue, to continue, that is what is necessary.

But you will ask, What is your definite aim?

That aim becomes more definite, will stand out slowly and surely, as the rough draft becomes a sketch, and the sketch becomes a picture – little by little, by working seriously on it, by pondering over the idea, vague at first, over the thought that was fleeting and passing, till it gets fixed.

I must tell you that with evangelists it is the same as with artists. There is an old academic school, often detestable, tyrannical, the accumulation of horrors, men who wear a cuirass, a steel armour, of prejudices and conventions; when these people are in charge of affairs, they dispose of positions, and by a system of red tape they try to keep their protégés in their places and to exclude the other man. Their God is like the God of Shakespeare's drunken Falstaff, 'the inside of a church'; indeed, by a curious chance some of these evangelical (???) gentlemen find themselves with the same point of view on spiritual things as that drunken character (perhaps they would be somewhat surprised to discover this if they were capable of human emotions). But there is little fear of their blindness ever changing to clear-sightedness in such matters. . . .

For the moment it seems that things are going very badly with me, and it has already been so for a considerable time and may continue awhile in the future; but after everything has seemed to go wrong, perhaps a time will come when things will go right. I don't count on it, perhaps it will never happen; but if there is a change for the better, I should consider it so much gain, I should be contented, I should say, At last! you see *there was something after all!* . . .

But I always think that the best way to know God is to love many things. Love a friend, a wife, something – whatever you like – you will be on the way to knowing more about Him; that is what I say to myself. But one must love with a lofty and serious intimate sympathy, with strength, with intelligence; and one must always try to know deeper, better and more. That leads to God, that leads to unwavering faith.

To give you an example: someone loves Rembrandt, but seriously – that man will know there is a God, he will surely believe it. Someone studies the history of the French Revolution – he will not be unbelieving, he will see that in great things also there is a sovereign power manifesting itself. Maybe for a short time somebody takes a free course at the great university of Hardship, and pays attention to the things he sees with his eyes and hears with his ears, and thinks them over; he, too, will end in believing, and he will perhaps have learned more than he can tell. To try to understand the real significance of what the great artists, the serious masters,

tell us in their masterpieces, *that* leads to God; one man wrote or told it in a book; another, in a picture. Then simply read the Gospel and the Bible: it makes you think, and think much, and think all the time. Well, think much and think all the time, it raises your thoughts above the ordinary level without your knowing it. We know how to read – well then, let us read!

It is true that there may be moments when one becomes somewhat absent-minded, somewhat visionary; some become too absent-minded, too visionary. This is perhaps the case with me, but it is my own fault; maybe there is some excuse after all – I was absorbed, preoccupied, troubled, for some reason – but one overcomes this. The dreamer sometimes falls into a well, but is said to get out of it afterward. And the absent-minded man also has his lucid intervals in compensation. He is sometimes a person who has his reasons for being as he is, but they are not always understood at first, or are unconsciously forgotten most of the time, from lack of interest. A man who has been tossed back and forth for a long time, as if on a stormy sea, at last reaches his destination; a man who has seemed good-for-nothing and incapable of any employment, any function, ends in finding one and becoming active and capable of action – he shows himself quite different from what he seemed at first.

I write somewhat at random whatever comes to my pen. I should be very glad if you could see in me something more than an idle fellow. Because there are two kinds of idleness, which are a great contrast to each other. There is the man who is idle from laziness and from lack of character, from the baseness of his nature. If you like, you may take me for such a one.

On the other hand, there is the idle man who is idle in spite of himself, who is inwardly consumed by a great longing for action but does nothing, because it is impossible for him to do anything, because he seems to be imprisoned in some cage, because he does not possess what he needs to become productive, because circumstances bring him inevitably to that point. Such a man does not always know what he could do, but he instinctively feels, I am good for something, my life has a purpose after all, I know that I could be quite a different man! How can I be useful, of what service can I be? There is something inside of me, what can it be? This is quite a different kind of idle man; if you like, you may take me for such a one! . . .

One cannot always tell what it is that keeps us shut in, confines us, seems to bury us; nevertheless, one feels certain barriers, certain gates, certain walls. Is all this imagination, fantasy? I don't think so. And one asks, 'My God! is it for long, is it for ever, is it for all eternity?'

Do you know what frees one from this captivity? It is every deep, serious affection. Being friends, being brothers, love, that is what opens the prison by some supreme power, by some magic force. Without this, one remains in prison. Where sympathy is renewed, life is restored.

And the prison is also called prejudice, misunderstanding, fatal ignorance of one thing or another, distrust, false shame.

But to speak of other things, if I have come down in the world, you, on the contrary, have risen. If I have lost the sympathy of some, you, on the contrary, have gained it. That makes me very happy – I say it in all sincerity – and always will. If you hadn't much seriousness or depth, I would fear that it would not last; but as I think you are very serious and of great depth, I believe that it will. But I should be very glad if it were possible for you to see me as something more than an idle man of the worst type. . . . (133, July 1880, F.)

Vincent was now inwardly mature, but the process of maturation had been a long one. It was only now that he was ready to formulate for himself the basic principles of drawing whether from nature or from artistic exemplars. Formulations of the state of his soul, examinations of his image in the mirror (Who am I? What do I look like?) – these had been present all along; so had his understanding of other people's paintings and drawings; what he had never formulated was what he himself might have to express, in drawing and painting, out of the totality of his emotional experience of life.

The second important point was the restoration of the original unity of the arts. This was no vague concept but a concrete one, tried by experience and substantiated by examples. Literature, painting and the Bible were seen as streams that ultimately sprang from a single source. This was to make his modernism, right up to the Auvers period, almost at the end of the century,

something different from that of all the other modern artists – Naturalists, Realists, Impressionists or Symbolists – of his time. These long letters should be read in the knowledge of the value of what he has left us, and every line will tell not only of *la grande université de la misère*, the great university of Hardship; not only of the cry of despair, 'How long, my God!', but also of a perfectly lucid realization of the pathetic social state in which he was living. Equally lucid and strong was his faith that sooner or later, almost certainly later, things would take a turn for the better.

Vincent now began to draw in earnest. His remark that he was now looking at things in an entirely new way implicitly dismisses, as of no significance, his previous impulses to draw at The Hague, in England, and at Amsterdam.

... If you still have the book with the etchings after Michel, please lend me that sometime, too, but there is no hurry. For the moment I have enough to keep me busy, but I should like to see those landscapes again, for now I look at things with other eyes than I did before I began to draw.

I hope that you will not be too dissatisfied with the drawings after Millet when you see them; those little wood engravings are admirable.

As I already have twenty prints after Millet, you can understand that if you could send me some more, I would make them readily, for I try to study that master seriously. I know that the large etching of *The Diggers* is rare, but be on the lookout for it, and tell me what it will cost. Someday or other I shall earn a few pennies with some drawings of miners; I should like to have that print and *The Copse* as soon as I am able to buy it, even if it is rather expensive. The other day I bought for 2.50 francs two volumes of the *Musée Universel*, in which I found a large number of interesting woodcuts, including three of Millet's.

I cannot tell you the pleasure Mr Tersteeg gave me by letting me have the *Exercices au fusain* and the *Cours de dessin Bargue* for a while. I worked almost a whole fortnight on the former, from early morning until night, and daily I seem to feel that it invigorates my pencil. ... (135, Sept. 1880, F.)

... Between times I am reading a book on anatomy and another on perspective which Mr Tersteeg also sent me. The style is very dry, and at times those books are terribly irritating, but still I think I do well to study them.

So you see that I am in a rage of work, though for the moment it does not produce very brilliant results. But I hope these thorns will bear their white blossoms in due time, and that this apparently sterile struggle is no other than the labour of childbirth. First the pain, then the joy. ... (136, 24 Sept. 1880, F.)

Eventually, he could stand the isolation and hardship of the Borinage no longer. With autumn coming on, he moved to Brussels.

... Boy, if I had stayed in Cuesmes a month longer, I should have fallen ill with misery. You must not imagine that I live richly here, for my chief food is dry bread and some potatoes or chestnuts which people sell here on the street corners, but by having a somewhat better room and by occasionally taking a somewhat better meal in a restaurant whenever I can afford it, I shall get on very well. But for almost two years I have had a hard time in Borinage – it was no pleasure trip, I assure you. The expenses here will be somewhat more than 60 fr., which cannot be helped. Drawing materials, studies to copy – for instance, for anatomy – all cost money, and yet they are strictly necessary: only in this way shall I obtain a fair return, otherwise I could never succeed. ... (138, 1 Nov. 1880.)

Vincent made the acquaintance of a young Dutch artist, Anton Ridder van Rappard, who was to become a friend and correspondent, and began to have thoughts of living and working with a fellow-artist. *81, 85*

... I have also been to see Mr Van Rappard, who now lives at Rue Traversière 6a, and had a talk with him. He is a fine-looking man; of his work I saw only a few small pen-and-ink

landscapes. But judging from the way he lives, he must be wealthy, and I do not know whether he is the person with whom I might live and work, because of financial reasons. But I certainly shall go and visit him again. He impressed me as one who takes things seriously. . . . (138, 1 Nov. 1880.)

Vincent was staying at a small hotel, now demolished, at 72 Boulevard du Midi, for 50 francs a month including a daily supply of bread and coffee, which he found expensive. His father was sending him 60 francs a month. Van Rappard, as well as others, had advised him to work at the Academy, where he enrolled, but hesitated to follow up his enrolment. At all events it has never been proved that he actually attended the school. Van Rappard allowed him to work in his studio for a while. Academies, like universities, were to Vincent respectable but disastrous institutions. In an academy one might benefit, when short of money, by seeking contact with other students and being allowed to work from the nude in heated premises without having to pay. He also benefited from lessons in perspective from an unidentified, mediocre painter with sound technical skills, and managed to borrow a good illustration of a skeleton from him. He now started a procedure that was to continue throughout the rest of his life, and began to supply, first to his parents and later only to Theo, three or four times a month the painful details of his expenditure and the reasons why he could not make ends meet. We know all the details of his worn-out trousers, coats, underwear and shoes; but money to buy his working materials and to pay his models was of paramount importance from then onwards.

The idea of living with Theo in Paris had already passed through the brothers' minds (letter 136, 24 Sept. 1880: 'It would certainly be my great and ardent wish to go to Paris or to Barbizon or elsewhere. But how could I, when I do not earn a cent?') Cost alone was a consideration in reaching a decision whether Vincent would now go and live at Heyst, Calmphout, Schaerbeek, Katwijk, Scheveningen, or with his parents at Etten. On 12 April 1881 he was able to report that he was leaving for Etten the same day.

1 Vincent van Gogh as a boy
Vincent was born on 31 March 1853, at Zundert in Brabant, one year after the stillbirth of a first Vincent Willem. His disconcerting gaze – with 'those small, narrowed, piercing eyes of his', in the words of a later acquaintance (p.31) – is recorded in only two photographs. This, the earlier, bears an inscription to say that it was taken in Brussels (where his uncle Hein lived from 1863 onwards). If it is true that the photograph represents Vincent as a boy of thirteen (1866), it might have been taken between the end of his time at boarding-school at Zevenbergen and the beginning of his secondary education at Tilburg. There, although near the top of his class, he stayed for only two years; he left school in March 1868, for reasons still unexplained.

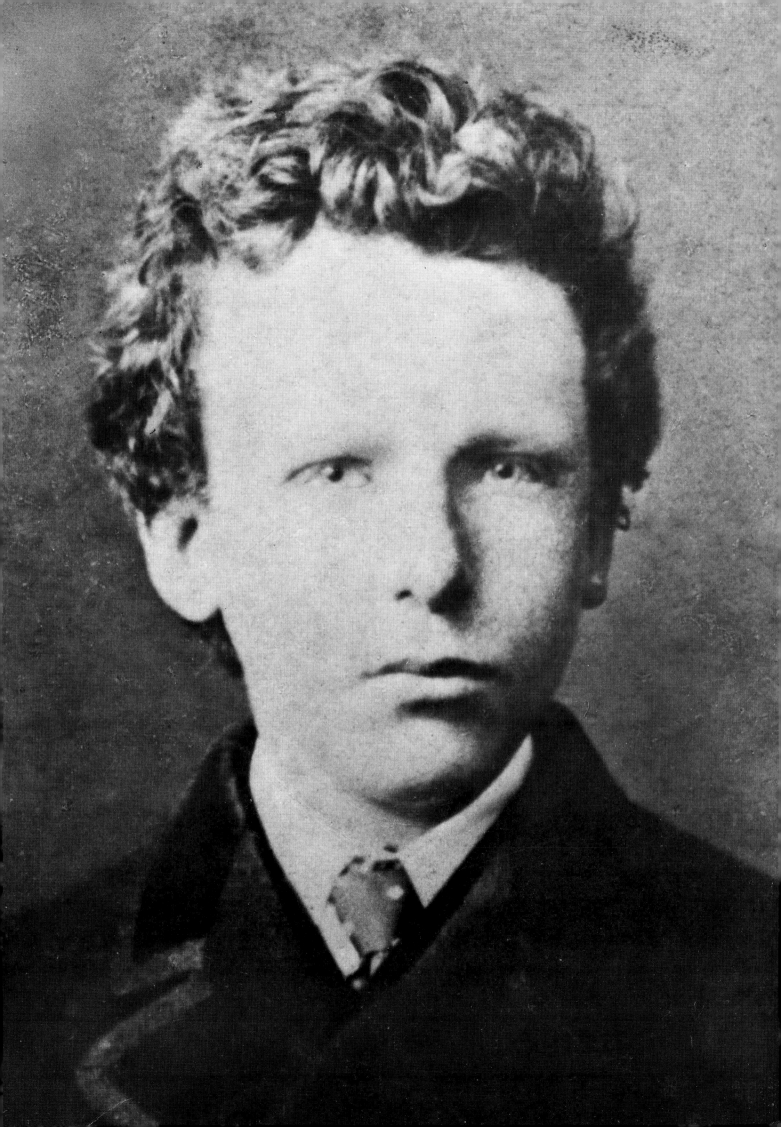

2,3 Vincent's grandparents
Vincent van Gogh (1789–1874), pastor at Breda from 1822
onwards, married in 1811 Elisabeth Huberta Vrijdag
(1790–1875), who came of a Swiss family (Freytag). Of
their six sons, no less than three married girls from the
Carbentus family.

4,5 The church and town hall of Zundert
These were the first public buildings Vincent saw; the town
hall at Auvers, at the end of his life, was curiously similar (*203*).

Opposite:

8 The house where Vincent and Theo were born, in 1853
and 1857 respectively

6 Theodorus van Gogh

7 Anna Cornelia van Gogh-Carbentus

The painter's father (1822–85) was the only one of the twelve children of Vincent and Elisabeth Huberta van Gogh to follow his father's theological vocation. He became pastor of Zundert on 1 April 1849 and married Anna Cornelia Carbentus (1819–1907). They moved to Helvoirt in 1871, and in 1875 to Nuenen, where Theodorus van Gogh died. Vincent's mother (daughter of Willem Carbentus, one of the best bookbinders of his time, who worked for the Dutch Court) combined certain artistic abilities with a strong character and perseverance.

9 Interior of Goupil & Cie (ancienne maison
Vincent van Gogh), Plaats 14, The Hague

10 Vincent van Gogh (1820–88)

11 Rembrandt van Rijn. *Burgomaster Ja*
Six 1647

The setting of an art gallery like Goupil &
Cie, where the young Vincent van Gogh
began to learn the art trade, was of a
Victorian opulence. The founder of the
Hague branch was Vincent's uncle
Vincent, his father's brother and married
to a sister of young Vincent's mother. This
uncle's cultivated appreciation of literature
and art, his understanding of the tensions
which his nephew underwent, meant a
great deal to Vincent on several occasions
during his troubled early career. Vincent,
always ready to link his impressions of
people with those of pictures, wrote of the
etching *Burgomaster Six* by Rembrandt: 'I
sometimes think they [Uncle Vincent and
another uncle, Cor] must have resembled
him when they were younger' (37). Of
Uncle Vincent, he wrote 'the poet died
young in him, the man survived' (81).

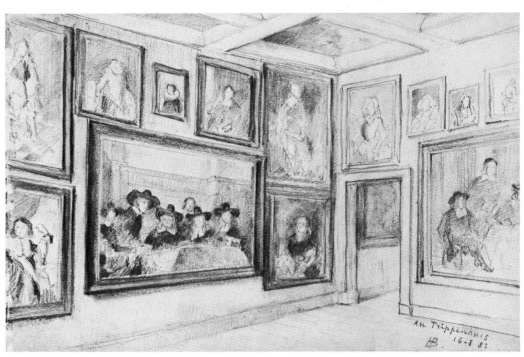

12 The Trippenhuis, Amsterdam
13 Henri de Braekeleer.
Staalmeesterszaal, in the Trippenhuis, 1883
14 August Jernberg. *The 'Night Watch' in the Trippenhuis,* 1885

Vincent, the apprentice art dealer, passionately desired to extend his knowledge of painting. The Trippenhuis in Amsterdam was a former private mansion arranged as a State museum. He often went there, and in his letters analysed his experiences. He even had an exact memory of the hanging.

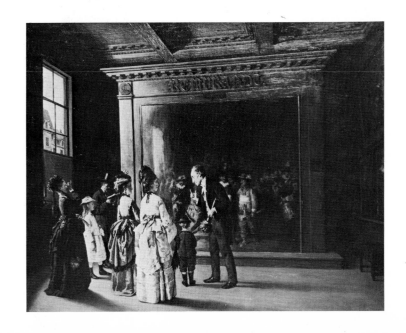

Puritans and exiles

20 G.H. Boughton. *Early Puritans of New England Going to Worship*, 1867
21 G.H. Boughton. *The Landing of the Pilgrim Fathers*, 1869
22 G.H. Boughton. *Deserted*, 1859

From the time of his first stay in London (1873), Vincent admired George Henry Boughton (1834–1905), born in England, educated in America and Holland. Boughton's love for New England, the Pilgrim Fathers, and the Puritans generally, his feeling for a special kind of landscape, and his motifs from Brabant, coincided with Vincent's own ideas. Boughton showed a marked interest in the bleak Dutch landscape.

23 J.E. Millais. *Chill October*, 1870
24 J.E. Millais. *The Lost Piece of Silver*
(*The Lost Mite*)

John Everett Millais (1829–96) aroused
Vincent's warm appreciation with a
landscape, *Chill October*. As with
Boughton's *Deserted*, this was doubtless
because it shows a feeling for landscape
similar to that which Van Gogh himself
was later to express. He was excited to
receive, from Anton Mauve, a
confirmation of his own high opinion of
Chill October. Millais' *The Lost Mite*
attracted Vincent's attention by showing 'a
young woman who early in the morning,
at dawn, is looking for the mite she has
lost' (102, 15 July 1877).

25 Mathijs (Thijs) Maris. *Souvenir of
Amsterdam*, 1871
Thijs Maris' painting, from memory, of a
corner of Amsterdam received a lyrical
description from Vincent in letter 24. Thijs
Maris was a typical, introverted, isolated
Dutch painter, living outside his own
country and full of nostalgia and dreams.
Vincent defended him against those who
ridiculed him: he saw him as 'the
personification of everything high and
noble' (268). 'I spoke once or twice to
Thijs Maris. I dared not speak to
Boughton because his presence overawed
me' (332).

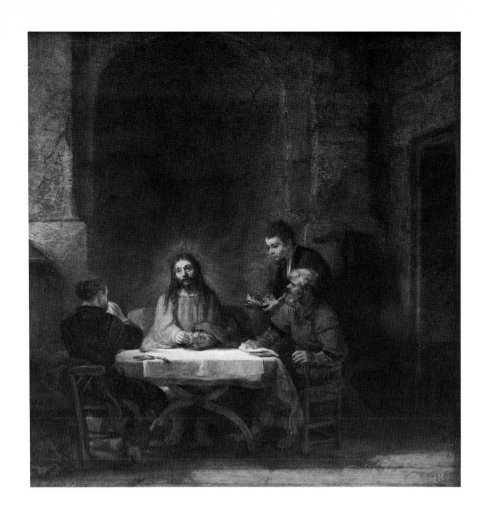

26 Rembrandt van Rijn. *The Men of Emmaus*

The *Men of Emmaus* of Rembrandt in the Louvre was to Vincent an image of human and supernatural elements emanating from a simple realistic motif; it even became a measure for his own impressions. 'Don't you think that when [Uncle Jan and Uncle Cor] sit together, as often happens of an evening, in that lovely, restful room which you also know, it is a sight which warms the heart, especially if one looks at them with love as I do? And yet the *Men of Emmaus* of Rembrandt is even more beautiful, and it might have been the same What they lack, their homes and families also lack' (108).

27 Jacob van Ruisdael. *The Copse*

The Copse was also in the Louvre. He longed for an engraving of it for his wall, and when he received one (by Daubigny), he expressed his enthusiasm with his relative Anton Mauve's catch-phrase, 'That is *it!*' (*Dat is het*).

28 Adriaen van Ostade, *Family Portrait*, 1654
A surprise for Vincent in Paris in 1875 was the family group by Van Ostade; Vincent thought it was the painter's own family, but this now seems doubtful. This delicately painted, lively and skilfully composed group received a detailed description in letter 35, proving the intensity with which Vincent looked at paintings.

29 Jules Breton. *Blessing of the Harvest in Artois*, 1857
Jules Breton (1827–1906) had a great influence on Vincent, both as a poet and as a painter. He saw this *Blessing of the Harvest* in the Luxembourg in 1875.

Serious sentiment

31 Anonymous. *The Mineshaft (Rescue Team Going Down after a Firedamp Explosion)*

30 Gustave Doré. *Exercise Yard at Newgate Gaol*, 1872

32 Auguste Lançon. *Men Shovelling Snow*, 1881

33 Hubert van Herkomer. *Sunday at Chelsea Hospital*, 1871

34 Edwin Buckman. *People Waiting for
Ration Tickets in Paris*, 1870

35 Luke Fildes. *Homeless and Hungry*, 1877
36 Luke Fildes. *The Empty Chair, Gad's
Hill, June 9th, 1870*

37 M.W. Ridley. *Heads of the People: the
Miner*, 1876

The great gain of Vincent's first stay in
England was not his experience of painting
but his discovery of the high graphic
quality of the English illustrated
magazines. The images on these two
pages, all collected by Vincent himself,
give some idea of his feeling for the way in
which ordinary people lived and worked.
He started collecting in earnest only after
his return to Holland and his decision to
become an artist. 'At night when I cannot
sleep, which often happens, I look at the
wood engravings with renewed pleasure'
(229).
His collection included Gustave Doré's
famous *Exercise Yard at Newgate Gaol*, here
squared up by Vincent for the copy he
made in the last year of his life; a number
of coalmining and urban subjects; Fildes'
view of Dickens' study the morning after
his death, which was to have repercussions
in Vincent's own art; and Herkomer's
Sunday at Chelsea Hospital, home of British
military pensioners. '[The English artists]
choose subjects which are as true as
Gavarni's or Daumier's, but have
something noble and a more serious
sentiment.'

38 Ary Scheffer. *Christ on the Mount of Olives*, 1839

39 Ary Scheffer. *Christus Consolator (Christ the Comforter)*, 1837

Christ the Comforter

Leaving England for good at the end of 1878, Vincent was a prey to religious obsessions reflected in his admiration of Ary Scheffer's *Christs*, with their overblown pathos. It was a moment of great weakness. A rare example of his imagination and its moods is given by Vincent in a sensitive description of a Rembrandt drawing he had seen in London, all inspired by his poetic feelings of 'blessed twilight' (109).

40 Attrib. Rembrandt. *Christ with Mary and Martha (The House at Bethany)*, c.1650

41 Marinewerf (dockyard commandant's house),
Amsterdam, in 1890

42 Vice-Admiral Johannes
van Gogh (1817–85)
43 The Rev. Johannes
P. Stricker

Amsterdam

His environment in Amsterdam in 1878, in the house of his
uncle the Vice-Admiral, could not have been more
comfortable; he must have seemed even more of an odd-
man-out than usual in such a setting. The same was true of
the house of the Rev. J.P. Stricker and his wife, a sister of
Vincent's mother. The cemetery entrance is a reminder of
some magnificent paintings and drawings of similar
avenues, done later in Brabant.

44 Oosterbegraafplaats, Oosterpark, Amsterdam

The Borinage

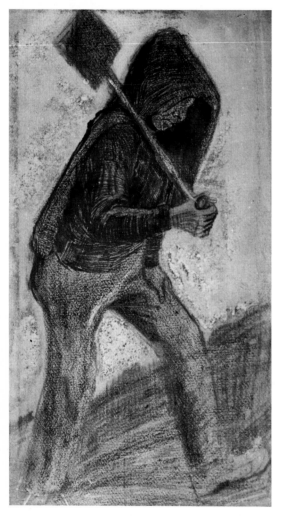

Greater contrast is unthinkable than that between the comfort of Amsterdam and the bleakness and squalor of the Borinage, on the Belgian–French border, where Vincent settled late in 1878 as a lay preacher. In his work among the small evangelical community of Wasmes and Cuesmes, Vincent used a small book of seventy metrical psalms. He underlined a number of texts; as here, from Psalm 77: 'in the day of my trouble I sought the Lord . . . I remembered God, and was troubled'. In this, the phase of Vincent's life which led up to his decision to become an artist, he felt an increasing urge to draw. This *Coal-heaver* is one of the few examples to have survived destruction.

46 Coal-heaver, Jul.–Aug. 1879

47 Vincent's psalter

II

THE DUTCH PERIOD

'In a few years I must finish a certain body of work'

1881 Etten
1881–1883 The Hague
1883 Drenthe
1883–1885 Nuenen

Since 22 October 1875 Vincent's father had been minister at Etten, again in Brabant, not far from Eindhoven and the Belgian border. Vincent had already taken refuge there three times, on the failure of successive attempts to find his way in life. He now returned with the intention of making Etten, for reasons of cheapness, the base of a new and lifelong career as a painter. No one – except Theo, who was away working for Goupil in Paris – had any confidence in his chances of success.

50–53 The months Vincent now spent at Etten bore witness above all to the onset of an intense concentration on nature, the human figure and the landscape. Almost everything he drew at Etten is a primitive Vincent, the work of a man who was not to be satisfied with external appearances only.

... Nature certainly is 'intangible', yet one must seize her, and with a strong hand. And then after one has struggled and wrestled with nature, sometimes she becomes a little more docile and yielding. I do not mean to say that I have reached that point already – no one thinks so less than I – but somehow I get on better. The struggle with nature sometimes reminds one of what Shakespeare calls 'the taming of the shrew' (that means conquering the opposition by perseverance, *bon gré et mal gré*). In many things, but especially in drawing, I think that 'holding tight is better than letting go'.

More and more I feel that drawing the figure is a good thing which indirectly has a good influence on drawing landscape. If one draws a willow as if it were a living being – and after all, it really is – then the surroundings follow in due course if one has concentrated all one's attention only on that same tree, not giving up until one has put some life into it. ... (152, 12–15 Oct. 1881.)

The idea of triumph through persistence – significantly seen in terms of victory over a woman – accompanies the other obsession of Vincent's stay at Etten. To add to the existing family tensions, Vincent now fell in love with his 49 thirty-five-year-old cousin Kee. Since her husband's death in October 1878 she had been living with her parents, the Strickers, in Amsterdam. In 1881 she came with her four-year-old son to stay with her aunt and uncle at Etten.

There is something in my heart that I must tell you; perhaps you know about it already and it is no news to you. I want to tell you that this summer a deep love has grown in my heart for Kee; but when I told her this, she answered me that to her, past and future remained one, so she could never return my feelings.

Then there was a terrible indecision within me about what to do. Should I accept her 'no, never, never'; or, considering the question not finished or decided, should I keep some hope and not give up?

I chose the latter. And up to now I do not repent the decision, though I am still confronted by the 'no, never, never'. Of course, since that time I have met with many *petites misères de la vie humaine* which, written in a book, would perhaps serve to amuse some people, but can hardly be termed pleasant sensations if one has to experience them oneself. ...

Kee herself thinks she will never change her mind, and the older people try to convince me that she cannot; yet they are afraid of that change. The older people will change in this affair, not when Kee changes her mind, but only when I have become somebody who earns at least 1000 guilders a year. Again forgive me the harsh outlines in which I draw things. You will perhaps hear it said of me that I try to force the situation, and similar expressions, but anybody will understand that forcing is absurd in love. ...

Rappard has been here; he brought water colours with him which were very good. Mauve will come here soon, I hope, otherwise I shall go to him. I am drawing a good deal, and believe I am improving; I work more with the brush than before. It is so cold now that I draw exclusively from the figure indoors, a seamstress, a basket weaver, etc. ... (153, 3 Nov. 1881.)

This major development should be seen in relation to his new-found will to activate the creative powers of which he had at last become aware. By virtue

of what Vincent called 'the mourning in her', Kee also represented Michelet's 'woman in black'. It was a uniquely important event.

... My love has made me resolute, and I feel energy – new, healthy energy in me. Just the way everybody else who really loves feels. So what I want to say, brother, is no more nor less than that I firmly believe that any man is unconscious of some peculiar great hidden force, deeply hidden in him, until sooner or later he is awakened by meeting someone of whom he says, 'She, and no other.' ...

Boy, I must see her face again and speak to her once more; if I do not do it soon, something will happen at the silver wedding which would perhaps do me great harm. Don't ask me to go into it. If you were in love too, you would understand; because you are not in love, I should not be able to make it clear to you.

Theo, I want money for the trip to Amsterdam; if I have but just enough, I will go. Father and Mother have promised not to oppose this if only I leave them out of the matter, as it were.

Brother, if you send it to me, I will make lots of drawings for you of the Heike, and whatever you want. And they would not get worse if the 'no, never, never' began to thaw. For *aimer encore* is also the best recipe for *dessiner encore*.

Could you help me with the money, boy? If it is only 20 fr., Father will perhaps give me another 10 (leaving him out of it, 'pretending not to know') and then I'm off like a flash. You understand, old fellow! (157, 12 Nov. 1881.)

It proved quite impossible to bridge the gulf existing between, on the one hand, his own love and the sense of liberation which he described so haltingly to Theo, and, on the other, the inability of his mother and father to show even the very smallest measure of understanding.

... And now that I have got so far, Father would say, Because you write letters to Kee and therefore make trouble between us (*for this is the chief reason*, for whatever they may say of my being too unconventional, or the like, it is just talk), because difficulties arise, I am showing you the door.

Isn't it too bad, and wouldn't it be ridiculous to stop work that has been started, and is beginning to succeed, for that reason? ... No, no, no, there is something wrong, it cannot be right that they want to put me out of the house just at this moment. There is no excuse, and it would thwart me in my work. So I cannot allow it. ... (159, 18 Nov. 1881.)

Vincent's pleas to Theo for money to go and see Kee in Amsterdam were pathetic. And yet, at the same time, he wrote another of his wise and beautifully phrased assessments of his own and Theo's ideas about their generation and the future, managing, as ever, to rise above personal concerns and take a broad view.

... We are full-grown men now, and stand like soldiers in the rank and file of our generation. We do not belong to the same generation as Father and Mother and Uncle Stricker. We must be more faithful to the modern than to the old – to look back towards the old is fatal. ... (160, 19 Nov. 1881.)

His visit to Kee's house in Amsterdam brought matters to a head.

... I went there thinking, Perhaps the 'no, never, never' is thawing, the weather is so mild.

And on a certain evening I strolled along the Keizersgracht looking for the house, and I found it. I rang the bell and heard that the family was still at dinner. But then I was asked to come in. But they were all there except Kee. And they all had a plate before them, but there was not one too many, and this little detail struck me. They wanted me to believe that Kee was out, and had taken away her plate, but I knew that she was there, and I thought this rather like a play or a farce. After some time I asked (after the usual greeting and small talk), 'But where is Kee?'

Then Uncle repeated my question, saying to his wife, 'Mother, where is Kee?'

And Mother answered, 'Kee is out.'

For the moment I did not inquire further, and talked a little about the exhibition at Arti, etc. But after dinner the others disappeared and Uncle S. and his wife and the undersigned remained alone and settled down to discuss the 'case in question'. Uncle S. opened the discussion as a minister and a father, and said that he was just about to send a letter to the undersigned, and that he would read the letter aloud.

But I asked again, 'Where is Kee?' (For I knew that she was in town.)

Then Uncle S. said, 'Kee left the house as soon as she heard that you were here.' . . .

And – do you want me to tell you the rest, boy? It is somewhat risky to be a realist, but Theo, Theo, you yourself are also a realist – oh, bear with my realism. I told you that to some my secrets are not secrets. I do not take it back, think what you will of me, and whether or not you approve of what I did is of less consequence.

I continue. From Amsterdam I went to Haarlem and spent a few hours pleasantly with our little sister Willemien, and I walked with her. In the evening I went to The Hague, and at about seven o'clock I arrived at Mauve's.

And I said, Listen, Mauve, you intended to come to Etten and were to initiate me, more or less, into the mysteries of the palette; but I thought it would not be a matter of a few days, so I have come to you, and if you agree, I shall stay four to six weeks, or more or less if you say so, and then we must see what we can do. It is very bold of me to ask so much of you, but you see, 'the sword is in my loins'.

Then Mauve said, Did you bring anything with you? Yes, here are a few studies. And then he praised them a great deal too much, at the same time criticizing, but too little. Well, the next day we put up a still life and he began by telling me, This is the way to keep your palette. And since then I've made a few painted studies, and then later, two water colours.

So that is the result of the work, but working with the hands and brains is not everything in life. . . .

Then I thought, I should like to be with a woman – I cannot live without love, without a woman. I would not value life at all, if there were not something infinite, something deep, something real.

But then I said to myself, You said 'she, and no other', and now you would go to another woman; it is unreasonable, it is contrary to all logic. . . .

But under the circumstances I fought a great battle within myself, and in the battle some things remained victorious, things which I knew of physic and hygienics and had learned by bitter experience. One cannot live too long without a woman with impunity. And I do not think that what some people call God, and others, supreme being, and other, nature, is unreasonable and without pity; and in short, I came to the conclusion, I must see whether I can find a woman.

And, dear me, I hadn't far to look. I found a woman, not young, not beautiful, nothing remarkable, if you like, but perhaps you are somewhat curious. She was rather tall and strongly built; she did not have a lady's hands like Kee, but the hands of one who works much; but she was not coarse or common, and had something very womanly about her. She reminded me of some curious figure by Chardin or Frère, or perhaps Jan Steen. Well, what the French call *une ouvrière*. She had had many cares, one could see that, and life had been hard for her; oh, she was not distinguished, nothing extraordinary, nothing unusual. 'Every woman at every age can, if she loves and is a good woman, give a man, not the infinity of a moment, but a moment of infinity.' . . .

That woman has not cheated me – oh, he who regards all such women as cheats, how wrong he is, and how little understanding he shows. That woman was very good to me, very good, very kind – in what way I shall not tell my brother Theo, because I suspect my brother Theo of having had some such experience. So much the better for him. Did we spend much money together? No, for I did not have much, and I said to her, Listen, you and I don't need to make ourselves drunk to feel something for each other; just put what I can spare in your pocket. And I wish I could have spared more, for she was worth it.

And we talked about everything, about her life, about her cares, about her misery, about her health, and with her I had a more interesting conversation than, for instance, with my very learned, professorial cousin. (164, *c*.21 Dec. 1881.)

Nearly five months later, Vincent gave his brother more details, but moved the meeting with 'the woman' from December to January, *after* the writing of letter 164. The later letter (193) certainly refers to Christine Clasina (Sien) Hoornik; the earlier one presumably also does so.

... That cold terrible reception in Amsterdam was too much for me, my eyes were opened at last.

Enough. Then Mauve diverted and encouraged me; I threw myself into my work with all my strength. Then toward the end of January, after I had been thrown over by Mauve and had been ill for a few days, I met Christine.

Theo, you say that if I had really loved Kee, I shouldn't have done this. But do you understand better now that I couldn't go any further after what happened in Amsterdam – should I have despaired then? Why should an honest man despair – I am no criminal – I don't deserve to be treated in such an inhuman way. Well, what can they do this time? It's true they got the best of me, they thwarted me there in Amsterdam. But I'm not asking their advice any more now, and being of age, I ask you, Am I free to marry – yes or no? Am I free to put on a workman's clothes and live like a workman – yes or no? Whom am I responsible to, who will try to force me?

To hell with anyone who wants to hinder me. ... (193, 14 May 1882.)

... You must know, Theo, that Mauve has sent me a paintbox with paint, brushes, palette, palette knife, oil, turpentine – in short, everything necessary. So it is now settled that I shall begin to paint, and I am glad things have gone so far.

Well, I have been drawing a good deal recently, especially studies of the figure. ... I am now *52–53* longing to hear what Mauve will have to say. The other day I made some drawings of children, too, and liked it very much.

These are days of great beauty in tone and colour; after I have made some progress in painting, I will succeed in expressing a little of it. But we must stick to the point, and now that I have begun drawing the figure, I will continue it until I am more advanced; and when I work in the open air, it is to make studies of trees, viewing the trees like real figures. ...

But, Theo, I am so very happy with my paintbox, and I think my getting it now, after having drawn almost exclusively for at least a year, better than if I had started with it immediately. I think you will agree with me in this. ...

For, Theo, with painting my real career begins. Don't you think I am right to consider it so? ... (165, December 1881.)

He was to find himself back in The Hague sooner than he had expected.

Thanks for your letter and the enclosed. I was at Etten again when I received it; as I told you, I had arranged this with Mauve. But now you see I am back again in The Hague. On Christmas Day I had a violent scene with Father, and it went so far that Father told me I had better leave the house. Well, he said it so decidedly that I actually left the same day.

The real reason was that I did not go to church, and also said that if going to church was compulsory and if I was *forced* to go, I certainly should never go again out of courtesy, as I had done rather regularly all the time I was at Etten. But oh, in truth there was much more at the back of it all, including the whole story of what happened this summer between Kee and me.

I do not remember ever having been in such a rage in my life. I frankly said that I thought their whole system of religion horrible, and just because I had gone too deeply into those questions during a miserable period in my life, I did not want to think of them any more, and must keep clear of them as of something fatal.

Was I *too* angry, *too* violent? Maybe – but even so, it is settled now, once and for all. ... (166, 29 Dec. 1881.)

Vincent's entire output at The Hague, between Christmas 1881 and September 1883, was produced in an atmosphere of mostly ambiguous emotions, thoughts and actions, the origins of which are to be found at Etten. He never thought of The Hague as a place where he might settle permanently.

69

Drawing from letter 166.

54, 57 Vincent's relationship with Christine – whom he at first referred to as Sien, but after a while merely as 'the woman', suggesting a change in his feelings towards her – developed into settled cohabitation. The affair represented a challenge to his family, and to society, which, without ever fully believing in it himself, he wanted to carry through by marrying her. He had to defend his intentions to everyone. In view of his Adamistic condemnation of the bourgeois world, and of hypocrisy in the Church, he did not find it hard to do so.

... It happens often enough that I am at quite a loss as to what to do. Now this morning I felt so miserable that I went to bed; I had a headache and was feverish from worry because I dread this week so much, and do not know how to get through it. And then I got up, but went back to bed again; now I feel a little better, but I wanted you to know that I did not exaggerate in yesterday's letter. If only I continue working hard, it will not be long before I earn something with my work; but meanwhile I am greatly harassed by scarcity of funds. ... Sometimes my clothes need repairing, and Mauve has already given me a few hints about that too, which I shall certainly carry out; but it cannot all be done at once. You know my clothes are chiefly old things of yours which have been altered for me, or a few have been bought ready-made and are of poor material. So they look shabby, and especially all my dabbling in paint makes keeping them decent even more difficult; it is the same with boots. My underwear is also beginning to fall apart. You know that I have been without means for a long time already, and then many things get dilapidated.

And sometimes one involuntarily becomes terribly depressed, if only for a moment, often just when one is feeling cheerful, as I really am even now. That's what happened this morning; these are evil hours when one feels quite helpless and faint with overexertion. ...

Now that I can work at Pulchri [art club] with a model two evenings a week, perhaps four days with the model would be enough if necessary; and now I have found that old woman, it needn't be so expensive as it was at first when I had a new one every day. For I have already had several models, but they are either too expensive or they think it's too far to come here, or they make objections afterward and do not come back. But I think I have hit on the right one in this old woman. (172, 22 Jan. 1882.)

... Well, my youth is gone – not my love of life or my energy, but I mean the time when one feels so lighthearted and carefree. I really say, So much the better, now there are much better things, after all. ... (173, 26 Jan. 1882.)

He was in close touch with only a small circle of acquaintances consisting mainly of Mauve and Tersteeg (with both of whom he quarrelled) and the painters Weissenbruch, van der Weele and Georg Hendrik Breitner. The highly-strung, irritable Mauve gave him good advice, and professionally Vincent always had the greatest respect for him. This is understandable when one studies Mauve's work, unfortunately out of fashion at the present time.

... At present Weissenbruch is the only one allowed to see Mauve, and I thought I would go and have a talk with him. So today I went to his studio, the attic which you know too. As soon as he saw me, he began to laugh and said, 'I am sure you have come to talk about Mauve'; he knew at once why I came, and I did not have to explain.

Then he told me that the reason for his visiting me was really that Mauve, who was doubtful about me, had sent Weissenbruch to get his opinion about my work.

And Weissenbruch then told Mauve, He draws confoundedly well, I could work from his studies myself.

And he added, 'They call me "the merciless sword", and I am; I would not have said that to Mauve if I had found no good in your studies.'

Now as long as Mauve is ill or too busy with his large picture, I may go to Weissenbruch if I want to find out anything, and Weissenbruch told me that I need not worry about the change in Mauve's attitude toward me.

Then I asked Weissenbruch what he thought of my pen drawings. 'These are the best,' he said.

I told him that Tersteeg had scolded me about them. 'Pay no attention to it,' he said. 'When Mauve said you were a born painter, Tersteeg said No, and Mauve then took your part against Tersteeg – I was there. If it happens again, I will take your part too, now that I have seen your work.'

I do not care so much about that 'taking my part,' but I must say that sometimes I cannot bear Tersteeg's saying to me over and over again, 'You must begin to think about earning your own living.' I think it is such a dreadful expression, and then it is all I can do to keep calm. I work as hard as I can and do not spare myself, so I deserve my bread, and they ought not to reproach me with not having been able to sell anything up to now.

I tell you these details because I do not understand why you have neither written nor sent me anything this month.

Is it possible that you have heard something from Tersteeg that has influenced you?

I can assure you once more that I work hard to make progress on things which would be easy to sell, that is, water colours, but I cannot succeed immediately. If I succeed in making them by and by, it would still be rapid progress, considering the short time I have been working. But I cannot succeed right away. ... (175, 13 Feb. 1882.)

[PS.] *Theo, it is almost miraculous!!!*

First comes your registered letter, second, C. M. asks me to make 12 small pen drawings for him, views of The Hague, apropos of some that were ready. (The *Paddemoes*, the *Geest* and the *Vleersteeg* were finished.) At 2.50 guilders apiece, price fixed by me, with the promise that if they suit him, he will take 12 more at his own price, which will be higher than mine. In the third place, I just met Mauve, happily delivered of his large picture, and he promised to come and see me soon. So '*ça va, ça marche, ça ira encore!*'

And another thing touched me – very, very deeply. I had told the model not to come today – I didn't say why, but nevertheless the poor woman came, and I protested. 'Yes, but I have not come to pose – I just came to see if you had something for dinner.' She had brought me a dish of beans and potatoes. These are things that make life worth living after all. ...

The following words in Sensier's *Life of Millet* appealed to me, and touched me very much, sayings of Millet's: 'Art is a battle – in art you have to risk your own skin.' 'Work like a whole gang of Blacks: I would rather say nothing than express myself feebly.' ... (180, 11 March 1882.)

The correspondence also contains the one remark that proves that Theo had encouraged him to become an artist. By now, Vincent was unsuccessfully urging Theo to follow suit. There is a remarkable coherence in all that he was experiencing and reading, and in what he admired in others; and in his work all this was sometimes embodied in a single figure (185, *Sorrow*).

... In my opinion the enclosed is the best figure I have drawn yet, therefore I thought I should send it to you. It is not the study from the model, and yet it is directly after the model. You should know that I had two underlayers beneath my paper. I had been working hard to get the

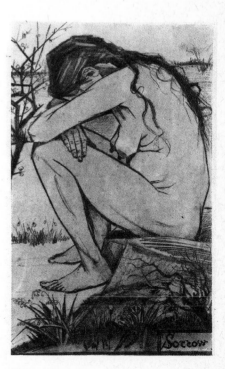

Sorrow, Apr. 1882.
Inscribed 'How can it be that there is in the world one woman alone – deserted? MICHELET'.

right contour; when I took the drawing from the board, it had been imprinted quite correctly on the two underlayers, and I finished them immediately according to the first study. So this one is even fresher than the first. I am keeping the other two for myself, I wouldn't like to part with them. ... (186, c.10 Apr. 1882.)

Mauve's behaviour towards Vincent became less encouraging, and Vincent was distressed. He suspected that people's opinion of him was being adversely affected by the fact that he was living with Sien.

Today I met Mauve and had a very painful conversation with him, which made it clear to me that Mauve and I are separated forever. Mauve has gone so far that he cannot retract, at least he certainly wouldn't want to. I had asked him to come and see my work and then talk things over. Mauve refused point-blank: 'I will certainly not come to see you, that's all over.'

At last he said, 'You have a vicious character.' At this I turned around – it was in the dunes – and walked home alone.

Mauve takes offence at my having said, 'I am an artist' – which I won't take back, because, of course, these words connote, 'Always seeking without absolutely finding.' It is just the opposite of saying, 'I know, I have found it.'

As far as I know, that word means, 'I am seeking, I am striving, I am in it with all my heart.'

I have ears, Theo. If somebody says, 'You have a vicious character,' what should I do next?

I turned around and went back alone, but with a heavy heart because Mauve had dared to say this to me. I shall not ask him to explain it, nor shall I excuse myself. And still – and still – and still – ! I wish Mauve were sorry for it.

They suspect me of something – it is in the air – I am keeping something back. Vincent is hiding something that cannot stand the light.

Well, gentlemen, I will tell you, you who prize good manners and culture, and rightly so if only it be the true kind: Which is the more delicate, refined, manly – to desert a woman or to stand by a forsaken woman?

Last winter I met a pregnant woman, deserted by the man whose child she carried. A pregnant woman who had to walk the streets in winter, had to earn her bread, you understand how.

I took this woman for a model, and have worked with her all winter. I could not pay her the full wages of a model, but that did not prevent my paying her rent, and, thank God, so far I have been able to protect her and her child from hunger and cold by sharing my own bread with her. ... The woman is now attached to me like a tame dove. For my part, I can only marry once, and how can I do better than marry her? It is the only way to help her; otherwise misery would force her back into her old ways, which end in a precipice. She has no money, but she helps me earn money in my profession. ... (192, late Apr. 1882.)

Mauve's own temperament made him a difficult mentor for any young artist. In 1885 he moved to Laren, which was the home of the portrait painter Jan Veth (whom Vincent, incidentally, had met at Dordrecht). Veth was a placid and easy-going person, very unlike Vincent; but he wrote to his future biographer, Jan Huizinga:

Mr Mauve lives here. He once corrected my work. Although he gave me much encouragement, I must say that he more or less demolished everything I had done. ... I don't know anyone else who is so guided by momentary impressions as Mauve. If he suddenly discovers something in one's work that is not too bad, he positively falls over himself to be pleasant. On the other hand, if he has anything at all against one, or if he is in a bad mood, then he is absolutely impossible to live with. He has a great heart and a weak head; he is very childlike, very passionate, and the only reason why he ranks so high as a human being is that he is such a great artist. (Jan Huizinga, *Leven en werk van Jan Veth*, Haarlem 1927, p.819.)

During the summer of 1882 Vincent was lonely and much given to reflection. Sien was in a maternity hospital in Leyden, while he himself had been treated

for venereal disease at a Hague hospital and was due to return there. His greatest problems, those relating to work and money, were often summarized with notable clarity, while his analyses of the creative process show an ever-increasing awareness of what took place prior to the actual work of painting.

... In life it is the same as in drawing – one must sometimes act quickly and decisively, attack a thing with energy, trace the outlines as quickly as lightning.

This is no time for hesitation or doubt; the hand must not tremble, nor must the eye wander, but remain fixed on what is before one. And one must be so absorbed in it that in a short time something has been brought onto the paper or the canvas which was not there before, in such a way that later one hardly knows how it was hammered off. The period of discussing and thinking must precede the decisive action. There is little room for reflection or argument in the *action* itself.

To act quickly is the function of a man, and one has to go through much before one is able to do it. The pilot sometimes succeeds in using a storm to make headway, instead of being wrecked by it.

What I wanted to say to you again is this: I have no great plans for the future; if momentarily I feel rising within me the desire for a life without care, for *prosperity*, each time I go fondly back to the trouble and the cares, to a *life full of hardship*, and think, It is better this way; I learn more from it, it does not degrade me, this is not the road on which one perishes. (197, 12/13 May 1882.)

... You know I wrote you a lot about Kee last year, so I think you know what went on in my mind. Don't think that I exaggerated my feelings then; I had a strong, passionate love for her, quite different from that for Sien. When I unexpectedly learned in Amsterdam that she had a kind of aversion to me, that she considered my behaviour as coercing her and refused even to see me, and that 'she left her own house as soon as I entered it' – then, but not before, that love for her received a death blow. And I only perceived this when I awoke to reality here at The Hague this winter.

I then felt an inexpressible melancholy inside, which I cannot possibly describe. I know that then I often, often thought of a manly saying of father Millet's: 'It has always seemed to me that suicide was the deed of a dishonest man.'

The emptiness, the unutterable misery within me made me think, Yes, I can understand people drowning themselves. But I was far from approving this. I found strength in the above-mentioned saying, and thought it much better to take heart and find a remedy in work. ... It is hard, very hard, aye, quite impossible to consider last year's love an illusion, as Father and Mother do, but I say, *'Though it never will be, it might have been.'* ...

The feeling between Sien and me is *real*; it is no dream, it is reality. I think it is a great blessing that my thoughts and energy have found a fixed goal and a definite direction. ...

Do not imagine that I think myself perfect, or that I think that many people's taking me for a disagreeable character is no fault of mine. I am often terribly melancholy, irritable, hungering and thirsting, as it were, for sympathy; and when I do not get it, I try to act indifferently, speak sharply, and often even pour oil on the fire. I do not like to be in company, and often find it painful and difficult to mingle with people, to speak with them. But do you know what the cause is – if not at all, of a great deal of this? Simply nervousness; I am terribly sensitive, physically as well as morally, the nervousness having developed during those miserable years which drained my health. Ask any doctor, and he will understand at once that nights spent in the cold street or in the open, the anxiety to get bread, a continual strain because I was out of work, the estrangement from friends and family, caused at least three-fourths of my peculiarities of temper, and that those disagreeable moods or times of depression must be ascribed to this. But you, or anyone who will take the trouble to think it over, will not condemn me, I hope, because of it, nor find me unbearable. I try to fight it off, but that does not change my temperament; and even though this may be my bad side, confound it, I have a good side too, and can't they credit me with that also? ... (212, 6 July 1882.)

Vincent's father now seems to have made an attempt, or at least a proposal, to have his son committed to a mental home at Gheel (in Belgium). Vincent never managed to forget this. It was mentioned in the course of a stormy

interview with Tersteeg in which Vincent's former employer, in his own tactless, not to say insulting manner, fairly accurately expressed the family's point of view.

This time I have to tell you something about a visit from Mr Tersteeg. This morning, he came here and saw Sien and the children. I could have wished that he had shown a kind face to a young little mother just out of childbed. But that was asking too much.

Dear Theo, he spoke to me in a way which you can perhaps imagine.

'What was the meaning of that woman and that child?'

'How could I think of living with a woman, and children into the bargain?'

'Wasn't it just as ridiculous as driving my own four-in-hand all over town?'

To which I answered that this was certainly quite a different case.

'Had I gone mad? It was certainly the result of an unsound mind and temperament.'

I told him that I had just received the most reassuring information from persons more competent that he, namely the physicians at the hospital, as much about the condition of my body as about the power of my mind to stand exertion. . . .

As for my constitution – Tersteeg is not my physician and he does not understand my constitution in the least – when I want information on the subject, I shall go to my own doctor and ask for it, but I absolutely refuse to discuss it with him any more. But it is certain that there are few things more harmful either to the woman or to myself than visits like that one we just went through. Avoiding these is absolutely one of the first medical orders I shall have to carry out. *Never* has a doctor told me that there was something abnormal about me in the way and in the sense Tersteeg dared to tell me this morning. That I was not able to think or that my mind was deranged. No doctor has told me this, neither in the past nor in the present; certainly I have a nervous constitution, but there is definitely no real harm in that. So those were serious insults on Tersteeg's part, just as they were on Pa's, but even worse, when he wanted to send me to Gheel. I cannot take such things lying down. I am looking forward to discussing my indisposition further with you, what caused it, etc. . . . (216, 18 July 1882.)

Van Gogh remained faithful to the subjects he had loved so much in the days before he started painting. Once again his walls were covered with Boughtons, Millets, Ruysdaels, Herkomers and De Groux. The nineteenth century, with its many constituent layers, remained part of him – although he had progressed far beyond it, and nothing of that tradition is in fact to be seen in his original work. He saw himself clearly to be a man of his time.

. . . Personally, I find in many modern pictures a peculiar charm which the old masters do not have.

For me one of the highest and noblest expressions of art is always that of the English, for instance, Millais and Herkomer and Frank Holl. What I mean about the difference between the old masters and the modern ones is this – perhaps the modern ones are deeper thinkers.

There is a great difference in sentiment between *Chill October* by Millais and *Bleaching Ground at Overveen* by Ruysdael; and also between *Irish Emigrants* by Holl and *The Bible Reading* by Rembrandt. Rembrandt and Ruysdael are sublime, for us as well as for their contemporaries; but there is something in the modern painters that appeals to us more personally and intimately.

It is the same with the wood engravings by Swain and those of the old German masters.

So, I think it was a mistake a few years ago when the modern painters went through a period of imitating the old masters.

Therefore I think old Millet is right in saying, 'I think it absurd that men should wish to seem other than they are.' It seems like a commonplace saying, yet it is fathomless, as deep as the ocean, and personally I think one would do well to take it to heart. . . . (218, 21 July 1882.)

. . . I saw a dead willow trunk there [Scheveningen], just the thing for Barye, for instance. It was hanging over a pool that was covered with reeds, quite alone and melancholy, and its bark was moss-covered and scaly, somewhat like the skin of a serpent – greenish, yellowish, but mostly a dull black, with bare white spots and knotted branches. I am going to attack it tomorrow morning.

I also did a bleaching-ground at Scheveningen right on the spot, washed in at one sitting, almost without preparation, on a piece of very coarse torchon [unbleached linen]. Enclosed a few small sketches of it. . . .

. . . You see I am quite taken up by landscape, but it is because Sien is not yet fit to pose; nevertheless, the figure remains the principal thing for me.

When you come, I shall take care to be near the house as long as you are in town so you will know where to find me; and then while you attend to business and pay your calls, I will go on drawing as usual. I can meet you by appointment wherever you wish, but for several reasons it is better for us both, I think, if I do not go with you to see Tersteeg or Mauve, etc. And then, I am so used to my working clothes, in which I can lie or sit on the sand or the grass, whichever is necessary (for in the dunes I never use a chair, only an old fish basket sometimes); so my dress is a little too Robinson Crusoe-like for paying calls with you. . . . (220, 26 July 1882.)

Vincent's discussions of the creative process set him apart from the Hague painters, in spite of similarities of subject-matter. He was looking at their studios, however, and visited the Post and Mesdag collections, where he saw numerous works by French artists such as Daubigny, Courbet, Breton, Rousseau and Millet. His descriptions of landscape have a precision, an awareness of structure, light and colour, which still make them a joy to read.

You must not take it amiss if I write you again – it is only to tell you that painting is such a joy to me.

Last Saturday night I attacked a thing I had been dreaming of for a long time. It is a view of the flat green meadows, with haycocks. It is crossed by a cinder path running along a ditch. And on the horizon in the middle of the picture the sun is setting, fiery red. I cannot possibly draw the effect in such a hurry, but this is the composition.

But it was purely a question of colour and tone, the variety of the sky's colour scheme – first a violet haze, with the red sun half covered by a dark purple cloud which had a brilliant fine red border; near the sun reflections of vermilion, but above it a streak of yellow, turning into green and then into blue, the so-called *cerulean blue*; and then here and there violet and grey clouds, catching reflections from the sun.

The ground was a kind of carpetlike texture of green, grey and brown, but variegated and full of vibration – in this colourful soil the water in the ditch sparkles.

It is something that Emile Breton, for instance, might paint.

Then I have painted a huge mass of dune ground – thickly painted and sticky.

And as for these two, the small marine and the potato field, *I am sure no one could tell that they are my first painted studies.*

To tell you the truth, it surprises me a little. I had expected the first things to be a failure, though I supposed they would improve later on; but thought I say so myself, they are not bad at all, and I repeat, it surprises me a little. . . .

As you perhaps know, there is an exhibition of the Black and White Society. There is a drawing by Mauve – a woman at a weaving loom, probably in Drenthe – which I think superb.

No doubt you saw some of them at Tersteeg's. There are splendid things by Israëls – including a portrait of Weissenbruch, with a pipe in his mouth and his palette in his hand. By Weissenbruch himself, beautiful things – landscapes and also a marine.

There is a very large drawing by J. Maris, a splendid town view. A beautiful W. Maris, among other things, a sow with a litter of pigs, and cows. Neuhuys, Duchâtel, Mesdag. By the last, besides a fine large marine, two Swiss landscapes which I think rather stupid and dull. But the large marine is splendid. . . .

But this much I want to tell you – while painting, I feel a power of colour in me that I did not possess before, things of broadness and strength.

Now I am not going to send you things *at once* – let it ripen a little first – but know that I am full of ambition and believe that for the present I am making progress. . . .

Neither do I believe that it will hinder me if my health should give way a little from time to time. As far as I can see, the painters who occasionally cannot work for a week or two are not

the worst ones. It may be because they are the ones 'who risk their own skins', as old Millet says. That doesn't matter, and in my opinion one must not spare oneself when there is something important to do. If a short period of exhaustion follows, it will soon pass, and so much is gained that one harvests one's studies just the way a farmer harvests his crops. Now for myself, I have not yet thought of taking a rest. . . . (225, 15 Aug. 1882.)

His letters are full of interesting information about his intelligent but also compulsive manner of working, and about the various stages in the development of his conceptions. Applying the paint to the canvas straight from the tube was one of his technical innovations; it was more than just a spontaneous impulse to achieve an immediate result.

. . . The wood is becoming quite autumnal – there are effects of colour which I very rarely find painted in Dutch pictures.

In the woods, yesterday toward evening, I was busy painting a rather sloping ground covered with dry, mouldered beech leaves. This ground was light and dark reddish-brown, made more so by the shadows of trees casting more or less dark streaks over it, sometimes half blotted out. The problem was – and I found it very difficult – to get the depth of colour, the enormous force and solidity of that ground – and while painting it I perceived for the very first time how much light there still was in that dusk – to keep that light and at the same time the glow and depth of that rich colour.

For you cannot imagine any carpet as splendid as that deep brownish-red in the glow of an autumn evening sun, tempered by the trees.

From that ground young beech trees spring up which catch light on one side and are brilliant green there; the shadowy sides of those stems are a warm, deep black-green.

Behind those saplings, behind that brownish-red soil, is a sky very delicate, bluish-grey, warm, hardly blue, all aglow – and against it all is a hazy border of green and a network of little stems and yellowish leaves. A few figures of wood gatherers are wandering around like dark masses of mysterious shadows. The white cap of a woman bending to reach a dry branch stands out suddenly against the deep red-brown of the ground. A skirt catches the light – a shadow is cast – a dark silhouette of a man appears above the underbrush. A white bonnet, a cap, a shoulder, the bust of a woman moulds itself against the sky. Those figures are large and full of poetry – in the twilight of that deep shadowy tone they appear as enormous terracottas being modelled in a studio. . . .

It struck me how sturdily those little stems were rooted in the ground. I began painting them with a brush, but because the surface was already so heavily covered, a brush stroke was lost in it – then I squeezed the roots and trunks in from the tube, and modelled it a little with the brush. Yes – now they stand there rising from the ground, strongly rooted in it.

In a certain way I am glad I have not *learned* painting, because then I might have *learned* to pass by such effects as this. Now I say, No, this is just what I want – if it is impossible, it is impossible; I will try it, though I do not know how it ought to be done. *I do not know myself* how I paint it. I sit down with a white board before the spot that strikes me, I look at what is before my eyes, I say to myself, That white board must become something; I come back dissatisfied – I put it away, and when I have rested a little, I go and look at it with a kind of fear. Then I am still dissatisfied, because I still have that splendid scene too clearly in my mind to be satisfied with what I made of it. But I find in my work an echo of what struck me, after all. . . .

You see I am absorbed in painting with all my strength; I am absorbed in colour – until now I have restrained myself, and I am not sorry for it. If I had not drawn so much, I should not be able to catch the feeling of and get hold of a figure that looks like an unfinished terracotta. But now I feel myself on the open sea – the painting must be continued with all the strength I can give it. . . . (228, Sept. 1882.)

Vincent always retained the old academic distinction between *studies* and completed *paintings*, and often returned to the theme, even as late as Arles. To him it was essential to distinguish between the work produced as a direct reflection of what had inspired him, either because it caught his eye or for

analytical reasons, and that in which inwardly inspired elements played an active part in transforming the given subject.

I consider making studies like sowing, and making pictures like reaping.

I believe one gets sounder ideas when the thoughts arise from direct contact with things than when one looks at them with the set purpose of finding certain facts in them.

It is the same with the question of the colour scheme. There are colours which harmonize together wonderfully, but I try my best to make it as I see it, before I set to work to make it as I feel it. And yet feeling is a great thing, and without it one would not be able to do anything. . . .

It is already late. I have not slept well these last few nights. It is all that beautiful autumn scenery that I have on my mind, and the desire to profit by it. But I wish I *could* sleep at the right time, and I try my best, for it makes me nervous; but there is no help for it. . . . (233, 19 Sept. 1882.)

The descriptions of the search for his themes are far from sentimental; nor are they deliberately symbolic. They correspond quite naturally to the emotions he felt in a period of increasingly intense loneliness. Themes such as trodden grass by the roadside, frozen cabbages, rusty rails in yellow sand, hungry crows, a low grey sky, were such as could be observed, and transformed into music, only by a man whose inner life was embodied in just such images.

. . . Your description of that night effect again struck me as very beautiful. It looks very different here today, but beautiful in its own way, for instance, the grounds near the Rhine railway station: in the foreground, the cinder path with the poplars, which are beginning to lose their leaves; then the ditch full of duckweed, with a high bank covered with faded grass and rushes; then the grey or brown-grey soil of spaded potato fields, or plots planted with greenish purple-red cabbage, here and there the very fresh green of newly sprouted autumn weeds, above which rise bean stalks with faded stems and the reddish or green or black bean pods; behind this stretch of ground, the red-rusted or black rails in yellow sand; here and there stacks of old timber – heaps of coal – discarded railway carriages; higher up to the right, a few roofs and the freight depot – to the left, a far-reaching view of the damp green meadows, shut off far away at the horizon by a greyish streak, in which one can still distinguish trees, red roofs and black factory chimneys. Above it, a somewhat yellowish yet grey sky, very chilly and wintry, hanging low; there are occasional bursts of rain, and many hungry crows are flying around. Still, a great deal of light falls on everything; it shows even more when a few little figures in blue or white smocks move over the ground, so that shoulders and heads catch the light. . . .

But it's on days like this that one would like to go and see some friend or would like a friend to come to the house; and it's on days like this that one has an empty feeling when one can go nowhere and nobody comes. But it's then that I feel how much the work means to me, how it gives tone to life, apart from approval or disapproval; and on days which would otherwise make one melancholy, one is glad to have a will. . . . (238, Oct. 1882.)

The profound emotion with which he interpreted certain natural phenomena is more evident in his letters than in the works he produced at this time.

. . . At times I feel a great desire to be in London again. I should so much love to know more about printing and wood engravings.

I feel a power in me which I must develop, a fire that I may not quench, but must keep ablaze, though I do not know to what end it will lead me, and shouldn't be surprised if it were a gloomy one. In times like these, what should one wish for? What is relatively the happiest fate? . . .

Sometimes I have such a longing to do landscape, just as I crave a long walk to refresh myself; and in all nature, for instance in trees, I see expression and soul, so to speak. A row of pollard willows sometimes resembles a procession of almshouse men. Young corn has something inexpressibly pure and tender about it, which awakens the same emotion as the expression of a sleeping baby, for instance.

The trodden grass at the roadside looks tired and dusty like the people of the slums. A few days ago, when it had been snowing, I saw a group of Savoy cabbages standing frozen and benumbed, and it reminded me of a group of women in their thin petticoats and old shawls which I had seen standing in a little hot-water-and-coal shop early in the morning. ...

When one is in a sombre mood, how good it is to walk on the barren beach and look at the greyish-green sea with the long white streaks of the waves. But if one feels the need of something grand, something infinite, something that makes one feel aware of God, one need not go far to find it. I think I see something deeper, more infinite, more eternal than the ocean in the expression of the eyes of a little baby when it wakes in the morning, and coos or laughs because it sees the sun shining on its cradle. If there is a 'ray from on high', perhaps one can find it there. (242, ?5 Nov. 1882.)

Vincent was already longing for some form of collaboration, the beginnings of a desire to work as a group, which he could not achieve in The Hague.

... The truth is that whenever different people love the same thing and work at it together, their union makes strength; combined, they can do more than if their separate energies were each striving in a different direction. By working together one becomes stronger and a whole is formed, though the personality of each need not be blotted out by working together. And therefore I wish that Rappard were entirely better; we do not really work together, but we have the same thoughts about many things. He is recovering, though, and we are already fussing over our wood engravings again. ... (262, 25/29 Jan. 1883.)

In 1883 he drew up a balance sheet of his thirty years, and was conscious of his desolate face in the mirror, and of the oppressive weight of the judgment of those who regarded him as a failure. Later, his emergent idea that 'life is only a kind of sowing time, and the harvest is not here' was to develop into a fundamental belief.

... Sometimes I cannot believe that I am only thirty years old, I feel so much older.

I feel older *only* when I think that most people who know me consider me a failure, and that it might really be so if some things do not change for the better; and when I think *it might be so*, I feel it so intensely that it quite depresses me and makes me as downhearted as if it were really so. In a calmer and more normal mood I am sometimes glad that thirty years have passed, and not without teaching me something for the future, and I feel strength and energy for the next thirty years, if I live that long.

And in my imagination I see years of serious work ahead of me, and happier than the first thirty.

How it will be in reality doesn't depend *only* on myself, the world and circumstances must also contribute to it.

What concerns me and what I am responsible for is making the most of the circumstances and trying my best to make progress.

For the working man, the age of thirty is just the beginning of a period of some stability, and as such, one feels young and full of energy.

But at the same time a chapter of life is closed; it makes one melancholy, thinking some things will never come back. And it is no silly sentimentalism to feel a certain regret. Well, many things really begin at the age of thirty, and certainly all is not over then. But one doesn't expect to get from life what one has already learned it cannot give; rather one begins to see more and more clearly that life is only a kind of sowing time, and the harvest is not here.

Perhaps that's the reason why one is sometimes indifferent to the world's opinion, and if that opinion depresses us all too strongly, we may shake it off.

Perhaps I had better tear up this letter again. ... (265, 8 Feb. 1883.)

His melancholy could be gentle as well as bitter; he gave an unprejudiced and sympathetic response to Theo, who like himself had taken pity on a sick woman and was unsure whether to marry her. His mood of intense loneliness persisted; it was at this time that he began to be affected by the shortcomings of 'the woman', and by the lack of response to his work.

... Yes, I often think of what you wrote recently. I think there must be a great difference between the woman you met and the one I have already lived with for a full year, but what they have in common is their misfortune and their sex.

Don't you also think that if one meets someone in such a way – I mean, so weak and defenceless – something makes one surrender completely, so that one cannot imagine ever being able to desert such a person? Generally speaking, such an encounter is an apparition. Have you read Erckmann-Chatrian's *Madame Thérèse*? It has a description of a woman who is recovering – very touching and beautiful; it is a simple book, but at the same time, deep.

If you don't know *Madame Thérèse*, do read it. I think she will like it too, and be touched by it.

At times I regret that the woman with whom I live understands neither books nor art. But (though she definitely can't) doesn't my still being so attached to her prove that there is something sincere between us? Perhaps she will learn later on, and it may strengthen the bond between us; but now, with the children, you will understand that she has her hands full already. And especially because of the children she comes into contact with reality, and involuntarily she learns. Books and reality and art are alike to me. Somebody out of touch with real life would bore me, but somebody right in the midst of it knows and feels naturally.

If I did not look for art in reality, I should probably find her stupid; as it is I only wish it were otherwise, but after all I am contented with things as they are. ... (266, 11 Feb. 1883.)

Vincent's depressions were deepening. The relationship with 'the woman' only exacerbated his longing for contact at a deeper level, and the situation between them deteriorated rapidly. He was soon to leave her and her children. This was the moment when he made his lucid assessment – discussed in the Introduction, p. 14 – of his chances of survival. Depressions which one cannot, in Vincent's words, 'exactly account for' may sometimes obscure the view of the future, or else clarify an inexplicable sudden insight into a development and its duration. Vincent experienced both phenomena. He both foresaw the duration of his creative life, and wished himself already dead.

[PS.] In fact, I have no real friend but you, and when I am in low spirits, I always think of you. I only wish you were here, that we might again talk together about moving to the country.

Except for what I told you about, there is nothing particular the matter with me, and things are going well – but perhaps I am a little feverish or something – I feel miserable. I had to pay money right and left – landlord, paint, baker, grocer, shoemaker, heaven knows what – and only a little is left. But the worst is that after many such weeks, one feels one's resistance ebbing, and is overcome by a pervading feeling of weariness.

If you can't send anything at once, brother, at all events try to write me by return of mail if possible. And as to the future, if there is some danger, tell it straight out, '*homme avisé en vaut deux* [forewarned is forearmed]', it is better to know exactly what one has to fight against.

I have tried to work a little today, but suddenly I was overcome by a depression which I cannot exactly account for. At such moments one wishes one were made of iron, and regrets that one is only flesh and blood. ...

And now I thought, I am sorry that I didn't fall ill and die in the Borinage that time, instead of taking up painting, for I am only a burden to you. And yet I cannot help it, for one must go through many phases to become a good painter, and what one makes in the meantime is not exactly bad if one tries one's utmost; but there ought to be people who see it in the light of its tendency and objective, and who do not ask the impossible.

Things are looking dark now. If it were only for me, but there is the thought of the woman and the children, poor creatures whom one would keep safe, and feels responsible for.

The woman has been doing well recently.

I cannot talk about it with them, but for myself it became too much today. Work is the only remedy; if that does not help, one breaks down.

And you see the trouble is that the possibility of working depends on selling the work, for there are expenses – the more one works, the greater the expenses are (though the latter is not true in every respect). When one does not sell and has no other income, it is impossible to make the progress which would otherwise follow of its own accord.

The fact is, brother, that the general state of affairs oppressed me more than I could bear, and I am telling you my thoughts. I only wish you would come soon. And do write soon, for I need it. Of course there is nobody but you that I can speak to about it, for it does not concern other people, and they have nothing to do with it. (302, 22 July 1883.)

[PS.] Without any definite motive, I can't help adding a thought which often occurs to me. Not only did I begin drawing relatively late in life, but it may also be that I shall not live for so very many years.

If I think of that in a coldly calculating manner, as if I were making an estimate of something, it is in the nature of things that I cannot possibly know anything definite about it.

But in comparison with various persons whose lives one might happen to know, or in comparison with some people with whom one is supposed to have many things in common, one can draw some conclusions which are not completely without foundation. Therefore, as to the time ahead in which I shall still be able to work, I think I may safely presume: that my body will keep a certain number of years *quand bien même* – a certain number, between six and ten, for instance. I can assume this the more safely as at present there is no immediate *quand bien même*.

This is the period which I can firmly count on; for the rest, it would be speculating too much at random to dare say something definite about myself, because whether or not there will be anything after that time depends especially on those, let's say, first ten years.

If one wears oneself out too much in those years, one doesn't live past forty; if one is strong enough to resist certain shocks which generally attack one then, to solve some more or less complicated physical difficulties, then between forty to fifty one is again in a new, relatively normal fairway.

But for the present, such calculations are irrelevant; as I said, one can only take plans for a period of between five and ten years into account. I do *not* intend to spare myself, nor to avoid emotions or difficulties – I don't care much whether I live a longer or a shorter time; besides, I am not competent to take care of my physique the way a physician, for instance, can.

So I go on like an ignoramus who knows only one thing: '*In a few years I must finish a certain body of work.*' I need not rush myself too much – there is no good in that, but I must work on in complete calmness and serenity, as regularly and fixedly as possible, as concisely and pointedly as possible. The world concerns me only in so far as I feel a certain indebtedness and duty toward it because I have walked this earth for thirty years, and, out of gratitude, want to leave some souvenir in the shape of drawings or pictures – not made to please a certain taste in art, but to express a sincere human feeling. So this work is my aim – and when one concentrates on that one idea, everything one does is simplified in that it is not chaotic, but all done with one object in mind. . . . (309, 4/8 Aug. 1883.)

He re-examined not only the fate of Christine and her children, but also the situation regarding Kee with which it was so inextricably linked.

. . . I would rather give up everything than put too heavy a burden on your shoulders. Then I shall definitely go to London at once to work at *anything*, even carrying parcels, and I will leave art till better times, at least the painting and having a studio. When I look back on the past, I always run up against the same never-quite-cleared-up fatal facts which coincided in the months from August 1881 till February 1882. . . . (312, 17 Aug. 1883.)

. . . There is no anguish greater than the soul's struggle between duty and love, both in their highest meaning. When I tell you I choose my duty, you will understand everything.

A simple word about it during our walk made me feel that absolutely nothing is changed within me in that respect, that it is and remains a wound which I carry with me; it lies deep and cannot be healed. After years it will be the same as it was the first day. . . .

And my own future is a cup that will not pass from me unless I drink it.

So '*Fiat voluntas.*' . . . (313, 18 Aug. 1883.)

Intermingled with all this, the conflict about clothes was one of the recurrent signs of Vincent's self-protective obsession with personal autonomy. Eccentricities of dress had been given as the explanation for his dismissal from Goupil in 1876; seven years later, the memory still rankled.

... As to my clothes, dear brother, I put on what was given me, without wanting more, without asking for more. I have worn clothes I got from Father and from you, which sometimes do not fit me the way they ought to because of the difference in our sizes. If you will drop the matter of defects in my attire, I shall remain content with what I have, and even be grateful for little, though of course later I hope to remind you of it and say, 'Theo, do you remember the time when I walked about in a long clergyman's coat of Father's?' etc. It seems to me that it is infinitely better to take things as they are *now*, and laugh over them together later, when we have made our way, rather than quarrel about them now.

For the moment I have the suit you brought for me to wear when I go out, and more things that are still quite presentable. But you must excuse my not putting them on in the studio or when I work out-of-doors – it would be spoiling them recklessly, for one always gets some stains on one's clothes while painting, especially if one tries to catch an effect even in rain and storm. ...

[PS.] I do not hesitate about the work.

You have read [Alphonse Daudet's] *Fromont Jeune et Riszler aîné*, haven't you? Of course I do not find you in Fromont Jeune, but in Riszler aîné – in his being absorbed in his work, his resoluteness *there*, for the rest a simple fellow and rather careless and shortsighted, wanting little for himself, so that he himself did not change when he became rich – I find some likeness to myself.

All my ideas about my work are so well ordered, so definite, that I think you would do well to accept what I say: Let me go my own way, just as I am. My drawings will become good, even if we continue as we have till now; but as their turning out well depends a little on the money for my obligations and expenses – and not just on my efforts – be as liberal as you can about the money, and if you see a chance of finding any help from others, don't neglect it. But in fact, I have said everything I have to say in these few lines. ...

You must not let my conduct when I left Goupil's deceive you as to my real character. If business had meant to me then what art does now, I would have acted more resolutely. But then I was in doubt whether it was my career or not, and I was more passive. When they said to me, 'Hadn't you better go,' I replied, 'You think I had better go, so I shall go' – no more. At the time more things were left unspoken than said aloud.

If they had acted differently then, if they had said, 'We do not understand your behaviour on this or that occasion, explain it,' things would have turned out differently. ...

But they did not ask me anything, but just said, 'You are an honest and active employee, but you set a bad example to the others.' And I did not say anything in reply because I did not want to have any influence on my staying or not.

But I could have said a lot of things in reply if I had cared to, and such things as I believe would have made it possible for me to stay.

I tell you this because I do not understand why you do not know that the reason then was quite another than my manner of dressing. ... (315, 20/21 Aug. 1883.)

Leaving The Hague disposed of his main problem, which was how to resolve the 'Kee-Christine' situation in a manner acceptable both to himself and to the outside world. Here he was considering not only the two women, but above all the question whether, because of his work as a painter, he would have to abandon forever any idea of having what he called a *real* life with a wife and children.

... You write about your walk that Sunday in Ville d'Avray; at the same moment on the same day, I too was walking alone, and I too want to tell you something about that walk, when our thoughts probably met again. As I wrote you, I had spoken to the woman – we felt that in the future it would be impossible for us to stay together, nay, that we should make each other unhappy, yet we both felt how strongly we are attached to each other – and then I went far out into the country to have a talk with nature. Well, I walked to Voorburg and from there to Leidendam. You know the scenery there, splendid trees, majestic and serene, right next to horrible green toy summerhouses and all the absurdities the heavy fancy of retired Dutchmen can invent in the form of flower plots, arbours and porches. Most of the houses very ugly; some, however, old and stately. Now at that very moment, high over the meadows,

boundless as the desert, one mass of clouds after the other came sailing on, and the wind first struck the row of country houses with their clumps of trees on the other side of the canal, bordered by the black cinder path. Those trees were superb; there was drama in each *figure* I was going to say, but I mean in each tree. But the scene as a whole was even more beautiful than those scourged trees viewed apart, because at that moment even those absurd little summerhouses assumed a curious character, dripping with rain and dishevelled.

It seemed to me an image of how even a man of absurd deportment and conventions, or another one full of eccentricities and caprice, may become a dramatic figure of a peculiar type, if only real sorrow strikes him – a calamity befalls him. And the thought crossed my mind, how at moments when today's deteriorating society is society seen against the light of a renewal, it stands out as a large, gloomy silhouette.

Yes, for me, the drama of storm in nature, the drama of sorrow in life, is the most impressive. . . . (319, *c.* 4 Sept. 1883.)

In sorrow, Vincent took leave of Sien and her children and left for Hoogeveen, in the north-eastern province of Drenthe, on 11 September 1883. He speaks of sorrow so often that he seems to accept it as the inescapable condition of his life; there is in him a cult of sorrow.

The twenty-two letters he wrote in the next three months contain a wealth of material. Intermingled with a recapitulation of his past life, some magnificent pages bear witness to the dramatic, symphonic way in which he experienced nature. The difference between his state of mind now and in the Borinage is striking. Vincent had found a distant horizon, and was now capable of seeing the darkness and suffering of his own life in a wider, universal context.

In Drenthe, he straightaway discovered another strange little graveyard. He had already visited many: Père Lachaise in Paris, the Jewish cemetery and Oosterse Begraafplaats in Amsterdam, where he went to pick snowdrops, the village churchyards of Brabant, and those in England which he frequently recalled along with the ivy he associated with them.

Your letter just arrived, so I know that the mail will reach me regularly.

70 Some days ago I wrote you a line to tell you a few things about the country around here. Everything is beautiful here, wherever one goes. The heath is much vaster than in Brabant, at least near Zundert or Etten – a little monotonous in the afternoon, and especially when the sun shines, but I would not miss that very effect, which I tried vainly to paint several times. Nor is the sea always picturesque; but those moments and effects, too, must be studied if one does not want to be deceived in their real character. Then the heath is sometimes far from attractive at that hot midday hour – it is aggravating, monotonous, and wearying like the desert, as inhospitable and hostile, so to speak. Painting it in that blazing light and rendering the planes vanishing into infinity makes one dizzy.

However, one must not suppose it has to be taken sentimentally; on the contrary, that is what it hardly ever is. In the evening when a poor little figure is moving through the twilight – when the vast sun-scorched earth stands out darkly against the delicate lilac hues of the evening sky, and the very last little dark-blue line at the horizon separates the earth from the sky – that same aggravating, monotonous spot can be as sublime as a Jules Dupré. . . .

Yesterday I found one of the most curious cemeteries I ever saw. Imagine a patch of heath surrounded by a hedge of thickly grown little pine trees, so that one would think it just an ordinary little pine wood. There is an entrance, however, a short avenue, and then one sees a number of graves overgrown with grass and heather. Many of them marked with white posts bearing the names. . . . (325, *c.* 17 Sept. 1883.)

His basic problem was to find some means of earning a living so that he could relieve the burden on Theo; his brother was thinking of emigrating to America because of career problems. Vincent approached their art dealer uncle

in Amsterdam, C.M. van Gogh, without success. Like a drowning man, he now let all his troubles pass rapidly before his mind's eye.

... I was very sceptical about the plan of studying, whether the promise to carry it through was sincere and well considered. I then thought that they had made the plan rashly and that I had approved of it rashly. And in my opinion it always remains an excellent thing that a stop was put to it then, which I brought about on purpose and arranged so that the shame of giving it up fell on me, and on nobody else. You understand that I, who have learned other languages, might have managed to master that miserable little bit of Latin – which I declared, however, to be too much for me. This was a fake, because I then preferred not to explain to my protectors that the whole university, the theological faculty at least, is, in my eyes, an inexpressible mess, a breeding place of Pharisaism. ...

I tell you, brother, I am not good from a clergyman's point of view. I know full well that, frankly speaking, prostitutes are bad, but I feel something human in them which prevents me from feeling the slightest scruple about associating with them; I see nothing very wrong in them. I haven't the slightest regret about any past or present association with them. If our society were pure and well regulated, yes, then they would be seducers; but now, in my opinion, one may often consider them more as sisters of charity.

And *now*, as in other periods when civilization is in a decline, the corruption of society has turned all the relations of good and evil upside down, and one falls back logically upon the old saying, 'The first shall be last, and the last shall be first.'

Like you, I have visited Père Lachaise. I have seen there graves of marble, for which I have an indescribable respect. I feel the same respect before the humble tombstone of Béranger's mistress, which I looked for on purpose (if I remember correctly, it is in a corner behind his own), and there I particularly remembered Corot's mistress too. Silent muses these women were, and in the emotion of those gentle masters, in the intimacy, the pathos of their poetry, I always feel a woman's influence everywhere. ... (326, 22 Sept. 1883.)

His current misery was so total as to have its comic side.

As I feel the need to speak out frankly, I cannot hide from you that I am overcome by a feeling of great anxiety, depression, a *je ne sais quoi* of discouragement and despair more than I can tell. And if I cannot find comfort, it will be too overwhelming.

I take it so much to heart that I do not get on better with people in general; it worries me a great deal, because so much of my success in carrying out my work depends on it.

Besides, the fate of the woman and the fate of my poor little boy and the other child cut my heart to shreds. I would like to help them still, and I cannot. I am at a point where I need some credit, some confidence and warmth, and, look here, I find no confidence. You are an exception, but it makes me feel even more how hopeless everything is just because you have to bear the brunt of it all.

And if I look at my equipment, everything is too miserable, too insufficient, too dilapidated. We have gloomy rainy days here, and when I come to the corner of the garret where I have settled down, it is curiously melancholy there; through one single glass pane the light falls on an empty colour box, on a bundle of worn-out brushes, in short, it is so curiously melancholy that fortunately it also has a comical aspect, enough not to make one weep over it, but to take it gaily. For all that, it is very disproportionate to my plans, very disproportionate to the seriousness of my work – so here is an end of the gaiety. ... (328, *c.* 26 Sept. 1883.)

In the meantime he would not and could not go on like that, without food or shelter, the eternal wanderer, a vagabond. From the viewpoint of his personal shipwreck, he took a close look at the world of art dealers, going over all the things that might have been different at Goupil's. He tried to persuade Theo to stop working for the firm and become a painter too, although this would clearly have meant the end of his financial support and therefore a disaster for the Van Gogh family as well as for the woman Theo was helping in Paris.

... But as to that despairing struggle without getting light anywhere, I know how awful it is too – with all one's energy one cannot do anything, and thinks oneself crazy, or Heaven knows

what. In London how often I stood drawing on the Thames Embankment, on my way home from Southampton Street in the evening, and it came to nothing. If there had been somebody then to tell me what perspective was, how much misery I should have been spared, how much further I should be now! Well, let bygones be bygones. It has not been so. I spoke once or twice to Thijs Maris. I dared not speak to Boughton because his presence overawed me; but I did not find it there either, that help with the very *first* things, the A B C.

Let me repeat now that I believe in you as an artist, and that you may become so still, yes, that in a very short time you would think over in all calmness whether you are an artist or not, whether you would succeed in producing something or not, if you learned to spell the above-mentioned A B C and if at the same time you wandered through the cornfields and the moors, to renew what you yourself express as 'I used to feel myself part of nature; now I do not feel that way any longer.'

Let me tell you, brother, that I myself have experienced so deeply, so very deeply what you say there. That I have been through a period of nervous, arid overstraining – there were days when I could not see anything in the most beautiful landscape just because I did not feel myself part of it. It is the street and the office and the care and the nerves that make it so.

Do not be angry with me when I say that at this moment your soul is sick – it is true, you know; it is not right for you not to feel yourself part of nature, and I think the most important thing is to restore that. I must look into my own past to find why I lived in that stony, arid mood for years, and why it became worse instead of better, though I tried to remedy it.

Not only did I feel hardened instead of sensitive toward nature, but, much worse still, I felt exactly the same toward people.

They said I was out of my mind, but I knew myself that it was not true, for the very reason that I felt my own disease deep within me, and tried to remedy it. I exhausted myself in hopeless, unsuccessful efforts, it is true, but because of that fixed idea of reaching a normal point of view again, I never mistook my own desperate doings, worryings and drudgings for my real innermost self. At least I always felt, 'Just let me do something, be somewhere, and it *must* redress itself. I will rise above it, let me keep hold of patience to redress things.'

This was the ground which gave way under my feet; think how miserable anyone would be if such a ground gave way. I had been with Goupil for six years. I was rooted there, and I thought that if I left them, I could look back on six years of clean work, and that if I presented myself elsewhere, I might refer to my past with full assurance. . . . All right, but by and by a person out of work, *l'homme de quelque part*, becomes a suspicious character. . . . (332, 12 Oct. 1883.)

. . . It seems to me that the whole art business is rotten – to tell you the truth, I doubt if the present enormous prices, even for masterpieces, will last. A *je ne sais quoi* has passed over it which has chilled everything – and enthusiasm has been put to flight. Is this of great influence on the artists? Not at all, for generally the greatest of them personally profited but little from those enormous prices, except in their last period, when they were already famous, and they – Millet and others, particularly Corot – would not have painted less, or less beautifully, without that enormous rise. And whatever may be said of the art business, for the present it will remain so that he who can make a thing worth seeing will always find certain persons interested in it, who will make it possible for him to earn a living.

I would rather have 150 francs a month as a painter than 1500 francs a month in another position, even as an art dealer. . . . (335, *c.* 22 Oct. 1883.)

Some time ago you wrote me about a certain difference in our respective physiognomies. All right. And your conclusion was that I was more of a thinker. What can I say to that? I do feel in myself a faculty for thinking, but that faculty is not what I feel specially organized in me. I think myself to be something other than specially a thinker. When I think of you, I see very characteristic action, that is well and good, but also most decidedly not isolated but on the contrary accompanied by so much sentiment, and real *thought* too, that for me the conclusion is that there is more resemblance than difference between you and me. I do not say there is no difference – but having learned to know you better of late, the difference seems smaller to me than I used to think sometimes in former years.

When I consider our temperament and type of physiognomy, I find similarity, and a very pronounced resemblance between, for instance, the Puritans and ourselves besides. I mean the

people in Cromwell's time or thereabouts, the little group of men and women who sailed from the Old World to America in the *Mayflower*, and settled there, firmly resolved to live simple lives. . . .

If I mention the Pilgrim Fathers, it is because of the physiognomy, to show you that certain reddish-haired people with square foreheads are neither only thinkers nor only men of action, but usually combine both elements. In one of Boughton's pictures I know a little figure of one of those Puritans, for which I should think *you* had posed if I didn't know better. It is exactly, exactly the same physiognomy – a small silhouette on a rock against a background of sea and fog; I can show you myself also, that is to say, that *variation* of the same physiognomy, but my profile is less characteristic. . . .

20, 21

I myself have sometimes thought about that being a thinker, but more and more it becomes clear to me that it was not my vocation, and because of the unfortunate prejudice that a man who feels the need to think things over is *not* practical, and belongs only among the dreamers, because this prejudice is greatly respected in Society, I often met with rebuffs because I didn't keep things to myself enough.

But since then that very history of the Puritans, and the history of Cromwell, as for instance Carlyle gives it, made me see that thinking and acting do not exclude each other, and that the sharp dividing lines which are drawn nowadays between thinking and acting – as if the one excluded the other – do not really exist. As to doubting whether one is an artist or not – that question is too much of an abstraction. . . . (338, 29 Oct. 1883.)

Again he wrote about his problems with women, describing the situation in increasingly powerful terms. At the same time however – and this typifies the greatness of Vincent's vision – he was totally responsive to the tremendous drama of nature that was being enacted on the autumnal heathland.

. . . Imagine a trip across the heath at three o'clock in the morning, in an open cart (I went with the landlord, who had to go to the market in Assen), along a road, or *diek* as they call it here, which had been banked up with mud instead of sand. It was even more curious than going by barge. At the first glimpse of dawn, when everywhere the cocks began to crow near the cottages scattered all over the heath and the few cottages we passed – surrounded by thin poplars whose yellow leaves one could hear drop to earth – an old stumpy tower in a churchyard, with earthen wall and beech hedge – the level landscapes of heath or cornfields – it all, all, all became exactly like the most beautiful Corots. A quietness, a mystery, a peace, as only he has painted it.

But when we arrived at Zweeloo at six o'clock in the morning, it was still quite dark; I saw the real Corots even earlier in the morning.

The entrance to the village was splendid: Enormous mossy roofs of houses, stables, sheepfolds, barns.

The broad-fronted houses here stand between oak trees of a splendid bronze. In the moss are tones of gold green; in the ground, tones of reddish, or bluish or yellowish dark lilac grey; in the green of the cornfields, tones of inexpressible purity; on the wet trunks, tones of black, contrasting with the golden rain of whirling, clustering autumn leaves – hanging in loose tufts, as if they had been blown there, and with the sky glimmering through them – from the poplars, the birches, the lime and apple trees.

The sky smooth and clear, luminous, not white but a lilac which can hardly be deciphered, white shimmering with red, blue and yellow in which everything is reflected, and which one feels everywhere above one, which is vaporous and merges into the thin mist below – harmonizing everything in a gamut of delicate grey. I didn't find a single painter in Zweeloo, however, and people said *none* ever came *in winter*.

I, on the contrary, hope to be there *just* this winter.

As there were no painters, I decided not to wait for my landlord's return, but to walk back, and to make some drawings on the way. So I began a sketch of that little apple orchard, of which Liebermann made his large picture. And then I walked back along the road we had driven over early in the morning.

For the moment the whole country around Zweeloo is entirely covered – as far as the eye can see – with young corn, the very, very tenderest green I know.

With a sky over it of a delicate lilac-white, which gives an effect – I don't think it can be painted, but which is for me the keynote that one must know in order to understand the keynotes of other effects.

A black patch of earth – flat – infinite – a clear sky of delicate lilac-white. The young corn sprouts from that earth, it is almost mouldy-looking with that corn. That's what the good fertile parts of Drenthe are basically; the whole in a hazy atmosphere. Think of Brion's *The Last Day of Creation*; yesterday it seemed to me that I understood the meaning of that picture.

The poor soil of Drenthe is just the same – but the black earth is even blacker still – like soot – not lilac-black like the furrows, and drearily covered with ever-rotting heather and peat. I see that everywhere, the incidentals on the infinite background: on the moors, the peat sheds; in the fertile parts, the very primitive gigantic structures of farms and sheepfolds, with low, very low little walls and enormous mossy roofs. Oak trees all around them.

When one has walked through that country for hours and hours; one feels that there is really nothing but infinite earth – that green mould of corn or heather, that infinite sky. Horses and men seem no larger than fleas. One is not aware of anything, be it ever so large in itself; one only knows that there is earth and sky. However, in one's quality of a little speck noticing other little specks – leaving the infinite apart – one finds every little speck to be a Millet.

I passed a little old church exactly, exactly *The Church at Gréville* in Millet's little picture in the Luxembourg; instead of the little peasant with his spade in that picture, there was here a shepherd with a flock of sheep walking along the hedge. There was not a glimpse of the true sea in the background, but only of the sea of young corn, the sea of furrows instead of the sea of waves.

The effect produced was the same. Then I saw ploughmen, very busy – a sandcart, a shepherd, road menders, dungcarts. In a little roadside inn I drew an old woman at the spinning-wheel, a dark little silhouette out of a fairy tale – a dark little silhouette against a light window, through which one saw the clear sky, and a small path through the delicate green, and a few geese pecking at grass.

And then when twilight fell – imagine the quiet, the peace of it all! Imagine then a little avenue of poplars with autumn leaves, imagine a wide muddy road, all black mud, with an infinite heath to the right and an endless heath to the left, a few black triangular silhouettes of sod-built huts, through the little windows of which shines the red light of the little fire, with a few pools of dirty yellowish water that reflect the sky, and in which trunks lie rotting; imagine that swamp in the evening twilight, with a white sky over it, everywhere the contrast of black and white. And in that swamp a rough figure – the shepherd – a heap of oval masses, half wool, half mud, jostling each other, pushing each other – the flock. You see them coming – you find yourself in the midst of them – you turn around and follow them. Slowly and reluctantly they trudge along the muddy road. However, the farm looms in the distance – a few mossy roofs and piles of straw and peat between the poplars.

The sheepfold is again like the silhouette of a triangle – dark. The door is wide open like the entrance to a dark cave. Through the chinks of the boards behind it gleams the light of the sky. The whole caravan of masses of wool and mud disappear into that cave – the shepherd and a woman with a lantern shut the doors behind them.

That coming home of the flock in the twilight was the finale of the symphony I heard yesterday.

That day passed like a dream, all day I was so absorbed in that poignant music that I literally forgot even food and drink – I had a piece of brown bread and a cup of coffee in the little inn where I drew the spinning-wheel. The day was over, and from dawn till twilight, or rather from one night till the other, I had lost myself in that symphony. . . . (340, Oct.–Nov. 1883.)

Life in Drenthe proved intolerable, despite its wealth of inspiration, and Vincent was forced to take refuge in his parents' home. They had moved from Etten to nearby Nuenen in September 1883.

... So for several reasons I made up my mind to go home for a while. A thing which, however, I was very loath to do.

My journey began with a good six-hour walk across the heath – to Hoogeveen. On a stormy afternoon in rain and snow.

That walk cheered me greatly, or rather my feelings were so in sympathy with nature that it calmed me more than anything. I thought that perhaps going back home might give me a clearer insight into questions of how to act. ... (344, *c.* 5 Dec. 1883.)

Vincent's relations with his parents remained difficult, now that he had come to stay with them indefinitely.

I was lying awake half the night, Theo, after I wrote you last night.

I am sick at heart about the fact that, coming back after two years' absence, the welcome home was kind and cordial in every respect, but basically there has been no change whatever, not the slightest, in what I must call the most extreme blindness and ignorance as to the insight into our mutual position. And I again feel almost unbearably disturbed and perplexed.

The fact is that things were going extremely well until the moment when Father – not just in the heat of passion, but also because he was 'tired of it' – banished me from the house. It ought to have been understood then that this was supremely important to my success or failure – that things were made ten times more difficult for me by this – almost insupportable. ...

Nothing, nothing of all that.

In Father's mind there was not then, there is not now, the faintest shadow of a doubt that what he did was the right thing.

Father does not know remorse like you and me and any man who is human.

Father believes in his own righteousness, whereas you and I and other human creatures are imbued with the feeling that we *consist* of errors and efforts of the lost souls. I commiserate with people like Father – *in my heart of hearts I cannot be angry with him* – because I think they are more unhappy than I. Why do I think them unhappy? – because the good within them is wrongly applied, so that it acts like evil – because the *light* within them is black and spreads darkness, obscurity around them. ...

[Written in the margin] They think *they did no harm at the time*, this is *too* bad. (345, 6/7 Dec. 1883.)

The tone of his letters to Theo became almost hostile as he pursued, obsessively, the argument he had started in Drenthe, about the art trade and Theo's position in it. Seemingly coherent lines of reasoning are followed by untenable conclusions; his greatest desire is to recapture something of the aspirations that the brothers had shared in youth.

... I thought of you, brother, during that long walk across the heath in the evening, in the storm. I thought of a passage, I don't know from what book: 'Two eyes watched, lightened by true tears.' I thought, *I am disillusioned.* I thought, I have believed in many things which I now know are really sorry fallacies – I thought, Those eyes of mine, here on this gloomy evening, wide awake in this deserted region – if they have been full of tears at times, why shouldn't these have been wrung from me by a sorrow that disenchants – yes – and disturbs illusions – but at the same time – makes one wide *awake.*

I thought, *Is it possible* that Theo is satisfied with many things that worry me?

Is it possible that it is only my own melancholy when I cannot enjoy some things as I used to do? ... (344, *c.* 5 Dec. 1883.)

I do not beg for your mediation, I do not beg for anything personal on your part; but I ask you point-blank how we stand – are you a 'Van Gogh' too? I have always looked upon you as 'Theo'.

In character I am rather different from the various members of the family, and essentially. I am *not* a 'Van Gogh'. If you became a 'personality' – if you were going to play a part in the world – like Father or C.M., or even V. – all right, I should not try to interfere, I should take you at your own valuation, I should be silent about it; but our ways would diverge so much that I should not think it advisable to continue our financial relations. I hope you will understand what I want to express. If not, you'll have to give it time. ... (345a, 7/8 Dec. 1883.)

Friction between Vincent and his parents culminated in the image of himself as a dog.

I feel what Father and Mother think of me *instinctively* (I do not say *intelligently*).

They feel the same dread of taking me into the house as they would about taking a big rough dog. He would run into the room with wet paws – and he is so rough. He will be in everybody's way. *And he barks so loud.* In short, he is a foul beast.

All right – but the beast has a human history, and though only a dog, he has a human soul, and even a very sensitive one, that makes him feel what people think of him, which an ordinary dog cannot do.

And I, admitting that I am a kind of dog, leave them alone. ... (346, Dec. 1883.)

... Without being personal, just for the sake of an impartial character study, as if I did not speak about you and me but about strangers, for the sake of analysis, I point out to you once more how it was last summer. I see two brothers walking about in The Hague (*see them as strangers*, do not think of yourself and me).

One says, 'I must maintain a certain standing, I must stay in business, I don't think I shall become a painter.'

The other says, 'I am getting to be like a dog, I feel that the future will probably make me more ugly and rough, and I foresee that "a certain *poverty*" will be my fate, but, but *I shall be a painter.*'

So the one – a certain standing as an art dealer.

The other – poverty and painter.

And I see those same brothers in former years, when you had just entered the world of pictures, when you just began to read, etc., etc. – I see them near the mill at Rijswijk or, for instance, on a walk to Chaam in winter across the snowy heath early in the morning! *Feeling, thinking* and *believing* so exactly alike that I ask myself, Are those the same??? The question is, How will things turn out – will they separate forever, or will they forever follow the same path? ... (347, Dec. 1883.)

Seeing Sien again on a brief visit to The Hague brought to the surface Vincent's resentment of Theo's part in his decision to leave; he wrote of losing his respect for Theo. The strain on the brothers' relationship was growing; and Vincent even went so far as to say that he could no longer accept Theo's support. His outbursts of anger were short-lived, however, and he was quick to retract. They mainly fastened on Theo's lack of success in promoting his work; for at this time Vincent was still expecting something to come of sales and exhibitions.

... Well, our friendship, brother, has received a bad shock from this, and if you were to say we certainly did not make a mistake, and if it should appear to me that you are still in the same frame of mind – then I should not be able to respect you as much as in the past. Because at the time I respected you for the very fact that, at a moment when others cut me because of my being with her, you were the one to help me keep her alive. I do not say there was no need for a change or a modification, but – I think we, or rather I, have gone too far.

As I now have a studio here, more than one financial difficulty is less ruinous perhaps.

I will end by saying: Please think it over – but if your state of mind remains the same as last summer after what I have said, I cannot feel the same respect for you as in the past. For the rest, I have resolved never to speak another word with you about a possible change in your circumstances and your career, for it is as if I see two natures in you, struggling within your breast – a phenomenon I perceive in myself too, but it may be that some problems are solved because of my being four years older, problems which in your case are more or less in a state of ferment. ... (350, 25–28 Dec. 1883.)

... Just listen – after having read your letter about the drawings, I at once sent you a new water colour of a weaver, and five pen drawings. For my part I will also tell you frankly that I think it true what you say, that my work must become much better still, but at the same time, that your energy to sell them for me may become somewhat stronger too.

You have *never sold a single one for me* – neither for much nor for little – and in fact *you have not even tried.*

You see, I am not *angry* about it, but – we must call things by their names. In the long run, I would certainly not put up with that.

You, on your part, can also continue to speak out frankly.

As to being salable or unsalable, that is an old file, on which I do not intend to blunt my teeth. Well, you see my answer is that I send you some new ones, and I will go on doing so very willingly – I ask no better.

But I insist on your speaking out quite frankly – that is what I like best – whether you intend to interest yourself in them henceforth, or whether your dignity does not allow it. Leaving the past for what it was, I must face the future, and apart from what you think of it, I decidedly intend to try and sell them. (358, *c.* 1 Mar. 1884.)

One of these days I am going to send you another pen-and-ink drawing of a weaver – larger than the other five; the loom seen from the front – it will make this little series of drawings more complete; I believe they will look best if you have them mounted on grey Ingres.

It would rather disappoint me if you sent these little weavers back to me. And if none of the people you know would care to take them, I should think that you might take them for yourself, as the beginning of a collection of pen-and-ink drawings of Brabant artisans.

Which I should love to make, and which, as I shall be in Brabant pretty often now, I should be very eager to do.

On condition of making a series of them, which must be kept together, I will price them low, so that though I might make many drawings of the same kind, they might be kept together. But I, for my part, will agree to what you think best.

And you see it is not my aim to break off relations with you; I only wanted to point out that it seemed necessary to me that, when I send the pen drawings, you at least show them to somebody. (359, *c.* 9 Mar. 1884.)

Vincent's friendship with the unhappy Margo (or Margot) Begemann, who was living at Nuenen with her parents, friends and neighbours of the parson's family, complicated his position at home and in the village community when Margo tried to poison herself. His account is remarkably calm and rational, showing unmistakable insight into suicide attempts and the symptoms of poisoning. Margo undoubtedly loved him, and the question of marriage arose. Family opposition flared up again, although there is no evidence that Vincent was particularly keen. Once, as a break in the silent endurance of a permanent sorrow, the image of Kee fleetingly reappeared.

... Something terrible has happened, Theo, which hardly anybody here knows, or suspects, or may ever know, so for heaven's sake keep it to yourself. To tell you everything, I should have to fill a volume – I can't do it. Margot Begemann took poison in a moment of despair; after she had had a discussion with her family and they slandered her and me, she became so upset that she did it (in a moment of decided *mania*, I think). Theo, I had already consulted the doctor about certain symptoms of hers three days before; I had secretly warned her brother that I was afraid she would get brain fever, and that I was sorry to state that, in my eyes, the Begemann family acted extremely imprudently in speaking to her the way they did. This had no effect, at least no other than that they told me to wait two years, which I decidedly refused to do, saying that *if* there was a question of marriage, it had to be very soon or not at all.

Well, Theo, you have read *Mme Bovary* – do you remember the first Mme Bovary who died in a nervous attack? Here it was something like that, but complicated by her having taken poison.

She had often said when we were quietly walking together, 'I wish I could die now' – I had never paid any attention to it.

One morning, however, she slipped to the ground. At first I only thought it was weakness. But it got worse and worse. Spasms, she lost her power of speech, and mumbled all kinds of things that were only half intelligible, and sank to the ground with many jerks and convulsions, and so on. In any case it was different from a nervous collapse, though there was

a great similarity, and suddenly I grew suspicious, and said – Did you happen to swallow something? She screamed 'Yes'. Well, then I took matters in hand and no mistake – she insisted on my swearing that I should never tell anybody – I said, That's all right, I'll swear anything you like, but only on condition that you throw that stuff up immediately – so put your finger down your throat until you puke, or else I'll call the others. Well, now you understand the rest. . . .

But for heaven's sake, what is the meaning of that standing, and of that religion, which the respectable people maintain? – oh, they are perfectly *absurd*, making society a kind of lunatic asylum, a perfectly topsy-turvy world – oh, that mysticism. You will understand how everything, everything passed through my mind these last few days, and how absorbed I was in this sad story.

Now that she has tried this and failed, I think it has given her such a fright that she will not readily try it a second time; the failure of a suicide is the best remedy against a future suicide. . . . (375, Sept. 1884.)

[PS.] . . . It is a pity that I didn't meet her *before*, for instance, ten years ago. Now she gives me the impression of a Cremona violin which has been spoiled by bad, bungling repairers.

And the condition she was in when I met her proved to be rather too damaged.

But originally it was a rare specimen of great value, and *even now* she has, in spite of drawbacks, great value.

The only thing I ever saw again of Kee was a picture taken a year later; was she changed for the worse? On the contrary, *more interesting*.

That disturbing the tranquillity of a woman, as theological people call it (sometimes theologians *sans le savoir*), is sometimes *the breaking of stagnation or melancholy*, which steals over many people, and is *worse* than *death itself*. Some people think it terrible to hurl them back into life, into love, and one must consider very carefully how far one may go. But if one does it with motives other than egoism, well, then the women themselves will sometimes get *angry*, and may even hate instead of love, *que soit*.

But they will *not easily despise* the man who did it, while they do despise the men who have extinguished the manliness in themselves. Well, those are the deep things of life. . . . (377, Sept. 1884.)

After his earlier signs of interest in paint and the original techniques he had thought out at The Hague, Vincent became totally engrossed in rules of colour and drawing – 'the line' – at this time. Through lack of knowledge of the Impressionists, he looked mainly to Delacroix, not realizing that the latter was also a welcome source for the French avant-garde, Signac and Lautrec in particular.

. . . Please write me some more details about the Manet exhibition: tell me which of his pictures are there. I have always found Manet's work very original. Do you know that article of Zola's on Manet? I am sorry to have seen so very few of his pictures. I should especially like to see his figures of nude women. I do not think it exaggerated that some people, for instance Zola, *rave* about him, although I, for my part, do not think he can be reckoned among the very first of this century. But his is a talent which *certainly* has its *raison d'être*, and that is a great thing in itself. The article which Zola wrote about him is published in the volume *Mes Haines*. For my part, I cannot agree with Zola's *conclusions*, as if Manet were a man who opens a new future to modern ideas of art; I consider *Millet*, not Manet, to be that essentially modern painter who opened a new horizon to many. (355. *c.* 24 Jan. 1884.)

. . . The *laws* of colours are unutterably beautiful, just because they are *not accidental*. In the same way that people nowadays no longer believe in fantastic *miracles*, no longer believe in a God who capriciously and despotically flies from one thing to another, but begin to feel more respect and admiration for and faith in nature – in the same way, and for the same reasons, I think that in art, the old-fashioned idea of innate genius, inspiration, etc., must be, I do not say put aside, but thoroughly reconsidered, verified – and greatly modified. However, I do not deny the existence of genius, or even its being innate. But I certainly do deny the inference that theory and instruction should, as a matter of course, always be useless.

The same thing which I applied in the woman spinning and the old man spooling yarn, I hope, or rather I shall try, to do much *better* later on.

But in these two studies from life *I have been a little more myself* than I succeeded in being in most of the other studies – except perhaps in some of my drawings. . . . (371, July 1884.)

Enclosed you will find some interesting pages about *colour*, namely the great principles which Delacroix believed in.

Add to this '*les anciens ne prenaient pas par la ligne, mais par les milieux*', that means, starting with the circular or elliptical bases of the masses, instead of with the contour.

I found the exact words for the latter in Gigoux's book, but the fact itself had already preoccupied me a long time. I believe the fuller of sentiment a thing one makes is, and the more true to nature, the more it is criticized and the more animosity it rouses, but after all, in the end it will rise above criticism. . . .

[Enclosure:] . . . 'The ancients admitted only three primary colours: yellow, red and blue, and the modern painters do not admit any others. In fact, these three colours are the only indissoluble and irreducible ones. . . .' (401, Summer 1885.)

. . . *There is a school – I believe – of impressionists. But I know very little about it.* But I do know who the original and most important masters are, around whom – as around an axis – the landscape and peasant painters will revolve. Delacroix, Corot, Millet and the rest. That is my own opinion, not properly formulated.

I mean there are (rather than persons) rules or principles or fundamental truths for *drawing* as well as for *colour*, which *one proves to fall back on* when one finds out an actual truth.

In drawing, for instance – that question of drawing the figure starting with the circle – that is, to say, using the elliptical planes as a foundation. A thing which the ancient Greeks already knew, and which will remain valid till the end of the world. . . . (402, Summer 1885.)

He could not resist seeking every opportunity to place Theo in a position opposed to him instead of alongside him. A prospective Delacroix exhibition in Paris provided a reason for mentioning *Liberty on the Barricade*, which he thought referred to the revolution of 1848. (In fact, this famous canvas was inspired by the revolt of 1830.)

. . . You tell me that within a short time there will be an exhibition of Delacroix's work. All right. You will certainly see there a picture, *La Barricade*, which I know only from biographies of Delacroix. I believe it was painted in 1848. You also know a lithograph by De Lemud, I believe; if it is not by him, then by Daumier, also representing the barricade of 1848. I wish you could just imagine that you and I had lived in that year 1848, or some such period, for on the occasion of Napoleon's coup d'état, there was again something of the kind. I will not make any offensive remarks – that has never been my object – I try to make it clear to you in how far the difference that has sprung up between us is connected with the general drift of society, and, as such, is something quite different from premeditated reproaches. So take that period of 1848. . . .

I begin with Guizot and Louis-Philippe, were they bad or tyrannical? Not exactly; in my opinion they were people like Father and Grandfather, for instance, like old Goupil. In short, people with a very venerable appearance, deep – serious – but if one looks at them a little more closely and sharply, they have something gloomy, dull, stale, so much so that it makes one sick. Is this saying too much??? . . . But my opinion is, if you and I had lived *then*, you would have been on the Guizot side, and I on the Michelet side. And both remaining consistent, with a certain melancholy, we might have confronted each other as direct enemies, for instance on such a barricade, you before it as a soldier of the government, I behind it, as a revolutionary or rebel. . . . (379, Sept. 1884.)

The only nearby town he visited occasionally was Eindhoven. He even made a few acquaintances there and gave some lessons to amateurs, including Willem van de Wakker and Anton Kerssemakers. His keen theoretical interest in rules of colour and music also led him to take some pianoforte lessons. He designed

Drawing from letter 402.

six panels representing peasant life for the dining room of a rich goldsmith called Hermans. He provided the sketches, the goldsmith copied them, and Vincent made the copies into paintings. The rich gentleman failed to pay for his services.

To writers, Mallarmé among others, a blank sheet of paper frequently represents a paralysing challenge. Vincent described an analogous experience with a new canvas. He even likened it to life itself, and perhaps to women. It was characteristic of him that he proceeded to make a fierce attack on the unwritten, the unsullied.

... You do not know how paralysing that staring of a blank canvas is; it says to the painter, *You can't do anything*. The canvas stares at you like an idiot, and it hypnotizes some painters, so that they themselves become idiots. Many painters are afraid of the blank canvas, but the blank canvas is afraid of the really passionate painter who is daring – and who has once and for all broken that spell of 'you cannot'.

Life itself is also for ever turning toward a man an infinitely vacant, discouraging, hopeless, blank side on which nothing is written, no more than on a blank canvas. But however vacant and vain and *dead* life may present itself, the man of faith, of energy, of warmth, and who knows something, does not let himself be led astray by it. He steps in and acts and builds up, in short he *breaks – ruins* they call it. ... (378, Oct. 1884.)

He wished, more cogently than ever before or later, that conventional morality might be renewed, but said nothing of changing the social structure.

... To me personally, an important difference between *before* and *after* the revolution – is the change in social position of women and the collaboration that is desired between men and women, with equal rights, equal freedom.

But I can find neither the words nor the time, nor the inclination, to go into this more deeply. Enough, the conventional morals are in my opinion quite *wrong*, and I hope they will be *changed* and *renewed* in time. ... (388, *c.* 7 Dec. 1884.)

In his remote corner of Brabant he remained very much alive to what was going on in the art world, keeping in touch mainly through Theo and by reading. In 1884, for instance, he read about the Paris Salon in *L'Illustration*, which also included reproductions of work by Puvis de Chavannes. A critic's comment that the medieval or Neo-Gothic style of artists like Leys was being superseded by realism in the style of De Groux reinforced his own convictions.

94, 97
96

... And at this very moment I could tell you some new names of people who are hammering again on the same old anvil which De Groux hammered on. If it had pleased De Groux at that time to dress his Brabant characters in medieval costumes, he would have run parallel with Leys in genius, and also in fortune.

However, he didn't, and *now*, years later, there is a considerable reaction against that medievalism, though Leys always remains Leys, and Thijs Maris, Thijs Maris, and Victor Hugo's *Notre Dame, Notre Dame*.

But the realism *not wanted* then is *in demand* now, and there is more need of it than ever.

The realism that has character and a serious sentiment.

I can tell you that for my part I shall try to keep a straight course, and shall paint the simplest, the most common things. ... (390, 15–17 Dec. 1884.)

The year 1885 began in deep depression, and letter 392 is characteristic of the coherence between the elements within and beyond Vincent's mental and sentimental receptiveness. His realism was essentially symbolic, although he did not use the actual symbolic signs which caused problems in the emerging Symbolist writing and art. His concern, since Courrières, with the dying

breed of weavers fitted in with this mood. He must have been prepared to understand their social decline by Charlotte Brontë's novel *Shirley*, an astonishing pre-Zola social document which he had read in 1881 (148).

... I've hardly ever begun a year with a gloomier aspect, in a gloomier mood, nor do I expect any future of success, but a future of strife.

It is dreary outside, the fields a mass of lumps of black earth and some snow, with mostly days of mist and mire in between, the red sun in the evening and in the morning, crows, withered grass, and faded, rotting green, black shrubs, and the branches of the poplars and willows rigid, like wire, against the dismal sky. This is what I see in passing, and it is quite in harmony with the interiors, very gloomy, these dark winter days.

It is also in harmony with the physiognomy of the peasants and weavers. I don't hear the *79, 80* latter complain, but they have a hard time of it. A weaver who works steadily weaves, say, a piece of 60 yards a week. While he weaves, a woman must spool for him, that is supply the shuttles with yarn, so there are two who work and have to live on it.

On that piece of cloth he makes a net profit, for instance, of 4.50 guilders a week, and nowadays when he takes it to the manufacturer, he is often told that he cannot take another piece home for one or two weeks. So not only are wages low, but work is pretty scarce too.

Consequently, there is often something agitated and restless about these people.

It is a different spirit from that of the miners, among whom I lived during a year of strikes and many accidents. That was even worse, yet it is often pathetic here too; the people are quiet, and literally *nowhere* have I heard anything resembling rebellious speeches.

But they look as little cheerful as the old cab horses or the sheep transported by steamer to England. ... (392, Jan. 1885.)

Vincent's premonitions (letter 392) proved to be right; his father died suddenly on 26 March 1885. Although his reactions were sober, the rhythm of his work was momentarily disturbed. He was full of what was to be the most mature and powerful achievement of his Brabant period: *The Potato Eaters*. It *48* was not directly inspired by works by Zola such as *Germinal*, but reading Zola did encourage him to work on a scheme which was the result of the powerful impression made on him by peasants eating their frugal meal in their lamp-lit hovel. Vincent had already found himself a place to work at the home of the Roman Catholic sexton, one Schafrath, so that he would not longer be tied to the family circle at the parsonage which was increasingly ill-disposed towards him. His sisters, particularly Anna, had become a great source of annoyance. The death of his father provided him with an excuse to move in with Schafrath. He had two rooms there, a small dark one which he used as a studio, and an attic room to sleep in. He neglected himself, going short of food and sleep. The urge to paint, and thereby progress towards a solution to his problems, always proved stronger than his instinct for self-preservation.

I have wondered a little at not having heard from you yet. You will say that you have been too busy to think of it, and of course I understand this.

It is late in the evening, but I want to tell you once more how sincerely I hope that in the future our correspondence will become somewhat more animated than it has been of late.

Enclosed you will find two scratches of a few studies I made, while at the same time I am again working on those peasants around the dish of potatoes. I have just come home from this cottage and have been working at it by lamp-light, though I began it by daylight this time.

This is what the composition looks like.

I painted it on a rather large canvas, and as the sketch is now, I think there is some life in it.

Yet I am sure C.M., for instance, would find fault with the drawing, etc. Do you know what a positive argument against that is? That the beautiful effects of light in nature demand a very quick hand in drawing.

Now I know quite well that the great masters, especially in the period of their ripest experience, knew both how to be elaborate in the finishing and at the same time to keep a thing

Drawing from letter 399.

full of life. But certainly that will be beyond my power for the present. At the point I am now, however, I see a chance of giving a true impression of what I see.

Not always literally exact, or rather never exact, for one sees nature through one's own temperament.

The advice I want to give, you know, is the following: Don't let the time slip by; help me to work as much as possible, and from now on keep all the studies together.

I do not like to sign any of them yet, for I do not want them to circulate as pictures, which one would have to buy up again when one had some reputation. But it will be a good thing if you show them, for you will see that someday we shall find somebody who wants to do the same thing I propose to you now, namely make a collection of studies. . . .

You are looking for new ideas for the art trade; the idea of being *kind* to art lovers is not new, but it is one that *never gets old*.

Like that of guaranteeing a purchase. And I ask you, isn't it better for an art lover to possess from one painter, for instance, twenty quite different sketches at the same price which he in all fairness would have to pay for *one* finished picture which, as a salable article, had its value on the market? If I were in your place, as you know so many young painters who haven't a reputation yet, I would try to bring *painted studies* on the market, not as pictures, but mounted in some way on gilt Bristol, for instance, or black, or deep red. . . . (399, 11 Apr. 1885.)

. . . I will not send the *Potato Eaters* unless *I know for sure* there is *something* in it.

But I am getting on with it, and I think there are completely different things in it than you can ever have seen in my work. At least, so distinctly.

I mean the life especially. I paint this *from memory on the picture itself.* But you know yourself how many times I have painted these heads!

And then I drop in every night to correct some details on the spot.

But in the picture I give free scope to my own head in the sense of *thought* or imagination, which is not so much the case in *studies*, where no creative process is allowed, but where one finds food for one's imagination in reality, in order to make it exact.

But you know I wrote to M. Portier, 'Up till now I have made only *studies*, but the *pictures* will come.' And I will stick to that.

I intend to send soon a few more studies from nature too.

It is the *second* time that a saying of Delacroix's has meant so much to me. The first time it was his theory about colours, but later I read a conversation he had with other painters about the making, namely the *creation* of a picture.

He claimed that the best pictures are made from memory. *Par cœur!* he said, And about that conversation I read that, when all those worthy people were going home in the evening, Delacroix, with its usual vivacity and passion, loudly called after them in the middle of the boulevard, *Par cœur! par cœur!* probably to the great astonishment of the respectable passers-by. . . . (403, end April 1885.)

I just received *Germinal*, and started to read it at once. I have read about fifty pages, which I think splendid; I once travelled through those same parts on foot.

Enclosed is a sketch of a head, which I just brought home.

There was the same one among the last studies I sent you, namely the largest of all. But painted smoothly.

Now I have not smoothed down the brush stroke and in fact the colour is quite different too.

I haven't yet made a head so much 'painted with earth', and more will follow now.

If all goes well – if I earn a little more – so that I can travel more – then I hope to go and paint the miners' heads someday.

But I shall work on till I am absolute master of my hand, so that I can work even more quickly than now, and, for instance, bring home about thirty studies within a month. I do not know if we shall earn money, but if it is only enough to let me work terribly hard, I shall be satisfied; the main thing is to do what one wants to do. . . . (409, 15 May 1885.)

Drawing from letter 409.

A lengthy passage from *Germinal* provides the best example of Van Gogh's method of quoting from the books he read. The quoted passage describes how the former student Souvarine saw his girlfriend, the anarchist Anouchka, executed by hanging in Moscow, a sublimely tragic moment when he amidst

the crowds and she on the scaffold caught each other's eyes. If Van Gogh had the book in front of him, he deliberately limited the quotation to that unfathomable moment of life and death. He left out completely the reasons given for those looks and for the actual event, as well as its effect on the character Souvarine. The latter was not a Marxist but held views close to Bakunin's, and as an anarchist saw total destruction as the only means of creating a new and better world. A fervent reader of almost everything Zola wrote, in the course of his reading he blended his own thoughts with an active visual imagination. From the point of view of literary criticism this naturally produced a transformed image.

... '"Did I tell you how she died?"
'"Who do you mean?"
'"My woman over there in Russia."
'Etienne made a vague gesture, wondering at the trembling of the voice, and at this sudden need of confidence in this habitually reticent fellow, in his stoical detachment from others and from himself. He only knew that the woman was his mistress, and that she was hanged in Moscow.
'Souvarine resumed: "The last day in the square, I was there. . . . It was raining – the clumsy fellows lost their heads, upset by the pelting rain, they had taken twenty minutes to hang four others. She stood waiting. She did not see me, she was looking for me in the crowd. I got on top of a stone pillar and she saw me, our eyes never left each other. Twice I wanted to cry out, to hurl myself over the heads to join her. But what would have been the good of it? One man less, one soldier less; and I guessed that she was saying no with her big fixed eyes, when they met mine."' . . . (410, 1 June 1885.)

Totally absorbed in the complex problems of planning a figure composition such as the *Potato Eaters*, which Theo now showed to the Paris artist Charles Serret, Vincent still provided occasional flashes of evidence of his thoughts on the problems of painting out of doors as opposed to in a studio. Like his preoccupation with Delacroix, these were matters which had been digested by the Impressionists earlier on. But before his late initiation to Impressionism in Paris, Vincent – like Manet and Renoir, and to a lesser extent Monet and his followers – continued with figure painting, which was to enable him to resist total conversion to Impressionist theories.

He was increasingly anxious to exhibit his works in sequences. This approach was more modern than it seems, since Van Gogh thereby revealed the great importance of *continuity*. He was no longer concentrating on individual completed works, or on isolated major works, but on the general flow. His life's work was to be completed within a time he knew to be limited; and so he instinctively aimed for directness and above all speed. There were to be no real pauses, no gaps, no deviations; but, as in his letters, no real order either. As always, any arranging, setting in order, would have been rational interference.

. . . It won't be so very long before things we can show will become more important. You will notice yourself, and it is a fact which pleases me enormously, that more and more they begin to arrange exhibitions of one person, or of a very few who belong together.
This is something in the art world which I am sure contains more promise for the future than any other undertaking. It is a good thing they begin to understand that a Bouguereau does not show off well next to a Jacque, a figure by Beyle or Lhermitte does not do beside a Schelfhout or Koekkoek. Disperse the drawings of Raffaelli and judge for yourself whether it *110* would be possible to get a good idea of that original artist. . . .
. . . But *even* in this century, how relatively few among the innumerable painters want the figure – yes, above all – for the figure's sake, that is to say for the sake of line and modelling,

but cannot imagine it otherwise than in action, and want to do what the old masters avoided – even the old Dutch masters who clung to many conventional actions – and I repeat – want *to paint the action for the action's sake.*

So that the picture or the drawing has to be a drawing of the figure for the sake of the figure and the inexpressibly harmonious form of the human body, but at the same time a digging of carrots in the snow. Do I express myself clearly? I hope so, and just tell this to Serret. . . .

Tell him that I adore the figures by Michelangelo though the legs are undoubtedly too long, the hips and the backsides too large. Tell him that, for me, Millet and Lhermitte are the real artists for the very reason that they do not paint things as they are, traced in a dry analytical way, but as *they* – Millet, Lhermitte, Michelangelo – feel them. Tell him that my great longing is to learn to make those very incorrectnesses, those deviations, remodellings, changes in reality, so that they may become, yes, lies if you like – but truer than the literal truth. . . .

You recently wrote that Serret had spoken to you 'with conviction' about certain faults in the structure of the figures of *The Potato Eaters.*

But you will have seen from my answer that my own criticism also disapproves of them on that score, but I pointed out that this was an impression after my having seen the cottage in the dim lamplight for many evenings, after having painted forty heads, so it is clear that I started from a different point of view. . . .

Rather than say there must be character in a digger, I define it by saying, That peasant *must* be a peasant, that digger *must* dig, and then there will be something essentially modern in them. But I feel myself that from these very words conclusions may be drawn that I do not intend, even if I should add a whole oration. . . . (418, July–Aug. 1885.)

Van Gogh became impatient if his continuity, his élan, was checked. He would become nervous, charged with tension like a brooding storm, eruptive and anxious to force the birth-throes of his creation. Michelet said of himself, 'Grasp what is becoming a reality the moment it becomes a reality'; 'Let us seize them this very hour'; 'Time passes quickly, they will change.'

. . . What struck me most on seeing the old Dutch pictures again is that most of them *were painted quickly,* that these great masters, such as Frans Hals, a Rembrandt, a Ruysdael and so many others – dashed off a thing from the first stroke and did not retouch it so very much.

And please note this too – if it was right, *they left it as it was.* I have especially admired the hands by Rembrandt and Hals, certain hands in *The Syndics,* even in *The Jewish Bride,* and in Frans Hals, hands that lived, but were not finished in the sense they demand nowadays.

And heads too – eyes, nose, mouth done with a single stroke of the brush without any retouching whatever. Unger, Bracquemond have etched it well – just as it was painted – and one can see in their etchings the way of painting. . . .

Those are the things which I believe in, but every day I hate more and more those pictures which are light all over. It is a bad thing for me when they say that I have 'no technique'; it is possible that this will blow over, as I make no acquaintances among the painters; it is true that, on the contrary, *those who talk most about technique* are in my eyes weakest in it!

I wrote you so already. But when I show something of my work in Holland, I know beforehand what will be said, and by what kind of critics. Meanwhile I am going quietly to the old Dutch masters, and to the pictures by Israëls, and to those who have a direct affinity with Israëls, which the modern painters do not have. They are almost diametrically opposed to Israëls. . . .

What they call brightness is in many cases an ugly studio tone of a cheerless city studio. The dawn in the morning or the twilight in the evening does not seem to exist, there only seems to be midday, from 11 to 3, a very decent hour indeed, but – often insipid as a milksop. . . . (427, Oct. 1885.)

. . . 'The true painters are the ones who do not make local colour' – that was what Blanc and Delacroix discussed once.

Mightn't I presume to infer from it that a painter had better start from the colours on his palette than from the colours in nature? I mean, when one wants to paint, for instance, a head, and sharply observes the reality one has before one, then one may think: That head is a

89

90

harmony of red-brown, violet, yellow, all of them broken – I will put a violet and a yellow and a red-brown on my palette and these will break each other. . . .

A portrait by Courbet is much truer – manly, free, painted in all kinds of beautiful deep tones of red-brown, of gold, of colder violet in the shadow with black as *repoussoir*, with a little bit of tinted white linen, as a rest for the eye – finer than a portrait by whomever you like, who has imitated the colour of the face with horribly punctilious *precision*.

A man's head or a woman's head, well observed and at leisure, is divinely beautiful, isn't it? Well, one loses that *general harmony* of tones in nature by painfully exact imitation; one keeps it by recreating in a parallel colour scale which may be not exactly, or even far from exactly, like the model. . . . (429, end Oct. 1885.)

Briefly leaving his quiet backwater, he paid a visit to Amsterdam to see the museum. His analysis of the colours in a work by Hals is so outstanding, lively and clear that only a painter who could also write well and was engrossed in the study of the rules of colour, could so record them from memory. As usual, he also had to mention Delacroix because this artist and his ideas formed part of the debate that was going on inside him.

. . . I do not know whether you remember the one to the left of the *Night Watch*, as pendant of *The Syndics*, there is a picture (unknown to me till now) by Frans Hals and P. Codde, about twenty officers full length. Did you ever notice that??? that alone – that one picture – is worth the trip to Amsterdam – especially for a colourist. There is a figure in it, the figure of the flag-bearer, in the extreme left corner, right against the frame – that figure is in grey, from top to toe, I shall call it pearl-grey – of a peculiar neutral tone, probably the result of orange and blue mixed in such a way that they neutralize each other – by varying that keynote, making it somewhat lighter here, somewhat darker there, the whole figure is as if it were painted with one same grey. But the leather boots are of a different material than the leggings, which differ from the folds of the trousers, which differ from the waistcoat – expressing a different material, differing in relation to colour – but all one family of grey. But just wait a moment! *88*

Now into that grey he brings blue and orange – and some white; the waistcoat has satin bows of a divine soft blue, sash and flag orange – a white collar.

Orange, blanc, bleu, as the national colours were then – orange and blue, side by side, that most splendid colour scale, against a background of a grey, cleverly mixed by uniting just those two, let me call them poles of electricity (speaking of colours though) so that they annihilate each other against that grey and white. Further, we find in that picture – other orange scales against another blue, further, the most beautiful blacks against the most beautiful whites; the heads – about twenty of them, sparkling with life and spirit, and a technique! a colour! the figures of all those people superb and full size.

But that orange blanc blue fellow in the left corner . . . I seldom saw a more divinely beautiful figure. It is unique.

Delacroix would have raved about it – absolutely raved. I was literally rooted to the spot. Well you know *The Singer*, that laughing fellow – a bust in a greenish-black with carmine, carmine in the flesh colour too. . . .

Bürger has written about Rembrandt's *Jewish Bride*, just as he wrote about van der Meer of Delft, as he wrote about *The Sower* by Millet, as he wrote about Frans Hals, with devotion, and surpassing himself. *The Syndics* is perfect, is the most beautiful Rembrandt; but *The Jewish Bride* – not ranked so high, what an intimate, what an infinitely sympathetic picture it is, painted 'with a hand of fire'. You see, in *The Syndics* Rembrandt is true to nature, though *even there*, and always, he soars aloft, to the very highest height, the infinite; but Rembrandt could do more than that – if he did not have to be *literally* true, as in a portrait, when he was free to *idealize*, to be poet, that means Creator. That's what he is in *The Jewish Bride*. How Delacroix would have understood that picture. What a noble sentiment, infinitely deep. . . . *89*

In Amsterdam I also saw pictures of today, Witkamp and others. Witkamp is one of the best, reminds one of Jules Breton; others whom I have in mind but I shall not name, who always talk about what *they* call technique, I found *weak in that very technique*.

You know all those cold grey tones which they think distinguished, but which are flat and uninteresting, childishly mixed. Nowadays they bring on the market ordinary colours

purposely mixed with pure white, for the convenience of painters who paint in what they call a distinguished light colour scale. (426, 10/11 Oct, 1885.)

After years of longing to make a sale, and countless begging letters, to pay for essential expenditure, Vincent now had an opportunity to sell something to his Eindhoven acquaintance Kerssemakers.

You know those three pollard oaks at the bottom of the garden at home; I have laboured over them for the fourth time. I had been at them for three days with a canvas the size of, let's say, the *Cottage* and the *Country Churchyard* which you have.

The difficulty was in the tufts of havana-brown leaves: modelling them and giving them their form, colour and tone. In the evening I took it to that acquaintance of mine in Eindhoven, who has a rather stylish drawing-room, where we put it on the wall (grey paper, furniture black and gold). Well, never before have I been so convinced that I shall make things that do well, that I shall succeed in calculating my colours, so that I have it in my power to make the right effect. This was havana, soft green and white (grey), even *pure* white, direct from the tube (you see that I, for my part, though I speak about black, have no prejudice against the other extreme, even the utmost extreme).

Now, though that man has money, though he took a fancy to it, I felt such a glow of courage when I saw that it was good, that, as it hung there, it created an atmosphere by the soft melancholy harmony of that combination of colours, *that I could not sell it.*

But as he had a fancy for it, I gave it to him, and he accepted it just as I had intended, without many words, namely little more than, 'The thing is damned good.'

I don't think so yet myself. First I must see a little more of Chardin, Rembrandt, old Dutch and French painters, and think it over well – because I want to make it more elaborate with less paint than I used, for instance, in this thing. ... (431, 8–12 Nov. 1885.)

81, 85 The correspondence with Van Rappard had become acrimonious. His relationship with the artist had taken the form of an exchange of views with a colleague, and thus complemented what he wrote to Theo, but never more than that. Van Rappard's academic criticism of *The Potato Eaters* – proportions, anatomy, state of completion, suggestion of space – was based on the lithograph Vincent had made of it. It led to a impassioned series of letters in self-defence from Vincent, and, ultimately, to a final break.

... You will agree with me that such work is not meant seriously. Fortunately you can do better than that, but why then did you see and treat everything so superficially? Why didn't you study the movements? *Now* they are only posing. How far from true that coquettish little hand of the woman in the background is – and what connection is there between the coffeepot, the table and that hand that is lying on top of the handle? What on earth is that kettle doing? – it isn't standing, it isn't being lifted up – so what then? And why isn't that man to the right allowed to have a knee, a belly and lungs? Or are they located in his back? And why must his arm be a yard too short? And why must he do without one half of his nose? And why must that woman on the left have some sort of little tobacco-pipe stem with a little cube at the end for a nose?

And after that, while working in such a manner, you dare invoke the names of Millet and Breton? Come on! In my opinion art is too sublime a thing to be treated so nonchalantly. (Van Rappard to Vincent, R51a, 24 May 1885.)

I just received your letter – to my surprise. You are herewith getting it back. (Vincent to Van Rappard, R51, 24 May 1885.)

... Millet was mentioned. All right, my friend, I'll answer you.

You wrote, 'And such a one dares invoke Millet and Breton.'

My answer to that is that I most seriously advise you *not* to fight with me. As for me – I go my own way – you see? I don't want to pick a quarrel with anyone, so *not with you* either, even now. I should let you say whatever you liked; if you were to have more observations of the

same kind, it would leave me stone cold, and that would be all. But for the moment I want to say this much, you have said more than once that I do not care for the form of the figure, it is beneath me to pay attention to it, and – my dear fellow – it is beneath you to say such an unwarranted thing. You have known me for years – just tell me, have you ever seen me work otherwise than after the model, never sparing expense, however heavy at times, though I am surely poor enough.

Not in your last letter, but repeatedly and ad nauseam in your previous letters you wrote about '*technique*', which was the reason for the letter to which you did not reply. What I answered to that, and what I will answer again is, There is the conventional meaning, which is being given more and more to the word technique, *and* the real meaning – *science*. Very well, Meissonier himself says, '*La science nul ne l'a*' [nobody has science]. ... (Vincent to Van Rappard, R52, before 6 July 1885.)

... As for my work, that scene of the potato eaters – you saw the lithograph of it – is a subject that I tried to paint, being inspired by the peculiar light effect in that grimy cottage. It is kept in such a low scale of colours that the *light* colours, smeared on white paper, for instance, would look like ink stains; but on the canvas they stand out like lights because of the great forces opposed to them, for instance by putting on absolutely unmixed Prussian blue. My own criticism is that by paying attention to this, I lost sight of the form of the torsos. Heads and hands, however, were done very carefully; and as they were of the greatest importance and all the rest was nearly entirely dark (therefore *quite different* in effect from the lithograph), my painting the picture *as I did* is to be excused to a greater extent than you think. And besides, the real picture differs in design from *either* the rough sketch for it, which I still have and which I made in that cottage by the light of a little lamp, *or* from the lithograph.

I want to tell you further that I have drawn quite a number of heads since you were here, and quite a lot of peasants besides: diggers, weeders, harvesters. The thing that occupied my attention, either directly or indirectly, and was the great problem in all this, was colour. I mean the *breaking* of the colours – mixing red with green, blue with orange, yellow with violet, always the combination of the complementary colours, their influence on each other – of which nature is as full as of light and brown. Another problem – which engrosses me every day anew – is precisely the one I think you asserted I neglected: rendering the form and its modelling, its great lines and masses – one considers the contours in the *last* instead of the *first* place in doing this.

Herewith two sketches of smaller compositions – I painted both of them. Lately I have been working mostly on things of a smaller size. ...

And as for other questions – I cannot always keep quiet under it; now and then it seems to me as though people were touching my body, so much do I feel taken up by the question, and so much is my conviction a part of myself.

It is true that there are faulty things in that lithograph as well as in my other work – certainly there are. But my other work proves so clearly that I render what I see that people cannot be justified, or speaking in good faith, when they judge my work otherwise than as a whole and in a broader way, taking into account my purpose and endeavour – namely to paint *le paysan chez soi*, peasants in their surroundings. ... (Vincent to Van Rappard, R57, Sept. 1885.)

However little he agreed with his father, it was the death of Theodorus Van Gogh which made Vincent grasp the opportunity to cut himself loose first from the family home, then from Nuenen, and finally from the Netherlands. He had now found a pattern of life whereby each idea he had of moving came to fruition as soon as a phase in his work had been completed.

Theo was briefly informed of his brother's decision to go to Antwerp, a town suggested previously as one of the places where he might possibly sell some paintings and see some more works of art. The move was to be temporary, he thought, just for a few months, and then he would go back *if need be*. It does not sound very convincing.

... I must say I am longing for Antwerp now. Probably the first thing I shall do there will be to go and see the pictures by Leys in his *dining hall*, if it is open to the public. You know that

83, 84

97

Walk on the Ramparts, and those which Bracquemond etched, *The Table* and *The Servant Maid*.

I imagine it will be beautiful there this winter, especially the docks with snow.

Of course I shall take a few pictures with me, and they will be those that I would otherwise have sent to you one of these days. A big mill on the heath in the evening, and a view of the village behind a row of poplars with yellow leaves, a still life, and a number of drawings of figures. ... (434, 15–20 Nov. 1885.)

... I repeat, as to my rather sudden departure from here, if I hadn't had trouble with the models, I should have spent the winter here. But working steadily with models here is not so much hampered by the priest's opposition, which in itself would have been neutralized by my ignoring it completely, but the worst is that though I have the courage to stand my ground, people hesitate, and are more frightened than I thought they would be.

And I am not going to undertake it unless I am quite sure that they have the courage. Now it might help if I go away for a couple of months, and if it doesn't help, then not one of those to whom I gave something for it every week last winter will earn a penny with it this winter. ... (435, 18–22 Nov. 1885.)

His mother wrote an undated and unpublished letter (Van Gogh Museum Archives, Amsterdam): 'Friday morning – The Hague', in which she explained to Jo van Gogh-Bonger that, when moving from Nuenen to Breda on 30 March 1886, 'under unfavourable circumstances for assessing Vincent's work, perhaps we did not sufficiently appreciate the things we found'. Considering the few belongings Vincent took with him to Antwerp, and his large output, the work he left behind at Nuenen can hardly have been negligible, even allowing for what he had sent to Theo. There was a 'man who helped us clear up and move', and his mother thought it might well be possible that 'something was distributed from that quarter, but I do not know any facts'. She would get someone to ask the man. For the trade this became a welcome source when suggesting the possible provenance of works supposedly by Van Gogh. Van Gogh had left about seventy painted studies at The Hague (letter 329).

48 The Potato Eaters, 1885
The definitive version of *The Potato Eaters* is the synthesis of all the ideas of Vincent's Dutch period: all he had learned from Millet and Breton, and from reading Zola (*Germinal* and *La Terre*), his religious and moral conviction of the value of working people and their lives, his feeling of being bound to the earth, his union with the group that sits at night around the table. The tension of his creativity in the months from January to March 1885, before the definitive composition came to fruition, was enormous. Numerous heads of peasants were drawn. After growing up among the masters of the Hague School, and absorbing the masterpieces of the Dutch seventeenth century, Vincent now appeared in his maturity as a Dutch painter, an authentic genius, distancing himself with a sure hand from everyday aesthetic rules and fashions, with a mastery of proportion, colour and space. 'By continually witnessing peasant life, at all hours of the day, I have become so absorbed in it that I hardly think of anything else' (400).

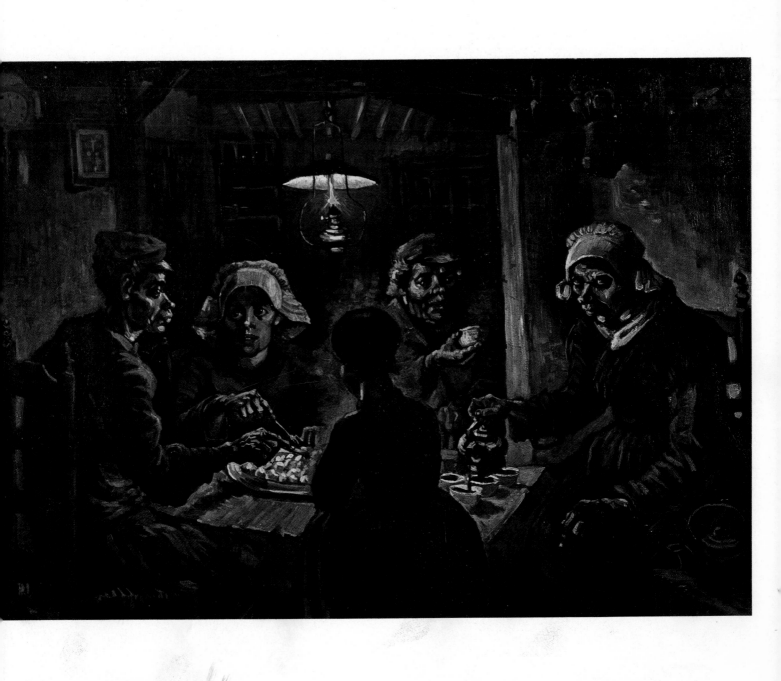

Etten and Kee

'Well, the same thing that Weissenbruch has said about a landscape, a peat bog, Mauve said about a figure, i.e. an old peasant who sits brooding by the hearth, as if he saw things from the past rising in the glow of the fire or in the smoke' (177). In general the letters of the Etten period (1881) inform us better of his deep-rooted, violent and obdurate love for his cousin Kee than about his work. He discussed technical problems, briefly and unemotionally. The works themselves, however, show the development of a great power to express his own melancholy, gloomy temper.

49 Kee Vos-Stricker, 1879

50 Corner of a Garden with an Arbour, June 1881

51 Shacks, 1881

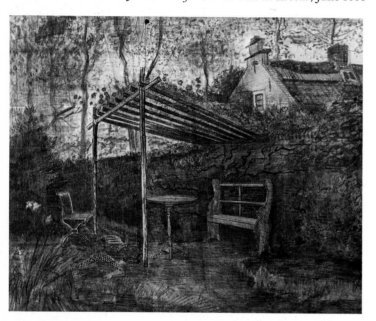

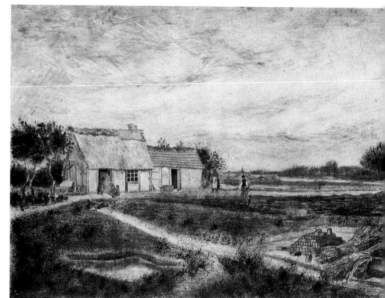

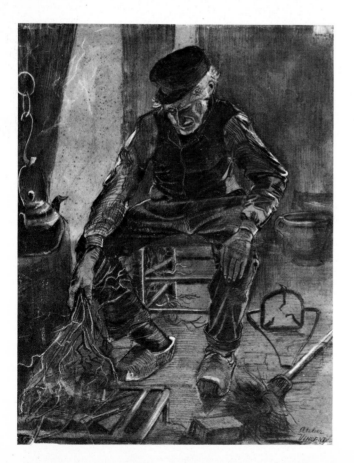

52 Old Peasant by the Fire, Nov. 1881
53 Worn Out, 1881

The Hague and Sien

In The Hague in the following year, 1882, he lived with Christine Hoornik (Sien), an alcoholic prostitute, whom with some of his old missionary zeal he attempted to rehabilitate. A series of seated or crouching figures, mostly female – and mostly of Sien – maintain the mood of the seated peasants of 1881.

55 Girl (Sien's Daughter with Shawl: Left Profile), Jan. 1883

54 The Great Lady, 1882

56 Weeping Woman (Woman with her Head in her Hands, Seated on a Basket), 1883

57 Sien with a Cigar, Sitting on the Ground by a Stove, Apr. 1882

103

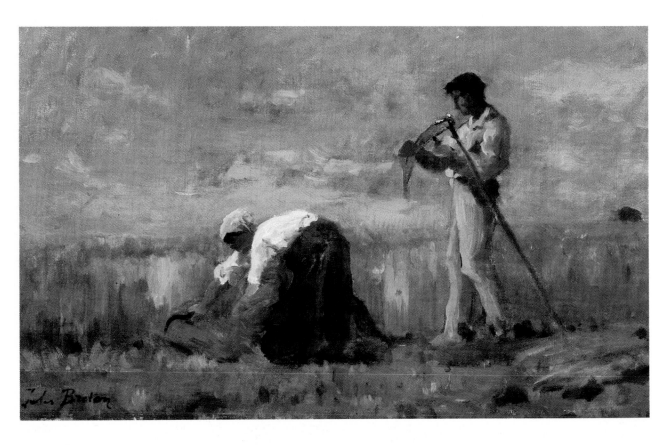

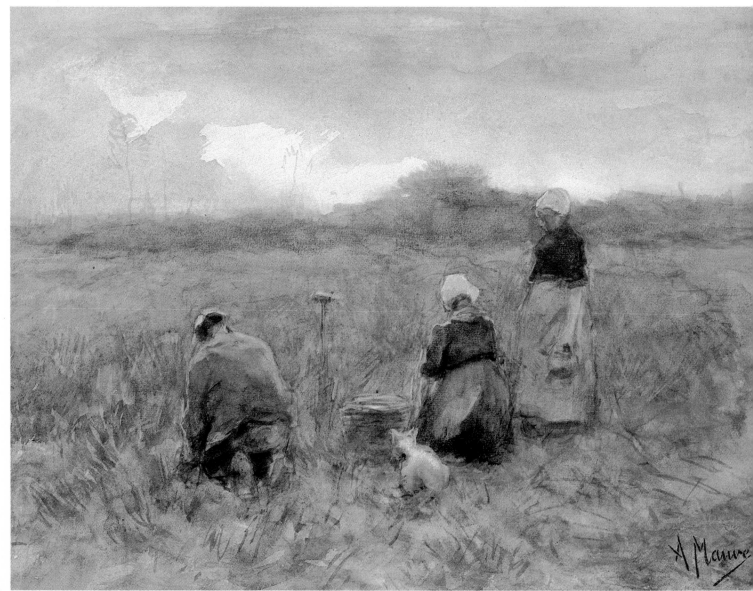

Seen in The Hague

Vincent's background did not lie exclusively in Dutch, but also in English and French, art. He had adored the work of Breton since 1875. In The Hague he saw the collection of the Hague School painter H.W. Mesdag, in which Breton, Millet and Jacob Maris were represented by the three paintings seen here. Mesdag did not collect conventional fashionable subjects, but sought just the qualities which also appealed to Van Gogh. Millet was a mentor of his all his life; he constantly cited maxims, such as 'I would never do away with suffering, for it often is what makes artists express themselves most energetically'; 'Because I go to work in clogs, I shall manage'; and one which Van Gogh was to reaffirm at the cost of this own life: 'In art you have to risk your own skin' (406).

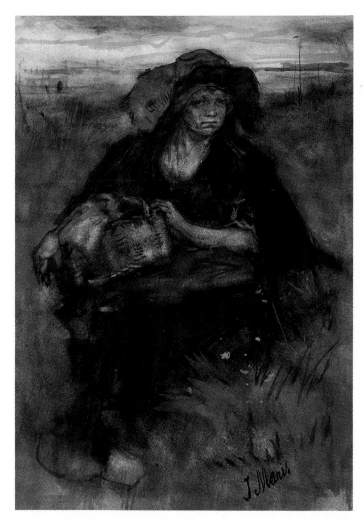

61 Jacob Maris. *Evening on the Dunes (Fisherman's Wife, Seated)*

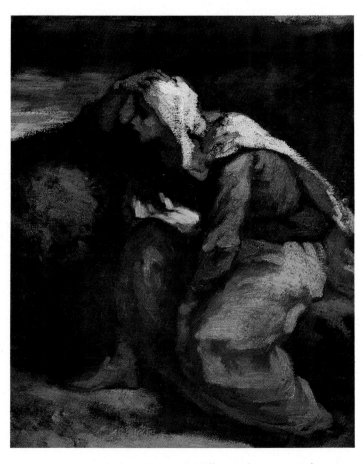

60 Jean-Francois Millet. *Fisherman's Wife, c.*1849

Anton Mauve, who married one of Mrs Van Gogh's numerous sisters, Jet Carbentus, had the merit of teaching Van Gogh, in The Hague period, a considerable amount about the techniques of painting and drawing. Moreover, his critical spirit and total commitment to his own work enhanced his authority in Vincent's eyes. They fell out; Vincent is too readily blamed for this by his biographers, the volatile Mauve being at least as difficult as he was. Vincent never ceased to revere Mauve as an artist. Jacob Maris (1837–99) was the eldest of three brothers, all painters. Long considered to be the greatest Dutch artist of the century, he caught Vincent's imagination through his use of subdued warm colour (in his early work) and his scenes of the life of the poor.

Left:
58 Jules Breton. *The Harvest*
59 Anton Mauve. *Digging Potatoes*

62 Jules Dupré. *Evening*
63 Charles-François Daubigny. *Sunset at Villerville*, 1866
64 Anton Mauve. *Sale of Wood*, c.1881

Left:

Three more works with which Vincent saw in the Mesdag collection. Jules Dupré was a pure landscape painter, a mixture of French and English influences (Barbizon and Constable). This dark Dupré is an example of that painter's evolution towards a broader vision, suppressing details. A lifelong admirer of Daubigny, Vincent painted *Daubigny's Garden* at Auvers shortly before he died (*211*). Not only the English illustrators but the Hague artists Mauve and Breitner showed figures in groups, a theme which attracted Vincent principally during his Hague period.

Urban reality

Left:
65 Roofs seen from the Artist's Attic Window,
July 1882
66 Road at Loosduinen, 1882

Five drawings of 1882 show how fast, after leaving Etten in December 1881, Vincent gained his astonishing mastery of drawing. He left the famous masters of the Hague School behind him and developed a different and ultimately more modern style of expressive realism, combining an almost photographic exactness with an expressive use of perspective and a great feeling for space (65,66). His choice of subjects is modern (67,68): the fascination of urban and suburban life, deeply felt in all its ugliness. Vincent responded to his environment not as an aesthete, reacting against the surrounding squalor, but as an artist, responding imaginatively to an unspoken menace: a man with a presentiment of the rootless and disorientated urban culture that was to come.

67 Gas-holders (The Gas Tanks of
The Hague). Mar. 1882
68 Factory in The Hague (Sterkman's
Factory), Mar. 1882
69 Entrance to the Pawnshop, The Hague,
Mar. 1882

Nuenen

Vincent's last stay with his parents was also the longest since childhood: at Nuenen, from December 1883 to November 1885. These were two years of intensive work, in the studio he rented from the local Catholic sacristan. Theodorus van Gogh was pastor of the little Reformed Church and lived in the vicarage. Here, as with all the other places where Vincent lived as an artist, photographs remind us how intense, and how exact, was the painter's experience of the tangible world.

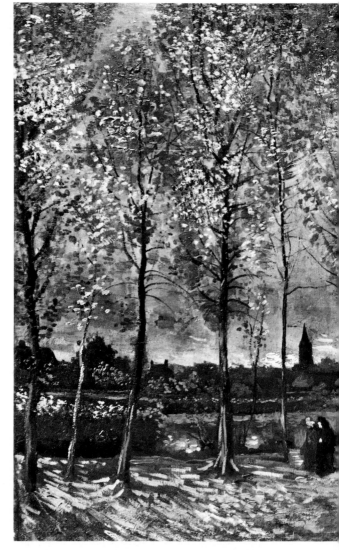

76 Lane of Poplars at Nuenen, autumn 1885
In 1885, from early spring onwards, Vincent underwent a series of emotional shocks which stimulated his creative powers. His father died on 26 March. He left his parents' house, to live and work alone; trouble with the parish priest over rumours of misbehaviour with one of his models intensified his unrest. He created a

74 The Vicarage at Nuenen, autumn 1885
75 The vicarage at Nuenen

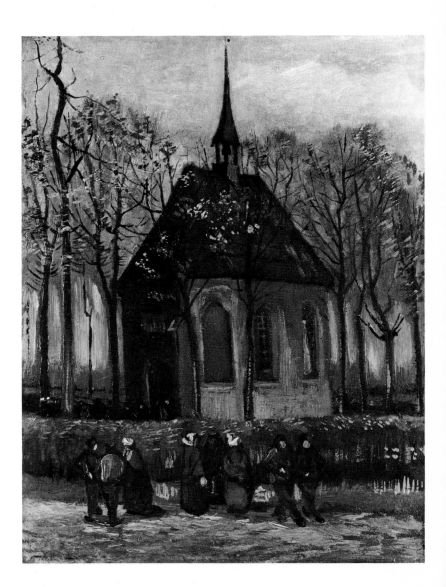

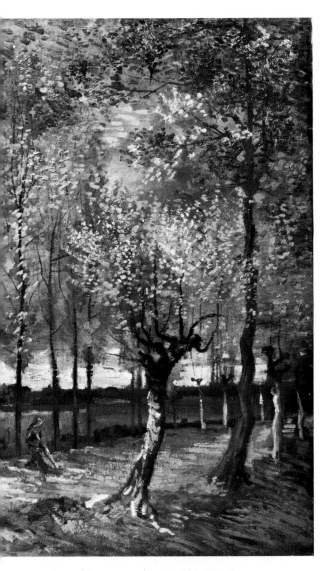

number of the masterpieces of his Dutch phase. The *Lane of Poplars* is a revelation of autumn colours, so rich that some art historians have supposed that he retouched it in Paris. There are other colourful autumn lanes, all with the figure of the 'woman in black'. He had realized the possiblities that Brabant offered; he was ripe to leave.

77 *Coming out of Church in Nuenen*, Jan. 1884
78 Nuenen church

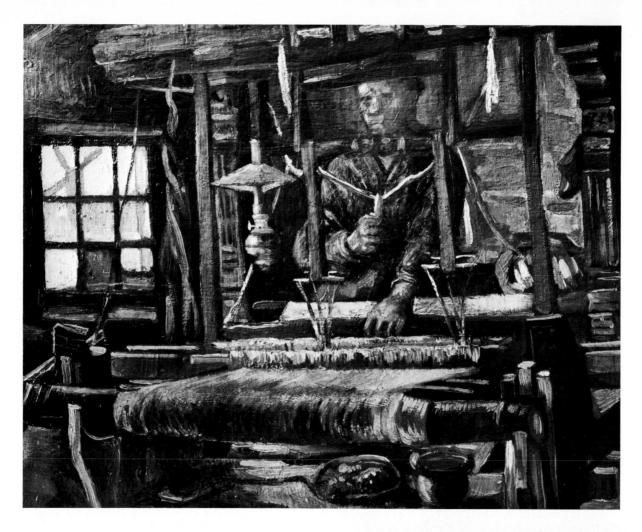

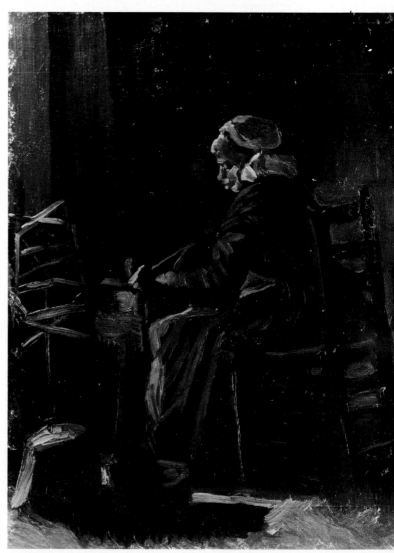

79 *Weaver, Facing Front*, July 1884
From the time he first read Charlotte
Brontë's *Shirley* (at Etten, 1881), and
through the Borinage and The Hague,
weavers had a mysterious fascination for
Van Gogh. This is one of his best paintings
of this subject, a monumental construction
with a towering figure working
energetically behind his loom.

80 *Woman Spinning*, 1885
The profile and structure of the seated
woman, and the paint, are elements of the
period which produced *The Potato Eaters*.
The Zola-like atmosphere and the brutish
expressions of the human figures are far
from any sentimental feeling.

81 Anton van Rappard. *The Brickworks*, 1885
82 Constantin Meunier. *The Brickmakers*
Vincent admired Constantin Meunier
more than he did Van Rappard, a friend
and contemporary whom he had known
since Brussels (1880). Vincent's
knowledge of Meunier was so great that
he could remember having seen a picture
by Meunier in the same spirit as one that
Van Rappard was engaged upon in 1885
(421).

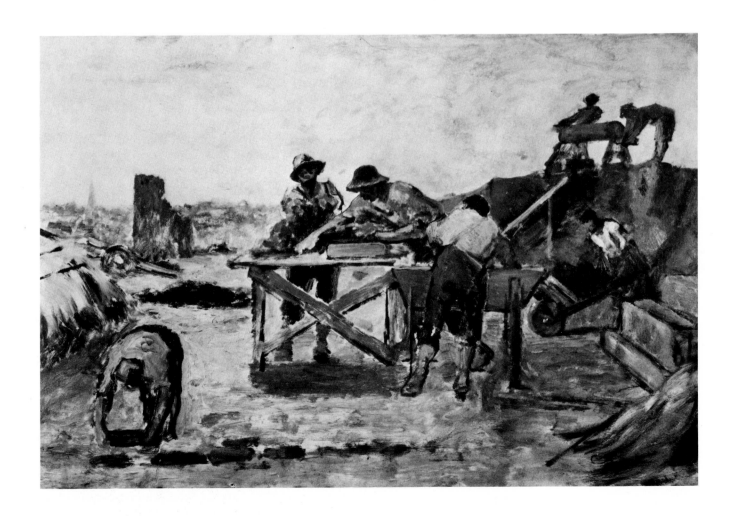

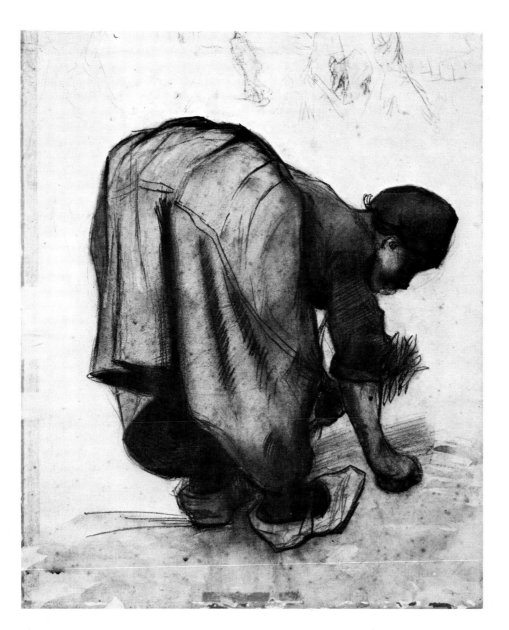

83 *Peasant Woman Stooping*, Aug. 1885
84 *The Reaper with Cap, Moving to the Right*, Aug. 1885

Artists are children of their time; and two artists of different stature, like Van Gogh and Van Rappard, may share a common subject matter. The difference, when it comes to the survival of the artists' works, lies in their spirit. Van Rappard has left much good work; but he believed in the rules of the academies, and Van Gogh believed only in himself and in Delacroix. In the Dutch period, both his colour and his drawing attain an intensity of vision, in the depiction of human labour, that remains unequalled in art before or since. Mauve, in related themes, was delicate, serious, subtle, and his work is still of great value; so is that of his associate Breitner. But Vincent, capable of total spiritual commitment, fearless in transgressing the unwritten limitations that hemmed the artist in, became after his death the yardstick by which his contemporaries were measured.

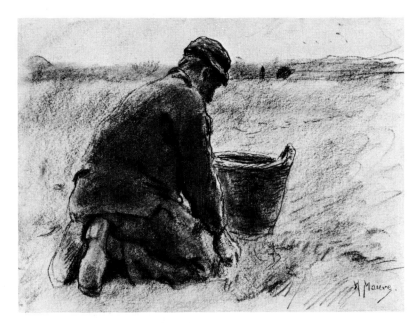

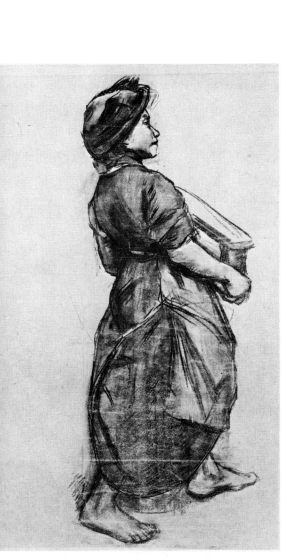

85 Anton van Rappard. *Girl Holding a Brick Mould*, 1885
86 Anton Mauve. *The Potato-digger*
87 Georg Hendrik Breitner. *Couple Walking*

A hand of fire

88 Frans Hals and Pieter Codde. *The Company of Captain Reynier Reael...,* 1633–36
Vincent had a profound love of tradition; but he was never a mere follower. In October 1885, shortly before he left his native land for good, he stood for the last time in the new Rijksmuseum in Amsterdam. He was especially interested by one relatively little-known picture by Hals (finished by Codde), and in particular by the flagbearer at the left (letter 426, perhaps the best critical analysis he ever wrote).

89 Rembrandt van Rijn. *The Jewish Bride,* c. 1666
Of Rembrandt's famous *Jewish Bride,* which he did not rank as high as The *Syndics,* he wrote: 'what an infinitely sympathetic picture it is, painted "with a hand of fire". In *The Jewish Bride* Rembrandt is a 'poet; that means "creator"'.

90 Jozef Israëls. *Alone in the World,* 1878
He must have absorbed pictures until he reached the point of exhaustion. About the work by Jozef Israëls, whom he had admired since his early days, he said, 'an old woman huddles together like a bundle of rags near the bedstead in which the corpse of her husband lies . . . let them jabber about technique as much as they like, in pharisaical, hollow, hypocritical terms'. Vincent thought it a masterpiece.

III

ANTWERP AND PARIS

'Colour seeking life'

1885–1886 Antwerp
1886–1888 Paris

In November 1885 Vincent left his native land, sadly, but with a feeling of relief. He was never to return. His letters from Antwerp, over the ensuing three months, are not on the same level of creative excitement as those from Drenthe or Brabant. Nevertheless, they are – and with Van Gogh it could hardly be otherwise – documents of great interest: by turns acute, stimulating, and almost haughty in his contempt for the Antwerp Academy.

97 ... I shall begin by telling you that I saw Leys's dining hall, you know, *The Walk on the Ramparts*, *The Skaters*, *The Reception* and *The Table*, and on a panel between the windows *St Luke*. To my astonishment the composition was somewhat different from the ultimate compositions, at least I imagine so – although I have not yet been able to compare photos of the *pictures* with them.

 Then, it was painted in fresco – *i.e.* on the plaster of the wall. Now fresco really must and can last for centuries, but these have already faded considerably, and the one over the mantelpiece especially (part of *The Reception*) already shows some cracks. The highly ingenious son of Baron Leys has also improved the hall by having a door enlarged so that in *The Skaters*, the legs of the fellows standing on the bridge looking over the railings have been cut away, which makes a deplorable effect. Besides, the light is terribly bad there: now, that hall was originally painted – I imagine – to be used by lamplight. Therefore, because I honestly could not see anything, I gave the servant a tip and asked her to light the chandelier for me, and then I could see better.

 After so much that had rather disappointed me – in the first place that the colour in the fresco, and, alas, I am afraid *bad* fresco, is not what we are used to from Leys – after so much that disappointed me – after all it is superb.

 The maidservant, the woman near the baker's shop, the lovers and other figures in *The Walk on the Ramparts* – the bird's-eye view of the city, the silhouette of the towers and roofs against the sky, the bustle of skaters on the frozen moat – are superbly executed. ... (436, Nov. 1885.)

104 Amidst numerous impressions of the busy life of the port, and descriptions of several areas of the town, Van Gogh's discovery of Japanese prints – in Antwerp of all places – was to be significant for his entire future development. It seems simpler than in fact it is. He pinned a few pictures to the wall of his rented room, and some influence began to make itself felt in the way he looked at people in the town. There was also a link with a book, *Chérie*, by Edmond de Goncourt (1884). Jules de Goncourt had died, and in the introduction to *Chérie* Edmond spoke of their close collaboration. Vincent regretted that he and Theo were unable to work along similar lines. In one of Vincent's favourite books, *Germinie Lacerteux*, the Goncourts had proved that it was possible to maintain aesthetic standards and artistic values despite deep concern for their terrible subject, the misery of the poorer classes. At an early date the Goncourts had also introduced the subject of Japan and Japanese art into their writings and activity as collectors, even though they were not the first to do so.

 Van Gogh bought some Japanese prints in Antwerp and fell in love with this particular art form, which, unbeknown to him, had already had a fruitful effect on Braquemond, Manet, the other Impressionists and Whistler.

 ... This morning I took a most satisfactory walk in the pouring rain, the object of this excursion being to get my things at the customhouse; the various dockyards and warehouses on the quays are splendid.

 I have walked along the docks and the quays several times already, in all directions. Especially when one comes from the sand and the heath and the quiet of a peasant village, and has been in none but quiet surroundings for a long time, the contrast is curious. It is an unfathomable confusion. One of Goncourt's sayings was: 'Japonaiserie for ever.' Well, those docks are a famous Japonaiserie, fantastic, peculiar, unheard of – at least one can take this view of it.

I should like to walk there with you, just to know whether we see alike. One could make everything there, city views – figures of the most varied character – the ships as the principal things, with water and sky a delicate grey – but above all – Japonaiserie. I mean, the figures are always in action, one sees them in the queerest surroundings, everything fantastic, and at all moments interesting contrasts present themselves.

A white horse in the mud, in a corner where heaps of merchandise are lying covered with oilcloth – against the old smoky black walls of the warehouse. Quite simple, but an effect of Black and White.

Through the window of a very elegant English bar, one will look out on the dirtiest mud, and on a ship from which, for instance, attractive merchandise like hides and buffalo horns is being unloaded by hideous dock hands or exotic sailors; a very dainty, very fair young English girl is standing at the window looking at it, or at something else. . . . There will be Flemish sailors, with almost exaggeratedly healthy faces, with broad shoulders, strong and plump, and thoroughly Antwerp folk, eating mussels, or drinking beer, and all this will happen with a lot of noise and bustle – by way of contrast – a tiny figure in black with her little hands pressed against her body comes stealing noiselessly along the grey walls. Framed by raven-black hair – a small oval face, brown? orange-yellow? I don't know. For a moment she lifts her eyelids, and looks with a slanting glance out of a pair of jet-black eyes. It is a Chinese girl, mysterious, quiet like a mouse – small, bedbug-like in character. What a contrast to that group of Flemish mussel eaters.

Another contrast – one passes through a very narrow street, between tremendously high houses, warehouses, and sheds.

But down below in the street pubs for all nationalities with masculine and feminine individuals to match, shops selling eatables, seamen's clothes, glaringly colourful and crowded.

That street is long; every moment one sees something striking. Now and again there is a noise, intenser than anywhere else, when a quarrel is going on; for instance, there you are walking, looking about, and suddenly there is a loud cheering and all kinds of shouting. In broad daylight a sailor is being thrown out of a brothel by the girls, and pursued by a furious fellow and a string of prostitutes, of whom he seems rather afraid – at least I saw him scramble over a heap of sacks and disappear through a warehouse window. . . .

And so my studio is all fixed up. If I could get good models for almost nothing, I should not be afraid of anything.

I do not think it so very bad either that I have not got so much money as to be able to force things by paying for them. Perhaps the idea of making portraits and having them paid for by posing is the safer way, because in a city it is not the same as it is with the peasants. Well, one thing is sure, Antwerp is very curious and fine for a painter.

My studio is not bad, especially as I have pinned a lot of little Japanese prints on the wall, *104* which amuse me very much. You know those little women's figures in gardens, or on the beach, horsemen, flowers, knotty thorn branches. . . . (437, 28 Nov. 1885.)

Of course he was familiar with Rubens' art, but it was only after moving to Antwerp that he made a thorough analysis of his work and discovered its value to himself. We can share his fascination with some of the artist's less popular paintings, not prime examples of his art but possessing a wealth of fine qualities.

. . . Rubens is certainly making a strong impression on me; I think his drawing tremendously good – I mean the drawing of heads and hands in themselves. I am quite carried away by his way of drawing the lines in a face with streaks of pure red, or of modelling the figures of the hands by the same kind of streaks. I go to the museum fairly often, and then I look at little else but a few heads and hands of his and of Jordaens'. I know he is not as intimate as Hals and Rembrandt, but in themselves those heads are so alive.

Probably I don't look at those which are generally admired most. I look for fragments like, for instance, those blonde heads in *St Theresa in Purgatory*. I am now looking for a blonde *98* model just because of Rubens. But you must not be angry if I tell you that I cannot make both ends meet this month. I have bought some more colours and two new kinds of drawing

brushes which suit me splendidly and with which I can work more accurately. . . . (430, 8–15 Dec. 1885.)

He was a close student of contemporary art in Antwerp. Apart from Leys, he was also familiar with Henri de Braekeleer, Constantin Meunier, Félicien Rops and Henri de Groux, and updated his views on them. The younger artists of whom he took special note included Edgard Farasyn and Jan Verhas, who, a hundred years later, again appear to stand out amidst many mediocrities, and to have some quality – albeit of local value only.

. . . I have seen two collections of modern pictures, first, what was bought at the exhibition for the raffle, and then a collection of pictures that was for sale.

So I saw several fine things, two studies by Henri de Braekeleer; you know that he is absolutely different from the old De Braekeleer, I mean the one who is a famous colourist, and who analyses rigorously. He is somewhat like Manet, that is to say as original as Manet.

One study was of a woman in a studio, or some such interior, with Japanese objects; the woman wore a costume of yellow and black. The flesh colour, white with carmine. In the surroundings, all kinds of quaint little tones. The other one was a half-finished study of a landscape. Yellow, faded, flat fields as far as the eye can see, crossed by a black cinder path, with a ditch alongside; over it, a sky of lilac grey, with accents of carmined lilac. Far away the little red patch of vermilion of a roof, and two little black trees. Hardly anything, and yet for me a great deal, because of the peculiar sentiment in the juxtaposition of colours. I also saw an old study by De Groux, a woman beside a cradle, somewhat like an old Israëls.

Further, what shall I say about those modern pictures? I thought many of them *splendid*, and then I mean especially the work of the colourists, or of those who try to be so, who look everywhere for mother-of-pearl-like combinations in the light parts. But to me it is not always perfect by a long shot; it is too affected. I prefer to see a simple brush stroke and a less far-fetched, difficult colour. More simplicity, in short that intelligent simplicity which is not afraid of frank technique.

I like Rubens just for his ingenuous way of painting, his working with the simplest means.

I don't count Henri de Braekeleer among those who look for mother-of-pearl effects everywhere, because his is a curious, very interesting endeavour to be literally true, and he stands quite apart. I also saw various grey paintings, including a printing shop by Mertens, a picture by Verhaert representing his own studio, where he himself is sitting etching and his wife standing behind him. . . . (439, 8–15 Dec. 1885.)

91 He also made a remarkable discovery in the Andrieskerk or church of St Andrew (1523), in the poor fisherman's quarter: a superb stained glass window which he described from memory – there were no catalogues at the time. The thoroughness of his powers of observation and concentration on the colours in particular is remarkable. After his studies in Brabant, he felt colour was the most important thing for him as a painter. Stained glass windows had long fascinated him, in England for instance, while the related technique of Cloisonnism (see p. 195) occupied his mind at Arles for a while.

. . . By the way, let me begin by answering your question of some time ago, about the picture by Franck or Francken at Saint-André, which I saw today. I think it is a good picture – especially fine in sentiment – the sentiment is not very Flemish or Rubens-like. It reminds one more of Murillo. The colour is warm, in a reddish colour scheme like Jordaens sometimes is.

The shadows in the flesh are very strong, that is what Rubens has not, and Jordaens often has, and it gives something mysterious to the picture which one must appreciate in that school.

I could not get near enough to analyse the technique close up, which would have been well worth while. The head of Christ is less conventional than the Flemish painters usually conceive it.

But I imagine I can also do it in that way, and the picture did not tell me anything new. And as I am not satisfied with what I can do now, and try to make progress – enough – let's talk

about other pictures. What struck me in that church was a sketch by Van Dyck or Rubens (?), *The Deposition from the Cross*, which hung high, but seemed very beautiful to me. Much sentiment in the pale corpse – this by the way.

There is a painted window which I think superb – very, very curious. A beach, a green sea with a castle on the rocks, a sparkling blue sky of the most beautiful tones of blue, greenish, whitish, deeper, higher of tone.

An enormous three-master, quaint and phantasmal, stands out against the sky, diffusion everywhere, light in the dark, dark in the light. In the blue a figure of the Holy Virgin, bright yellow, white, orange. Higher up the window reappears dark green, with black, with fiery red.

Well – do you remember it? It is very beautiful, and Leys would certainly have fallen in love with it, or James Tissot in his old style or Thijs Maris.

I saw some pictures bought for the Musée Moderne, by Verhas and Farasyn. . . . (443, Jan. 1886.)

During Vincent's months in Antwerp one problem urgently required a solution: where was he to go now that he specifically wanted to make studies from the nude and was anxious to find an environment where he could gain *103* constructive help? He decided, late and reluctantly, on the Academy.

. . . Always to be in a state of exile, forever having to make great efforts, always half measures! But never mind – the family stranger than strangers is one fact – and being through with Holland is a second fact. *It is quite a relief.*

That is my only feeling, and yet I have been so deeply attached to it all that at first the estrangement drove me crazy. . . .

About models this month I think I shall go and see Verlat, who is the director of the academy here – and I must see what the conditions are, and if one could work there from the nude. I shall take a portrait and some drawings with me then. . . . (443, early Jan. 1886.)

Karel Verlat (1824–90) was a talented, ambitious, superficial man, authoritarian as a teacher. He had worked in Paris for eighteen years and failed to progress beyond a glorification of tradition. Vincent could hardly object to Verlat's conviction that drawing was of prime importance; but he naturally came into conflict with the anti-Delacroix doctrine that contour must dominate. Van Gogh thought Verlat's colour hard, as did the critic Max Rooses (*Oude en nieuwe Kunst*, Ghent 1896). But Verlat did urge his students to go to the Near East, because of the southern light; it is conceivable that this may have roused something in Van Gogh.

The thought of entering the studio of Fernand Cormon, in Paris, was already in Vincent's mind; although *any* established painter was likely to object strongly to his manner of working.

. . . I am sorry to have to tell you more categorically that I am literally worn out and overworked. Just think, I went to live in my own studio (in Nuenen) on 1 May and I have not had a hot dinner more than perhaps six or seven times since. I do not want you to tell Mother that I am not well, for good reasons, for perhaps she would begin to worry, thinking that it was not kind to let things happen as they did, namely – that I did not stay at home to avoid these very consequences.

I will not mention it, so don't you, either.

But I have lived *then*, and I do *here*, without any money for a dinner, because the work costs me too much, and I have relied too much on my being strong enough to stand it.

What the doctor tells me is that I absolutely must *take better care of myself*, and until I feel stronger I must take more rest.

It is an *absolute* breakdown.

Now I have made it worse by smoking a great deal, which I did the more because then one does not feel an empty stomach so much. . . .

What we must do, and where the greatest trouble lies, is this. To pay the models oneself is too great a burden; as long as one hasn't enough money, one must use the opportunities offered by the studios like those of Verlat or Cormon. And one must live in the artists' world, and work at the clubs where one shares the cost of the models. ...

For speaking of Cormon, I think he would tell me much the same thing as Verlat, namely that I must draw from the nude or plaster casts for a year, just because I have always been drawing from life. ...

Drawing in itself, the technique of it, comes easily enough to me. I am beginning to do it like writing, with the same ease. ... (449, 3 Feb. 1886.)

I decidedly want to tell you that it would make me feel much better if you would approve of my coming to Paris much earlier than June or July. The more I think about it, the more anxious I am to do so.

Just think, if all goes well, and if I had good food, etc., all that time, which certainly will leave something to be desired, even in that case it will take about six months before I shall have recovered entirely. ...

If I rent a garret in Paris, and bring my paintbox and drawing materials with me, then I can finish what is most pressing at once – those studies from the ancients, which certainly will help me a great deal when I go to Cormon's. I can go and draw either at the Louvre or at the Ecole des Beaux-Arts. ...

After all I am glad I went to the academy, for the very reason that I have abundant opportunity to observe the results of *prendre par le contour*.

For that is what they do systematically, and that is why they nag me. 'First make a contour, your contour isn't right; I won't correct it if you do your modelling before having seriously fixed your contour.'

You see that it always comes to the same thing. And now you ought to see how flat, how lifeless and how insipid the results of that system are; oh, I can tell you I am very glad just to be able to see it close up. Like David, or even worse, like Pieneman in full bloom. I wanted to say at least twenty-five times, 'Your contour is a cheat, etc.'; but I have not thought it worth while to quarrel. Yet I irritate them even though I don't say anything; and they, me. ...

They go so far as to say, 'Colour and modelling aren't much, one can learn that very quickly, it's the contour that is essential and the most difficult.' ...

Just yesterday I finished the drawing I made for the evening class's competition. It is the figure of Germanicus that you know. Well, I am sure I shall place last, because all the drawings of the others are exactly alike, and mine is absolutely different. But I saw how that drawing they will think best was made. I was sitting just behind it, and it is correct, it is whatever you like, but it is *dead*, and that's what all the drawings I saw are. ... (452, Feb. 1886.)

93 Vincent's short and turbulent involvement with the Antwerp Academy ended with the unanimous decision of the professorial board to send him back to repeat the elementary course. The decision was registered on 31 March, by which time he had left; so it seems unlikely that, as some have supposed, this humiliating decision prompted his departure. In any case, the value of his own inventions was confirmed to him by the opposition he had experienced.

In the face of apparently evasive answers from Theo, Vincent pursued the idea of coming to Paris, constantly varying the details of his proposals: should they put off the idea of living together, renting a separate attic for Vincent? Or should they share an apartment? (To which he added suggestions on how to divide it up.) He would like them to work, and think, together, even share a regular woman; and so on. It seems pointless to analyse in rational terms a decision which came to emotional fruition in sickness, exhaustion and grinding poverty.

Without a positive response from Theo, Vincent did the only thing that could advance his plans: he took a train to Paris.

Do not be cross with me for having come all at once like this; I have thought about it so much, and I believe that in this way we shall save time. Shall be at the Louvre from midday on or sooner if you like.

Please let me know at what time you could come to the Salle Carrée. As for the expenses, I tell you again, this comes to the same thing. I have some money left, of course, and I want to speak to you before I spend any of it. We'll fix things up, you'll see.

So, come as soon as possible. (459, early Mar. 1886, F.)

The famous brief letter Vincent wrote at the Gare du Nord and sent round to Goupil by messenger marks the beginning of a period of almost two years for which the kind of documentation which is otherwise available in such profusion, both before and afterwards, is all but lacking. The period therefore provides instructive examples of the kind of problems that occur when only the actual works of art – the objects which, after all, are of paramount and essential importance – are available.

The phase when Vincent heard a lot about the Impressionists, but did not know them, was not past. He now became familiar with the movement through what he saw in Theo's gallery and during his visits to art galleries, through the enthusiasm for Japonaiserie, and through contacts with artists whose work formed the sequel to Impressionism: Georges Seurat, Paul Signac, Emile Bernard, Emile Anquetin, Louis Angrand.

His arrival did not make life any easier for Theo, as the latter's friend Andries Bonger reported in his letters home.

. . . Did I tell you that Van Gogh has moved to Montmartre? They now have a big, spacious apartment (by Parisian standards) and their own household. They are now keeping their own cook *in optima forma*. Theo is still looking frightfully ill; he literally has no face left at all. The poor fellow has many cares. Moreover, his brother is making life rather a burden to him, and reproaches him with all kinds of things of which he is quite innocent. . . . (Andries Bonger to Bonger family, 462a, 23 June 1886.)

. . . It now appears that Theo's brother is here for good, at least for three years, in order to work in the painter Cormon's studio. I think I told you in the summer what a queer life this brother has led. The man hasn't the slightest notion of social conditions. He is always quarrelling with everybody. Consequently Theo has a lot of trouble getting along with him. (Andries Bonger to Bonger family, 462a, 1886.)

Vincent stayed only three or four months with Cormon. His letter to the *109* young English painter Horace Mann Livens, who was studying in Antwerp, mentions that he had been obliged to give up figure painting entirely.

Since I am here in Paris I have very often thought of yourself and work. You will remember that I liked your colour, your ideas on art and literature and I add, most of all your personality. I have already before now thought that I ought to let you know what I was doing where I was. But what refrained me was that I find living in Paris is much dearer than in Antwerp and not knowing what your circumstances are I dare not say come over to Paris from Antwerp without warning you that it costs one dearer, and that if poor, one has to suffer many things – as you may imagine – . But on the other hand there is more chance of selling. There is also a good chance of exchanging pictures with other artists.

In one word, with much energy, with a sincere personal feeling of colour in nature I would say an artist can get on here notwithstanding the many obstructions. And I intend remaining here still longer.

There is much to be seen here – for instance Delacroix, to name only one master. In Antwerp I did not even know what the impressionists were, now I have seen them and though *not* being one of the club yet I have much admired certain impressionists' pictures – *Degas* nude figure – *Claude Monet* landscape.

And now for what regards what I myself have been doing, I have lacked money for paying models else I had entirely given myself to figure painting. But I have made a series of colour studies in painting, simply flowers, red poppies, blue corn flowers and myosotys, white and rose roses, yellow chrysanthemums – seeking oppositions of blue with orange, red and green, yellow and violet seeking *les tons rompus et neutres* to harmonize brutal extremes. Trying to render intense colour and not a grey harmony.

Now after these gymnastics I lately did two heads which I dare say are better in light and colour than those I did before.

So as we said at the time: in *colour* seeking *life* the true drawing is modelling with colour.

I did a dozen landscapes too, frankly *green* frankly *blue*.

And so I am struggling for life and progress in art. . . .

[PS.] With regard my chances of sale look here, they are certainly not much but still *I do have* a beginning.

At the present moment I have found four dealers who have exhibited studies of mine. And I have exchanged studies with many artists.

Now the prices are 50 francs. Certainly not much – but – as far as I can see one must sell cheap to rise and even at costing price. And mind my dear fellow, Paris is Paris. There is but one Paris and however hard living may be here, and if it became worse and harder even – the french air clears up the brain and does good – a world of good.

I have been in Cormons studio for three or four months but I did not find that so useful as I had expected it to be. It may be my fault however, anyhow I left there too as I left Antwerp and since I worked alone, and fancy that since I feel my own self more.

Trade is slow here. The great dealers sell Millet, Delacroix, Corot, Daubigny, Dupré, a few other masters at exorbitant prices. They do little or nothing for young artists. The second class dealers contrariwise sell those at very low prices. If I asked more I would do nothing, I fancy. However I have faith in colour. Even with regards the price the public will pay for it in the long run. But for the present things are awfully hard. Therefore let anyone who risks to go over here consider there is no laying on roses at all.

What is to be gained is *progress* and what the deuce that is, it is to be found here. I dare say as certain anyone who has a solid position elsewhere let him stay where he is. But for adventurers as myself, I think they lose nothing in risking more. Especially as in my case I am not an adventurer by choice but by fate, and feeling nowhere so much myself a stranger as in my family and country. – Kindly remember me to your landlady Mrs Roosmalen and say her that if she will exhibit something of my work I will send her a small picture of mine. (Vincent to H.M. Livens, 459a, Aug.–Oct. 1886, e.)

Emile Bernard wrote to the poet and critic Albert Aurier two months later, giving some information about Vincent's approach to life studies. It is certain that Bernard caused dissension at Cormon's studio and took part in a campaign against Cormon, who totally rejected the new colour theories.

After writing to his mother on 12 January 1886 that Vincent – then still in Antwerp – was going to concentrate on portraiture, Theo was not able until eleven months later to report that Vincent had really begun to paint portraits, 'which have turned out well, but he always does it for nothing! It is a pity he is not developing any inclination to earn some money, for if he wanted to he could probably manage; but one cannot change people'. In March 1887 Theo wrote to Cor, the brother who was working as a labourer on the construction of the Eiffel Tower:

V. is continuing to study and he is working with talent. It is a pity though that his character is so against him. In the long run it is really impossible to get on with him. When he came here last year he was certainly difficult, but I thought there was some improvement all the same. Now he is his old self again and you simply cannot argue with him. This does not make things pleasant for me at home, and I am hoping for a change. There will probably be one, but it is unfortunate for him, since it would have been better for both of us if we had co-operated. (Theo to Cor, 11 Mar. 1887.)

While still in this mood, Theo declared his love to Dries Bonger's sister Jo; and relations between him and Vincent seem thereafter to have very markedly improved.

... We have made our peace, because there was no point in going on as we were. I hope it will last. For the time being there will be no changes and I am glad of it. For me it would have been strange to be living on my own again, and he would not have gained anything either. *I* asked him to stay. It may seem strange to you after what I wrote to you recently – but it is not weakness on my part, and since I am feeling much stronger than I did last winter I am full of hope that I shall be able to bring about an improvement in our relations. (Theo to Wil, 25 April 1887.)

The improvement in their relations was so great that they were both surprised to find how strong a bond there was between them. More than two years later Vincent even admitted to his mother from Saint-Rémy (letter 619), 'It is a good thing that I did not stay in Paris, for we, he and I, would have become too interested in each other'.

It is unfortunate that the more sensational aspects of the first difficult year, and the wreck of Theo's social life because of Vincent's boorishness, have had more publicity – as if they referred to the whole period – than has the second year when there was peace between them and a deep, mysterious attachment.

In an undated letter Vincent sent to Wil in 1887 (w1) there is evidence to show that it must have been written after Theo's visit to Holland in July–August. According to Vincent, Theo's sickly appearance on his return was largely accounted for by 'presumably a less cordial welcome from ac- quaintances and friends'. By way of allegory he referred to the germinating capacity inherent in every human being as in a grain of corn. 'Life is germination. The love in us is what the germinating capacity is in corn'. Vincent was certainly referring to Theo's love for Jo, which had met with little response in Amsterdam. He was more candid about himself when admitting to Wil that in Paris he had been involved in, 'not very decorous love affairs from which he usually extricated himself "ignominiously"' and recalled the days when he ought to have been in love but instead 'was absorbed in religious and socialistic devotions'.

Overall the Paris part of Van Gogh's oeuvre makes a less unified impression than the work produced in Brabant, but it is a more direct reflection of the vibrant, vital environment of painters who were roughly his contemporaries. The direct stimuli provided by Millet, Israëls, Mauve, De Groux and the English illustrators disappeared, and the painter of peasants donned a gentleman's suit except when he was working.

Van Gogh's initiation to Impressionism took place in 1886 only, his first year in Paris. Here, we believe, Paul Signac, ten years younger than he, was a *121* support to Vincent and his work even before 1887, when they worked out of doors at Asnières together until the end of May. Signac was well informed, and had known Seurat and Guillaumin since 1884, and Pissarro since 1885. Seurat, it seems, was more difficult for Vincent to approach. Vincent rated him highly, but knew himself well enough to realize that his own nature was the very opposite of Seurat's rational systematics. In his own evolution he fought shy of reducing his inventions to formulas which might then develop into mannerisms. It would be hard to call Van Gogh spontaneous in his work – his passion, his fury was the release of long-pent-up emotional energy. Manet, Renoir and above all Monet meant a great deal to him, but even so it would have been unthinkable for him to wish, as Monet did, to paint a series

of impressions of the light on a cathedral at set times or in successive seasons.

Van Gogh's reservations about Impressionism were the result not only of his own firm roots in earlier nineteenth-century traditions but of his mistrust of the momentary 'impression', with its implication of passivity in experiencing the passing of time, the flowing of water, the drifting of the clouds. Vincent's melancholy was an active one, and each disappointment, as well as each success, activated a psychic energy. In his way of observing things, each moment was always linked to all kinds of previous moments. He came to regard himself as an Impressionist, because the term was synonymous with modernity in art; but he always looked beyond observation to the importance of imagination. As he was to write to Bernard from Arles:

> ... Sometimes I regret that I cannot make up my mind to work more at home and extempore. The imagination is certainly a faculty which we must develop, one which alone can lead us to the creation of a more exalting and consoling nature than the single brief glance at reality – which in our sight is ever changing, passing life a flash of lightning – can let us perceive. ... (Vincent to Emile Bernard, B3, April 1888, F.)

The most characteristic works Van Gogh produced in Paris are the self-portraits which – in the metropolis with all its exciting distractions – were the outcome of his need to keep an eye on himself both literally and figuratively. The problem whether several small portraits were painted in Paris or elsewhere will not be dealt with here. The style of painting reveals not only all the technical phases he passed through in the course of those two years, but also all the phases of his physical condition. The 'mirror test' remained indispensable to him until well into his Saint-Rémy period. Since Antwerp, and perhaps before, he had been looking at himself, even when he was not painting, like a doctor who mercilessly diagnoses his own condition. Such scrutiny went beyond the self-questioning of an artist immediately absorbed by the colour problem facing him on his palette and on the canvas. A summing-up of the final results conveys some detachment: 'My own adventures are restricted chiefly to making swift progress toward growing into a little old man, you know, with wrinkles, and a tough beard and a number of false teeth, and so on. But what does it matter? I have a dirty and hard profession ...' (W1, summer-autumn 1887).

Alongside the self-portraits there are several portraits of acquaintances in which the brushwork reaches the same pitch of intensity (Tanguy, Reid, Segatori); perhaps the most Impressionistic works of the period are the suburban landscapes. So far, there was no debt to the Cloisonnists.

By juxtaposing touches of contrasting colour in the *Self-portrait with Easel*, in certain sections of the Segatori portrait, and in one of the Tanguy portraits, Vincent created effects which would be hard to parallel in works of this period by Monet, or Renoir, or Signac. Perhaps rather too barbaric for French taste, these works reach a level of achievement which Vincent himself rarely surpassed even at Arles. They demonstrate that even without a close collaboration with Gauguin, such as was to take place during the autumn of 1888 at Arles, Vincent could already produce flat effects and find inspiration in the actual material of the paint itself, thus reducing the model to a secondary importance. One has only to compare the lap of the figure in *La Berceuse* (Arles, 1889) with that in *Segatori* (Paris, 1887), who is in the same pose, to see that, both in the emotive and the compositional use of colour, the later work is inferior to the earlier. The *Berceuse* is seated in front of a real background, a papered wall. *Segatori* has no background but a violent yellow surface which is

Self-portrait, 1887.

sometimes, we believe wrongly, considered to be an imitation of crinkly Japanese paper (*crépon*). This is neither paper nor wall, but a fantasy in yellow.

In Paris he paid repeated visits to Samuel Bing's shop to buy such Japanese colour woodcuts as were within his and Theo's means. By way of experiment he produced some reinterpretations of these works in oils. This enabled him to study the compositions in further detail, and in relation to his own ideas of colour, while transforming the graphic and material lightness of the originals into a totally Western, that is to say heavier, effect. The Japanese influence was not to mature until Arles, where there is little trace of Japanese subject matter in his work, but where he associated Japan with a kind of clarity and light that he could no longer call 'Impressionist'. His own imagination, in this sense, had become Japanese, and he was fascinated by such hints as he found in writers like Pierre Loti of the nature of Japanese, and in particular Zen Buddhist, thought and religion. He came to associate Japanese art with speed and spontaneity of execution, and to produce reed-pen drawings that are markedly Japanese in technique rather than subject matter.

The feelings with which Vincent left Paris were dangerously affected, if not yet dominated, by his sense of not having really lived, of *l'existence manquée*.

 133–135

136–138

149–51

Thank you for your letter and what it contained. It depresses me to think that even when it's a success, painting never pays back what it costs.

I was touched by what you wrote about home – 'They are fairly well but still it is sad to see them.' A dozen years ago you would have sworn that at any rate the family would always prosper and get on. It would be a great satisfaction to Mother if your marriage came off, and for the sake of your health and your work you ought not to remain single.

As for me – I feel I am losing the desire for marriage and children, and now and then it saddens me that I should be feeling like that at thirty-five, just when it should be the opposite. And sometimes I have a grudge against this rotten painting. It was Richepin who said

somewhere: 'The love of art makes one lose real love.' I think that is terribly true, but on the other hand real love makes you disgusted with art.

And at times I already feel old and broken, and yet still enough of a lover not to be a real enthusiast for painting. One must have ambition in order to succeed, and ambition seems to be absurd. I don't know what will come of it; above all I should like to be less of a burden to you – and that is not impossible in the future – for I hope to make such progress that you will be able to show my stuff boldly without compromising yourself.

And then I will take myself off somewhere down south, to get away from the sight of so many painters that disgust me as men. . . . (462, July–Aug. 1887, F.)

Reports of eccentric behaviour on Vincent's part, mostly late and unverifiable, serve only to underline the scarcity of clear biographical information about this phase in his life. It is tantalizing to know so little about the circles in which Vincent moved without Theo. What, for instance, was the role of the mysterious Comtesse de la Boissière and her daughter, of Asnières?

In any case, the relationship between the two brothers, which had been extremely strained, was fully restored by the time Vincent decided to leave Paris early in 1888. He was exhausted, nearly an alcoholic, and once more ready for a complete change of scene. He fitted in one visit to Seurat's studio before he left.

. . . Vincent left for the South last Sunday. He is going first to Arles to orient himself and then probably to Marseilles. . . . Years of worry and adversity have not made him any stronger and he felt a definite need to be in a more temperate climate. . . . I believe it will certainly do his health good and will also benefit his work. When he came here two years ago I did not think we would become so attached to each other, but the flat feels decidedly empty now that I am on my own again. If I find someone to live with I shall do so, but it is not easy to replace a person like Vincent. His knowledge and clear perception of the world are incredible. I am therefore convinced that if he has a few more years to live, he will make a name for himself. Through him, I came into contact with many painters among whom he is greatly respected. He is one of the champions of new ideas – or rather, as there is nothing new under the sun, of the regeneration of old ideas which have been corrupted by routine and have lost their colour. Furthermore, he has such a great heart that he is always trying to do something for others. So much the worse for those who do not know him or want to understand him. . . . (Theo to Wil, 24/26 Feb. 1888.)

91 The *Maris Stella* window, Andrieskerk, Antwerp, 16th century
After the excitement of his farewell to the old masters in Amsterdam, he wrote from Antwerp, where he arrived late in 1885, with less emotion about paintings and with more animation about the life of the port. But in the Andrieskerk in Antwerp, in January 1886, Vincent was impressed by a sixteenth-century window (the earliest one in the church, although he probably did not know this). The virgin is shown as *Maris Stella*, the Star of the Sea, protectress of mariners in distress. The symbolism of shipwreck, a recurrent element in other letters, is hidden in Vincent's account of this window to Theo, which reflects rather his close study of colour and colour theory: 'There is a painted window which I think superb – very, very curious. A beach, a green sea with a castle on the rocks, a sparkling blue sky of the most beautiful tones of blue, greenish, whitish, deeper, higher of tone. An enormous three-master, quaint and phantasmal, stands out against the sky, diffusion everywhere, light in the dark, dark in the light. In the blue a figure of the Holy Virgin, bright yellow, white, orange. Higher up the window reappears dark green, with black, with fiery red.'

Antwerp

On arriving in Antwerp, Vincent was not in a hurry to go to the academy. Only on 18 January 1886 did he register for an evening class in drawing from the Antique (plaster casts) and the painting class (444).

Right:
96 Charles de Groux. *Benedicite*, 1861
Along with the same Antwerp artist's *The Paupers' Bench*, this was a favourite with Van Gogh from a very early age. Working on his own *The Potato Eaters* (48), and later, Vincent's memory of De Groux did not fade.

97 Henri de Braekeleer. *Baron Leys' Dining-room*, 1869
Henri Leys was a famous painter in his time, who moved from history (subjects from the Middle Ages) to daily life,

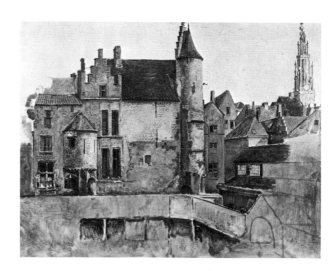

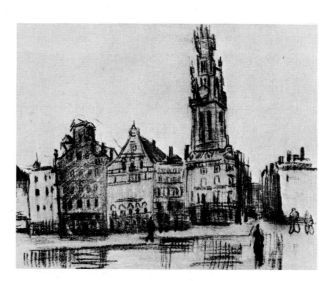

Left, above:
92 The house where Vincent lodged, in Beeldekenstraat (Rue des Images)
Left:
93 Academie Royale des Beaux-Arts, Antwerp
Top:
94 Henri Leys. *Het Steen, Antwerp*
Above:
95 *The Marketplace, Antwerp*, 18 December 1885.

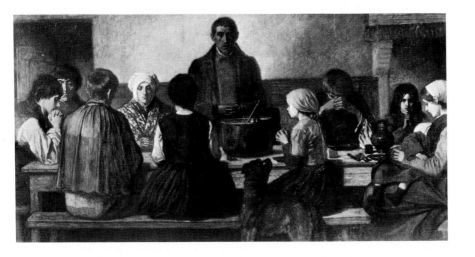

working in a sober and far from anecdotal style. Vincent liked his work, as is proved by the fact that his first visit in Antwerp was to Leys' dining-room, with its well-known murals by Leys himself. He was disappointed: 'Frescoes can last for centuries, but these are already faded considerably' (436). He nevertheless, curiously, did not give Leys up: 'after all, it is superb'. Another realist painter who interested Vincent in particular was Leys' nephew, Henri de Braekeleer. Vincent praised his 'curious . . . endeavour to be literally true'.

Flemish models

98 Peter Paul Rubens. *St Theresa Saving Bernardo de Mendoza from Purgatory* (detail), *c.*1638
Vincent was occupied in Antwerp with research into technical problems and other artists' handling of them. He was highly critical of Rubens from a psychological point of view, but interested by his use of colour, particularly in the flesh tones of this picture, modelled 'with streaks of pure red I don't look at those which are admired most. I look for fragments, like, for instance, those blonde heads in *St Theresa*' (439).

99 *Head of a Woman*, December 1885
'I have made two fairly big heads . . . then also a study of a woman. In the woman's portrait I have brought lighter tones into the flesh, white tinted with carmine, vermilion, yellow, and a light background of grey-yellow' (439).

100 *Portrait of a Woman*, early Dec. 1885
Vincent was always seeing magnificent heads in Antwerp, and enjoyed his visits to the docks, where he studied the townspeople as well as those who came from the ships. He wanted to earn some money by doing portraits, but the reverse happened: he spent so much on paying models that he had not enough left to buy food.

132

133

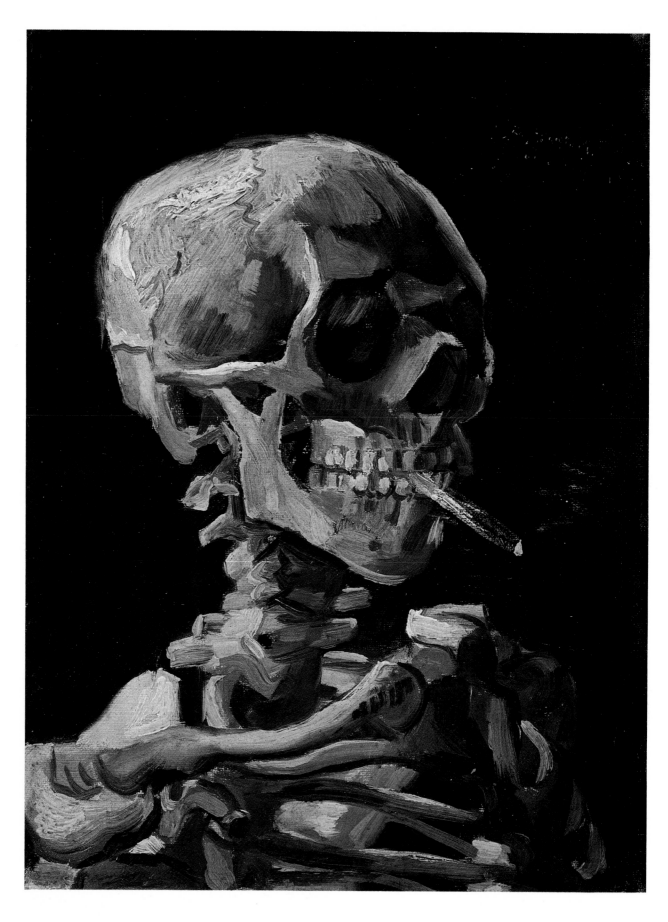

105 *Skull with Burning Cigarette*, Dec. 1885

106 Félicien Rops. *The Husbands' Train; The Death of the Sinner*

107 *Hanging Skeleton and Black Cat*, Dec. 1885–Jan. 1886

An artist hungry for technical and anatomical knowledge, as Van Gogh was, inevitably studies the skeleton: and here 'the drawing of the mass instead of outlines' (449) takes on a macabre twist. It was in Antwerp in 1885 that Vincent painted the curious and unexplained *Skull with Burning Cigarette*, a striking *memento mori* that is not without a connection with his own state: faint, overstrained, undernourished. Its black humour might also have a link with what he remembered and admired of the work of Félicien Rops, the Belgian illustrator; in 1873 he possessed a copy of Rops's *Uilenspiegel*, a kind of satirical-critical *Journal des arts*. Rops would have made a good illustrator of Baudelaire.

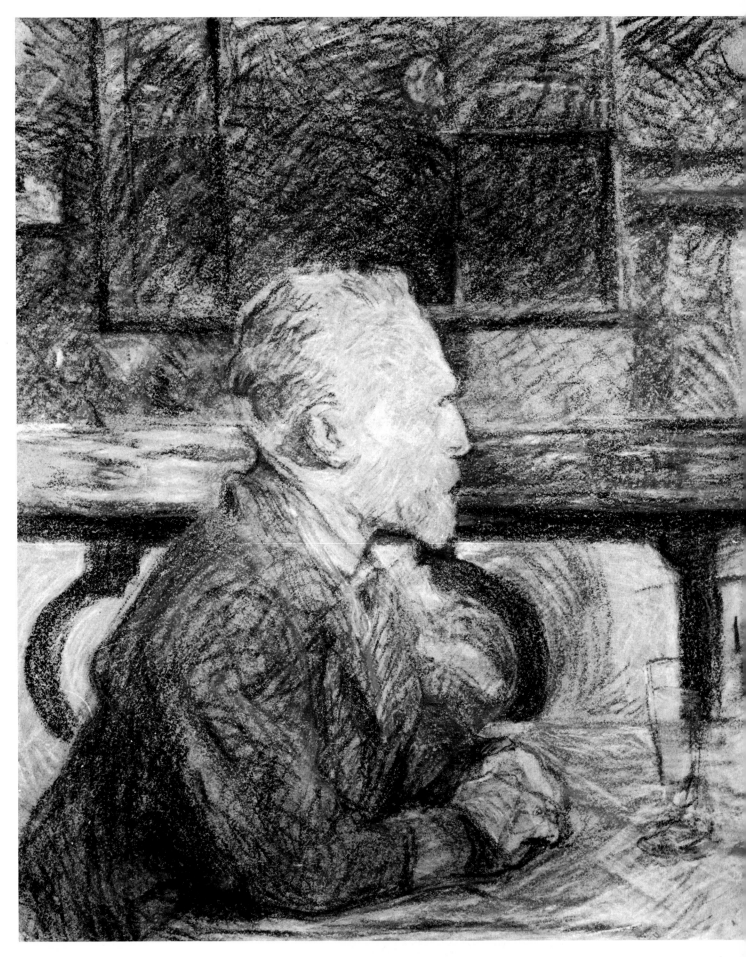

Parisian mirror

114 Henri de Toulouse-Lautrec. *Vincent van Gogh*, 1886

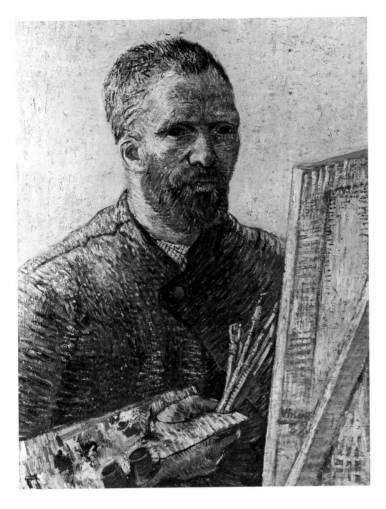

It was at the café Le Tambourin, in the Boulevard de Clichy, that Lautrec is said to have drawn this pastel of Vincent (*left-hand page*). All the man's energy and genius are expressed in the leonine tension of his pose. This is the most impressive image of Vincent in Paris as an outsider saw him, recognizably the man whom we see in the self-portraits.

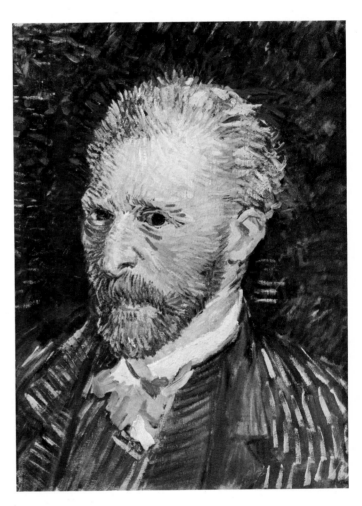

115 Self-portrait with Easel, early 1888

116 Self-portrait with Grey Felt Hat, summer 1887

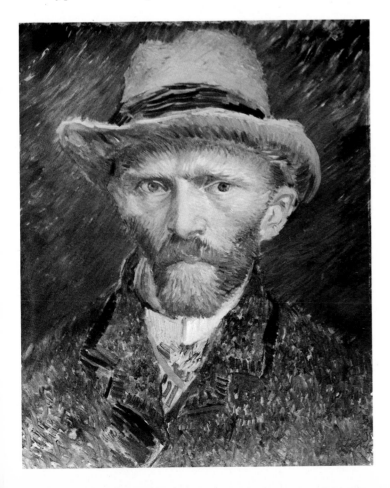

117 Self-portrait, autumn 1887

These three self-portraits, taken together with the pastel by Lautrec, provide a close-up view of Vincent's forced existence in Paris, which brought him to the point of total exhaustion, 'almost an invalid and almost a drunkard' (544a). The last dates from early in 1888, just before he left; it is 'the face of death', painted in the mirror (w7).

Impressions at Theo's

118 Claude Monet. *Four Boats in Winter Quarters, Etretat,* 1885
Vincent greatly admired Monet, and among the works he remembered seeing at Theo's this seems particularly calculated to appeal to him, with its thick impasto and strong structural brush strokes.

119 Louis Anquetin. *Avenue de Clichy,* 1887
This view, with its leafless trees and warmly clad figures, was presumably painted in the autumn, and Vincent saw it 'not too many months before his departure from Paris' (B. Welsh-Ovcharov, *Vincent van Gogh: his Paris Period,* Utrecht 1976).

120 Adolphe Monticelli. *Vase of Flowers,*
1875–80
A work owned by Theo and praised by
Vincent. Vincent's relationship to the
works of Monticelli was a curious one.
Vincent analysed his passion for colour
with all his knowledge of Delacroix,
considering Monticelli also as a disciple.
He often discussed Monticelli's
personality, and identified himself with his
fate, which was to be underestimated as a
painter and slandered as a drunkard.

121 Paul Signac. *Still-life with
Maupassant's Book 'Au Soleil',* dated 1883
Vincent's firm friendship with Signac was
exceptional in that there was never a
quarrel between them. This still-life must
have had a strong influence on Vincent,
antedating that of the Montmartre views
by Signac which Rewald refers to, and
which were painted between 1884 and
1887. Signac was a source of information
for Vincent concerning Pontillist theory
and technique (Seurat himself being
difficult to approach).

Woman

122 Plaster Statuette, 1886–87
Less brutal than the few nudes we have that were done from life, the numerous ones done from casts are rarely the kind of academic work that the Antwerp professors could have acknowledged.

123 Nude Woman on a Bed, 1887
There is a drawing (F1404) for this, one of very few extant nudes by Van Gogh; there is a suggestion that after his death many were destroyed. Its character is exotic, even bestial.

124 The Italian Woman, with Carnations (La Segatori), winter 1887–88
This portrait of Agostina Segatori (proprietress of the Tambourin, with whom Vincent is said to have had an affair) is one of the peaks of Van Gogh's Paris achievement. We can easily forget the sitter, and the suggestions of folk art, Japan, and a few fellow painters (Monticelli, Guillaumin). Vincent creates here a modern, and greatly intensified, symphonic structure of contrasting coloured brush strokes, the synthesis of all he had absorbed since Nuenen concerning new possibilities for colour.

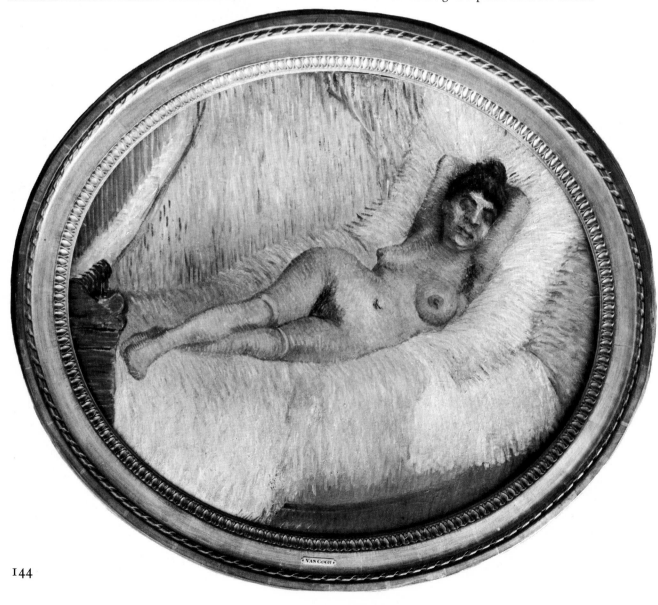

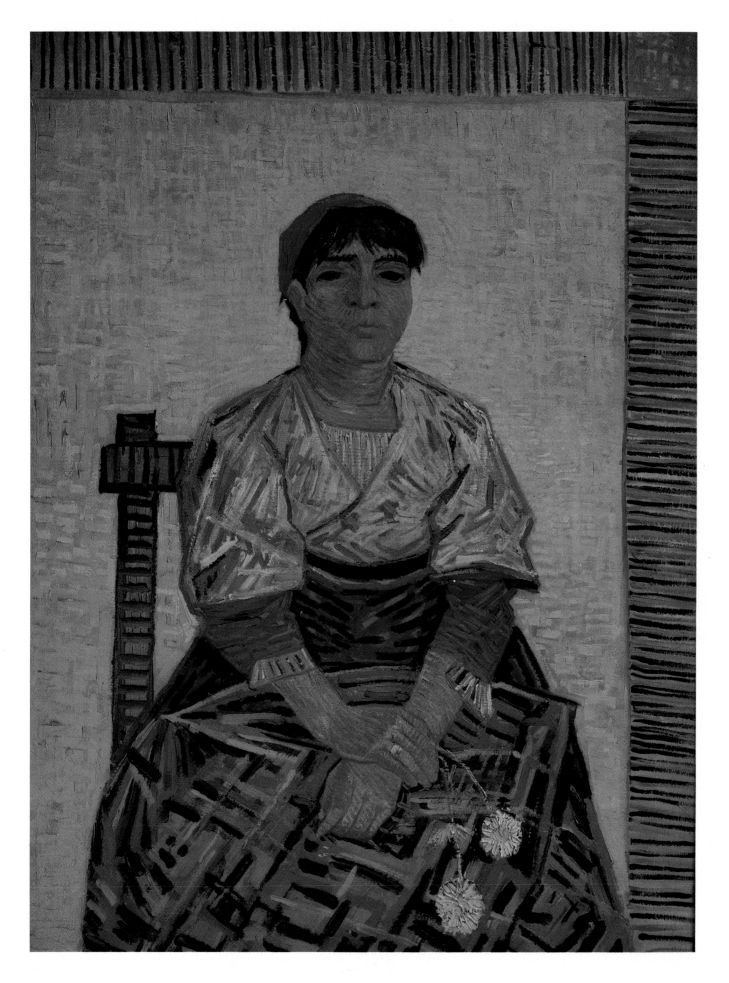

Asnières

125 Asnières, on the first loop of the Seine north of Paris, early 1887. Van Gogh (seen from behind) and Emile Bernard discuss the endless problems of art.

126 Riverside Walk near Asnières, early summer 1887
This Impressionistic style, almost immaterial in effect, with points of colour – *pointilles* – represents a very brief phase in Van Gogh's painting, although Impressionistic influences lasted longer in his drawing.

127 Factory near the Pont de Clichy, Asnières, summer 1887
The same year and season as *126*, but a great contrast: long, clear, rhythmical strokes, structuring and accentuating the forms; here and there a resemblance to Signac.

Right:
128 Bridge at Asnières, late 19th c.
It was the landscape itself that attracted the artists, rather than any mutual influence; they painted the same scenes consecutively, not concurrently. Photographs do not always make illuminating comparisons with paintings; but here the photograph, with the train on the bridge, shows how impressive were the compositional elements provided by these semi-artificial landscapes.

129 Emile Bernard. *Bridge at Asnières*, autumn 1887

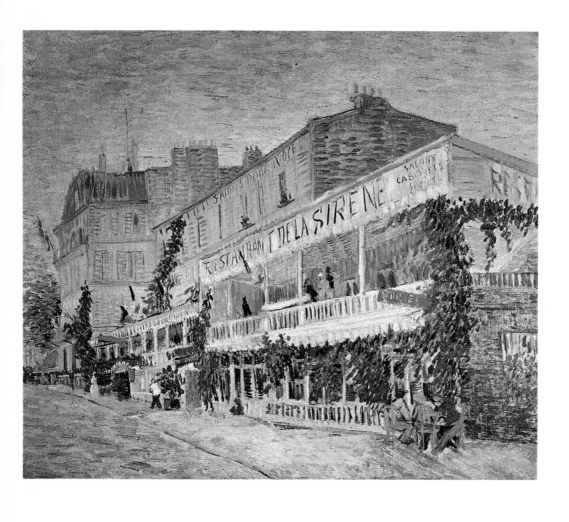

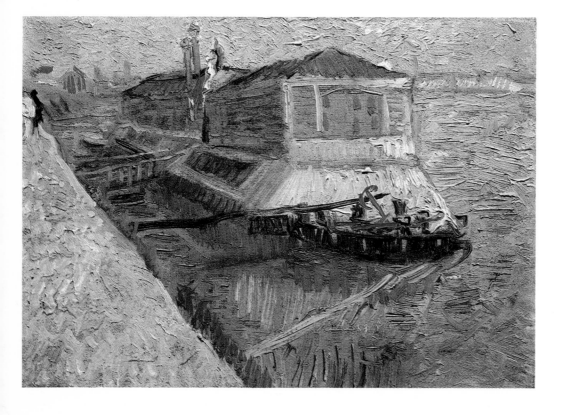

130 Restaurant de la Sirène, Asnières, early summer 1887
Vincent never follows the Pointillist technique strictly,
setting up a static pattern of dots, but expresses a
movement that is between drawing and painting.

131 Bathing Place on the Seine, Asnières, summer 1887
An example of Vincent's use of the Manet-like, strong
structural brush stroke.

132 Factories at Asnières Seen from the Quai de Clichy,
summer 1887
Emile Bernard lived at Asnières with his parents; and the
two artists often met Signac there during the spring of
1887. All faced the same influences: the leadership of Seurat
(strict Pointillism) and the flat colours and strong outlines
derived from the Japanese (Anquetin). Asnières satisfied
Vincent's interest in landscape and in the semi-industrial
suburban scene (the *banlieue*).

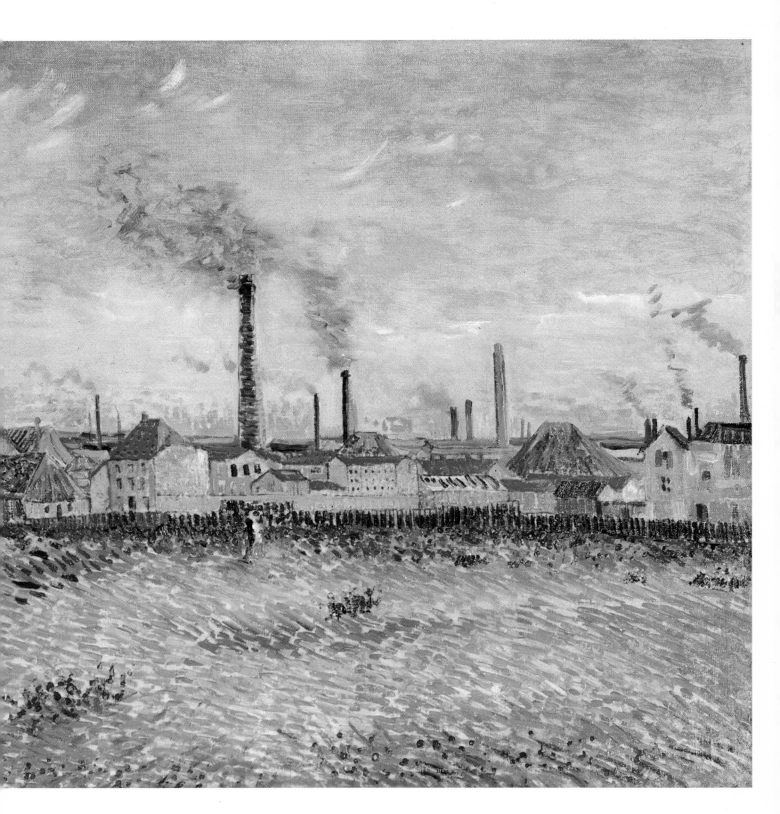

Japan in Paris

133 Utagawa Kuniyoshi. *Portrait of a Woman Viewing Flowers, with an Inset of Local Industry, Bitchu Province*, 1852
The clean-cut, flat silhouette and the pose have a striking similarity to one of the two portraits of Madame Ginoux, painted in Arles (*155*), which was painted with 'Japanese' speed in less than an hour. The use of Japanese prints in the background is itself a Japanese practice.

Opposite page:
134 Utagawa Hiroshige. Plum Trees in Flower, 1857
135 Utagawa Hiroshige. Shower on the Ohashi Bridge near Ataka, 1857

This page:
136 Flowering Plum Tree, first half 1887
137 The Bridge in the Rain, summer 1887

Vincent possessed twelve prints from the series *Famous Places in Edo*; and the two oil paintings on the right are enlarged copies, made by squaring up the originals, and with added Japanese lettering (including, it is said, a clearly legible advertisement for a brothel).

138 Japonaiserie: Oiran, summer 1887
After a print, *The Actor*, by Kesai Yeisen (1790–1848), with variations Van Gogh took from various sources (including *Paris illustré*). His copies of Japanese prints are typical Western interpretations, with line subordinated to colour.

151

139 Père Tanguy, autumn 1887
A larger and more detailed version (F636) has in the
background only Japanese prints. This one, the earlier, has
also an autumn still-life by Van Gogh himself (F383); here,
the sitter has more tension and vitality, the expression is
more direct.

IV

ARLES

'Something greater than I,
which is my life – the power to create'

1888–1889 Arles

Vincent's output in Arles is largely a continuation of the best work he had done in his last few months in Paris. Colour now came to dominate more and more; in his drawings the line improved immensely, particularly when drawn with a reed pen (a Japanese tool); the Impressionist influence waned. He developed the idea of a small collective of artists who might solve common problems in art or life more easily than an individual working alone. With characteristic generosity and drive, he proposed to use his rented Maison Jaune in Arles as a modest centre of work and debate for himself and guests. The idea began to take shape with the longed-for arrival of Gauguin in October 1888, and ended in disaster at Christmas with Gauguin's hasty departure and Vincent's admission to the local hospital. Vincent failed to save his health, but succeeded in rescuing his work from defeat and ruin. The interest in religion that had disappeared in Paris, as well as an increasing interest in the possibility of life after death, were to complicate his spiritual life to a considerable degree.

... When I left you at the station to go south, very miserable, almost an invalid and almost a drunkard, I still felt vaguely that we had put our very heart into our discussions with so many interesting people and artists that winter, but I hadn't the courage to hope.

After continued efforts on your part and mine, now at last something is beginning to show on the horizon: Hope. ... (544a, 29 Sept. 1888, F.)

196

He had abandoned the abject image of himself as a dog, and now likened himself and his friends to worn-out cab horses.

But, old boy, you know, I feel as though I were in Japan – I say no more than that, and mind, I haven't seen anything in its usual splendour yet.

That's why – even although I'm vexed that just now expenses are heavy and the pictures worthless – that's why I don't despair of the future success of this idea of a long sojourn in the Midi.

Here I am seeing new things, I am learning, and if I take it easy, my body doesn't refuse to function.

For many reasons I should like to get some sort of little retreat, where the poor cab horses of Paris – that is, you and several of our friends, the poor impressionists – could go out to pasture when they get too beat up.

I was present at the inquiry into a crime committed at the door of a brothel here; two Italians killed two Zouaves. I seized the opportunity to go into one of the brothels in a small street called 'des ricolettes'.

That is the extent of my amorous adventures among the Arlésiennes. The mob *all but* (the Southerner, like Tartarin, being more energetic in good intentions than in action) – the mob, I repeat, all but lynched the murderers confined in the town hall, but in retaliation all the Italians – men and women, the Savoyard monkeys included – have been forced to leave town.

I should not have told you about this, except that it means I've seen the streets of this town full of excited crowds. And it was indeed a fine sight.

I made my last three studies with the perspective frame I told you about. I attach some importance to the use of the frame because it seems not unlikely to me that in the near future many artists will make use of it, just as the old German and Italian painters certainly did, and, as I am inclined to think, the Flemish too. The modern use of it may differ from the ancient practice, but in the same way isn't it true that in the process of painting in oils one gets very different effects today from those of the men who invented the process, Jan and Hubert van Eyck? And the moral of this is that it's my constant hope that I am not working for myself alone. I believe in the absolute necessity of a new art of colour, of design, and – of the artistic life. And if we work in that faith, it seems to me there is a chance that we do not hope in vain. ... (469, 17 Mar. 1888, F.)

Some of his work was accepted for the Salon des Indépendants in Paris. He insisted that his name be given as Vincent only, justifying this with the

argument that it would be impossible for people to pronounce Van Gogh. However, this argument did not apply to the Netherlands and Belgium, where he had also regularly signed his works as Vincent. He had probably started doing so in Brabant to dissociate himself from his family. Vincent started a fashion among artists which has continued to this day.

... On the whole I'm very glad that [my works have] been put with the other impressionists.

But though it doesn't matter in the least this time, in the future my name ought to be put in the catalogue as I sign it on the canvas, namely Vincent and not Van Gogh, for the simple reason that they do not know how to pronounce the latter name here.

I return to you enclosed Tersteeg's and Russell's letters. It might perhaps be interesting to keep the artists' correspondence. ...

[PS.] Paris doesn't pay: I'd be sorry to see the Seurats in a provincial museum or in a cellar, those pictures ought to stay in living hands – if only Tersteeg would. If three permanent exhibitions are started, there must be one great Seurat in Paris, one in London, and one in Marseilles. (471, 24 Mar. 1888, F.)

The news of Mauve's early death came as a blow to him. There was no rancour left about their erstwhile disagreements at The Hague. On the contrary, Vincent sent to his aunt Jet, Mauve's widow, the now popular *Flowering Tree, Souvenir of Mauve*, signed 'Vincent', although it was supposed first to have been signed 'Vincent Theo'. It is not known whether Theo had objected to the use of his name.

... I have been working on a size 20 canvas in the open air in an orchard, lilac ploughland, a reed fence, two pink peach trees against a sky of glorious blue and white. Probably the best landscape I have done. I had just brought it home when I received from our sister a Dutch notice in memory of Mauve, with his portrait (the portrait, very good), the text, poor and nothing in it, a pretty water colour. Something – I don't know what – took hold of me and brought a lump to my throat, and I wrote on my picture

<p style="text-align:center">SOUVENIR DE MAUVE
VINCENT THEO</p>

and if you agree we two will send it, such as it is, to Mrs Mauve. I chose the best study I've painted here purposely; I don't know what they'll say about it at home, but that does not matter to us; it seemed to me that everything in memory of Mauve must be at once tender and very gay, and not a study in any graver key.

> *'O never think the dead are dead,*
> *So long as there are men alive,*
> *The dead will live, the dead will live.'*

That's how I feel it. Nothing sadder than that. ... (472, 30/31 Mar. 1888, F.)

... The air here certainly does me good. I wish you could fill your lungs with it; one effect it has on me is comical enough – one small glass of brandy makes me tipsy here, so that as I don't have to fall back on stimulants to make my blood circulate, there is less strain on my constitution. The only thing is that my stomach has been terribly weak since I came here, but after all that's probably only a matter of time. I hope to make great progress this year, and indeed I need to. ...

Mauve's death was a terrible blow to me. You will see that the pink peach trees were painted with a sort of passion.

I must also have a starry night with cypresses, or perhaps above all, a field of ripe corn; there are some wonderful nights here. I am in a continual fever of work. ... (474, 9 Apr. 1888. F.)

Particularly in his letters from Arles, Van Gogh created, in words, an undefined environment for a strange continuity of thought which deviates totally from the rational discipline of continuity. It is not unlike a staccato

played by a nervous violinist. There is also a simultaneity of memory and observation which constantly jostle each other. In the manuscripts of his letters acceleration and retardation are clearly visible, ignoring the rules of punctuation. The increases and decreases in the size of the writing follow a process of intense concentration and subsequent relaxation, as if he were trying to articulate a concept.

... I think there would be something to do here in portraits. Although the people are blankly ignorant of painting in general, they are much more artistic than in the North in their own persons and their manner of life. I have seen figures here quite as beautiful as those of Goya or Velásquez. They will put a touch of pink on a black frock, or devise a garment of white, yellow and pink, or else green and pink, or else *blue and yellow*, in which there is nothing to be altered from the artistic point of view. Seurat would find some very picturesque men's figures here in spite of their modern clothes.

Now, as for portraits, I am pretty sure they'd take the bait.

But first before I dare start along that line, I want my nerves steadier, and also to be settled in so that I could have people in my studio. And if I must tell you roughly what I figure it would take to get me quite well and acclimatized for good, it will mean a year, and to set me up completely, a cool thousand francs. If during the first year – the present year – I spend 100 francs on food and 100 francs on this house per month, you see there won't be a cent left in the budget for painting.

But at the end of that year I should have a decent establishment and my own health to show for it – of that I am sure. And in the meantime I should spend my time drawing every day, with two or three pictures a month besides.

In figuring what it would cost to set me up, I am also counting in a complete new set of linen and clothes and shoes.

And at the end of the year I should be a different man.

I should have a home of my own and the peace to get back my health. ...

My poor Theo, our neurosis, etc., also comes from our way of life, which is a bit too artistic; but it is also a fatal inheritance, for in civilization the stock becomes enfeebled from one generation to the next. Take our sister Wil. She has never drunk or led a wild life, and yet we know a portrait of her in which she has the look of a madwoman. [*These last two sentences omitted in* CLVG.] If we want to face up to the true state of our own temperament we shall have to number ourselves among those who suffer from a neurosis whose origins lie far in the past. ...

However, if we want to live and work, we must be very sensible and look after ourselves. Cold water, fresh air, simple good food, decent clothes, a decent bed, and no annoyances. And not to let oneself go with women, or with life that *is* life, as much as one would like to. ... (481, 3/4 May 1888, F.)

... It is a filthy town this, with the old streets. As for the women of Arles that there's so much talk about – there is, isn't there? – do you want to know my real opinion of them? They are, no question about it, really charming, but no longer what they must have been. As things are now, they are more often like a Mignard than a Mantegna, for they are in their decadence. That doesn't prevent them from being beautiful – very beautiful, and I am talking now only of the type in the Roman style – rather boring and commonplace. But what exceptions there are!

There are women like a Fragonard and like a Renoir. And some that can't be labelled with anything that's been done yet in painting. The best thing to do would be to make portraits, all kinds of portraits of women and children. But I don't think that I am the man to do it. I'm not enough of a M. Bel Ami for that.

But I should be heartily glad if this Bel Ami of the Midi, which Monticelli was not – but was by way of being – whom I feel to be coming, though I know it isn't myself – I should be heartily glad, I say, if a kind of Guy de Maupassant in painting came along to paint the beautiful people and things here lightheartedly. As for me, I shall go on working and here and there among my work there will be things which will last, but who will be in figure painting what Claude Monet is in landscape? However, you must feel, as I do, that such a one will come. Rodin? He does not work in colour, he's not the one. But the painter of the future will

be *a colourist such as has never yet existed*. Manet was working toward it, but as you know the impressionists have already got a stronger colour than Manet. But this painter who is to come – I can't imagine him living in little cafés, working away with a lot of false teeth, and going to the Zouaves' brothels, as I do. . . . (482, 3/4 May 1888, F.)

. . . We do not feel we are dying, but we do feel the truth that we are of small account, and that we are paying a hard price to be a link in the chain of artists, in health, in youth, in liberty, none of which we enjoy, any more than the cab horse that hauls a coachful of people out to enjoy the spring.

So what I wish for you; as for myself, is to succeed in getting back your health, because you must have that. That *Hope* by Puvis de Chavannes is so true. There is an art of the future, and *196* it is going to be so lovely and so young that even if we give up our youth for it, we must gain in serenity by it. Perhaps it is very silly to write all this, but I feel it so strongly; it seems to me that, like me, you have been suffering to see your youth pass away like a puff of smoke; but if it grows again, and comes to life in what you make, nothing has been lost, and the power to work is another youth. Take some pains then to get well, for we shall need your health. (489, *c*. 19 May 1888, F.)

[PS.] . . . So if it has come to this, that you have to travel around like this, with never any peace, it honestly kills any desire in me to get back my own ease of mind.

If you agree to these proposals, all right – but then ask these Goupils to take me on again, at my old wages, and take me with you on these journeys. People matter more than things, and the more trouble I take over pictures, the more pictures in themselves leave me cold. The reason why I try to make them is to be among the artists. You understand, it would make me wretched to be forcing you to make money. Rather, let's be together whatever happens. Where there's a will there's a way, and I think if you can get well now, you will be well for quite a number of years. But don't kill yourself now, either for me or for anybody else. You know the portrait of the elder Six, the man going away, his glove in his hand. Well, *live* until you go away like that; I can see you do so, married. You would carry it off well. Think it over, and consult [Dr] Gruby before you accept such a proposal. (492, *c*. 29 May 1888, F.)

I have thought of you [Gauguin] very often, and the reason why I did not write sooner is that I did not want to write empty phrases. The deal with Russell has not come off yet, but for all that Russell has bought some impressionists, e.g. Guillaumin and Bernard, so bide your time – he will come to it of his own accord, but after two refusals I could not possibly insist any longer, as the refusals also contained a promise for the future.

I wanted to let you know that I have just rented a four-room house here in Arles.

And that it would seem to me that if I could find another painter inclined to work in the South, and who, like myself, would be sufficiently absorbed in his work to be able to resign himself to living like a monk who goes to the brothel once a fortnight – who for the rest is tied up in his work, and not very willing to waste his time, it might be a good job. Being all alone, I am suffering a little under this isolation.

So I have often thought of telling you so frankly.

You know that my brother and I greatly appreciate your painting, and that we are most anxious to see you quietly settled down.

Now the fact is that my brother cannot send you money in Brittany and at the same time send me money in Provence. But are you willing to share with me here? If we combine, there may be enough for both of us, I am sure of it, in fact. Once having attacked the South, I don't see any reason to drop it.

I was ill when I came here, but now I am feeling better, and as a matter of fact, I am greatly attracted by the South, where working out-of-doors is possible nearly all the year round.

However, it seems to me that life is more expensive here, but on the other hand the chances of getting more pictures done are better. However this may be, if my brother were to send 250 francs a month for us both, we might share, should you care to come. Only in this case it would be necessary to have our meals at home as much as possible; we might engage some kind of charwoman for a few hours a day, so as to avoid all the expense of going to an inn.

And you would give my brother one picture a month; you could do what you like with the rest of your work. . . . (Vincent to Paul Gauguin, 494a, *c*. 5 June 1888, F.)

... If Gauguin were willing to join me, I think it would be a step forward for us. It would establish us squarely as the explorers of the South, and nobody could complain of that. I must manage to get the firmness of colouring that I got in the picture that kills the rest. ...

This last picture can bear the surroundings of red brick, with which my studio is paved. When I put it on the ground, with this background of red, *very red* brick, the colour of the picture does not become hollow or bleached. The country near Aix where Cézanne works is *141* just the same as this, it is still the Crau. If coming home with my canvas, I say to myself, 'Look! I've got the very tones of old Cézanne!' I only mean that Cézanne like Zola is so absolutely part of the countryside, and knows it so intimately, that you must make the same calculations in your head to arrive at the same tones. Of course, if you saw them side by side, mine would hold their own, but there would be no resemblance. (497, 12–13 June 1888, F.)

161–62 He continued to work hard to make the Maison Jaune habitable at the lowest
147–48 possible cost, painting sunflower decorations to welcome Gauguin. He was still pinning his hopes on the establishment of a centre for artists, although even he sometimes felt the idea was utopian. From time to time he went for
150–51 longish excursions, for instance to the seaside at Saintes-Maries-de-la-Mer. A walk along the beach there inspired one of his wonderful brief description of ecstatic nocturnal experiences.

... One night I went for a walk by the sea along the empty shore. It was not gay, but neither was it sad – it was – beautiful. The deep blue sky was flecked with clouds of a blue deeper than the fundamental blue of intense cobalt, and others of a clearer blue, like the blue whiteness of the Milky Way. In the blue depth the stars were sparkling, greenish, yellow, white, pink, more brilliant, more sparklingly gemlike than at home – even in Paris: opals you might call them, emeralds, lapis lazuli, rubies, sapphires. The sea was very deep ultramarine – the shore a sort of violet and faint russet as I saw it, and on the dunes (they are about seventeen feet high) some bushes Prussian blue. ... (499, 22 June 1888, F.)

Despite repeated lapses into inactivity, his energies prevailed as a result of all he was seeing and inwardly experiencing of nature. These thoughts and sentiments may be summed up in one word, 'Japan'.

... I wish you could spend some time here, you would feel it after a while, one's sight changes: you see things with an eye more Japanese, you feel colour differently. The Japanese draw quickly, very quickly, like a lightning flash, because their nerves are finer, their feeling simpler.

I am convinced that I shall set my individuality free simply by staying on here.

I have only been here a few months, but tell me this – could I, in Paris have done the drawing of the boats *in an hour*? Even without the perspective frame, I do it now without measuring, just by letting my pen go. ...

Anquetin and Lautrec – I think – will not like what I am doing; there has been an article, it seems, in the *Revue Indépendante* on Anquetin, which called him the leader of a new trend, in which the Japanese influence is even more apparent. I have not read it, but anyway the leader of the Petit Boulevard is undoubtedly Seurat, and young Bernard has perhaps gone further in the Japanese style than Anquetin. Tell them that I have done a picture of boats, that and the *Pont de l'Anglais* could go to Anquetin. What Pissarro says is true, you most boldly exaggerate the effects of either harmony or discord which colours produce. It is the same as in drawing – accurate drawing, accurate colour, is perhaps not the essential thing to aim at, because the reflection of reality in a mirror, if it could be caught, colour and all, would not be a picture at all, no more than a photograph. ... (500, 23 June 1888, F.)

It is all too easy to overlook the way in which a person may be going through a crisis long before it leads to any specific act, and long before there is any reason for the outside world to intervene. The continual wane of Vincent's ambitions; his condition during harvest time when he devoted himself wholly to painting his theme and subsequently felt exhausted; the doubtful remedy he

referred to; his sense of being old and broken before his time; all these add up to a kind of litany clearly indicating the destructive effect on a weak constitution of an excessive urge to create. The same process also included the lucid but sombre moments when Vincent summoned up supernatural images suggesting some form of life after death. These were dreams in which a longing for death lay barely concealed.

He kept returning to Monticelli, with whose irregularities he felt he had great affinity both as a man and as an artist.

... It certainly is a strange phenomenon that all artists, poets, musicians, painters, are unfortunate in material things – the happy ones as well – what you said lately about Guy de Maupassant is fresh proof of it. That brings up again the eternal question: Is the whole of life visible to us, or isn't it rather that this side of death we see only one hemisphere?

Painters – to take them alone – dead and buried speak to the next generation or to several succeeding generations through their work.

Is that all, or is there more to come? Perhaps death is not the hardest thing in a painter's life.

For my own part, I declare I know nothing whatever about it, but looking at the stars always makes me dream, as simply as I dream over the black dots representing towns and villages on a map. Why, I ask myself, shouldn't the shining dots of the sky be as accessible as the black dots on the map of France? Just as we take the train to get to Tarascon or Rouen, we take death to reach a star. One thing undoubtedly true in this reasoning is that we *cannot* get to a star while we are *alive*, any more than we can take the train when we are dead.

So to me it seems possible that cholera, gravel, tuberculosis and cancer are the celestial means of locomotion, just as steamboats, buses and railways are the terrestrial means. To die quietly of old age would be to go there on foot. ... (506, 1–3 Aug. 1888, F.)

... As for landscapes, I begin to find that some done more rapidly than ever are the best of what I do. For instance, the one I sent you the cartoon of, the harvest, and the stacks too. It is true that I have to retouch the *whole* to rearrange the composition a bit, and to make the touch harmonious, but all the essential work was done in a single long sitting, and I change them as little as possible when I'm retouching.

But when I come home after a spell like that, I assure you my head is so tired that if that kind of work keeps recurring, as it has done since this harvest began, I become hopelessly absent-minded and incapable of heaps of ordinary things.

It is at times like these that the prospect of not being alone is not disagreeable.

And very often indeed I think of that excellent painter Monticelli – who they said was such a drinker, and off his head – when I come back myself from the mental labour of balancing the six essential colours, red – blue – yellow – orange – lilac – green. Sheer work and calculation, with one's mind strained to the utmost, like an actor on the stage in a difficult part, with a hundred things to think of at once in a single half hour.

After that, the only thing to bring ease and distraction, in my case and other people's too, is to stun oneself with a lot of drinking or heavy smoking. Not very virtuous, no doubt, but it's to return to the subject of Monticelli. I'd like to see a drunkard in front of a canvas or on the boards. It is too gross a lie, all the Roquette woman's malicious, Jesuitical slanders about Monticelli.

Monticelli, the logical colourist, able to pursue the most complicated calculations, subdivided according to the scales of tones that he was balancing, certainly overstrained his brain at this work, just as Delacroix did, and Richard Wagner. ... (507, c. 7 July 1888, F.)

In the meantime, aided by Pierre Loti's *Madame Chrysanthème*, Vincent was also endeavouring to enter factually into the spirit of a Japanese environment. This is why he could rightly claim that although one of his finest landscapes, *Harvest, La Crau*, superficially had nothing to do with Japan, it was the most Japanese thing he had ever painted. This is because of its light and clarity, the absolute accuracy of each form and line, the colourfulness and detail which are present throughout the work yet never predominate. Viewed in this way, Cloisonnism never had the significance for him that it did for other artists. It

141

was an end result created in Western style with a Japanese background, while Van Gogh – and this was only possible because of his ecstatic, Adamistic disposition – imagined that he was seeing and experiencing his subject from a genuine Japanese viewpoint.

. . . Have you read *Mme Chrysanthème*? It gave me the impression that the real Japanese have *nothing on their walls*, that description of the cloister or pagoda where there was *nothing* (the drawings and curiosities all being hidden in the drawers). That is how you must look at Japanese art, in a very bright room, quite bare, and open to the country. . . . (509, 18 July 1888, F.)

You will already have received my letter of this morning, in which I enclosed the 50-fr. note for Bing, and there is still more I want to write you about this Bing business! The point is that we do not know enough about Japanese prints.
 Fortunately we know more about the Japanese of France, the impressionists.
 So Japanese art proper, already interred in collections, already impossible to find in Japan itself, is becoming of secondary interest.
 But that doesn't mean that if I had a single day to see Paris again, I should not call at Bing's to see those very Hokusais and other drawings of the great period. Besides, Bing himself used to say to me, when I was admiring the ordinary prints, that after a while I should come to see that there are quite different things still. . . . (511, 22 July 1888, F.)

In a few lines Vincent managed to reduce his own and Theo's condition to a sense of the *vie manquée* familiar from nineteenth-century French literature. It should be noted that this was not because he no longer had any faith in his art, but because he could never reconcile himself to the fact that what he called genuine living life had eluded him because of the compulsion, the imposition, of his creative work.

. . . These painter's fingers of mine are growing supple, even though the carcass is going to pieces. And the merchant's head for selling – and a long job to learn it is – is getting more experience too. In our situation, which you may well say is so precarious, we must not forget our advantages, and let's try to hang on to our patience to do the right thing and see clearly. Isn't it true, for instance, that in any case it is better if someday they say to you, 'Go to London,' than chuck you out, your services no longer being required?
 I am getting older than you, and my ambition is to be less of a burden to you. And, if no actual obelisk of too pyramidal a catastrophe occurs, and there's no rain of frogs in the meantime, I hope to achieve it sometime. . . .
 My dear brother, if I were not broke and crazy with this blasted painting, what a dealer I'd make just for the impressionists. But there, I am broke. London is good, London is just what we need, but alas I feel I cannot do what I once could. But broken down and none too well myself, I do not see *any* misfortune in your going to London; if there is fog there, well, that seems to be increasing in Paris too.
 What's wrong – basically – is that we are getting older, and must behave accordingly; that's *all there is to it*. Yet there is something *for* as well as *against*, and we must make the best of it. . . . (513, 26/27 July 1888, F.)

. . . The more I am spent, ill, a broken pitcher, by so much more am I an artist – a creative artist – in this great renaissance of art of which we speak.
 These things are surely so, but this eternally living art, and this renaissance, this green shoot springing from the roots of the old felled trunk, these are such abstract things that a kind of melancholy remains within us when we think that one could have created life at less cost than creating art. . . . (514, 29 July 1888, F.)

The letters written between August and October, prior to Gauguin's ultimate arrival, contain indications that Van Gogh was on the verge of total collapse, though not in the sense of being confused. On the contrary, they are positive

because of their wealth of profound thoughts on life and death; the overwhelming impressions of life and landscape; their lyricism about all that he still wished to do, details of what he was reading, painting and drawing, in between writing letters – complete Van Gogh, in fact. The letters need to be read in their entirety if one wishes to comprehend the power of the stream welling up from his unconscious self and sweeping him along without any chance of finding calmer waters.

Vincent was unable to escape the desire for totality, the constant reliving of previous experiences, always present as such in the actuality of what he was engaged in doing. Of course it goes without saying that there was in all this an element of regression – but dominated by the urge to transcend the moment: to possess the whole.

I think you were right to go to our uncle's funeral, since Mother seemed to be expecting you. The best way to cope with death is to accept the illustrious departed, whatever he was, as being the best man in the best of all possible worlds, where everything is for the best. Which not being contested, and consequently incontestable, doubtless all that remains to be done is to return laudably to our own pursuits. I am glad that our brother Cor has grown bigger and stronger than the rest of us. And he must be stupid if he does not get married, for he has nothing but that and his hands. With that and his hands, or his hands and that, and what he knows of machinery, I for one would like to be in his shoes, if I had any desire at all to be anyone else.

And meanwhile I am in my own hide, and my hide caught in the wheels of the Fine Arts, like wheat between the millstones. . . .

I have come to the end both of paints and canvas and I have already had to buy some here. And I must go back for even more. So please do send the letter so that I'll have it on Saturday morning.

Today I am probably going to start on the interior of the café where I eat, by gaslight, in the evening. It is what they call here a 'café de nuit' (they are fairly common here), staying open all night. Night prowlers can take refuge there when they have no money to pay for a lodging or are too tight to be taken in.

All those things – family, native land – are perhaps more attractive in the imagination of such people as us, who are doing pretty well without native land or family, than they are in reality. I always feel I am a traveller, going somewhere and to some destination. If I tell myself that the somewhere and the destination do not exist, that seems to me very reasonable and likely enough.

When the brothel bouncer kicks anyone out, he has a similar logic, argues well too, and is always right, I know. So at the end of my career I shall prove to be wrong. So be it. Then I shall find that not only the Arts but everything else were only dreams, that one was nothing at all oneself. If we are *as flimsy as that*, so much the better for us, for then there is nothing to be said against the unlimited possibility of future existence. Whence comes it that in the present instance of our uncle's death, the face of the deceased was calm, peaceful, and grave, whereas it is a fact that he was rarely that way while living, either in youth or age? I have often observed a similar effect as I looked on the dead as though to question them. And for me that is *one* proof, though not the most serious, of a life beyond the grave.

And in the same way a child in the cradle, if you watch it at leisure, has the infinite in its eyes. In short, I know *nothing* about it, but it is just this feeling of *not knowing* that makes the real life we are actually living now like a one-way journey on a train. You go fast, but cannot distinguish any object very clearly, and above all you do not see the engine.

It is rather curious that Uncle as well as Father believed in a future life. Not to mention Father, I have several times heard Uncle arguing about it.

Ah – but then, they were more assured than we are, and got angry if you dared to go into it more deeply.

I do not think much of the *future* life of artists *through their works*. Yes, artists perpetuate themselves by handing on the torch, Delacroix to the impressionists, etc. But is that all?

If the kind old mother of a family, with her rather limited ideas, and tortured by the

Christian system, is to be immortal as she believes, and seriously too – and I for one do not gainsay it – why should a consumptive or neurotic cab horse with vast ideas, like Delacroix and de Goncourt, be any less immortal?

Granted, it seems that the most empty-headed should feel the springing of this unaccountable hope most keenly.

Enough. What's the good of worrying about it? But living in the full tide of civilization, of Paris, of the Arts, why shouldn't one hold on to this old-womanish 'ego', if the women themselves would not find strength to create and do things without their instinctive belief in 'that is *it.*'

Then the doctors will tell us that not only Moses, Mahomet, Christ, Luther, Bunyan and others were mad, but Frans Hals, Rembrandt, Delacroix too, and also all the dear narrow-minded old women like our mother.

Ah – that's a serious matter – one might ask these doctors: Where then are the sane people?

Are they the brothel bouncers, who are always right? Probably. Then what to choose? Fortunately there is no choice. (518, 6 Aug. 1888, F.)

... What I learned in Paris is leaving me, and I am returning to the ideas I had in the country before I knew the impressionists. And I should not be surprised if the impressionists soon find fault with my way of working, for it has been fertilized by Delacroix's ideas rather than by theirs. Because instead of trying to reproduce exactly what I have before my eyes, I use colour more arbitrarily, in order to express myself forcibly. Well, let that be, as far as theory goes, but I'm going to give you an example of what I mean.

156 I should like to paint the portrait of an artist friend [Eugène Boch], a man who dreams great dreams, who works as the nightingale sings, because it is his nature. He'll be a blond man. I want to put my appreciation, the love I have for him, into the picture. So I paint him as he is, as faithfully as I can, to begin with.

But the picture is not yet finished. To finish it I am now going to be the arbitrary colourist. I exaggerate the fairness of the hair, I even get to orange tones, chromes and pale citron-yellow.

Behind the head, instead of painting the ordinary wall of the mean room, I paint infinity, a plain background of the richest, intensest blue that I can contrive, and by this simple combination of the bright head against the rich blue background, I get a mysterious effect, like a star in the depths of an azure sky. ... (520, 11 Aug. 1888, F.)

At the same time Vincent continued to take a technical and factual interest in the composition and quality of the paint he employed.

Would you like to ask Tasset's opinion on the following question? To me it seems as though the more finely a colour is brayed, the more it becomes saturated with oil. Now needless to say, we don't care overmuch for oil.

If we painted like M. Gérôme and the other delusive photographers, we should doubtless ask for very finely brayed colours. But we on the contrary do not object to the canvas having a rough look. If then, instead of braying the colour on the stone for God knows how many hours, it was brayed just long enough to make it manageable, without worrying too much about the fineness of the powder, you would get fresher colours which would perhaps darken less. If he wants to make a trial of it with the three chromes, the malachite, the vermilion, the orange lead, the cobalt, and the ultramarine, I am almost certain that at much less cost I should get colours which would be both fresher and more lasting. Then what would the price be? I'm sure this could be done. Probably also with the reds and the emerald, which are transparent. ... (527, 22 Aug. 1888, F.)

Painting at it is now promises to become more subtle – more like music and less like sculpture – and above all it promises *colour*. If only it keeps this promise. ...

As for stippling [*le pointillé*] and making haloes and other things, I think they are real discoveries, but we must already see to it that this technique does not become a universal dogma any more than any other. That is another reason why Seurat's *Grande Jatte*, the landscapes with broad stippling by Signac, and Anquetin's boat, will become in time even more personal and even more original.

About my clothes, certainly they were beginning to be the worse for wear, but only last week I bought a black velvet jacket of fairly good quality for 20 francs, and a new hat, so there is no hurry. . . . (528, 26 Aug. 1888, F.)

Nothing escaped his notice. The lyricism of his utterances, and the images he employed, 'a wedding of two complementary colours, . . . the mysterious vibrations of kindred tones', go beyond simple description; this is a reliving, while he was writing, of what had taken place. The abrupt switches of tone, as when he refers to his *Night Café* as 'the ugliest I have done', are part of his *164* ecstatic mood. In the context of what was being painted elsewhere at the time, these works represented historically a tremendous leap, even after *La Segatori* and the final self-portraits painted in Paris. This was the discovery of the *115, 124* *terribilità* of colour, which he knew lay concealed in Delacroix. His reflections *193* at this time were not concerned with any pre-existing religious or historical context; they were totally modern. From a literary point of view, that is to say in the context of the letters, Vincent now came closer to Huysmans than to Zola. The *fin-de-siècle* perversity of 'Louis XII green' and 'malachite' and the 'sulphurous smell of crime' is not exactly what the reader expects when Vincent expresses his frequently quoted desire to use his art 'to say something comforting, as music is comforting'; nor does it reflect that other side of him which started thinking about Giotto and Puvis while he was at Arles.

. . . Oh, my dear brother, sometimes I know so well what I want. I can very well do without God both in my life and in my painting, but I cannot, ill as I am, do without something which is greater than I, which is my life – the power to create.

And if, frustrated in the physical power, a man tries to create thoughts instead of children, he is still part of humanity.

And in a picture I want to say something comforting, as music is comforting. I want to paint men and women with that something of the eternal which the halo used to symbolize, and which we seek to convey by the actual radiance and vibration of our colouring.

Portraiture so understood does not become like an Ary Scheffer just because there is a blue sky in the background, as in *St Augustine*. For Ary Scheffer is so little of a colourist.

But it would be more in harmony with what Eug. Delacroix attempted and brought off in his *Tasso in Prison*, and many other pictures, representing a *real* man. Ah! portraiture, portraiture with the thoughts, the soul of the model in it, that is what I think must come. . . .

So I am always between two currents of thought, first the material difficulties, turning round and round to make a living; and second, the study of colour. I am always in hope of making a discovery there, to express the love of two lovers by a wedding of two complementary colours, their mingling and their opposition, the mysterious vibrations of kindred tones. To express the thought of a brow by the radiance of a light tone against a sombre background.

To express hope by some star, the eagerness of a soul by a sunset radiance. Certainly there is no delusive realism in that, but isn't it something that actually exists? . . . (531, 3 Sept. 1888, F.)

Thank you a thousand times for your kind letter and the 300 francs it contained; after some worrying weeks I have just had one of the very best. And just as the worries do not come singly, neither do the joys. For just because I am always bowed under this difficulty of paying my landlord, I made up my mind to take it gaily. I swore at the said landlord, who after all isn't a bad fellow, and told him that to revenge myself for paying him so much money for nothing, I would paint the whole of his rotten joint so as to repay myself. Then to the great joy *164* of the landlord, of the postman whom I had already painted, of the visiting night prowlers and *154* of myself, for three nights running I sat up to paint and went to bed during the day. I often think that the night is more alive and more richly coloured than the day.

Now, as for getting back the money I have paid to the landlord by means of my painting, I do not dwell on that, for the picture is one of the ugliest I have done. It is the equivalent, though different, of the *Potato Eaters*. *48*

I have tried to express the terrible passions of humanity by means of red and green.

The room is blood red and dark yellow with a green billiard table in the middle; there are four citron-yellow lamps with a glow of orange and green. Everywhere there is a clash and contrast of the most disparate reds and greens in the figures of little sleeping hooligans, in the empty, dreary room, in violet and blue. The blood-red and the yellow-green of the billiard table, for instance, contrast with the soft tender Louis XV green of the counter, on which there is a pink nosegay. The white coat of the landlord, awake in a corner of that furnace, turns citron-yellow, or pale luminous green. . . .

The *Night Café* carries on the style of the *Sower*, as do the head of the old peasant and of the poet also, if I manage to do this latter picture.

It is colour not locally true from the point of view of the delusive realist, but colour suggesting some emotion of an ardent temperament.

193 When Paul Mantz saw at the exhibition the violent and inspired sketch by Delacroix that we saw at the Champs-Elysées – the *Bark of Christ* – he turned away from it, exclaiming, 'I did not know that one could be so terrible with a little blue and green.'

Hokusai wrings the same cry from you, but he does it by his *line*, his *drawing*, just as you say in your letter – 'the waves are *claws* and the ship is caught in them, you feel it'.

Well, if you make the colour exact or the drawing exact, it won't give you sensations like that. . . . (533, 8 Sept. 1888, F.)

. . . In my picture of the *Night Café* I have tried to express the idea that the café is a place where one can ruin oneself, go mad or commit a crime. So I have tried to express, as it were, the powers of darkness in a low public house, by soft Louis XV green and malachite, contrasting with yellow-green and harsh blue-greens, and all this in an atmosphere like a devil's furnace, of pale sulphur.

And all with an appearance of Japanese gaiety, and the good nature of Tartarin.

But what would Monsieur Tersteeg say about this picture when he said before a Sisley – Sisley, the most discreet and gentle of the impressionists – 'I can't help thinking that the artist who painted that was a little tipsy'. If he saw my picture, he would say that it was delirium tremens in full swing.

I see absolutely nothing to object to in your suggestion of exhibiting once at the *Revue Indépendante*, provided, however, that I am no obstacle to the others who usually exhibit there. . . .

152 Just as I'm writing to you, the poor peasant who is like a caricature of Father happens to have come into the café. The resemblance is terrible, all the same. Especially the uncertainty and the weariness and the vagueness of the mouth. I still feel it is a pity that I have not been able to do it. . . . (534, Sept. 1888, F.)

. . . Ideas for my work are coming to me in swarms, so that though I'm alone, I have no time to think or to feel, I go on painting, like a steam engine. I think there will hardly ever be a standstill again. And my view is that you will never find a live studio ready-made, but that it is created from day to day by patient work and going on and on in one place. . . .

The idea of the *Sower* continues to haunt me all the time. Exaggerated studies like the *Sower* and like this *Night Café* usually seem to me atrociously ugly and bad, but when I am moved by something, as now by this little article on Dostoievsky, then these are the only ones which appear to have any deep meaning. . . . (535, 10 Sept. 1888, F.)

140 . . . The third picture this week is a portrait of myself, *almost colourless*, in grey tones against a background of pale malachite.

I purposely bought a mirror good enough to enable me to work from my image in default of a model, because if I can manage to paint the colouring of my own head, which is not to be done without some difficulty, I shall likewise be able to paint the heads of other good souls, men and women.

The problem of painting night scenes and effects on the spot and actually by night interests me enormously. This week I have done absolutely nothing but paint and sleep and have my meals. That means sittings of twelve hours, of six hours and so on, and then a sleep of twelve hours at a stretch. . . . (537, 16/17 Sept. 1888, F.)

In September and October 1888, prior to Gauguin's arrival on 23 October, Van Gogh experienced a medley of moods consisting of moments of rarest happiness, a lucidity which he felt as a blessing, a state of grace ('I can't help it, I feel my brain is lucid'), and a powerful need for religion, a word now used to denote a religion of nature. Vincent was impressed by Tolstoy's concept of an approaching inner, private revolution. Sentiments about music and a 'more musical' way of life had acquired that same metaphorical value; but it remains uncertain what this meant to him. He found it difficult to define the relationship between music and colour. What in the work of Delacroix and Monticelli he called 'suggestive colour' was, for him, a related quality.

I wrote to you already, early this morning, then I went away to go on with a picture of a garden in the sunshine. Then I brought it back and went out again with a blank canvas, and that also is finished. And now I want to write you again.

Because I have never had such a chance, nature here being so *extraordinarily* beautiful. Everywhere and all over the vault of heaven is a marvellous blue, and the sun sheds a radiance of pale sulphur, and it is soft and as lovely as the combination of heavenly blues and yellows in a Van der Meer of Delft. I cannot paint it as beautifully as that, but it absorbs me so much that I let myself go, never thinking of a single rule. . . .

School of Giotto. *Death of the Virgin*, 14th c.
This work, attributed to Giotto, was to be seen in the Montpellier museum when Van Gogh and Gauguin visited it.

I am so happy in the house and in my work that I even dare to think that this happiness will not always be limited to one, but that you will have a share in it and good luck to go with it.

Some time ago I read an article on Dante, Petrarch, Boccaccio, Giotto and Botticelli. Good Lord! it did make an impression on me, reading the letters of those men.

And Petrarch lived quite near here in Avignon, and I am seeing the same cypresses and oleanders.

I have tried to put something of that into one of the pictures painted in a very thick impasto, citron yellow and lime green. Giotto moved me most – *always in pain*, and always full of kindness and enthusiasm, as though he were already living in a different world from ours.

And besides, Giotto is extraordinary. I understand him better than the poets Dante, Petrarch and Boccaccio.

I always think that poetry is more *terrible* then painting, though painting is a dirtier and a much more worrying job. And then the painter never says anything, he holds his tongue, and I like that too.

My dear Theo, when you have seen the cypresses and the oleanders here, and the sun – and the day will come, you may be sure – then you will think even more often of the beautiful *Sweet Land* by Puvis de Chavannes, and many other pictures of his.

There is still a great deal of Greece all through the Tartarin and Daumier part of this queer country, where the good folk have the accent you know; there is a Venus of Arles just as there is a Venus of Lesbos, and one still feels the youth of it in spite of all. . . .

143, 148, 164 What is Seurat doing? I should not dare to show him the studies already sent, but the ones of the sunflowers, and the cabarets, and the gardens, I would like him to see those. I often think of his method, though I shall not follow it at all; but he is an original colourist, and Signac too, though to a different degree, the *pointilleurs* have discovered something new, and at all events I like them very much. But I myself – I tell you frankly – am returning more to what I was looking for before I came to Paris. I do not know if anyone before me has talked about suggestive colour, but Delacroix and Monticelli, without talking about it, did it.

But I have got back to where I was in Nuenen, when I made a vain attempt to learn music, so much did I already feel the relation between our colour and Wagner's music.

It is true that in impressionism I see the resurrection of Eugène Delacroix, but the interpretations of it are so divergent and in a way so irreconcilable that it will not be impressionism which will give us the final doctrine.

That is why I myself remain among the impressionists, because it professes nothing, and binds you to nothing, and as one of the comrades I need not declare my formula.

Good Lord, how you have to mess about in life. I only ask for time to study, and do you yourself really ask for anything but that? . . . (539, *c.* 18 Sept. 1888, F.)

I know quite well that I have already written you once today, but it has been such a lovely day again. My great regret is that you cannot see what I am seeing here.

Since seven o'clock this morning I have been sitting in front of something which after all is no great matter, a clipped round bush of cedar or cypress growing amid grass. You already know this clipped bush, because you have had a study of the garden. Enclosed also a sketch of my canvas, again a square size 30.

The bush is green, touched a little with bronze and various other tints.

The grass is bright, bright green, malachite touched with citron, and the sky is bright, bright blue.

The row of bushes in the background are all oleanders, raving mad; the blasted things are flowering so riotously they may well catch locomotor ataxia. They are loaded with fresh flowers, and quantities of faded flowers as well, and their green is continually renewing itself in fresh, strong shoots, apparently inexhaustibly.

A funereal cypress is standing over them, and some small figures are sauntering along a pink path.

This makes a pendant to another size 30 canvas of the same spot, only from a totally different angle, in which the whole garden is in quite different greens, under a sky of pale citron.

But isn't it true that this garden has a fantastic character which makes you quite able to imagine the poets of the Renaissance, Dante, Petrarch, Boccaccio, strolling among these

bushes and over the flowery grass? It is true that I have left out some trees, but what I have kept in the composition is really there just as you see it. Only it has been overcrowded with some shrubs which are not in character. . . .

And to get at that character, the fundamental truth of it: that's three times now that I've painted the same spot.

It happens to be the garden just in front of my house. But this corner of the garden is a good example of what I was telling you, that to get at the real character of things here, you must look at them and paint them for a long time.

Perhaps you will see nothing from the sketch except that the line is now very simple. This picture is again painted very thickly, like its pendant with the yellow sky.

I hope to work again with Milliet tomorrow.

Today again from seven o'clock in the morning till six in the evening I worked without stirring except to take some food a step or two away. That is why the work is getting on fast.

But what will you say of it, and what shall I think of it myself, a little while from now?

I have a lover's insight or a lover's blindness for work just now.

Because these colours about me are all new to me, and give me an extraordinary exaltation.

I have no thought of fatigue, I shall do another picture this very night, and I shall bring it off.

If I tell you that it is very urgent for me to have:

 6 large tubes of chrome yellow, 1 citron
 6 ,, ,, malachite green
 3 ,, ,, Prussian blue
 10 ,, ,, zinc white
 A big tube like the zinc white and flake white
 Then that will be deducted from yesterday's order.
 And 5 metres of canvas, too.

I can't help it, I feel my brain is lucid, and I want as far as possible to make sure of enough pictures to hold my own when the others are making a great show for the year '89. Seurat with two or three of his enormous canvases has enough for an exhibition of his own, Signac is a good worker and has enough as well, and Gauguin and Guillaumin too. So, whether we exhibit or not, I do want to have the series of studies *Decoration* for the same time. . . . (541, 23/24 Sept. 1888, F.)

. . . I have read another article on Wagner – 'Love in Music' – I think by the same author who wrote the book on Wagner. How one needs the same thing in painting.

It seems that in the book *My Religion*, Tolstoi implies that whatever happens in the way of violent revolution, there will also be a private and secret revolution in men, from which a new religion will be born, or rather something altogether new, which will have no name, but which will have the same effect of comforting, of making life possible, which the Christian religion used to have. It seems to me that the book ought to be very interesting.

In the end we shall have had enough of cynicism and scepticism and humbug, and we shall want to live more musically. How will that come about, and what will we really find? It would be interesting to be able to prophesy, but it is even better to be able to feel that kind of foreshadowing, instead of seeing absolutely nothing in the future beyond the disasters that are all the same bound to strike the modern world and civilization like terrible lightning, through a revolution or a war, or the bankruptcy of worm-eaten states. If we study Japanese art, we see a man who is undoubtedly wise, philosophic and intelligent, who spends his time doing what? In studying the distance between the earth and the moon? No. In studying Bismarck's policy? No. He studies a single blade of grass.

But this blade of grass leads him to draw every plant and then the seasons, the wide aspects of the countryside, then animals, then the human figure. So he passes his life, and life is too short to do the whole.

Come now, isn't it almost a true religion which these simple Japanese teach us, who live in nature as though they themselves were flowers?

And you cannot study Japanese art, it seems to me, without becoming much gayer and happier, and we must return to nature in spite of our education and our work in a world of convention. . . . (542, 25/26 Sept. 1888, F.)

... When I left you at the station to go south, very miserable, almost an invalid and almost a drunkard, I still felt vaguely that we had put our very heart into our discussions with so many interesting people and artists that winter, but I hadn't the courage to hope.

196 After continued efforts on your part and mine, now at last something is beginning to show on the horizon: Hope.

It does not matter if you stay with the Goupils or not, you have committed yourself to Gauguin body and soul.

So you will be one of the first, or the first, dealer-apostle. I can see my own painting coming to life, and likewise a work among the artists. For if you try to get money for us, I shall urge every man who comes within my reach to produce, and I will set them an example myself.

And if we stick to it, all this will help to make something more lasting than ourselves. ... (544, c. 29 Sept. 1888, F.)

This morning I received your excellent letter, which I sent on to my brother; your concept of impressionism in general, of which your portrait is a symbol, is striking. I can't tell you how curious I am to see it – but this much I know in advance: this work is too important to allow me to make an exchange. But if you will keep it for us, my brother will take it at the first opportunity – which I asked him directly – if you agree, and let's hope that it will be soon.

For, once again, we are trying to hasten the possibility of your coming here. I must tell you that even while working I keep thinking incessantly of that plan to found a studio, which will have you and myself as permanent residents, but which the two of us would turn into a refuge and place of shelter for comrades at moments when they are encountering a setback in their struggle.

After you left Paris, my brother and I stayed together for a time, which will forever remain unforgettable to me! The discussions covered a wider field – with Guillaumin, with the Pissarros, father and son, with Seurat, whose acquaintance I had not made (I visited his studio only a few hours before my departure).

Often these discussions had to do with the problems that are so very near my brother's heart and mine, i.e. the measures to be taken to safeguard the material existence of painters and to safeguard the means of production (paints, canvases) and to safeguard, in their direct interest, their share in the price which, under the present circumstances, pictures only bring a long time after they leave the artists' possession.

When you are here, we are going to go over all these discussions.

However this may be, when I left Paris, seriously sick at heart and in body, and nearly an alcoholic because of my rising fury at my strength failing me – then I shut myself up within myself, without having the courage to hope!

Now, however, hope is breaking for me vaguely on the horizon; that hope in intermittent flashes, like a lighthouse, which has sometimes comforted me during my solitary life. ... (Vincent to Gauguin, 544a, Sept.–Oct. 1888, F.)

The letter of 13 October saw the appearance of the first signs of a crisis: fatigue, even exhaustion; exceptionally tired eyes; immoderate need of sleep, on one occasion up to sixteen hours on end; difficulty in concentrating on writing; uneven size of handwriting which was sometimes large with an excessive number of separated letters; no inclination for drawing. To us this seems enough to suggest Vincent was on the verge of a breakdown. He himself foresaw such a possibility when he attempted to define his possible madness, ruling out persecution mania and allowing for a reduced production.

Thank you for your letter and the 50-franc note it contained. Thank you for writing more about the picture by these Dutch artists. I have had gas installed in the studio and in the kitchen, which has cost me 25 francs. If Gauguin and I were to work every night for a fortnight, shouldn't we get it back? Only as Gauguin may come any day, I do desperately need another 50 francs.

I am not ill, but without the slightest doubt I'd get ill if I did not eat plenty of food and if I did not stop painting for a few days. As a matter of fact, I am again pretty nearly reduced to the madness of Hugo van der Goes in Emile Wauters' picture. And if it were not that I have almost

a double nature, that of a monk and that of a painter, as it were, I should have been reduced, and that long ago, completely and utterly, to the aforesaid condition.

Yet even then I do not think that my madness could take the form of persecution mania, since when in a state of excitement my feelings lead me rather to the contemplation of eternity, and eternal life.

But in any case I must beware of my nerves, etc. . . . (556, 21/22 Oct. 1888, F.)

Gauguin's arrival on 23 October ostensibly brought peace. They began to prepare their own canvases and use cheaper paint; they shared cooking chores, and Gauguin did some extra shopping. Each sought his 'own' Arlésienne.

Thanks for your letter and the 50-fr. note. As you learned from my wire, Gauguin has arrived in good health. He even seems to me better than I am.

Of course he is very pleased with the sale you have effected, and I no less, since in this way certain expenses absolutely necessary for the installation need not wait, and will not weigh wholly on your shoulders. Gauguin will certainly write you today. He is very interesting as a man, and I have every confidence that we shall do loads of things with him. He will probably produce a great deal here, and I hope perhaps I shall too. *157* *158*

And then I dare hope that the burden will be a *little* less heavy for you, and I even hope, *much* less heavy. I myself realize the necessity of producing even to the extent of being mentally crushed and physically drained by it, just because after all I have no other means of ever getting back what we have spent.

I cannot help it that my pictures do not sell.

Nevertheless the time will come when people will see that they are worth more than the price of the paint and my own living, very meagre after all, that is put into them.

I have no other desire nor any other interest as to money or finance, than primarily to have no debts.

But my dear boy, my debt is so great that when I have paid it, which all the same I hope to succeed in doing, the pains of producing pictures will have taken my whole life from me, and it will seem to me then that I have not lived. The only thing is that perhaps the production of pictures will become a little more difficult for me, and as to numbers, there will not always be so many. . . . (557, 24 Oct. 1888, F.)

. . . Gauguin, in spite of himself and in spite of me, has more or less proved to me that it is time I was varying my work a little. I am beginning to compose from memory, and all my studies will still be useful for that sort of work, recalling to me things I have seen. What then does selling matter, unless we are absolutely pressed for money? . . . (563, 2–11 Dec. 1888, F.)

The visit Gauguin and Vincent made to Montpellier was something of a turning-point; their reactions to it led to fierce arguments. His letter of 23 December gives a suspiciously calm account of how Gauguin, upset by Arles and Vincent in particular, wanted to leave, while Vincent, understandably, found this hard to bear. Gauguin had come to symbolize some of his most passionate hopes, which were concerned partly with Theo's interest in tying Gauguin to his business, and partly with his own efforts to test the practicability of his scheme for a society of painters living and working together which would act as a cure for his own loneliness and give the Maison Jaune a purpose.

Yesterday Gauguin and I went to Montpellier to see the gallery there and especially the Brias room. There are a lot of portraits of Brias, by Delacroix, Ricard, Courbet, Cabanel, Couture, Verdier, Tassaert, and others. Then there are pictures by Delacroix, Courbet, Giotto, Paul Potter, Botticelli, Th. Rousseau, very fine. Brias was a benefactor of artists, I need say no more to you than that. In the portrait by Delacroix he is a gentleman with red beard and hair, uncommonly like you or me, and made me think of that poem by de Musset – 'Wherever I touched the earth – a miserable fellow in black sat down close to us, and looked at us like a brother'. It would have the same effect on you, I'm sure. Please go to that bookshop where

they sell the lithographs after past and present artists, and see if you could get a not too expensive lithograph after Delacroix's *Tasso in the Madhouse*, since I think the figure there must have some affinity with this fine portrait of Brias. ...

Gauguin and I talked a lot about Delacroix, Rembrandt, etc. Our arguments are terribly *electric*, sometimes we come out of them with our heads as exhausted as a used electric battery. We were in the midst of magic, for as Fromentin says so well: Rembrandt is above all a magician. ...

Eugène Delacroix. *Alfred Bruyas*, 1853. Vincent always spelt his name Brias.

Tell Degas that Gauguin and I have been to see the portrait of Brias by Delacroix at Montpellier, for we have the courage to believe that *what is is*, and the portrait of Brias by Delacroix is as like you and me as another brother. ... (564, *c.* 15–20 Dec. 1888, F.)

Thank you very much for your letter, for the 100-fr. note enclosed and also for the 50-fr. money order.

I think myself that Gauguin was a little out of sorts with the good town of Arles, the little yellow house where we work, and especially with me.

As a matter of fact, there are bound to be grave difficulties to overcome here too, for him as well as for me.

But these difficulties are more within ourselves than outside.

Altogether I think that either he will definitely go, or else definitely stay.

I told him to think it over and make his calculations all over again before doing anything.

Gauguin is very powerful, strongly creative, but just because of that he must have peace. Will he find it anywhere if he does not find it here?

I am waiting for him to make a decision with absolute serenity. ... (565, 23 Dec. 1888, F.)

The very next day – Christmas Eve, often a bad time of year in Vincent's life – Gauguin called Theo to Arles after a series of dramatic developments. These have been over-emphasized in accounts of Vincent's life; a sensational approach does little to enhance our understanding of either the man or his work. The local paper carried the story the following week-end:

On Sunday last, at 11.30 p.m., one Vincent Vangogh, a painter, born in Holland, arrived at House of Tolerance [brothel] No. 1, asked for one Rachel, and handed her – his ear, saying 'Keep this and treasure it.' Then he disappeared. Informed of this action, which could only be that of a poor lunatic, the police went to the man's address the next morning and found him lying in bed and giving almost no sign of life. The unfortunate was admitted to hospital as an emergency case. ... (*Le Forum républicain* (Arles), 30 Dec. 1888, F.)

On 1 January 1889 Emile Bernard wrote to the critic Albert Aurier, giving Gauguin's version of what had happened. Gauguin's attitude may be open to criticism, and his account of the events may be subject to correction; but this is after all the nearest to an immediate first-hand account that we have. The few artists who were close to Vincent were shaken by what had happened, and the event seems to have shocked them into a fuller realization of his true significance as an artist.

In the meantime Theo had become engaged to be married. He had come to believe that his overtures to Jo Bonger in the summer of 1888 had been definitely rejected, or at least discouraged. Since the failure of his suit in the summer, he had avoided his friend Andries Bonger in Paris. A few days before 21 December, Jo Bonger, who had been staying with her brother for a month, happened to meet Theo and asked to speak to him. She believed it to be her fault that Andries and Theo were avoiding each other. Relations improved at a stroke. After consultations with parents, their engagement was announced in Holland early in 1889.

The coincidence of this engagement and the crisis between Vincent and Gauguin has tempted some authors to attribute to it an active part in Vincent's derangement. In fact, however, although Vincent knew all about the estrangement between Theo and Jo (and had repeatedly urged his brother to marry), he knew nothing of the rapprochement. This news was given by Theo in a letter to his mother on 21 December, and in other to Lies, to Vincent, and other members of the family, which were not sent until 24 December. There is nothing to suggest that Theo wrote to Vincent before Christmas Eve.

Vincent's nervous condition had clearly deteriorated since the arrival of Gauguin, who had proved too strong a stimulus. Sunday 23 December was the date not of a first crisis, but of a final stage in a crisis which had been threatening and developing for months and became acute after their visit to Montpellier on 13 December. Following an earlier, interrupted crisis which lasted from the end of August and was particularly serious around 13 October, Gauguin was welcomed by a man who was undoubtedly exhausted by ecstatic states of mind, depressions and overwork. Gauguin too was subject to bouts of depression. His part in Vincent's derangement can be limited to the fact that he brought inflammable material with him.

I take the opportunity of my first absence from the hospital to write you a few words of very deep and sincere friendship. I often thought of you in the hospital, even at the height of fever and comparative weakness.

Look here – was my brother Theo's journey really necessary, old man?

Now at least do reassure him completely, and I entreat you, be confident yourself that after all no evil exists in this best of worlds in which everything is for the best.

Then I should like you to give my kind regards to good old Schuffenecker, to refrain, until after more mature reflection on both our parts, from speaking ill of our poor little yellow house, and to remember me to the painters whom I saw in Paris. I wish you prosperity in Paris, with a good handshake.

[PS.] Roulin has been truly kind to me, it was he who had the presence of mind to make me *154* come out of that place before the others were convinced.

Please answer me. (Vincent to Gauguin, 566, 4 Jan. 1889, F.)

... You can see just what a disaster Gauguin's leaving is, because it has pushed us down again just when we had made a home and furnished it to take in our friends during bad times.

But we will keep the furniture, etc., in spite of it. And though everyone will be afraid of me now, in time that may disappear.

We are all mortal and subject to all the ailments that exist, and if the latter aren't of a particularly pleasant kind, what can one do about it? The best thing is to try to get rid of them.

I feel remorse too when I think of the trouble that, however involuntarily, I on my part caused Gauguin. But up to the last days I saw one thing only, that he was working with his mind divided between his desire to go to Paris to carry out his plans, and his life in Arles.

What will come of all this for him? . . .

Meanwhile the great thing is that your marriage should not be delayed. By getting married you will set Mother's mind at rest and make her happy, and it is after all almost a necessity in view of your position in society and in commerce. Will it be appreciated by the society to which you belong? Perhaps not, any more than the artists ever suspect that I have sometimes worked and suffered for the community. . . . So from me, your brother, you will not want banal congratulations and assurances that you are about to be transported straight into paradise. And with your wife you will not be lonely any more, which I could wish for our sister as well.

That, after your own marriage, is what I should set my heart on more than anything else. . . .

Whatever I think on other points, our father and mother were exemplary as a married couple.

And I shall never forget Mother at Father's death, when she said only one little word: it made me begin to love dear old Mother more than before. In fact, as a married couple our parents were exemplary, like Roulin and his wife, to cite another instance.

Well, take that same road. During my illness I saw again every room in the house at Zundert, every path, every plant in the garden, the views of the fields outside, the neighbours, the graveyard, the church, our kitchen garden at the back – down to a magpie's nest in a tall acacia in the graveyard.

It's because I still have earlier recollections of those first days than any of the rest of you. There is no one left who remembers all this but Mother and me. . . .

And after all I should like to go on exchanging my things with Gauguin even if sometimes it would mean a wrench to me too.

155 During your hasty visit did you see the portrait of Mme Ginoux in black and yellow? That portrait was painted in three-quarters of an hour. I must stop for the moment. . . . (573, 23 Jan. 1889, F.)

Paul Signac was the only artist to visit Vincent in hospital.

The last time I saw Vincent was in Arles in the spring of 1889. Then he was already in that town's asylum.

A few days before [sic] he had cut off the lobe of his ear under the circumstances you know of. But on the day of my visit he was quite sane, and the house physician gave me permission to go out with him. He had the famous bandage around his head and wore his fur cap. He led me to his apartments in Place Lamartine, where I saw his marvellous pictures, his

153, 164 masterpieces: *Les Aliscamps*, the *Night Café*, *La Berceuse*, the *Lock*, the *Saintes-Maries*, the *Starry Night*, etc. Imagine the splendour of those whitewashed walls, on which flowered those colourings in their full freshness.

Throughout the day he spoke to me of painting, literature, socialism. In the evening he was a little tired. There had been a terrific spell of mistral, and this may have enervated him. He wanted to drink about a quart of essence of turpentine from the bottle that was standing on the table in the room. It was high time to return to the asylum.

Next day I went to take leave of him; I went to Cassis; there he sent me a nice letter full of art and friendship, telling me how much pleasure my visit had afforded him, and illustrated with a fine drawing.

I never saw him again. . . . (Paul Signac, quoted from Gustav Cocquiot, *Vincent van Gogh*, Paris 1923; CLVG, III, 166–67.)

. . . I have seen Signac, and it has done me quite a lot of good. He was so good and straightforward and simple when the difficulty of forcing the door open presented itself – the police had closed up the house and destroyed the lock. They began by refusing to let us do it,

but all the same we finally got in. I gave him as a keepsake a still life which had annoyed the good gendarmes of the town of Arles, because it represented two bloaters, and as you know they, the gendarmes, are called that. You remember that I did this same still life two or three times in Paris, and exchanged it once for a carpet in the old days. That is enough to show you how meddlesome and what idiots these people are.

I found Signac very quiet, though he is said to be so violent; he gave me the impression of someone who has balance and poise, that is all. Rarely or never have I had a conversation with an impressionist so free from discords or conflict on both sides. For instance he has been to see Jules Dupré, and he admires him. Doubtless you had a hand in his coming to stiffen my morale a bit, and thank you for it.

I took advantage of my outing to buy a book, *Ceux de la glèbe*, by Camille Lemonnier. I have devoured two chapters of it – it has such gravity, such depth! Wait till I send it to you. This is the first time in several months that I have had a book in my hands. That means a lot to me and does a good deal toward curing me.

Altogether there are several canvases to be sent to you, as Signac could see, he was not frightened by my painting as far as I saw. Signac thought, and it is perfectly true, that I looked healthy.

And with it I have the desire and the inclination for work. Still, of course, if I had to endure my work and my private life being interfered with every day by gendarmes and poisonous idlers of municipal electors petitioning the Mayor whom they have elected and who consequently depends on their votes, it would be no more than human of me to relapse all over again. I am inclined to think that Signac will tell you very much the same thing. In my opinion we must firmly oppose the loss of the furniture, etc. Then – my Lord – I must have liberty to carry on my handicraft.

M. Rey says that instead of eating enough and at regular times, I kept myself going on coffee and alcohol. I admit all that, but all the same it is true that to attain the high yellow note that I attained last summer, I really had to be pretty well keyed up. And that after all, an artist is a man with his work to do, and it is not for the first idler who comes along to crush him for good.

Am I to suffer imprisonment or the madhouse? Why not? Didn't Rochefort and Hugo, Quinet and others set an eternal example by submitting to exile, and the first even to a convict prison? But all I want to say is that this is a thing above the mere question of illness and health.

Naturally one is beside oneself in parallel cases. I do not say equivalent, being in a very inferior and secondary place to theirs, but I do say parallel.

And that is what the first and last cause of my aberration was. Do you know those words of a Dutch poet's – 'I am attached to the earth by more than earthly ties'?

That is what I have experienced in the midst of much suffering – above all – in my so-called mental illness. . . .

I am thinking of frankly accepting my role of madman, the way Degas acted the part of a notary. But there it is, I do not feel that altogether I have strength enough for such a part.

You talk to me of what you call 'the real South'. The reason why I shall never go there is above. I rightly leave that to men who have a more well-balanced mind, more integrity than I. I am only good for something intermediate, and second rate, and self-effaced.

However intense my feelings may be, or whatever power of expression I may acquire at an age when physical passions have lessened, I could never build an imposing structure on such a mouldy, shattered past. . . . (581, 24 Mar. 1889, F.)

After having rambled along the coast, I settled in Cassis. I am sending you my address so that you can let me know how you are getting on. I have written to your brother, but he has not answered me at all. (Paul Signac to Vincent, postcard, 583a, 4 Apr. 1889, F.)

Many thanks for your postcard and the information it contained. As to my brother's not having replied to your letter, I am inclined to think that it is hardly his fault. I myself have not heard from him for a fortnight. The fact is that he is in Holland, where he is getting married one of these days.

Well, look here, without denying the least bit in the world the advantages of marriage, once it has been contracted, and of being quietly settled down in one's own home, when I think of the obsequial pomp of the reception and the lamentable congratulations on the part of the two

families (still in a state of civilization), not to mention the fortuitous appearances in those chemist's jars where the antediluvian civil and religious magistrates are kept – goodness gracious – mustn't one pity the poor wretch who is obliged, after having provided himself with the necessary documents, to repair to a locality, where, with a ferocity unequalled by the cruellest cannibals, he is married alive at a slow fire of receptions and the aforesaid funereal pomp.

I remain greatly obliged to you for your friendly and beneficial visit, which contributed considerably to raising my spirits. At present I am well, and I work at the sanatorium and its environs. I have just come back with two studies of orchards. ... (Vincent to Paul Signac, 583b, April 1889, F.)

... And now I am returning to my portrait of *La Berceuse* for the fifth time. And when you see it, you will agree with me that it is nothing but a chromolithograph from the cheap shops, and again that it has not even the merit of being photographically correct in its proportions or in anything else.

But after all, I want to make a picture such as a sailor at sea who could not paint would imagine to himself when he thinks of his wife ashore.

They are very attentive to me at the hospital these days, and this as well as many other things upsets me and makes me rather confused.

Meanwhile I imagine that you would rather get married without all the ceremony and congratulations of a wedding, and I'm quite sure in advance that you will avoid them as much as possible. ...

These last three months do seem so strange to me. Sometimes moods of indescribable mental anguish, sometimes moments when the veil of time and the fatality of circumstances seemed to be torn apart for an instant.

Certainly you are right after all, damn well right – even allowing for hope, the thing to do is to accept the probably disastrous reality. I am hoping once again to throw myself wholly into my work, in which I've fallen behind.

Oh, I must not forget to tell you a thing I have very often thought of. Quite accidentally I found in an article in an old newspaper some words written on an ancient tomb in the country between here and Carpentras.

Here is this very, very, very old epitaph, say dating from the time of Flaubert's *Salammbo*. 'Thebe, daughter of Thelhui, priestess of Osiris, who never complained of anyone.'

If you see Gauguin, you should tell him that. And I thought of a faded woman, you have the study of her at home, the woman who had such strange eyes whom I also met accidentally.

What does it mean, this 'she never complained of anyone'? Imagine a perfect eternity, why not, but don't let us forget that even in those old days reality had this – 'and she never complained of anyone'.

Do you remember that one Sunday good old Thomas came to see us and said, 'Ah but – are those the kind of women to make a man horny?'

It is not exactly a question of being horny, but from time to time in your life you feel thrilled through and through as if you were actually striking root in the soil. ... (582, 29 Mar. 1889, F.)

... I settled my bill at the hospital today, and there is still almost enough for the rest of the month out of the money I still have on deposit. At the end of the month I should like to go to the hospital in Saint-Rémy, or another institution of this kind, of which M. Salles has told me. Forgive me if I don't go into details and argue the pros and cons of such a step. ...

... What comforts me a little is that I am beginning to consider madness as a disease like any other and accept the thing as such, whereas during the crises themselves I thought that everything I imagined was real. Anyway, the fact is that I do not want to think or talk about it. You'll spare me any explanations, but I ask you and Messrs Salles and Rey to arrange things so that I can go there as a resident at the end of this month or the beginning of May.

Beginning again that painter's life I have been living, isolated in the studio so often, and without any other means of distraction than going to a café or a restaurant with all the neighbours criticizing, etc., *I can't face it*; going to live with another person, say another artist – difficult, very difficult – it's taking too much responsibility on oneself. I dare not even think of it.

So let's try three months to begin with, and afterward we shall see. ... Certainly these last

days were sad, with all the moving, taking away all my furniture, packing up the canvases that are going to you, but the thing I felt saddest about was that you had given me all these things with such brotherly love, and that for so many years you were always the one who supported me, and then to be obliged to come back and tell you this sorry tale – but it's difficult to express it as I felt it. The goodness you have shown me is not lost, because you had it and it remains for you; even if the material results should be nil, it remains for you all the more; but I can't say it as I felt it.

Meanwhile you do understand that if alcohol has undoubtedly been one of the great causes of my madness, then it came on very slowly and will go away slowly too, assuming it does go, of course. Or the same thing if it comes from smoking. ... (585, 21 Apr. 1889, F.)

Tomorrow being the first of May, I wish you a tolerable year, and above all health.

I should so like to be able to pass some physical strength on to you. At the moment I feel that I have more than enough. That doesn't mean that my head is still all that it ought to be.

How right Delacroix was, who lived on bread and wine only, and who succeeded in finding a manner of life in harmony with his profession. But the fatal question of money remains – Delacroix had property, Corot too. And Millet – Millet was a peasant and the son of a peasant. You will perhaps read with some interest the article which I have cut out of a Marseilles paper, because you will catch a glimpse of Monticelli in it, and I think the description of the picture representing a corner of the cemetery very interesting. But alas, that is still another lamentable story. How sad it is to think that a painter who succeeds, even only partially, involves in his turn half a dozen other artists who are worse failures than himself.

However, think of Pangloss, think of *Bouvard et Pécuchet*. I know it, then even that becomes clear, but perhaps these people do not know Pangloss or else forget all they know of him in the face of the fatal bite of actual despair and great grief.

And besides, under the name of optimism we are falling back once more into a religion which looks to me like the tail end of a kind of Buddhism. No harm in that; on the contrary, if you like.

I do not much like the article on Monet in the *Figaro*. How much superior that other article was in the *XIX^me Siècle*! There you saw the pictures and this only contains commonplaces that depress me.

Today I am busy packing a case of pictures and studies. ...

This study, like some others, has got spoiled by moisture during my illness.

The flood water came to within a few feet of the house, and on top of that, the house itself had no fires in it during my absence, so when I came back, the walls were oozing water and saltpetre.

That touched me to the quick, not only the studio wrecked, but even the studies which would have been a souvenir of it ruined; it is so final, and my enthusiasm to found something very simple but lasting was so strong. It was a fight against the inevitable, or rather it was weakness of character on my part, for I am left with feelings of profound remorse, difficult to describe. I think that was the reason why I have cried out so much during the attacks, it was because I wanted to defend myself and could not do it. For it was not for myself, it was just for painters like the unfortunates the enclosed article speaks of that that studio would have been of some use. ...

If I were without your friendship, they would remorselessly drive me to suicide, and however cowardly I am, I should end by doing it. There, as you too will see, I hope, is the juncture where it is permissible for us to protest against society and defend ourselves. You can be fairly sure that the Marseilles artist who committed suicide did not in any way do it as the result of absinthe, for the simple reason that no one would have offered it to him and he couldn't have had anything to buy it with. Besides, he would drink it, not solely for pleasure, but because, being ill already, he needed it to keep himself going.

M. Salles has been to Saint-Rémy – they are not willing to let me paint outside the institution, nor to take me for less than 100 francs.

This information is pretty bad. If I could get out of it by enlisting in the Foreign Legion for five years, I think I'd prefer that. ...

If I cannot work unless under surveillance! and in an institution! – Good Lord, is it worth paying money for that! Certainly in that case I could work just as well in the barracks, even

better. Anyway, I am thinking about it. You do the same. Let's remember that everything is always for the best in the best of worlds, which is not impossible. ... (588, 30 April 1889, F.)

Your kind letter did me good today, honestly – so now here's for Saint-Rémy. But I tell you once more, if on consideration and after consulting the doctor it should perhaps be either necessary or simply advisable and wise to enlist, let's give it the same consideration as everything else and have no prejudice against it. That's all! You must put aside any idea of sacrifice in it. The other day I again wrote our sister that all through my life, or at least most of it, I have sought something other than a martyr's career, for which I am not cut out.

If I find trouble or cause it, honestly, I am aghast at it. Certainly I should respect, I should heartily admire martyrs and the like, but you must know that in *Bouvard et Pécuchet*, for instance, there's something very different which accords better with these little lives of ours. ...

I see in the papers that there are some good things at the Salon.

Listen – do not become completely and exclusively impressionist; after all, if there is good in anything, don't let's lose sight of it. Certainly colour is progressing *primarily under the influence of* the impressionists, even when they go astray, but already Delacroix had reached more completeness than they.

And confound it all, Millet, who has hardly any colour, what work it is!

Madness is salutary in that one becomes less exclusive. ...

Ah, to paint figures as Claude Monet paints landscapes! That still, in spite of everything, remains to be done, unless one is to see only Monet in all the impressionists. For after all, in figure Delacroix, Millet, and several sculptors have done far better work than the impressionists and even J. Breton. In short, my boy, let's be fair, and, while withdrawing: I tell you whenever we think we are getting too old to class ourselves with the younger men, let us remember that in our time we have loved Millet, Breton, Israëls, Whistler, Delacroix and Leys.

And I'm quite sure that for my part I am pretty well convinced that I shall see no future beyond that, nor desire one.

Now society being what it is, we naturally cannot wish that it should conform to our personal needs. And so, though I am very, very glad to be going to Saint-Rémy, nevertheless it would be really fairer to men like myself to shove them into the Legion.

We can do nothing about it, it's more than likely that they would turn me down, at least here where what has happened to me is too well known, and above all exaggerated. I say this very, very seriously; physically I am better than I have been in years and years, and I could quite well be a soldier. Let's think this over again, even though I'm going to Saint-Rémy. ...

[PS.] ... So many distinctions in impressionism have *not* the importance that people have chosen to see in them. ...

They have lots of room here in the [Arles] hospital, there would be enough to make studios for a score or so of painters.

I really must make up my mind, it is only too true that lots of painters go mad, it is a life that makes you, to say the least, very absent-minded. If I throw myself fully into my work again, very good, but I shall always be cracked.

If I could enlist for five years, I should recover considerably and be more rational and more master of myself.

But one way or the other, it's all the same to me. ... (590, 3 May 1889, F.)

> 140 *Self-portrait*, Sept. 1888
> Dedicated *à mon ami Paul Gauguin*. To his sister Willemien
> he wrote of doing a self-portrait 'in which I look like a
> Japanese' (W7); and to Theo he described it as 'almost
> *colourless*, in grey tones against a background of pale
> malachite' (537). To the dedicatee, Gauguin, he wrote of it
> as 'all ash-coloured. ... I also exaggerate my personality
> ... aimed at the character of a simple Bonze, worshipping
> the Eternal Buddha' (see also *147*). In one of his last Paris
> self-portraits (*117*) he was already conscious of a certain
> decay. This, the first painted at Arles, shows him in an
> even worse state, recalling Job 10.8: 'Thine hands have
> made me and fashioned me together round about; yet thou
> dost destroy me.'

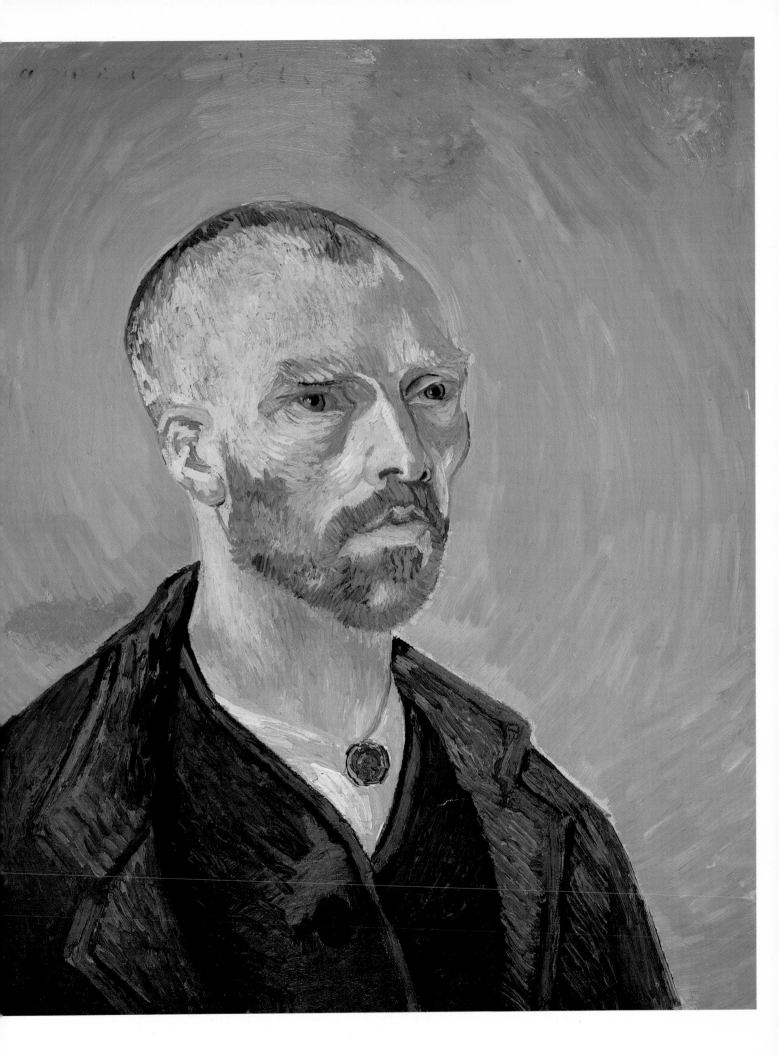

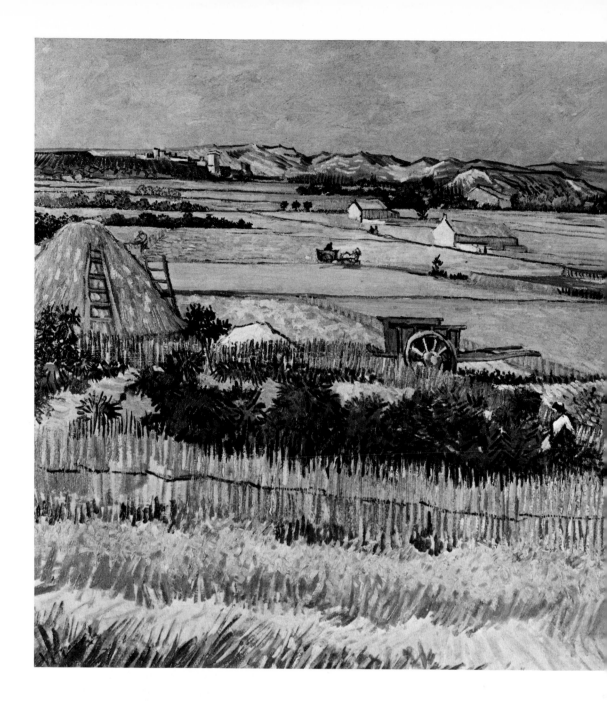

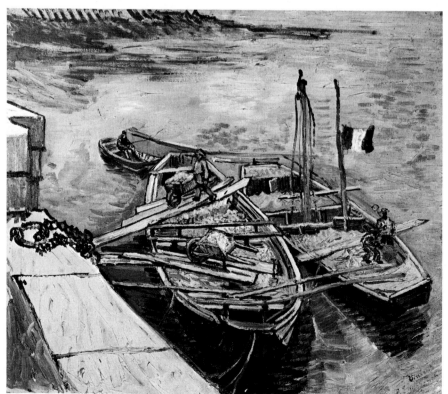

141 Harvest, La Crau, with Montmajour in the Background,
June 1888
Charles Mauron, in *Van Gogh au seuil de la Provence* (1959),
wrote: 'Japan is no longer, for Vincent, simply "The land
of gay colours", of colour prints, but that of Buddhist
wisdom.' This is the link between the monk-like *Self-
portrait* (previous page) and this lucid landscape, with its
Dutch, Provençal and Japanese echoes.

Opposite page:
142 Boats with Men unloading Sand, Aug. 1888
'All of it seen from the quay above,'
Vincent wrote to Bernard. 'No sky; it is
only a sketch or rather a scribble, done
during the full violence of the Mistral'
(B15). A scribble, but a masterpiece of
drawing with colour; it shows an
unhesitating hand and eye. The tension of
the outlines is stronger than that of a
Japanese woodcut.

Above:
**143 The Poet's Garden: Sunshine in the
Park,** Sept. 1888
September 1888 was a month in which
ecstatic states alternated with deep
depressions. His style varied from a light
Parisian (positive) Impressionism to a
bright, clear, lucid realism.
144 The Stevedores, end Aug. 1888

179

Sunflowers and sun

145 Sunflowers on the road from Arles to Tarascon, 1981
146 *The Road to Tarascon: Sky with Sun*, Aug. 1888

Since the destruction by fire, in 1945, of the wonderful
painting *Vincent on the Road to Tarascon* (F448), we are all
the more fortunate in the existence of this drawing. It is
astonishingly rich in different manners of drawing: ovals,
short straight lines, curves, a dance of dots and dashes of
different lengths, and stippling, together with a sun which
can only be described as an enormous vibration. The man
Vincent is invisible, but he is there.

147 Paul Gauguin. *Vincent Painting Sunflowers*, autumn
1888
148 *Fourteen Sunflowers*, summer 1888

Vincent started painting sunflowers in 1888 to decorate the
Maison Jaune to receive Gauguin. Gauguin, as a true
Symbolist, chose to paint an exhausted Vincent still
painting sunflowers out of season.

181

Profusion and rhythm

149 *A Garden*, July 1888
Van Gogh drew three different gardens at Arles; this is one
of which he also made painted studies. The rich profusion
of alternative means of suggesting detail – which is not,
however, really detail at all, but a celebration of the
luxuriant growth of grass and flowers – has been seen
already in *The Road to Tarascon* (146).

150 *Sailing Boats Coming Ashore*, 2nd half June 1888
151 *Street at Saintes-Maries-de-la-Mer*, 2nd half June 1888
The same graphic richness reappears in the drawings, also
done with a reed pen (a Japanese implement), which he
made on his only visit to the Mediterranean, at Saintes-
Maries. The drawing is almost an abstract rhythm; reality
is subordinated to the musical imagination.

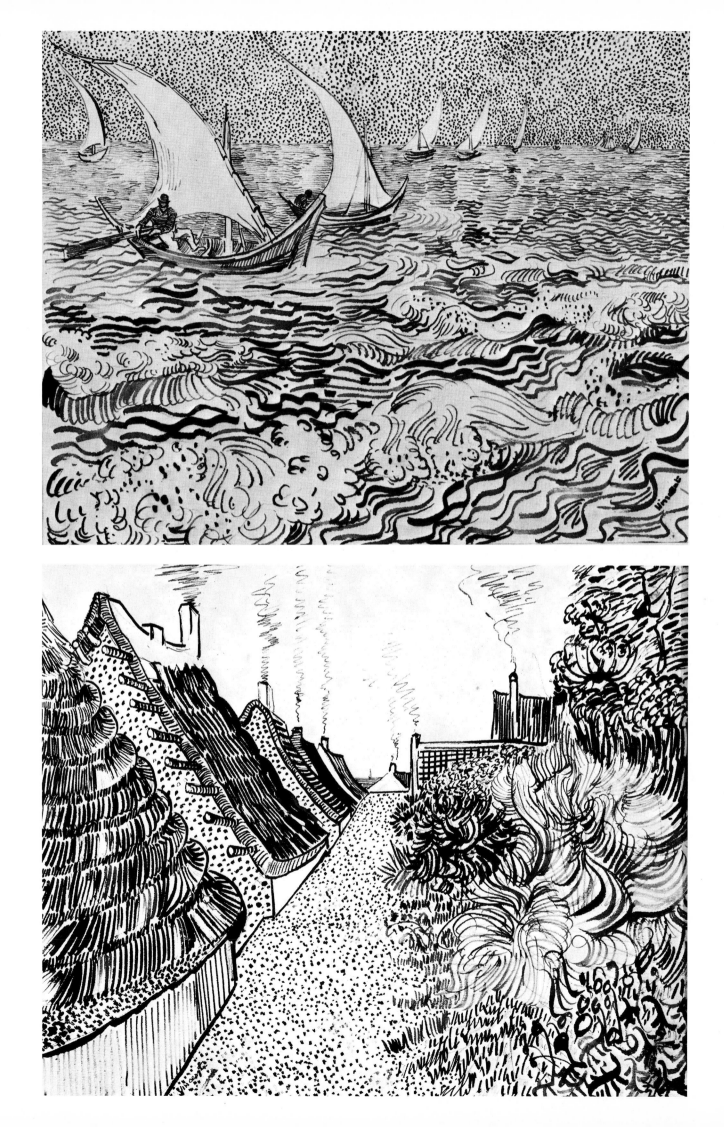

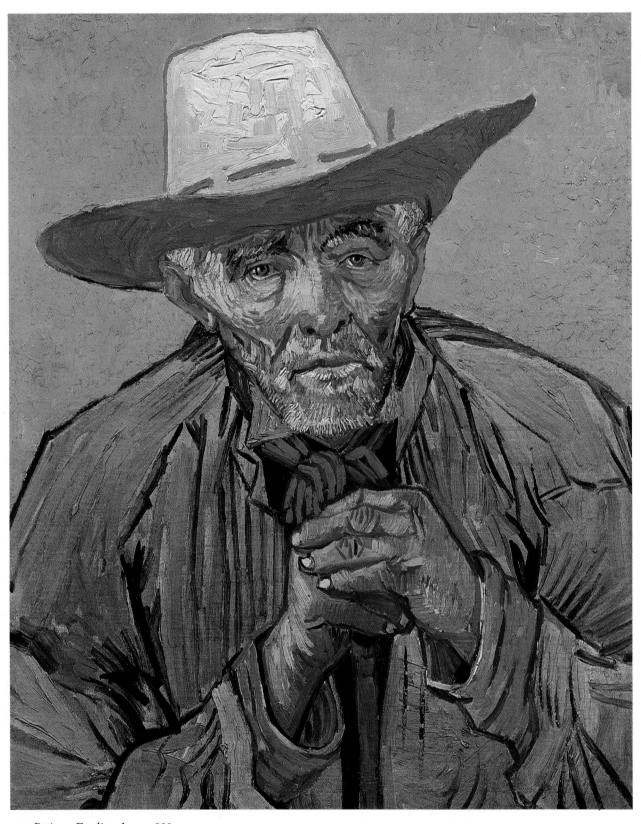

152 Patience Escalier, Aug. 1888

Vincent was linked by close friendship to four of the sitters for these paintings. The fifth, Patience Escalier, was a shepherd and gardener whom he saw in the Night Café (*164*); 'sunburned quality, tanned and airswept' (520). He remarked on the unlovely traces of uncertainty and weariness in Escalier's face, the 'vagueness of the mouth' associated with a 'terrible resemblance' to Vincent's own father. The resulting portrait has 'something of the eternal which the halo used to symbolize' (531).

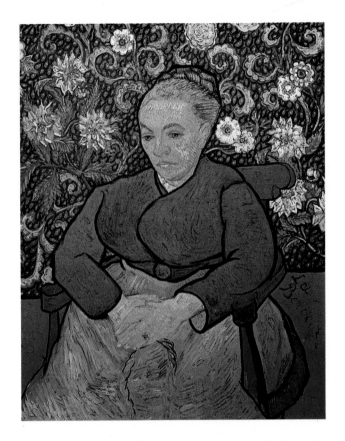

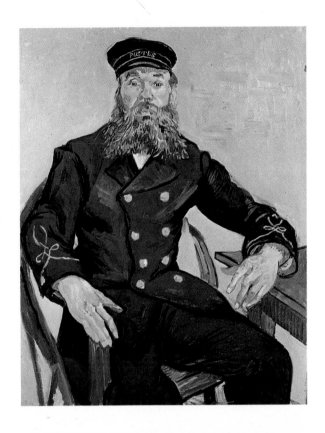

153 *La Berceuse: Mme Augustine Roulin*, Jan 1889

154 *Joseph Roulin Seated at a Table*, Aug. 1888

155 *L'Arlésienne: Madame Ginoux*, Nov. 1888

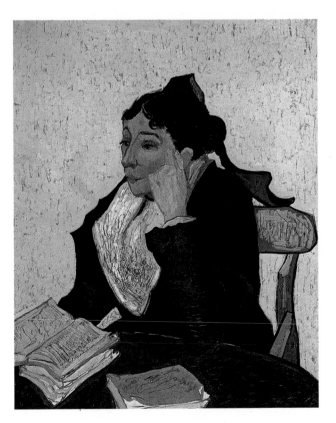

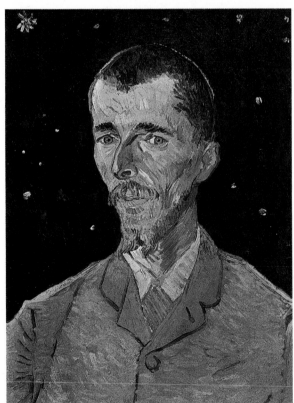

156 *The Poet: Eugène Boch*, Sept. 1888

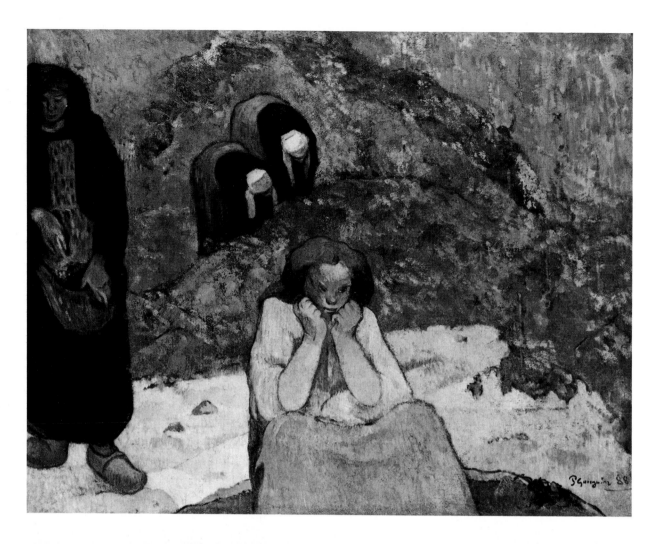

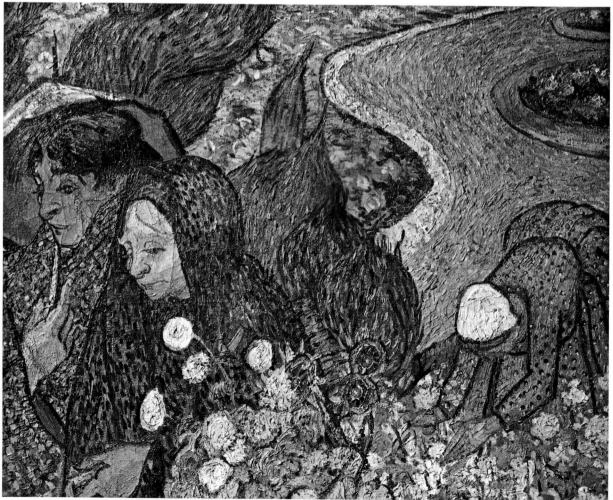

Gauguin

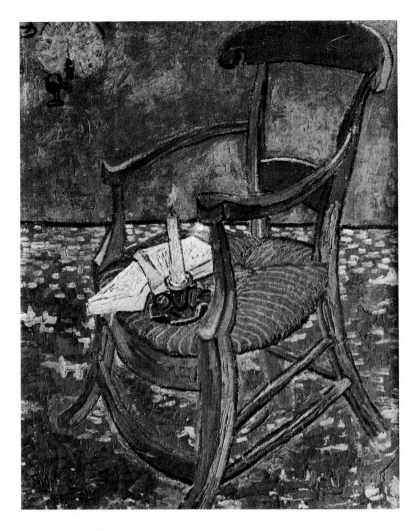

157 Paul Gauguin. *Vineyard at Arles with Breton Women*, 1888
158 *Memory of the Garden at Etten*, Nov. 1888

159 *Gauguin's Chair, Candle and Books (The Empty Chair)*, Dec. 1888
160 *Vincent's Chair with his Pipe and Tobacco Pouch*, Dec. 1888–Jan. 1889

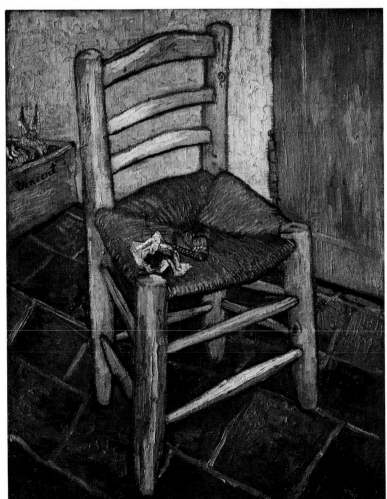

These four paintings, which date from the period in which the two painters lived together at the Maison Jaune, reflect their shared life, and their impassioned and often stormy discussions of the current issues of art. The two *Empty Chairs*, deliberately contrasted, must be seen in the context of Vincent's own early reactions to empty chairs: the Fildes engraving (*36*); his tears at the sight of the empty chair his father had occupied during a visit to Amsterdam. Here symbolic and realistic feeling are in perfect balance, along with painterly expression through colour. Albert Aurier was right to stress Vincent's capacity to create modern symbols. The *Garden at Etten* was another combination of memory, sorrow, current poetic feelings, and imagination in the absence of the motif (Gauguin's advice to Vincent). For both artists, at times, a true, symbiotic collaboration was imminent. Vincent's tragic act of self-inflicted violence on 23 December brought the episode to a dramatic end.

187

'A devilish yellow'

161 The Maison Jaune, before its destruction in the Second World War. Vincent rented the wing on the right before it became a *Bar-Tabac*

162 Vincent's House on the Place Lamartine, Arles (The Yellow House), Sept. 1888

163 Vincent's Bedroom in the Maison Jaune, Oct. 1888
164 The Night Café, Sept. 1888

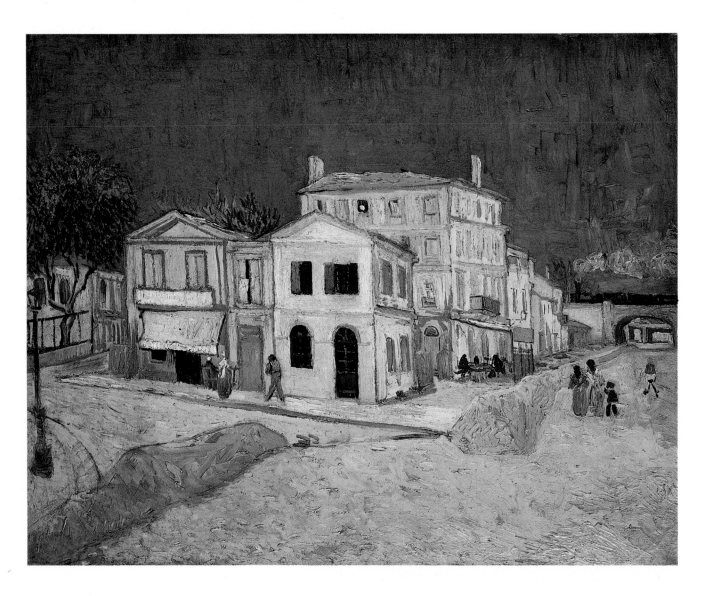

Right:
In September and October 1888 Vincent still spoke of harmony and consolation, but cannot have been aware of the intensity of his colours: he felt that *Vincent's Bedroom* was suggestive 'of rest or of sleep in general'. *The Night Café*, on the other hand, is 'a place where one can ruin oneself, go mad or commit a crime' (533).

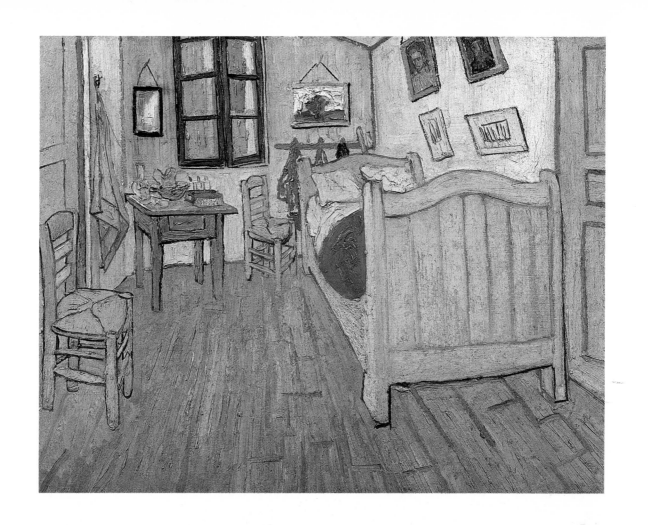

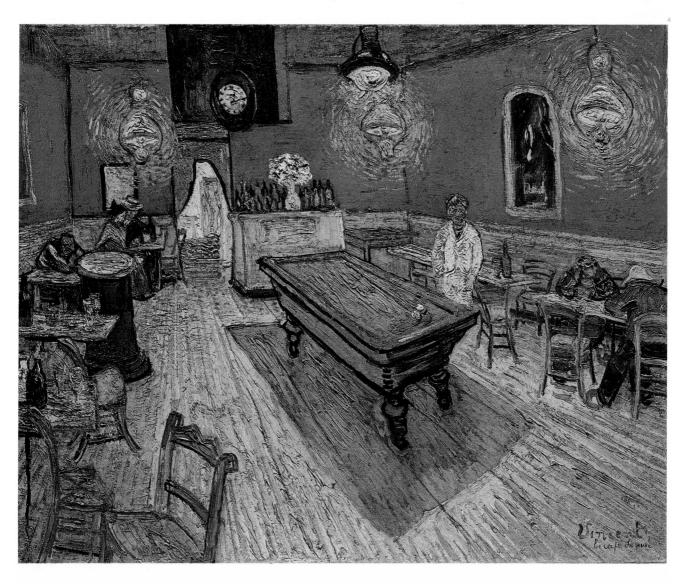

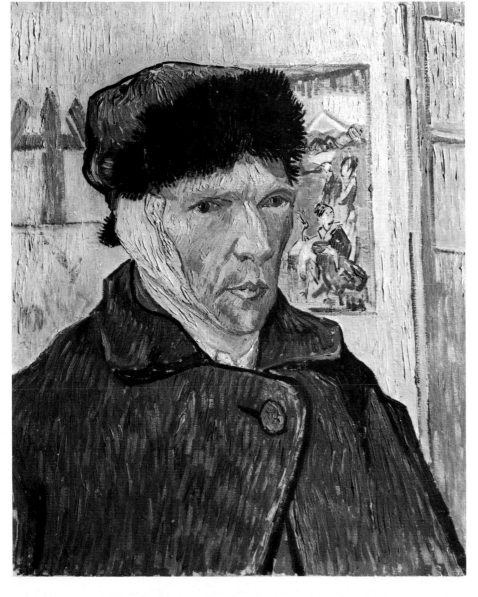

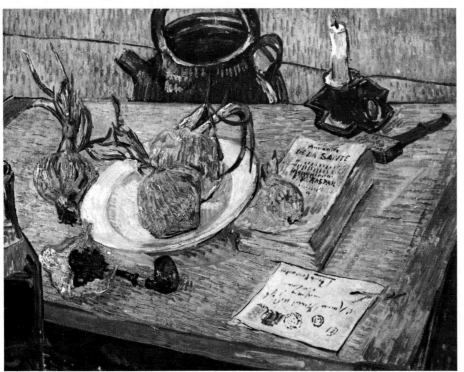

165 *Self-portrait with Bandaged Ear*, Jan. 1889
166 *Still-life on Table, with Book, Pipe, Candle, Letter and Onions*, Jan. 1889
167 *The Hospital Ward, Arles*, Apr.–Oct. 1889

All three works were painted in his studio at Arles after his stay in the local hospital and before he left for the hospital at Saint-Rémy; there he finished from memory the picture of the hospital ward. He was preoccupied with himself, his sickness, his state of mind and appearance (the mirror); everything around him, every object he painted, was an object of deep and more than purely artistic concern. The still-life is composed only of things with a special relation to his health; the book a health directory belonging to Dr Rey, the pipe a mainstay of his defences against depression. Arles continued to preoccupy him even at Saint-Rémy; he wanted to go back to see the people he loved. At the Maison Jaune he had tried to strike deep roots in this small Provençal town, which makes his enforced departure all the more tragic.

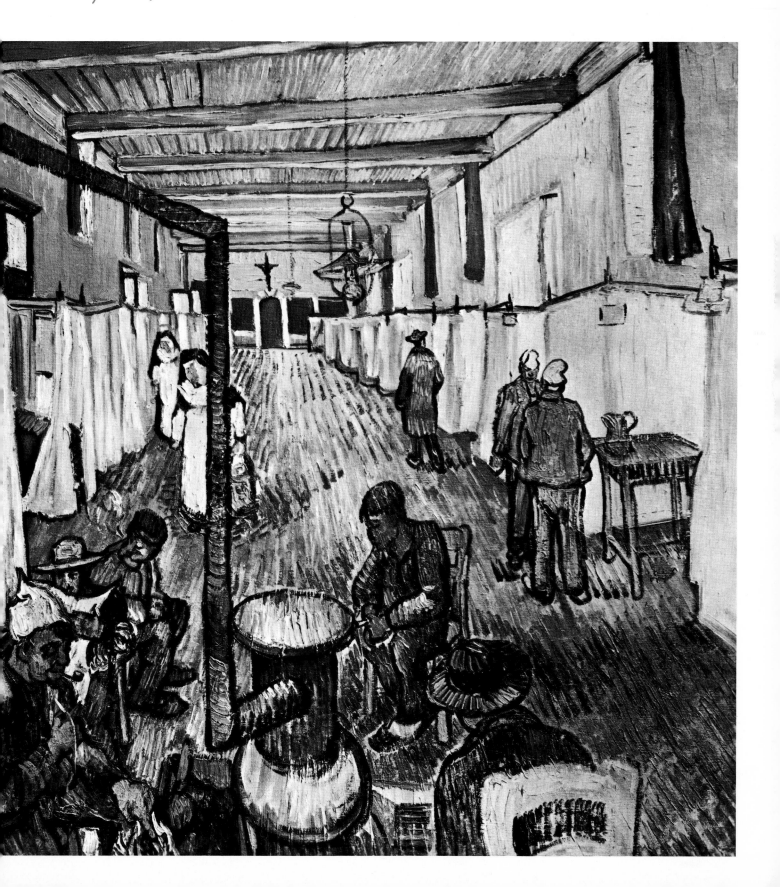

A hospital garden

168 Courtyard of the Arles hospital, 1981
169 *Courtyard of the Arles Hospital*, Apr.–
May 1889

In Paris Vincent had been too preoccupied
with theories of colour to attach great
significance to his drawings. His great
period of drawing seemed to be behind
him, with the peasants at Nuenen. In
Arles, we see the Impressionist context
disappear, the Japanese influence grow;
and there is a reconsideration of his Dutch
problems. His drawing in Arles is partly
classical: strong, sure, profoundly realistic.
After the late summer of 1888, something
happened inwardly. This drawing of the
hospital courtyard, a late Arles work,
shows a baroque movement, line more
freed from form, detail less important than
a constantly interrupted rhythm.

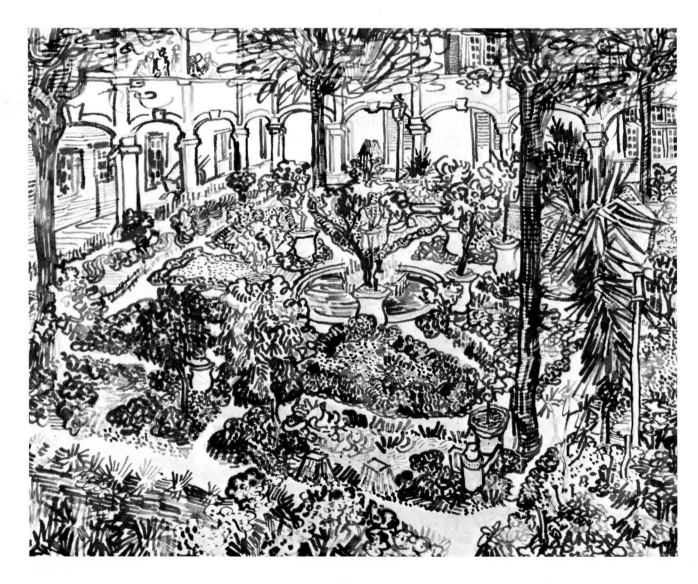

V

SAINT-RÉMY AND AUVERS

'Well, my own work, I am risking my life
for it and my reason has half foundered'

1889–1890 Saint-Rémy-de-Provence
1890 Auvers-sur-Oise

Life at Saint-Rémy meant struggling against the enclosed environment of the mental institution which Vincent believed himself to need. It was a struggle against his sickness, a struggle to save and preserve his creative powers through repeatedly interrupted, and sometimes forbidden, contacts with the overwhelming scenery beyond: 'I shall not conceal from you that being here is highly tedious, because of the monotony, and because the company of these unfortunates who do absolutely nothing is enervating' (614).

Time and again Vincent was insidiously debilitated by the destructive forces of his illness. Its roots lie in his childhood. This is a complex problem, since we are concerned with neurosis and, from his days at Arles onwards, with psychosis. According to Jean Delay's definition, neurosis is the psychological exaggeration of a character, a deviation which does not affect the personality or cause intellectual defects but leaves a way for suppressed energy and unbalanced emotions to escape from an impasse. Psychosis, however, is an organic process which does not benefit creativity. The personality is affected, intellectual deterioration takes place, and existing creative powers are checked (see the inaugural lecture by Professor Jean Delay, Paris, 'Névrose et création'; *Congrès des médecins aliénistes et neurologistes*, Liège, 19–26 July 1954, Masson, Paris).

It is disconcerting to find how precise an awareness Vincent had of what he experienced, heard and saw even when in a state of great emotional agitation. Even before those phenomena, which sprang from the unconscious and became conscious, were subjected to rational interpretation and suppression, Van Gogh dropped hints about them, sometimes breaking off and refusing to write more 'for fear of a relapse'. Vincent continued to work through his crises, except only at his worst periods, when his head felt empty, his energy had disappeared and the action involved in writing, reading and working became impossible. His great fear was that ultimately his creative powers might be affected. He himself mentioned that, despite the great effort involved, he had managed to complete several works and had even had ideas for new ones.

According to his letters, his stay at Saint-Rémy was marked by a constant preoccupation with attempts to account for his presence there. An 'accident like any other', he thought, but his reflections on the subject were sometimes cut short by irrational fear and horror. It was living on the borderline, and in the grip, of reason; living in the grip also of the community that was controlled by reason to the extent that was possible. And then suddenly again he was across the borderline, existing in a time and in a space in which the most violent emotions changed the image of time and space themselves. Vertiginous and mortal fears assailed him then.

Symptoms usually associated with schizophrenia occurred, but they were contradicted by others. He viewed things, as always, symbolically; he foresaw a catastrophic future for the world, but he was not subject to delusions in the medical sense. Similarly, with epilepsy: he knew it ran in his mother's family, but his symptoms were not conclusive proof of its presence.

Since Vincent managed time and again to transcend his syndrome, thereby eluding a whole succession of varying scientific diagnoses, the wisest opinion seems to me to be that of Jean Delay. He bases his views on writers, not on painters, but they apply to the relationship between neurosis and creativity in general. Delay said that the same phenomena that in some individuals can cause a neurosis to end in disaster can, in the case of certain gifted people, be transmuted into something of rare value. In these individuals – and this could

apply literally to Van Gogh – all conflict is so intensely experienced (*vécu*) that it approaches the borderline of a crisis. In Arles, it seems to me, Vincent went over into a crisis of this kind, which at Saint-Rémy gained lasting, but intermittent, control over his life. Again and again he reverted to a state of neurosis, in which his powers of thought were unimpaired and his personality undistorted, and in which he was able to restore the disturbed equilibrium in his work.

... It is rather queer perhaps that the result of this terrible attack is that there is hardly any very definite desire or hope left in my mind, and I wonder if this is the way one thinks when, with the passions lessened, one descends the hill instead of climbing it. And anyhow, my sister, if you can believe, or almost believe, that everything is always for the best in the best of worlds, then perhaps you will also be able to believe that Paris is the best of the cities in it.

Have you noticed that the old cab horses there have large beautiful eyes, as heartbroken as Christians sometimes have? However it may be, we are neither savages nor peasants, and it is perhaps *even a duty* to like civilization (so called). ...

It may well be that I shall stay here long enough – I have never been so peaceful as here and in the hospital in Arles – to be able to paint a little at last. Quite near here there are some little mountains, grey and blue, and at their foot some very, very green cornfields and pines. ...
(Vincent to Jo van Gogh-Bonger, 591, 9 May 1889, F.)

... I am again – speaking of my condition – so grateful for another thing. I gather from others that during their attacks they have also heard strange sounds and voices as I did, and that in their eyes too things seemed to be changing. And that lessens the horror that I retained at first of the attack I have had, and which, when it comes on you unawares, cannot but frighten you beyond measure. Once you know that it is part of the disease, you take it like anything else. If I had not seen other lunatics close up, I should not have been able to free myself from dwelling on it constantly. For the anguish and suffering are no joke once you are caught by an attack. Most epileptics bite their tongue and injure themselves. Rey told me that he had seen a case where someone had mutilated his own ear, as I did, and I think I heard a doctor here say, when he came to see me with the director, that he also had seen it before. I really think that once you know what it is, once you are conscious of your condition and of being subject to attacks, then you can do something yourself to prevent your being taken unawares by the suffering or the terror. Now that it has gone on decreasing for five months, I have good hope of getting over it, or at least of not having such violent attacks. There is someone here who has been shouting and talking like me *all the time* for a fortnight, he thinks he hears voices and words in the echoes of the corridors, probably because the nerves of the ear are diseased and too sensitive, and in my case it was my sight as well as my hearing, which according to what Rey told me one day is usual in the beginning of epilepsy. Then the shock was such that it sickened me even to move, and nothing would have pleased me better than never to have woken up again. At present this *horror of life* is less strong already and the melancholy less acute. But I have no *will*, hardly any desires or none at all, and hardly any wish for anything belonging to ordinary life, for instance almost no desire to see my friends, although I keep thinking about them. That is why I have not yet reached the point where I ought to think of leaving here; I should have this depression anywhere.

And it is only during these very last days that my aversion to life is in any way being radically modified. There is still some way to go from that to will and action. ... (592, 25 May 1889, F.)

Vincent regarded with some scepticism a new 'sect' which included artists such as Gauguin, Bernard and Anquetin. He was referring to Cloisonnism, *119, 129, 157* first considered critically at the 1981 exhibition in Toronto and Amsterdam organized by Bogomila Welsh-Ovcharov, and in studies based on the exhibition.

... The thing is that among the number of things you make, there are always some that you have felt more or put more into and that you want to keep in spite of everything. When I see a

picture that interests me, I can never help asking myself, 'In what house, room, corner of a room, in whose home would it do well, would it be in the right place?'

Thus the pictures of Hals, Rembrandt, Van der Meer [Vermeer], are only at home in an old Dutch house.

Now as to the impressionists – once again, if an interior is not complete without a work of art, neither is a picture complete if it is not in harmony with surroundings originating in and resulting from the period in which it was produced. And I do not know if the impressionists are better than their time or, on the contrary, are not yet so good. In a word, are there minds and interiors of homes more important than anything that has been expressed by painting? I am inclined to think so.

I have seen the announcement of a coming exhibition of impressionists called Gauguin, Bernard, Anquetin and other names. So I am inclined to think that a new sect has again been formed, no less infallible than those already existing.

Was that the exhibition you spoke of? What storms in teacups.

My health is all right, considering; I feel happier here with my work than I could be outside. By staying here a good long time, I shall have learned regular habits and in the long run the result will be more order in my life and less susceptibility. That will be so much to the good. ... (594, *c*. 9 June 1889, F.)

... Thank you very much for the package of colours. Subtract them from the order sent since, but if you could manage it *not* for the quantity of white. Thank you also very heartily for the Shakespeare. It will help me not to forget the little English I know, but above all it is so fine. I have begun to read the series of which I knew least, which formerly, distracted by other things or not having the time, I could not read; the series of the kings: I have already read *Richard II*, *Henry IV* and half of *Henry V*. ...

And so what Rembrandt has alone or almost alone among painters, that tenderness of gaze which we see, whether in the *Men of Emmaus* or in the *Jewish Bride* or in some such strange angelic figure as the picture you have had the good fortune to see, that heartbroken tenderness, that glimpse of a superhuman infinitude that seems so natural there – in many places you come upon it in Shakespeare too. And then above all he is full of portraits, grave or gay, like *Six* and like the *Traveller*, and like *Saskia*.

When I think of the impressionists and of all the problems of art nowadays, what lessons there are for us in that very thing. ...

If they dare call themselves primitives, certainly they would do well to learn a little to be primitives as *men* before pronouncing the word primitive as a title, which would give them a right to anything whatever. But as for those who may be the cause of the impressionists' unhappiness, well, they are in a pretty serious predicament, even though they make light of it. ...

How fine Zola's books will continue to be, just because there is life in them.

What has life in it too is that Mother is glad that you are married, and I think that this cannot be unpleasant to yourselves, you and Jo. But the separation from Cor will be harder on her than one can imagine. It is just in learning to suffer without complaint, in learning to look on pain without repugnance, that you risk vertigo, and yet it is possible, yet you may even catch a glimpse of a vague likelihood that on the other side of life we shall see good reason for the existence of pain, which seen from here sometimes so fills the whole horizon that it takes on the proportions of a hopeless deluge. We know very little about this, about its proportions, and it is better to look at a wheat field, even in the form of a picture. ... (597, 30 June–4 July 1889, F.)

... Old man – don't let's forget that the little emotions are the great captains of our lives, and that we obey them without knowing it. ... Don't forget henceforth that neither our spleen and melancholy, nor yet our feelings of good nature and common sense, are our sole guides, and above all not our final guardians; and if you find yourself faced with heavy responsibilities to be risked if not undertaken, honestly, let's not be *too* much concerned about each other. ... (603, 6 July 1889, F.)

He retained his urge to work even when fresh attacks occurred.

I thank Jo very much for having written, and knowing that you want me to drop you a line, I must let you know that it is very difficult for me to write, my head is so disordered. So I am taking advantage of an interval. Dr Peyron is very kind to me and very patient. You can imagine that I am terribly distressed because the attacks have come back, when I was already beginning to hope that it would not return.

It would perhaps be a good thing if you wrote a few words to Dr Peyron to tell him that working on my pictures is almost a necessity for my recovery, for these days without anything to do, and without being able to go to the room they had allotted me to do my painting in, are almost unbearable.

(My friend Roulin has written me too.)

I have received a catalogue of the Gauguin, Bernard, Schuffenecker, etc., exhibition, which I find interesting. Gauguin has also written a kind letter, though a little vague and obscure, but after all I must say that I think they are right to have an exhibition among themselves.

For many days *my mind has been absolutely wandering*, as in Arles, quite as much if not worse, and presumably the attacks will come back again in the future; it is *abominable*.

For four days I have been unable to eat because of a swollen throat.

I hope it is not complaining too much if I tell you these details, but I do it to show you that I am not yet in a condition to go to Paris or to Pont-Aven, unless it were to Charenton. I no longer see any possibility of having courage or hope, but after all, it wasn't just yesterday that we found this job of ours wasn't a cheerful one. . . . (601, *c.* 17 Aug. 1889, F.)

He made no reference to thoughts of suicide, but his physician, Dr Peyron, mentioned them to Theo in a note enclosed with Vincent's letter of 3/4 September.

I add a few words to your brother's letter to inform you that he has quite recovered from a crisis, that he has completely regained his lucidity of mind, and that he has resumed painting as he used to do. His thoughts of suicide have disappeared, only disturbing dreams remain, but they tend to disappear too, and their intensity is less great. His appetite has returned, and he has resumed his usual mode of life. (Dr Peyron to Theo, 602a, 3/4 Sept. 1889, F.)

There is coherence between his despondency about the series of attacks and the irresistible re-emergence of his old longing for the North, in which the word 'North' has both personal and aesthetic connotations. He wanted to rid himself of the Impressionistic palette and see what he could achieve again with greys.

. . . Your telling me of Maus having been to see my canvases made me think a good deal about the Belgian painters just now and during my illness.

Then memories overwhelmed me like an avalanche, and I tried to reconstruct that whole school of modern Flemish artists, until I was as homesick as a lost dog.

Which does no good, because our way lies – forward, and retracing one's steps is forbidden and impossible. I mean, we can think about the past without letting ourselves be drowned in too sad a longing. . . .

Well, Henri Conscience is by no means a perfect writer, but here and there, and a little everywhere, what a painter! And what human kindness in what he said and intended. I have a preface of his in my head all the time (that of *Le Conscrit*), in one of his books where he says that he had been very ill and that during his illness, in spite of his efforts, he felt his affection for men grow faint, and that on long walks in the open fields his feeling of love returned. This fatality in suffering and despair – there, I wound up again for another spell – I thank him for it.

I am writing this letter little by little in the intervals when I am tired of painting. Work is going pretty well – I am struggling with a canvas begun some days before my indisposition, a *Reaper*; the study is all yellow, terribly thickly painted, but the subject was fine and simple. For I see in this reaper – a vague figure fighting like a devil in the midst of the heat to get to the end of his task – I see in him the image of death, in the sense that humanity might be the wheat he is reaping. So it is – if you like – the opposite of that sower I tried to do before. But there's

nothing sad in this death, it goes its way in broad daylight with a sun flooding everything with a light of pure gold. . . .

My dear brother – it is always in between my work that I write to you – I am working like one actually possessed, more than ever I am in a dumb fury of work. And I think that this will help cure me. Perhaps something will happen to me like what Eug. Delacroix spoke of, 'I discovered painting when I no longer had any teeth or breath left', in the sense that my distressing illness makes me work with a dumb fury – very slowly – but from morning till night without slackening – and – the secret is probably this – work long and slowly. . . .

115–17

. . . And you will see this when you put the portrait with the light background that I have just finished next to the self-portraits in Paris, and that I look saner *now* than I did then, even much more so.

I am even inclined to think that the portrait will tell you how I am better than my letter, and that it will reassure you – it cost me some trouble to do. And then the *Reaper* is getting on, too, I think – it is very, very simple. . . .

There! The *Reaper* is finished, I think it will be one of those you keep at home – it is an image of death as the great book of nature speaks of it – but what I have sought is the 'almost smiling'. It is all yellow, except a line of violet hills, a pale fair yellow. I find it queer that I saw it like this from between the iron bars of a cell. . . . (604, 5–6 Sept. 1889, F.)

Although resisting the idea of being a martyr, he had some highly emotional thoughts about early Christians. His Adamism, his desire for a return to the origin of things, his liberation from the Church, re-awakened his weakened religious sentiments but now in a wider sense.

153

. . . And I must tell you – and you will see it in *La Berceuse*, however much of a failure and however feeble that attempt may be – if I had had the strength to continue, I should have made portraits of saints and holy women from life who would have seemed to belong to another age, and they would be middle-class women of the present day, and yet they would have had something in common with the very primitive Christians.

However, the emotions which that rouses are too strong, I shall stop at that, but later on, later on I do not say that I shall not return to the charge. . . . (605, 7 Sept. 1889, F.)

His critical faculties had remained intact. Dissatisfaction with his work referred particularly to *lines*, if these were impersonal or insensitive. He wanted them to be tauter and more considered. His ideas on Cloisonnism also came into this to some extent: here he is in agreement with Gauguin and Bernard.

. . . I am adding a study of flowers to the roll of canvases – nothing much, but after all I do not want to tear it up.

Altogether I think nothing in it *at all* good except the *Field of Wheat*, the *Mountain*, the *Orchard*, the *Olives* with the blue hills and the portrait and the *Entrance to the Quarry*, and the rest tells me *nothing*, because it lacks individual intention and feeling in the lines. Where these lines are tight and deliberate it begins to be a picture, even if it is exaggerated. That is a little what Gauguin and Bernard feel, they do not ask the correct shape of a tree at all, but they do insist that one can say if the shape is round or square – and honestly, they are right, exasperated as they are by certain people's photographic and fatuous perfection. They will not ask the correct tone of the mountains, but they will say: By God, the mountains were blue, were they? Then chuck on some blue and don't go telling me that it was a blue rather like this or that, it was blue, wasn't it? Good – make them blue and it's enough! . . . (607, 19 Sept. 1889, F.)

The idea of the North haunted him. Theo had found the address of a Dr Paul Gachet, at Auvers-sur-Oise, north of Paris; Vincent might be able to live there under his supervision. Vincent hesitated between desire to leave as soon as possible after an attack and fear of leaving too soon.

205

... If I come North, even supposing that there were no room at this doctor's house, it is probably that after your recommendation and old Pissarro's he would find me board either with a family or quite simply at an inn. The main thing is to know the doctor, so that in case of an attack I do not fall into the hands of the police and get carried off to an asylum by force.

And I assure you that the North will interest me like a new country. ... (609, 5 Oct. 1889, F.)

The minor Dutch painter J.J. Isaäcson wrote an article which mentioned (in a footnote) some works by Vincent which he had seen in Theo's apartment. Vincent, disturbed perhaps by the vein of shallow mysticism which runs through Isaäcson's work, took no pleasure in this first taste of publicity.

... M. Peyron has told me again that there is a considerable improvement and that he has good hopes for me – and that he has no objection to my going to Arles just now.

And yet very often terrible fits of depression come over me, and besides the more my health comes back to normal, the more my brain can reason coldly, the more foolish it seems to me, and a thing against all reason, to be doing this painting which costs us so much and brings in nothing, not even the outlay. Then I feel very unhappy, and the trouble is that at my age it is damnably difficult to begin anything else.

In some Dutch newspaper which you put in with the Millets – I notice some Paris letters that I attribute to Isaäcson.

They are very subtle and one guesses the author to be a sorrowful creature, restless, with a rare tenderness – a tenderness which makes me instinctively think of H. Heine's *Reisebilder*.

No need to tell you that I think what he says of me in a note extremely exaggerated, and that's another reason why I should prefer him to say nothing about me. And in all these articles I find, side by side with very fine things, something, I don't quite know what, that seems to me unhealthy. ... (611, *c.* 25 Oct. 1889, F.)

Van Gogh made no secret of his criticism of contemporary adaptations of the symbols of Christ by Bernard and Gauguin. In his opinion they painted Christ in the Garden of Olives without understanding olive trees; he could convey his own mystical experiences by painting the trees alone. Supported by the example of Puvis de Chavannes, he wanted to prove that in this way he could paint sentiments that were both ancient and modern. He was at this time working long hours and slowly. His mania for speed was a thing of the past.

... The thing is that this month I have been working in the olive groves, because their *Christs in the Garden*, with nothing really observed, have got on my nerves. Of course with me there is no question of doing anything from the Bible – and I have written to Bernard and Gauguin too that I considered that our duty is thinking, not dreaming, so that when looking at their work I was astonished at their letting themselves go like that. For Bernard has sent me photos of his canvases. The trouble with them is that they are a sort of dream or nightmare – that they are erudite enough – you can see that it is someone who is gone on the primitives – but frankly the English Pre-Raphaelites did it much better, and then again Puvis and Delacroix, much more healthily than the Pre-Raphaelites. ... (615, *c.* 18 Nov. 1889, F.)

... Only we mustn't forget that an old crock is an old crock and so in no case do I have the right to any pretensions. I think that at home in Holland they always value painting more or less, so that an institution would hardly object to letting me do it. However, over and above painting, it would be important to have the opportunity for an occupation, and it would cost less. Hasn't the country, and working in it, always been to our taste? And aren't we rather indifferent, you as much as I, to the life of a big city? ...

So that means that I do not hesitate to make copies. I should so much like, if I had time to travel, to copy Giotto's work, that painter who would be as modern as Delacroix, if he were not primitive, yet so different from the other primitives. However, I have not seen much of his work, but there is one piece which is comforting. ... (623, Jan. 1890, F.)

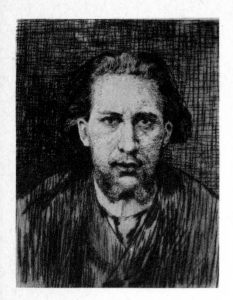

Albert Aurier.

Vincent was deeply moved by two events which took place in January 1890: the birth of his namesake Vincent in Paris on 31 January, and the appearance in the *Mercure de France* of the first basic study of his work, by Albert Aurier (1865–92). Vincent was undoubtedly pleased, and wanted to send copies to three men, all of them art dealers. They were Alexander Reid, H.C. Tersteeg, and C.M. van Gogh. None of them was now a friend, but all had once had it in their power to help him.

Aurier was a student of law, who wrote, painted and drew; Rémy de Gourmont called him 'an innovator in art criticism'. It was therefore no jaded professional scribe who was the first to boost Vincent's work. Vincent had indeed transmitted a spark. Aurier was an ardent admirer of the Italian Primitives, and Vincent's interest in Giotto, which had developed in isolation, is thereby placed in a wider context.

... In the case of Vincent van Gogh, despite the sometimes disconcerting strangeness of his work, it is difficult ... to contest the naïve truthfulness of his art, the ingenuity of his concepts. Indeed, independently of that undefinable aroma of good faith and of things really seen which all his pictures exhale, his choice of subjects, the constant harmony of the most excessive colours, the honesty in the study of characters, the continuous search for the essential meaning of each object, a thousand significant details unquestionably proclaim his profound and almost childlike sincerity, his great love of nature and of truth – of his own truth. ... What particularizes his entire work is the excess, excess in strength, excess in nervousness, in violence of expression. In his categorical affirmation of the character of things, in his frequently headstrong simplification of forms, in his insolence in depicting the sun face to face, in the vehement ardour of his drawing and of his colour, and even in the slightest particularities of his technique, he reveals a powerful being, a male, a bold man, often brutal and sometimes ingenuously delicate. This can be seen in the almost orgiastic excesses of everything that he has painted; he is a fanatic, an enemy of bourgeois sobriety and of trifling details, a kind of drunken giant, better able to move mountains than to handle *bibelots*, an ebullient brain which irresistibly pours its lava into all the ravines of art, a terrible and highstrung genius, often sublime, sometimes grotesque, almost always on the edge of the pathological. Lastly and above all, he is a hyper-aesthete with obvious symptoms who perceives with abnormal and possibly even painful intensity the imperceptible and secret character of lines and forms, and even more of colours, of light, of the magic iridescence of shadows, of nuances which are invisible to healthy eyes. And that is why the realism of this neurotic, why his sincerity and his truth are so different. ...

This robust and true artist, with the brutal hands of a giant, with the nerves of a hysterical woman, with the soul of a mystic, so original and so alone in the midst of the pitiful art of our time, will he experience some day – anything is possible – the joy of rehabilitation, the repentant cajoleries of fashion? Possibly. But whatever happens, and even if it should become fashionable, as is very unlikely, to pay for his canvases the prices commanded by the dwarfish infamies of M. Meissonier, I do not think that much real sincerity will ever enter into the belated admiration of the public at large. Vincent van Gogh is both too simple and too subtle for the contemporary *esprit bourgeois*. He will never be fully understood except by his brothers, the true artists, and the happy ones among the little people, the very little people. ... (Albert Aurier, 'Les Isolés. Vincent van Gogh', *Mercure de France*, January 1890, quoted in translation from John Rewald, *Post-Impressionism*, revised edn, New York and London 1978, F.)

Many thanks for your article in the *Mercure de France*, which greatly surprised me. I like it very much as a work of art in itself, in my opinion your words produce colour, in short, I rediscover my canvases in your article, but better than they are, richer, more full of meaning. However, I feel uneasy in my mind when I reflect that what you say is due to others rather than to myself. For example, Monticelli in particular. Saying as you do: 'He is, as far as I know, the only painter who perceives the colouration of things with such intensity, with such a metallic, gem-like quality', be so kind as to go and see a certain bouquet by Monticelli at my brother's – a bouquet in white, forget-me-not blue and orange – then you will feel what I want to say. But the best, the most amazing Monticellis have long been in Scotland and England. In a museum

in the North – the one in Lille, I believe – there is said to be a very marvel, rich in another way and certainly no less French than Watteau's *Départ pour Cythère*. At the moment M. Lauzet is engaged in reproducing some thirty works of Monticelli's.

Here you are; as far as I know, there is no colourist who is descended so straightly and directly from Delacroix, and yet I am of the opinion that Monticelli probably had Delacroix's colour theories only at secondhand; that is to say, that he got them more particularly from Diaz and Ziem. It seems to me that Monticelli's personal artistic temperament is exactly the same as that of the author of the *Decameron* – Boccaccio – a melancholic, somewhat resigned, unhappy man, who saw the wedding party of the world pass by, painting and analysing the lovers of his time – he, the one who had been left out of things. Oh! he no more imitated Boccaccio than Henri Leys imitated the primitives. You see, what I mean to say is that it seems there are things which have found their way to my name, which you could better say of Monticelli, to whom I owe so much. And further, I owe much to Paul Gauguin, with whom I worked in Arles for some months, and whom I already knew in Paris, for that matter.

Gauguin, that curious artist, that alien whose mien and the look in whose eyes vaguely remind one of Rembrandt's *Portrait of a Man* in the Galerie Lacaze – this friend of mine likes to make one feel that a good picture is equivalent to a good deed; not that he says so, but it is difficult to be on intimate terms with him without being aware of a certain moral responsibility. A few days before parting company, when my disease forced me to go into a lunatic asylum, I tried to paint 'his empty seat'.

It is a study of his armchair of sombre reddish-brown wood, the seat of greenish straw, and in the absent one's place a lighted torch and modern novels.

If an opportunity presents itself, be so kind as to have a look at this study, by way of a memento of him; it is done entirely in broken tones of green and red. Then you will perceive that your article would have been fairer, and consequently more powerful, I think, if, when discussing the question of the future of 'tropical painting' and of colours, you had done justice to Gauguin and Monticelli before speaking of me. *For the part which is allotted to me, or will be allotted to me, will remain, I assure you, very secondary. . . .*

And in conclusion, I declare that I do not understand why *you* should speak of Meissonier's 'Infamies'. It is possible that I have inherited from the excellent Mauve an absolutely unlimited admiration for Meissonier; Mauve's eulogies on Troyon and Meissonier used to be inexhaustible – a strange pair. . . .

In the next batch that I send my brother, I shall include a study of cypresses for you, if you will do me the favour of accepting it in remembrance of your article. I am still working on it at the moment, as I want to put in a little figure. The cypress is so characteristic of the scenery of Provence; you will feel it and say: 'Even the colour is black'. Until now I have not been able to do them as I feel them; the emotions that grip me in front of nature can cause me to lose consciousness, and then follows a fortnight during which I cannot work. Nevertheless, before leaving here I feel sure I shall return to the charge and attack the cypresses. The study I have set aside for you represents a group of them in the corner of a wheat field during a summer mistral. So it is a note of a certain nameless black in the restless gusty blue of the wide sky, and the vermilion of the poppies contrasting with this dark note.

You will see that this constitutes something like the combination of tones in those pretty Scotch tartans of green, blue, red, yellow, black, which at the time seemed so charming to you as well as to me, and which, alas, one hardly sees any more nowadays.

Meanwhile, dear Sir, accept my gratitude for your article. When I go to Paris in the spring, I certainly shall not fail to call on you to thank you in person. . . . (Vincent to Albert Aurier, 626a, 10/11 Feb. 1890, F.)

Proud of the honour bestowed upon him, he also wrote to the Ginoux family in Arles to tell them about the favourable publicity he was receiving. His sense of collectivity was genuine, and his sense of personality remained modest. He continued to regard himself as a link supported by his past and present.

Anna, a sister of his Belgian friend Boch, bought a canvas by Vincent at the *Vingtistes'* exhibition (*Les XX*) in Brussels for 400 francs, and a second Van Gogh from Tanguy a little later on. The tide was undoubtedly turning. The impressions of his work which a few visitors had gained at Theo's appartment

in Paris, and at Tanguy's, must have been powerful indeed to achieve such avant-garde publicity suddenly. It came too late for Vincent, as would soon become apparent. He paid another visit to Arles on 22/23 February, and there followed a relatively long crisis which inhibited his writing and his work.

. . . What am I to say about these last two months? Things are not going well at all. I am sadder and more wretched than I can say, and I do not know at all where I have got to.

The order for paints is rather big, so let me wait for half of it if it is more convenient to you.

While I was ill I nevertheless did some little canvases from memory which you will see later, memories of the North, and now I have just finished a corner of a sunny meadow, which I think is fairly vigorous. You will see it soon. . . .

Letters from home have come too, which I have not yet had the courage to read, I feel so melancholy. Please ask M. Aurier not to write any more articles on my painting, insist upon this, that to begin with he is mistaken about me, since I am too overwhelmed with grief to be able to face publicity. Making pictures distracts me, but if I hear them spoken of, it pains me more than he knows. . . . (629, 30 Apr. 1890, F.)

. . . I have talked to M. Peyron about the situation and I told him that it was almost impossible for me to endure my lot here, and that not knowing at all with any clearness what line to take, I thought it preferable to return North.

If you think well of it and if you mention a date on which you would expect me in Paris, I will have myself accompanied part of the way, either to Tarascon, or to Lyons, by someone from here. Then you can wait for me or get someone to wait for me at the station in Paris. Do what seems best to you. I will leave my furniture temporarily where it is in Arles. It is with friends, and I am sure that they will send it when you want it, but the carriage and packing would be almost as much as it is worth. I think of it as a shipwreck – this journey. Well, we cannot do what we like, nor what we ought to do, either. As soon as I got out into the park, I got back all my lucidity for work; I have more ideas in my head than I could ever carry out, but without it clouding my mind. The brush strokes come like clockwork. So relying on that, I dare think that I shall find my balance in the North, once delivered from surroundings and circumstances which I do not understand or wish to understand. . . . (630, 2 May 1890, F.)

. . . I have tried to be patient, up till now I have done no one any harm; is it fair to have me accompanied like a dangerous beast? No, thank you, I protest. If an attack comes, they know at every station what to do, and then I should let them do what they like.

But I dare believe that my mental balance will not fail me. I am so sorry to leave like this that my sorrow will be stronger than my madness, so I shall have, I think, the necessary poise. . . . (631, May 1890, F.)

These are valuable data because of the lucidity of Vincent's reactions to his condition, his fitness to work and the tremendous influence of nature on his creative powers. He was aware that '*My sorrow will be stronger than my madness*' – an unforgettable statement in which he established the nature of a grief that transcended mental confusion. To us, and perhaps also to him, it had a cause but no longer a name: '*I think of it as a shipwreck, this journey.*' His final request from Saint-Rémy was to his landlord at Arles, to dispatch the looking-glass which for years had been an indispensable aid to his self-confrontations.

. . . The rest of the furniture, goodness yes, there is the mirror, for instance, which I should like to have. Will you kindly paste strips of paper across the glass to prevent its breaking? – but the two chests of drawers, the chairs, tables, you may keep for your trouble, and if there are extra expenses, please let me know.

I greatly regret I fell ill on the day I came to Arles to say good-bye to you all – after that I was ill for two months without being able to work. However, at present I am quite well again. . . . (Vincent to Ginoux, 634a, 12/13 May 1890, F.)

Despite some qualms on the part of the Saint-Rémy doctor, and of Theo and Jo, Vincent left for Paris by night train on 16 May 1890 and arrived at 5 a.m.

the next day. He stayed for three days, with the idea of getting to know his sister-in-law and his young nephew, then three-and-a-half months old. There is nothing to suggest that any heated discussions about Theo's future in Paris took place at the time. However, Vincent did have some difficulty in getting used to Paris and normal family life. After three days he left by train for Auvers-sur-Oise, either by the last train on 19 May or next morning. On 2 June Theo and Jo were in a position to write calmly to Wil:

Vincent has been staying with us. He has never looked healthier, and his speech is quite normal again. He has had an operation, and all his teeth have gone because of the poor state of his stomach. However, he still feels that the fits may return and this is something he is afraid of. It seems that they come on suddenly, and that at Saint-Rémy nothing was done about them apart from making him rest. He writes that he is staying at an inn, c/o Ravoux, which suits him very well for the moment. . . . (Theo and Jo to Wil, 2 June 1890.)

I have been wanting to write you collectedly for several days already, but I've been absorbed in my work. This morning your letter arrived, for which I thank you, and for the 50-fr. note it contained. Yes, I think that for many reasons it would be good if we could be together again for a week of your holidays, if longer is impossible. I often think of you, Jo, and the little one, and I notice that the children here in the healthy open air look well. And yet even here it is difficult enough to bring them up, therefore it must be all the more terrible at times to keep them safe and sound in Paris on a fourth floor. But after all, we must take things as they come. M. Gachet says that a father and mother must naturally feed themselves up, he talks of taking 2 litres of beer a day, etc., in those circumstances. But you will certainly enjoy furthering your acquaintance with him, and he already counts on all of you coming, and talks about it every time I see him. He certainly seems to me as ill and distraught as you or me, and he is older and lost his wife several years ago, but he is very much the doctor, and his profession and faith still sustain him. We are great friends already, and as it happens, he already knew Brias of Montpellier and has the same idea of him that I have, that there you have someone significant in the history of modern art.

I am working at his portrait, the head with a white cap, very fair, very light; the hands also a light flesh tint, a blue frock coat and a cobalt blue background, leaning on a red table, on which are a yellow book and a foxglove plant with purple flowers. It has the same sentiment as the self-portrait I did when I left for this place. *205*

M. Gachet is absolutely *fanatical* about this portrait, and wants me to do one for him, if I can, exactly like it. I should like to myself. He has now got so far as to understand the last portrait of the Arlésienne, of which you have one in pink; he always comes back to these two portraits when he comes to see the studies, and he understands them exactly, exactly, I tell you, as they are. *155*

I hope to send you a portrait of him soon. Then I have painted two studies at his house, which I gave him last week, an aloe with marigolds and cypresses, then last Sunday some white roses, vines and a white figure in it.

I shall most probably also do the portrait of his daughter, who is nineteen years old, and with whom I imagine Jo would soon be friends. *200*

Then I am looking forward to doing the portraits of all of you in the open air; yours, Jo's and the little one's. . . . And I am well. I go to bed at nine o'clock, but get up at five most of the time. I hope that it will not be unpleasant to meet again after a long absence. . . .

Now nothing, absolutely nothing, is keeping us here but Gachet – but he will remain a friend, I should think. I feel that I can do not too bad a picture every time I go to his house, and he will continue to ask me to dinner every Sunday or Monday.

But till now, though it is pleasant to do a picture there, it is rather a burden for me to dine and lunch there, for the good soul takes the trouble to have four- or five-course dinners, which is as dreadful for him as for me – for he certainly hasn't a strong digestion. The thing that has somewhat prevented me from protesting against it is that it recalls the old times to him, when there were those family dinners which we ourselves know so well. But the modern idea of eating one – or at most two – courses is certainly progress, as well as a remote return to real antiquity. Altogether father Gachet is very, yes, very like you and me. . . . (638, 3 June 1890, F.)

It seems unlikely that it will ever be possible to produce a reliable reconstruction of the sequence of the works, or of the letters exchanged between Auvers and Paris, in this period of Van Gogh's life. For those whose desire it is to set in order, arrange and rearrange, it seems hard to accept the abrupt, shocking and uneven aspects of his last works, verging as they do on disorientation and chaos. And yet the destruction, the attack on order, proves to be the reality of a process. The letters are comparatively short, for Vincent, and afford some insight into his moods, particularly in relation to Gachet (both in criticism and self-projection). The one to his mother, probably written on 11 or 12 June, after the visit from Theo and his family, has profound undertones. Although he had formerly resented his father more than his mother, both parents had been equally incapable of understanding art. Now, suddenly, he had no reservations about confiding to his mother the thoughts that were passing through his mind both as a man and as an artist. The passage he quoted from I Corinthians 13 had impressed him deeply as early as 1877 (see p. 32); and farewells had always had a more than normal effect on his emotions. 'Through a glass, darkly' meant for Vincent, above all, the confrontation with a mirror turned solely towards himself, as a means of heightening self-awareness.

What struck me in your letter was that you say that, having gone to Nuenen, you saw all those things again, 'being thankful that they were once yours', and now being able to leave them to others with a peaceful mind.

As through a glass, darkly – so it has remained; life and the why of saying good-bye and going away and the continuance of unrest, one does not understand more of it than that.

For me life might well continue being isolated. Those whom I have been most attached to – I never descried them otherwise than through a glass, darkly. And yet there is a reason for there occasionally being more harmony in my work now. Painting is something in itself. Last year I read in some book or other that writing a book or painting a picture was like having a child. This I will not accept as applicable to me – I have always thought that the latter was the more natural and the best – so I say, only *if* it were so, only *if* it were the same.

This is the very reason why at times I exert myself to the utmost, though it happens to be this very work that is least understood, and for me it is the only link between the past and the present.

Last Sunday Theo, his wife and their child were here, and we lunched at Dr Gachet's. . . . (Vincent to mother, 641a, 11/12 June 1890.)

What is it in St Paul's words that struck such a profound chord in Vincent that he never reasoned them out and yet never forgot them? In a brilliant essay ('Le miroir des enigmes', *Enquêtes 1937–1952*, Paris 1957, pp. 177–83), Jorge Luis Borges discusses the text and its various translations, and in particular the fascination it exercised on Léon Bloy. Van Gogh knew himself to be impelled by unconscious emotions and forces (*sans le savoir*), and craved ultimate knowledge of himself. Borges quotes a telling passage from Bloy: 'The terrifying immensity of the abysses of the sky is an illusion, an external reflection of *our own abyss, seen in a mirror*. . . . If we see the Milky Way, this means that it truly exists in our souls.' Surely this is what Van Gogh saw as he peered into his looking-glass.

'If the symbolic function functions, we are inside,' said Jacques Lacan, whose own mirror contemplations are well known in psychoanalytical literature (*Séminaire II*, Paris 1978, p. 48). He added: 'We are so much inside that we cannot get out.' To get out, to leave – this, presumably, was how Vincent interpreted St Paul – was the action required if he was to pass from his isolation to an inner universe.

Did Theo's and Jo's family problems then worry Vincent and cause a worsening of his condition? There had been great anxiety over the baby; but this had abated, and the child was taking ass's milk. Nor were financial worries as threatening as at other times; Theo still planned to set up in business on his own, and, although he later abandoned the plan (letter to Wil, 22 July), he was still hoping that a major turning-point lay ahead when he wrote to Vincent at the end of June:

We have gone through a period of the greatest anxiety; our dear little boy has been very ill, but fortunately the doctor, who was uneasy himself, told Jo, You are not going to lose the child because of this. . . .

Don't bother your head about me or about us, old fellow, but remember that what gives me the greatest pleasure is the knowledge that you are in good health and that you are busy with your work, which is admirable. You have too much ardour as it is, and we shall be ready for the battle for a long time to come yet, for we shall have to battle all through life without eating the oats of charity they give to old horses in the mansions of the great. We shall draw the plough until our strength forsakes us, and we shall still look with admiration at the sun or the moon, according to the hour. . . . (Theo to Vincent, T39, 30 June 1890, F.)

Between 5 and 15 July Vincent is thought to have stayed one further day with Theo in Paris; he was invited on Saturday 5 July and replied that day that he would come by 'the first train on Sunday' – presumably the next day. The well-known outcome of the visit was that all three became more tense, more tired and more agitated.

. . . It is certain, I think, that we are all of us thinking of the little one, and that Jo must say what she wishes. Theo, like myself, will, I believe, agree to her opinion. For myself, I can only say at the moment that I think we all need rest. I feel – a failure. So much for me – I feel that this is the lot which I accept and which will not change.

But one more reason, *putting aside all ambition*, we can live together for years without ruining each other. You see that with the canvases which are still at Saint-Rémy, there are at least eight with the four here, I am trying not to lose my skill. It is the absolute truth, however, that it is difficult to acquire a certain facility in production, and by ceasing to work, I shall lose it more quickly and more easily than the pains it has cost to acquire it. And the prospect grows darker, I see no happy future at all.

Write me by return mail if you haven't already written, and good handshakes for both in thought. I wish there were a possibility of seeing each other again soon with more collected minds. (Vincent to Theo and Jo, 648, July 1890, F.)

A letter from Jo was intended to make him realize that he had taken too serious a view of the situation.

Jo's letter was really like a gospel to me, a deliverance from the agony which had been caused by the hours I had shared with you which were a bit too difficult and trying for us all. It was no slight thing when we all felt our daily bread was in danger, no slight thing when for reasons other than that we felt that our means of subsistence were fragile.

Back here, I still felt very sad and continued to feel the storm which threatens you weighing on me too. What was to be done – you see, I generally try to be fairly cheerful, but my life is also threatened at the very root, and my steps are also wavering.

I feared – not altogether but yet a little – that being a burden to you, you felt me to be rather a thing to be dreaded, but Jo's letter proves to me clearly that you understand that for my part I am as much in toil and trouble as you are.

There – once back here I set to work again – though the brush almost slipped from my fingers, but knowing exactly what I wanted, I have painted three more big canvases since.

They are vast fields of wheat under troubled skies, and I did not need to go out of my way to try to express sadness and extreme loneliness. I hope you will see them soon – for I hope to bring them to you in Paris as soon as possible, since I almost think that these canvases will tell

206, 208

211 you what I cannot say in words, the health and restorative forces that I see in the country. Now the third canvas is Daubigny's garden, a picture I have been thinking about since I came here.

I hope with all my heart that the intended journey will give you a little distraction. . . . (Vincent to Theo and Jo, 649, ?9 July 1890, F.)

Reassurance could be of no avail to a state of mind which was waiting for the decision to pull the trigger – any more than the first signs of worldly success could have lifted him out of his deep depression at Saint-Rémy. Before anyone could have suspected, and after Theo's prospects appeared to have brightened, Vincent was about to write his last two letters. One of them (652) was found on him, undated and unsigned, by Theo after his death. Its two final paragraphs make this the more important of the two. Dr Jan Hulsker – surely with reason – thought it was written before the other. In its last sentence, Vincent summarized his own crisis, the fatal state of his body and mind from which his work sprang; what he then did to himself was not the consequence of Theo's precarious financial position.

Thanks for your kind letter and for the 50-fr. note it contained.

There are many things I should like to write you about, but I feel it is useless. I hope you have found those worthy gentlemen favourably disposed toward you.

Your reassuring me as to the peacefulness of your household was hardly worth the trouble, I think, having seen the weal and woe of it for myself. And I quite agree with you that rearing a boy on a fourth floor is a hell of a job for you as well as for Jo.

Since the thing that matters most is going well, why should I say more about things of less importance? My word, before we have a chance to talk business more collectedly, we shall probably have a long way to go.

The other painters, whatever they think, instinctively keep themselves at a distance from discussions about the actual trade.

Well, the truth is, we can only make our pictures speak. But yet, my dear brother, there is this that I have always told you, and I repeat it once more with all the earnestness that can be expressed by the effort of a mind diligently fixed on trying to do as well as possible – I tell you again that I shall always consider you to be something more than a simple dealer in Corots, that through my mediation you have your part in the actual production of some canvases, which will retain their calm even in the catastrophe.

For this is what we have got to, and this is all or at least the main thing that I can have to tell you at a moment of comparative crisis. At a moment when things are very strained between dealers in pictures of dead artists, and living artists.

Well, my own work, I am risking my life for it and my reason has half foundered because of it – that's all right – but you are not among the dealers in men as far as I know, and you can still choose your side, I think, acting with humanity, but que veux-tu? (652, 23/24 July 1890, not sent, F.)

Thanks for your letter of today and the 50-fr. note it contained.

Perhaps I'd rather write you about a lot of things, but to begin with, the desire to do so has completely left me, and then I feel it is useless.

I hope that you will have found those worthy gentlemen well disposed toward you.

As far as I'm concerned, I apply myself to my canvases with all my mind, I am trying to do as well as certain painters whom I have greatly loved and admired.

Now I'm back, what I think is that the painters themselves are fighting more and more with their backs to the wall.

Very well . . . but isn't the moment for trying to make them understand the usefulness of a union already gone? On the other hand a union, if it should take shape, would founder if the rest should have to founder. Then perhaps you would say that some dealers might combine on behalf of the impressionists, but that would be very short-lived. Altogether I think that personal initiative remains powerless, and having had experience of it, should we start again?

I noticed with pleasure that the Gauguin from Brittany which I saw was very beautiful, and I think that the others he has done there must be so too.

Drawing from letter 651.

Perhaps you will look at this sketch of Daubigny's garden. It is one of my most purposeful canvases. I add a sketch of some old thatched roofs and the sketches of two size 30 canvases representing vast fields of wheat after the rain. Hirschig asked me to beg you to be kind enough to order for him the list of paints enclosed at the same colour merchant's whose paints you send me.

Tasset can send them to him direct, cash on delivery, but then he would have to give him the 20 per cent reduction, which would be simplest. Or else you could put them in with the package of paints for me, adding the bill, or telling me how much the total is, and then he would send the money to you. You cannot get anything good in the way of paints here.

I have reduced my own order to the barest minimum. Hirschig is beginning to understand things a little, it seems to me; he has done a portrait of the old schoolmaster, he has got him well – and then he has some landscape studies which are like the Konings at your place, almost the same in colour. They will come to be quite like these perhaps, or like the things by Voerman which we saw together.

Good-bye now, and good luck in business, etc., remember me to Jo and handshakes in thought.

[PS.] Daubigny's garden, foreground of grass in green and pink. To the left a green and lilac *211* bush and the stem of a plant with whitish leaves. In the middle a border of roses, to the right a wicket, a wall, and above the wall a hazel tree with violet foliage. Then a lilac hedge, a row of rounded yellow lime trees, the house itself in the background, pink, with a roof of bluish tiles. A bench and three chairs, a figure in black with a yellow hat and in the foreground a black cat. Sky pale green. . . . (651, 23/24 July 1890, F.)

Vincent left the Ravoux hotel with his painting gear on 27 July 1890 and, once he was out of sight, shot himself with a revolver. The scanty information provided by local people who saw him on that day leaves us in some doubt about the exact spot where the attempt took place: on the way to Chaponval or Commenay, or behind a manure heap in the yard of a small farm in Rue Boucher. The location of the bullet – chest or stomach – was never established officially. As usual, the story of this suicide attempt has been explained in a multitude of ways, with the prior indications which, according to Van Gogh's letters, occurred repeatedly from 1873 onwards, carrying most weight.

The maturing of his will to escape from the mysterious process of dying a natural death was wholly in tune with his character. He had always broken tensions by forced departures or forced decisions. He could never wait and see, either in his work or in his life as an artist. As Maurice Blanchot wrote in his subtle analysis of the subject, 'there is in suicide a remarkable intention to abolish the future as a mystery of death; one wishes in some way to kill oneself so that the future may be without secrets' (*L'Espace littéraire*, Paris 1955, pp. 127–31).

The initial failure of his attempt changed his situation in a way that was significant. He had precipitated the very confrontation he had hoped to escape. This enabled him to listen to what those who kept watch by his bedside said, so that the lucid calm of expectancy could come over him. He smoked his pipe as he waited. He was at last allowed to see behind the glass, 'face to face', in the morning of 29 July 1890.

Did Auvers, after Arles and Saint-Rémy, mark a genuine conclusion? For Van Gogh himself, the problem of his return to the North because of sickness was at the same time a problem which concerned his art. Impressionism and Neo-Impressionism had been absorbed and left behind; and as far as Symbolism was concerned he stood alone. Inwardly, though not outwardly, he was more of a thorough-going Symbolist than Bernard, Gauguin, Denis and the others; the man who could so easily have joined in the revival of the symbols of Christ had mentally worked out the reality of things according to their nature as well as his own, and he wanted to go on depicting that reality.

196–99 One significant influence of the period at Auvers – though not a new discovery – was Puvis de Chavannes. Puvis, with his mural-like style and soft, light colours, neither followed nor turned his back on the Impressionists, but revived, with a nineteenth-century slant, something of the measured and timeless dignity of the great fresco-painters who preceded Raphael and Michelangelo. His openness to such an influence suggests the beginning of a change in his work, which he failed to bring to a conclusion, torn as he was between the violence and distortion of some of his landscapes and the resignation and consolation of the Gachet portrait.

As in a Shakespeare play, the final act brought the collapse of a family. Theo's delicate health deteriorated sharply within a month of the funeral, and in September he collapsed completely. He died in a Utrecht clinic on 25 January 1891. Hard pressed though they had always been, he and Jo had always had hopes for the future; Vincent's death was swiftly followed by the end of those hopes. In September 1890, Theo's employers appointed a successor.

170 Two Poplars on a Road Through the Hills, Oct. 1889
In the asylum at Saint-Rémy-de-Provence, Vincent was for the first time completely taken care of, but no longer had the freedom to eat (or not eat) as he chose, to drink, and to overwork, that he had had in the Maison Jaune. He submitted to the rules, and reluctantly consented to be kept indoors when a crisis was near. The immediate surroundings were also different. Nature – vineyards, olive trees, poplars, cypresses, hills, ravines – provided more frequent subjects. A painting like this has great tension in the main lines of the composition and in every detail of the mobile, baroque handling. The brush strokes never repeat themselves. He was reading a lot of Shakespeare, and thinking of the Greeks (Homer, Socrates). His emotional and reflective life remained at a high level even in the asylum. Listening to the summer music of the cicadas, 'dear to the good Socrates . . . here certainly they still sing in ancient Greek' (601).

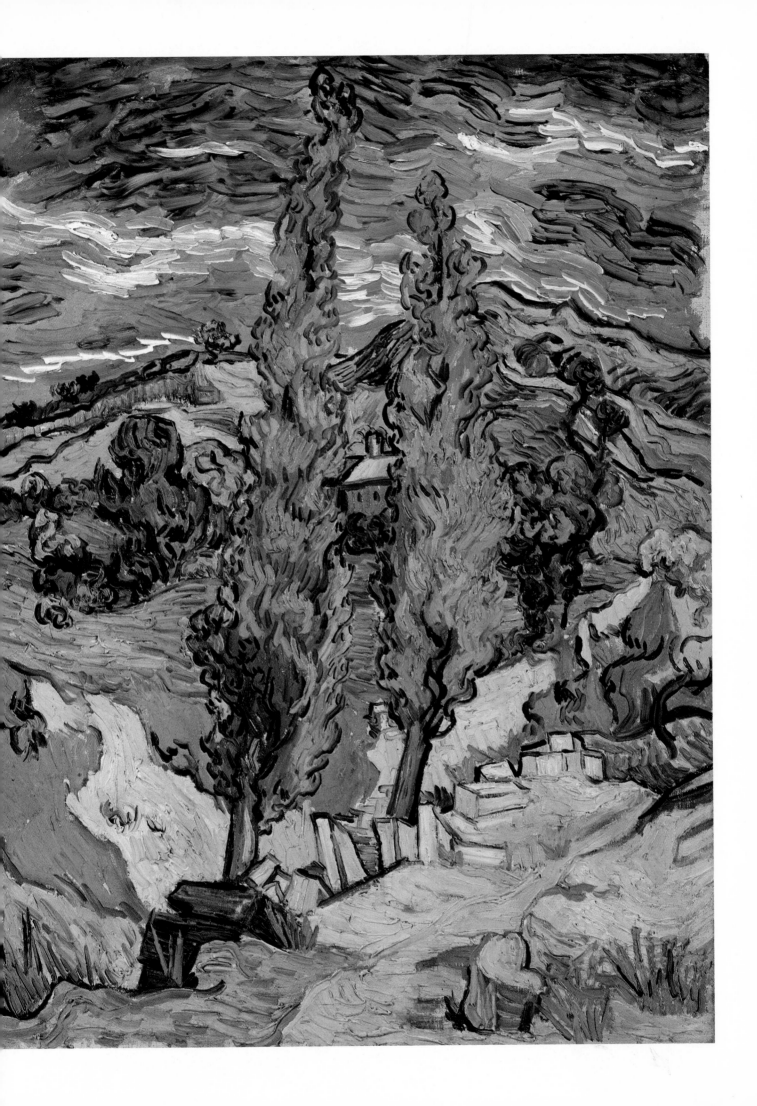

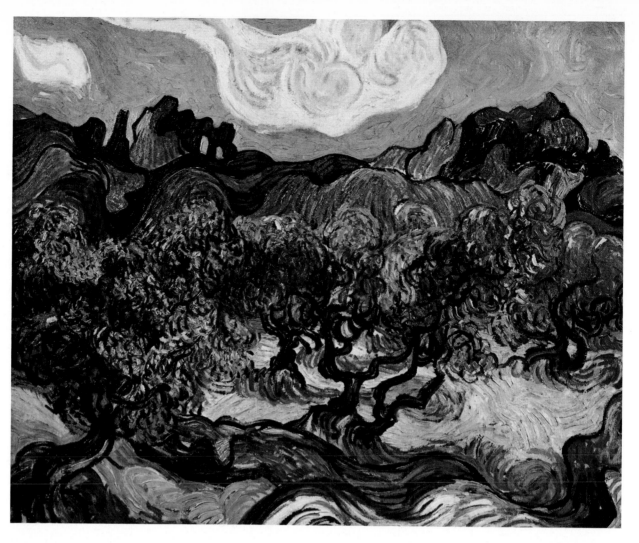

Saint-Rémy

171 *Olive Trees*, Sept.–Nov. 1889
172 *Undergrowth (Ivy)*, July 1889

173 *Pine Woods at Dusk*, Oct.–Dec. 1889
174 *Self-portrait*, Sept. 1889

These four works, of very high quality, all date from a phase of serious illness, after a crisis overtook him as he painted in the fields in July 1889. Between *Undergrowth*, probably the earliest in date, and *Olive Trees*, Vincent found his way to a direct transformation of the observed landscape into curving, moving lines that are sometimes outlines but mostly a fusion of brush strokes that convey both colour and line. He now went further than the Japanese had done: no question of a decorative line, but an inner process of instant obedience to the power of vision. Ivy had been a symbolic plant for Vincent since early in his life; it reappears in this period of ill-humour, fatigue and apathy. The *Pine Woods* has the biting incisive character of a wood-engraving; it was entirely painted in the painful atmosphere of a Mistral – something like his description: 'mournful pines . . . superb sky effects . . . sometimes red . . . sometimes of an extremely neutral tone, and again pale citron' (617). The *Self-portrait* (sometimes classed among the works painted at Auvers in 1890) shows a Vincent uncertain of any future, far from his own lucidity of mind, full of mistrust, tired to death.

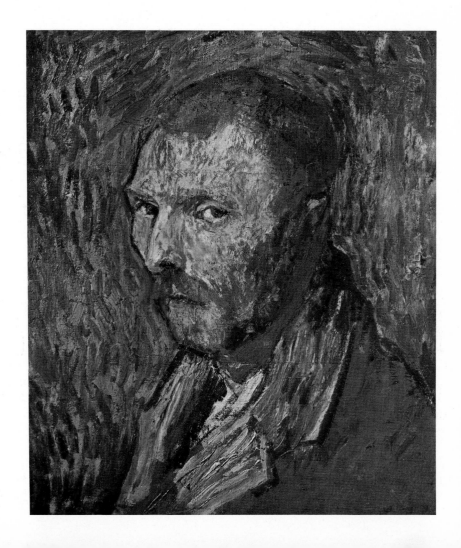

The view from inside

175 Fountain in the Garden of the Hôpital van Gogh, Saint-Rémy, 1981
176 Fountain in the Garden of the Hôpital Saint-Paul, Saint-Rémy, May–June 1889

177 Poppies in a Field, Apr. 1890
178 Wheatfield Behind the Hôpital Saint-Paul, June–Sept., 1889

His environment was subjected, in every part and in every detail, to the full power of his penetrating gaze; he did not see as an Impressionist but always looked beneath the surface, the light, the form. His eye encounters the same objects as does the camera, but expresses the communication of his inner life with the perceived outer world (see also *168, 169*). *Poppies in a Field* has sometimes been ascribed to the Arles period, plausibly so, in view of its classic and harmonious composition; but the same might be said of the Auvers landscape with train and carriage (F760), only a few months later. Van Gogh could be unpredictable at times.

The reaper theme, one painted on the spot and two replicas, was born 'some days before my indisposition' (604). He saw in the reaper 'the image of death, in the sense that humanity might be the wheat he is reaping'. Rilke wrote: 'Van Gogh might lose his mental composure, but his work was still there, behind the composure; he could not fall out of *that.*'

*179 Enclosure Behind Hôpital Saint-Paul
with Rising Sun*, Nov. 1889
180 Wheatfield with Peasant Bearing a Sheaf,
Oct. 1889
181 Study of Arum Lilies, Apr.–May 1890
182 Sower in the Rain, Jan.–Apr. 1890

Meyer Schapiro has analysed this drawing
(*179*), which is a subject that Van Gogh
could see from his window even when he
could not go out: 'Here there are two
competing centres or centred forms: one
subjective, with the vanishing point, the
projection of the artist not only as a
focusing eye, but also a creature of longing
and passion within this world; the other
more external, object-like, off to the side,
but no less charged with feeling.' (*Modern
Art*, New York 1978, p.88) The tension is
also in the graphic expression of space: no
real contours but groups of lines; even the
walls a staccato; everything open with the
exception of the house.
The same landscape in the rain (*182*): more
roughly done, less refinement in the
groups of short lines.
The study of arum lilies (*181*) represents a
strange reversion to a true contour, almost
decorative, with abstract, filled-in voids.
The painted landscape (*180*) is an
emotional mixture of drawing-as-colour
and baroque composition, with no centre,
'nothing but rough fields and rocks' (B2).

Convulsion

183 The Road-menders, Dec. 1889
184 Boulevard Mirabeau, Saint-Rémy-de-Provence

The town of Saint-Rémy rarely provided him with subjects. The painting known as *The Road-menders* is really a picture of enormous trees, with convulsive trunks – a piece of self-expression – with the street scene used simply as a background. The camera image seems utterly different.

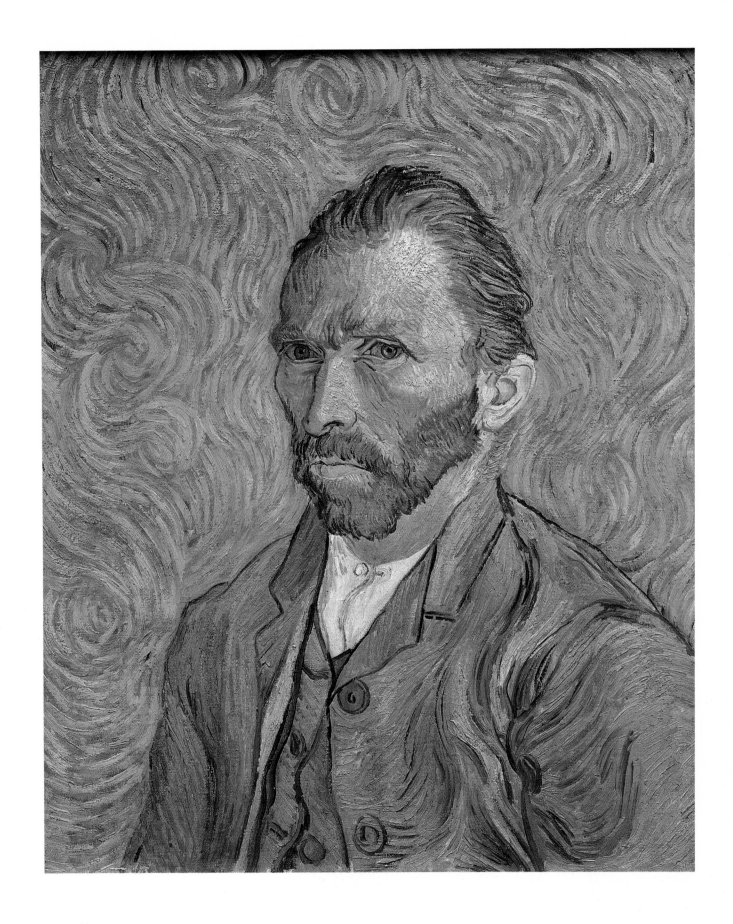

185 Self-portrait, Sept 1889

The *Self-portrait* must be one of the two
mentioned in letters 604, 607, W14 (not
Auvers, nor Paris, nor the one he sent to
Theo). It came from the Gachet family
directly to the Louvre.

Reinterpretations

It seems that, of the copies or paraphrases from the works of other artists, mostly painted at Saint-Rémy, some thirty-six still exist. Novotny and Chetham have studied this phenomenon thoroughly, and found a number of rational explanations for the origin of these works, although something irrational remains unsaid. Vincent's illness often kept him indoors; he had no models; he loved to do works in series, and was free to concentrate on experimentation, the themes being fixed. His original was always a monochrome print. 'I improvise colour on it, not, you understand, altogether myself, but searching for memories of *their* pictures – but the memory, "the vague consonance of colours which are at least right-feeling" – that is my own interpretation. . . . My brush goes between my fingers as a bow should on a violin, and absolutely for my own pleasure' (609).

192 Rembrandt van Rijn. *Raising of Lazarus, c.*1632
193 Eugène Delacroix. *Christ on the Lake of Genesareth, (The Bark of Christ),* 1854

194 *Raising of Lazarus (after Rembrandt)*,
May 1890
195 *Pietà (after Delacroix)*, Sept. 1889

The choice of themes echoes old religious
affinities. *The Bark of Christ* was
remembered for its *terribilità* of colour
(533); but his account of the Delacroix
Pietà has more of the pathos of Van Gogh
in it than that of Delacroix: 'There is in it
the greyish white countenance, the lost,
vague look of a person exhausted by
anxiety and weeping and waking, rather in
the manner of *Germinie Lacerteux*' (W14). 'I
was very distressed,' he told Theo, but 'if
you could see me working, my brain so
clear and my fingers so sure . . . that I have
drawn that *Pietà* without a single
measurement' (630). The *Raising of
Lazarus* is an adaptation of a section of
Rembrandt's etching, replacing the central
figure of Christ, and some others, by the
sun, as if Vincent had been aware of
Rembrandt's suggestion of 'the evocative
power of light' (Karel Boon, *The Complete
Etchings of Rembrandt*, New York n.d.)

Hope

196 Pierre Puvis de Chavannes. *Hope* (second version), 1872
197 Pierre Puvis de Chavannes. *Inter artes et naturam*, 1890
198 *Sketch from a Letter to Willemien* (W22), 4/5 June 1890

Puvis de Chavannes was linked with a change in Van Gogh's conception of art, which had been manifest at Arles through references to antiquity, Petrarch, Dante and Giotto. As early as Nuenen, Puvis had caught his attention. On the way north from Provence in 1890 he saw *Inter artes et naturam* at the Paris Salon and sketched it in a letter to his sister. He had, he told her, witnessed 'a rebirth, total but benevolent, of all the things one should have believed in, should have wished for – a strange and happy meeting of very distant antiquities and crude modernity' (W22). In the superb portrait of Puvis' wife, Princess Cantacuzène, he saw 'a woman already old, but exactly as Michelet wrote, "there is no such thing as an old woman".' The Symbolist generation admired Puvis as an example of what modern painting could aspire to be: 'Perhaps some day everyone will have neurosis, St Vitus' Dance, or something else. But doesn't the antidote exist? . . . See *Hope*, by Puvis de Chavannes' (574).

199 Pierre Puvis de Chavannes. *Princess Maria Cantacuzène*, 1883
200 *Young Girl in White Against a Background of Wheat*, 2nd half June 1890

201 Dr Gachet's house at Auvers-sur-Oise, 1981
202 *Dr Gachet's Garden*, May 1890
203 The Town Hall, Auvers, 1981
204 *Town Hall, Auvers*, July 1890

224

The portrait of Dr Gachet is the second of two versions (see F753). The expression, in both versions, is 'the grieving expression of our time' (643), and 'an expression of melancholy, which would look like a grimace to many who saw the canvas' (W23).

205 Dr Paul Gachet, June 1890

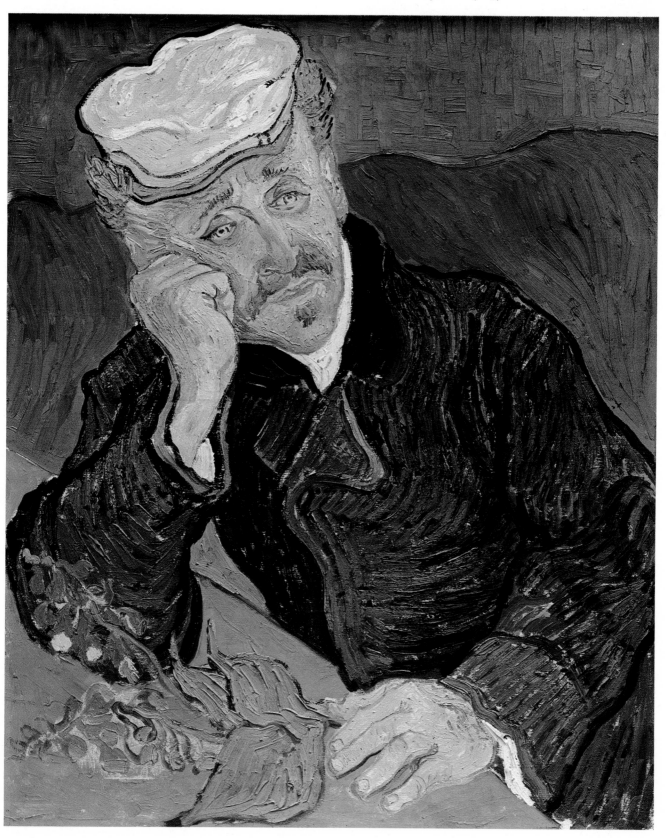

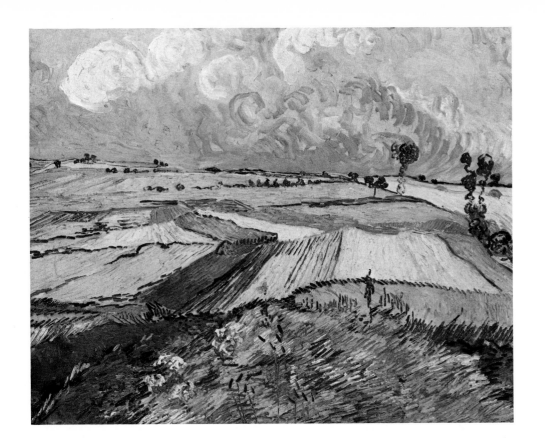

The harvest

The reapers of Nuenen had mostly been seen from the back or in profile. This frontal sketch proves how the grasp of movement dominates; curling lines unite figure, clouds and field. The background is not so much the sky as the plain itself, as an endless surface, imagined by Vincent in a great wealth of pale colour. In his landscapes of Auvers he deliberately adopted a new, elongated format. 'We are still far from the time when people will understand the curious relation between one fragment of nature and another, which all the same explain and enhance each other.' Every form in the horizontal picture is open, and the trees do not seem to be rooted in the earth but to be restless, animate figures. Repeated long horizontal lines comprise the main divisions; but all the forms converge irresistibly upon the horizon.

206 *The Plain of Auvers*, July 1890
207 *The Mower*, July 1890
208 *The Plain of Auvers*, July 1890

227

209 Landscape at Auvers in the Rain, July 1890

Last landscapes

Van Gogh's Auvers period lasted just sixty-nine days: enough for him to create at least fourteen paintings of very high quality, among over eighty items listed in the La Faille catalogue. Even if further research were to reduce the number of Auvers works, it would remain evident that Vincent's creative tension at this time was abnormally

210 Thatched Sandstone Cottages at Chapenval, July 1890

211 Daubigny's Garden, with Black Cat, June–July 1890

high. Those sixty-nine days are full of unanswered questions; even the dating of his letters is problematic. Art historians have written more about the duplicates of *Dr Paul Gachet* and of *Daubigny's Garden* than about other problems; it is, however, in the landscapes that Auvers witnessed crucial conflicts and changes of direction concerning pictorial space and colour. By contrast with Arles and Saint-Rémy, this unrest is not formulated in a distinctive 'Auvers style'. The works show a whirlwind succession of stylistic forms, from pseudo-classic to baroque. His capacity for ecstatic lucidity, his moments of communion with the stars, have disappeared.

212 Père Pilon's House,
June 1890

The end

213 Emile Bernard. *The Funeral of Vincent van Gogh at Auvers*, 1893
214 Paul van Rijssel (Dr Paul Gachet). *Vincent van Gogh on his Deathbed*, 29 July 1890
215 Gravestones of Vincent and Theo, Auvers

A few of the names of those who followed the coffin: Theo van Gogh, Paul Gachet, Père Tanguy, Emile Bernard, Charles Laval, Hirschig, Mademoiselle Mesdag, Ravoux, Andries Bonger, together with peasants and others from the locality.

When the family's tenure of Vincent's grave expired after fifteen years, Jo van Gogh-Bonger took another plot, in an extension of the cemetery, where the two brothers now lie side by side. Theo had survived his brother by less than six months.

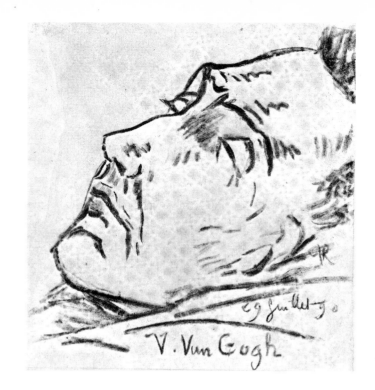

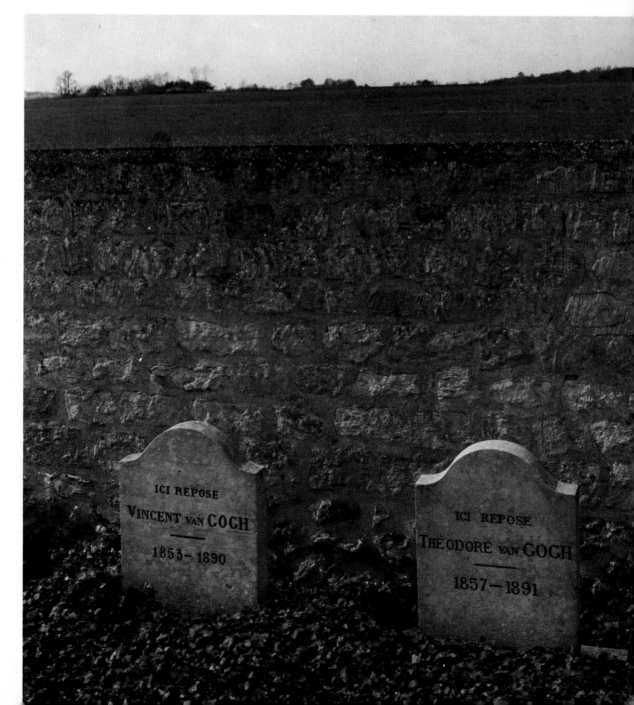

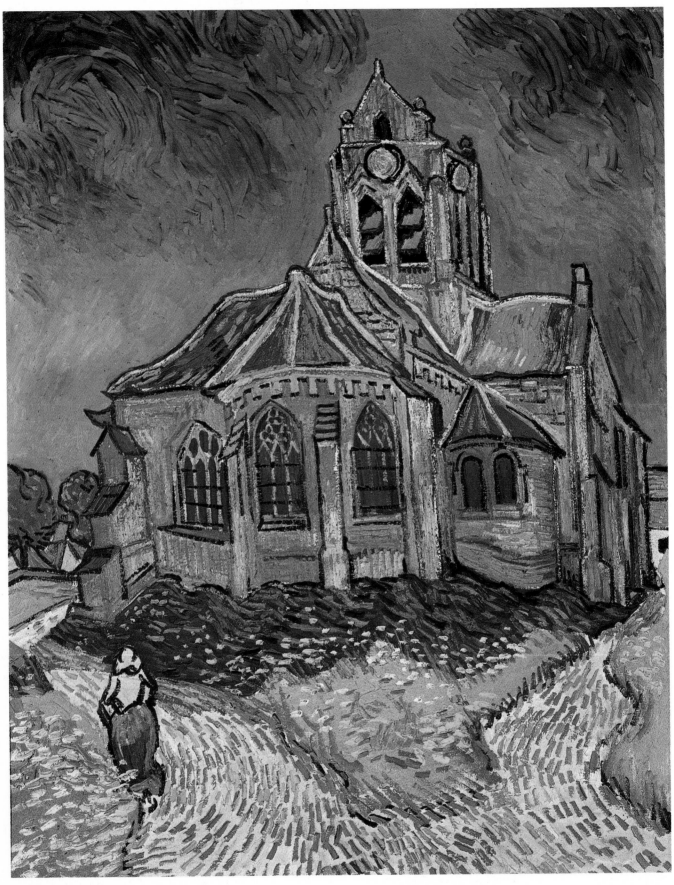

216 The Church at Auvers, 3–8 June 1890
Vincent described this work entirely in terms of colour;
and if he had not mentioned 'sand with the pink glow of
sunshine on it' (w22), we should not be aware of any
natural source of light in the picture at all. He has conjured
up a pure cobalt blue, deep, but also dark as night; the roof
is violet-orange. The church is transfigured, visionary,
more spectral than real.

232

BIBLIOGRAPHICAL NOTE

THE LETTERS

Vincent van Gogh, *Brieven aan zijn broeder*, edited and with an introduction by Jo van Gogh-Bonger, Amsterdam 1914. Three volumes; includes all letters to Theo; letters written in French printed in French. First reprint, 1924, unchanged. Second reprint, 1952–54, includes letters to Van Rappard, Bernard and Willemien, and from Theo to Vincent, plus informative articles and notes.

The Complete Letters of Vincent van Gogh, Greenwich, Conn., and London 1958. Three volumes. Reprinted 1978.

Letters of Vincent van Gogh, 1886–1890, Amsterdam and London 1977. A facsimile edition covering only the Paris and subsequent periods, including letters to Theo, Willemien, his mother, Eugène Boch and J.J. Isaäcson.

Van Gogh door Van Gogh, edited by Jan Hulsker, Amsterdam 1973. Extracts from the letters, presented in the context of the works, and revised datings.

Lettres de Paul Gauguin à Emile Bernard, 1881–1891, Geneva 1954.

Letters to an Artist: from Vincent van Gogh to Anton Ridder van Rappard, 1881–1885, New York 1937. (Dutch edition Amsterdam 1937.)

Lettres de Vincent van Gogh à Emile Bernard, Paris 1911.

Vincent van Gogh, *Briefe an Emile Bernard und Gauguin*, Basle 1921.

CATALOGUES

J.B. de la Faille, *The Works of Vincent van Gogh*, revised, augmented and annotated by an Editorial Board, chairman A.M. Hammacher, members Jan van Gelder, W. Jos de Gruyter, Jan Hulsker, Ellen Joosten, Horst Gerson, Sturla Gudlaugson, Amsterdam 1970.

Paul Lecaldano, *Tutta la pittura di Van Gogh*, with an introduction by Paul Aletrino, Milan 1971. (French edition, *Tout van Gogh*, Paris 1971.) Basically a concise edition of the above.

Jan Hulsker, *The Complete Van Gogh: Paintings, Drawings, Sketches*, Oxford and New York 1980. (Dutch edition, *Van Gogh en zijn weg*, Amsterdam 1977, 1979.) This is a reworking of the La Faille catalogue; dates are revised, paintings and drawings are mixed, and the numbering is changed. Some documentation has been omitted. Dates in the present book are based on Dr Hulsker's research.

SPECIALIZED STUDIES

English period
Alan Bowness, 'Vincent in England', in exhibition catalogue 'Van Gogh', Hayward Gallery, London 1968–69.
Vincent van Gogh on England, compiled from his letters by Ir.Dr. V.W. van Gogh, Amsterdam 1968.

Dutch period
Walter van Beselaere, *De Hollandsche Periode (1880–1885) in het werk van Vincent van Gogh*, Antwerp and Amsterdam 1937. (French edition Antwerp and Amsterdam 1937.)
Carlo Derkert, 'Theory and Practice in Van Gogh's Dutch Painting', *Kunsthistorisk Tidskrift*, XV 3/4, 1946.
Marc Edo Tralbaut, *Vincent van Gogh in Drenthe*, Assen 1959.
Paul Nizon, Die Anfänge van Goghs: der Zeichnungsstil der holländischen Zeit, diss. Bonn 1960.
Griselda Pollock, Vincent van Gogh and the Hague School, diss. London 1972. This formed the basis of the exhibition, with a full introductory text, 'Vincent van Gogh in zijn Hollandse jaren', Rijksmuseum Vincent van Gogh, Amsterdam 1980–81. (English summary of text.) The accent is on the Dutch artists. Only five of the French artists, and none of the Belgian and English artists, in whom Vincent was interested at this time, are represented.

Belgian periods
Marc Edo Tralbaut, *Vincent van Gogh in zijn Antwerpse periode*, Amsterdam 1948.
'Van Gogh en Belgique', exhibition catalogue with introduction by A.M. Hammacher and full biographical notes on artists, 'Les Affinités de Vincent van Gogh', by Gisèle Ollinger-Zinque, Musée des Beaux-Arts, Mons 1980.

Paris period
Bogomila Welsh-Ovcharov, Vincent van Gogh: his Paris Period, diss. Utrecht, 1976. The first investigation of the only remaining poorly documented period in his life.

Arles, Saint-Rémy and Auvers periods
W. Scherjon and W.J. de Gruyter, *Vincent van Gogh's Great Period, Arles, Saint-Rémy and Auvers-sur-Oise*, Amsterdam 1937.
Charles Mauron, *Van Gogh au seuil de la Provence: Arles, de février à octobre 1888*, Saint-Rémy-de-Provence 1959. Mauron (1899–1966), pioneer of the psychoanalytical method in literary criticism (Mallarmé, Racine, Baudelaire), also concerned himself with visual art, and with Van Gogh in particular. His profound vision of Vincent in Arles, and his lecture 'Vincent et Théo van Gogh: une symbiose', together with his 'Notes sur la structure de l'inconscient chez Vincent van Gogh', in *Psyche* (1953), 75–78, have long influenced me more

than the work of any other critic.
(A.M.H.)
'Van Gogh et les peintres d'Auvers-sur-Oise', exhibition catalogue with texts by Germain Bazin and Paul Gachet *fils*, detailed catalogue by Albert Chatelet, note on Vincent's last self-portrait by Michel Florisoone, Orangerie des Tuileries, Paris 1954.

Stylistic and technical research
Carlo Derkert, 'Theory and Practice in Van Gogh's Dutch Painting', *Kunsthistorisk Tidskrift*, XV, 3/4 (1946).
Mark Buchmann, *Die Farbe bei Vincent van Gogh*, Zürich 1948.
A.M. Hammacher, *Les Grands Maîtres du dessin: van Gogh*, Milan 1953.
Douglas Cooper, *Drawings and Watercolours by Vincent van Gogh*, Basle 1954, New York 1955.
Kurt Badt, *Die Farbenlehre van Goghs*, Cologne 1961.
A.M. Hammacher, 'Van Gogh's Life in his Drawings', 'Van Gogh's Relationship with Space', in exhibition catalogue 'Van Gogh', Marlborough Fine Art, London 1962.
'Vincent van Gogh dessinateur', exhibition catalogue with essays by Ir.Dr. V.W. van Gogh and A.M. Hammacher, Institut néerlandais, Paris 1966.
Matthias Arnold, Duktus und Bildform bei van Gogh, diss. Heidelberg 1973. A rare analysis of Van Gogh's brush stroke.

Illnesses
A.J. Westerman Holsteyn, 'Die psychologische Entwicklung Vincent van Goghs', *Images*, X, 4 (1924).
A. Hutter, 'De vijf diagnoses van de ziekte van Vincent van Gogh', *Nederlandse Tijdschrift voor Geneeskunde*, 7 (1931).
Victor Doiteau and Edgar Leroy, *La Folie de Vincent van Gogh*, with preface by Paul Gachet, Paris 1928.
Ryuzaburo Shikiba, *Van Gogh, his Life and Psychosis*, Tokyo 1932.
J. Beer, Essai sur les rapports de l'art et de la maladie de Vincent van Gogh, diss. Strasbourg 1936.
Antonin Artaud, *Van Gogh – le suicidé de la société*, Paris 1947.
G. Kraus, *De verhouding van Theo en Vincent van Gogh*, Amsterdam 1954. (Earlier version, in English: 'The relation of Theo and Vincent van Gogh', in 'Vincent van Gogh en de

psychiatrie', *Psychiatrische en Neurologische Bladen*, XLV [1941].)
Françoise Minkowska, *Van Gogh. Sa vie, sa maladie et son œuvre*, preface by Eugène Minkowski, Paris 1963. Although there have been criticisms of these studies, they constitute perhaps the closest psychoanalytical approach to Van Gogh, not clinically objective but personal, emotional, and with flashes of rare lucidity.
Marc Edo Tralbaut, 'Vincent van Gogh chez Aesculape – quelques apports nouveaux à la connaissance de la santé, la maladie et la mort du grand peintre', *Revue des lettres et des arts dans leurs rapports avec les sciences et la médecine* (Dec. 1957).
Marcel Heiman, 'Psychoanalytical Observations on the Last Paintings and Suicide of Vincent van Gogh', accompanied by critical observations by Arthur F. Valenstein and Anne Styles Wylie, *International Journal of Psychoanalysis*, 57 (1976), 71–79, 81–84.
Fernand Destaing, 'Le Soleil et l'orage ou la maladie de van Gogh', in his *La Souffrance et le génie*, Paris 1980. A recent reversion, with some revisions, to the epileptic diagnosis argued by Henri Gastaut in *Annales medico-psychologiques* (1956) and Jean Delay in *Congrès de médecins aliénistes et neurologues de France et de langue française*, Liège 1954.
Peter Gorsen, *Kunst und Krankheit: Metamorphosen der ästhetischen Einbildungskraft*, Frankfurt am Main 1980. A useful recent survey of the 'art and illness' issue in general.

Miscellaneous
C.S. Chatham, The Role of Vincent van Gogh's Copies in the Development of his Art, diss. Harvard 1960.
Fritz Novotny, 'Die Bilder van Goghs nach fremden Vorbildern', in *Festschrift Kurt Badt*, Berlin 1961.
Vincent: the Bulletin of the Rijksmuseum Vincent van Gogh (1970–76). A valuable source for points of detail concerning Vincent and his family. Unfortunately this quarterly closed after 16 numbers.
Bogomila Welsh-Ovcharov, *The Early Works of Charles Angrand and his Contact with Vincent van Gogh*, Utrecht and The Hague 1971.
'Les Sources de l'inspiration de van Gogh', exhibition catalogue with texts by Sadi de Gorter and Ir.Dr. V.W. van Gogh,

Institut néerlandais, Paris 1972.
Mark Roskill, *Van Gogh, Gauguin and the Impressionist Circle*, London and Greenwich, Conn., 1976.
Evert van Uitert, 'Van Gogh in anticipation of Paul Gauguin', 'Van Gogh and Paul Gauguin in Competition', 'Vincent's Original Contribution', *Simiolus*, 10/11 (1978, 1979, 1980). Three fully documented studies.
'Vorstelijke boekbanden uit de Koninklijke Bibliotheek', exhibition catalogue with scholarly text by J. Storm van Leeuwen, Royal Library, The Hague 1978. Describes Vincent's grandfather Willem Carbentus as one of the most important nineteenth-century bookbinders in The Hague; the first to mark his work with a personal stamp (from 1816 on).
'Japanese Prints Collected by Vincent van Gogh', exhibition catalogue with essays by Willem van Gulik and Fred Orton and 352 entries, Rijksmuseum Vincent van Gogh, Amsterdam 1978.
Charles Michael Peglau, Image and Structure in Van Gogh's Later Paintings, diss. Pittsburgh 1979. Remarkable analysis of the problems of pictorial space, with references to literary descriptions of landscape (Flaubert, *Bouvard et Pécuchet*).
'Les Amis de van Gogh', exhibition catalogue, compiled and with an essay by A.M. Hammacher, Institut néerlandais, Paris 1960. Includes several of the Cloisonnist artists featured in the 1981 Toronto exhibition.
'Vincent van Gogh and the Birth of Cloisonism', exhibition catalogue compiled and with text by Bogomila Welsh-Ovcharov, Art Gallery of Toronto 1981. The exhibition, also shown in Amsterdam with a different arrangement in 1981, presented about a hundred masterpieces to illuminate the comparatively new art-historical issue of Cloisonnism, which in turn is closely allied to Japonism.
Linda Nochlin, 'Van Gogh, Renouard and the Weavers' Crisis in Lyon: the Status of a Social Issue in the Art of the Later Nineteenth Century', in *Art the Ape of Nature: Studies in Honour of H.W. Janson*, New York 1981. A welcome study of art and the impact of industrialization; omits only the importance to Van Gogh of Brontë's *Shirley* and the walk to Courrières.

LIST OF ILLUSTRATIONS

PLATES

All works of art listed without an artist's name are by Vincent van Gogh (1853–90). The medium, where not specified, is oil on canvas. Dimensions are given in centimetres and inches, height before width. References to the catalogue by J.B. de la Faille, *The Works of Vincent van Gogh*, revised edition, Amsterdam 1970, are given in parentheses thus (F827).

ABBREVIATIONS
NMVG: Collection National Museum Vincent van Gogh, Amsterdam (Rijksmuseum Vincent van Gogh). SMKM: Collection State Museum Kröller-Müller, Otterlo, The Netherlands (Rijksmuseum Kröller-Müller).

1 Vincent van Gogh as a boy, 1866. NMVG.
2 Vincent's grandfather, Vincent van Gogh. NMVG.
3 Vincent's grandmother, Elisabeth Huberta Vrijdag. NMVG.
4 Town Hall of Zundert. NMVG.
5 Church of Zundert. NMVG.
6 Theodorus van Gogh (1822–85). NMVG.
7 Anna Cornelia van Gogh-Carbentus (1819–1907). NMVG.
8 The house where Vincent and Theo were born. NMVG.
9 Interior of Goupil & Cie, The Hague. NMVG.
10 Vincent van Gogh (1820–88). NMVG.
11 Rembrandt van Rijn (1606–69). *Burgomaster Jan Six*, 1647. Etching 24.5 × 19.1 (9⅝ × 7½). British Museum, London.
12 The Trippenhuis, Amsterdam. Photo Rijksmuseum, Amsterdam.
13 Henri de Braekeleer (1840–88). *Staalmeesterszaal, in the Trippenhuis*, 1883. Drawing 150 × 240 (59 × 94½). Rijksmuseum Stichting, Amsterdam.
14 August Jernberg (1826–96). *Nightwatch in the Trippenhuis*, 1895. 65 × 81 (25½ × 31¾). Malmö Museum.
15 Vincent van Gogh, c. 1872. NMVG.
16 Theo van Gogh, c. 1888–90. NMVG.
17 Emile Wauters (1846–1933). *Hugo van der Goes at the Red Monastery* (detail), 1872. 186 × 275 (73¼ × 108¼). Musées Royaux des Beaux-Arts de Belgique, Brussels. Photo ACL Brussels.
18 French School (formerly attrib. Philippe de Champaigne). *Woman in Mourning*, 17th c. 61 × 51 (24 × 20). Louvre, Paris. Photo Agraci.
19 Charles Bargue (d. 1883). *Cours de Dessin*, I 39. Edition Goupil.
20 George Henry Boughton (1833–1905). *Early Puritans of New England Going to Worship Armed to Protect Themselves from Indians and Wild Beasts*, 1867. Engraving 29.5 × 50 (11¾ × 19⅝).

21 George Henry Boughton (1833–1905). *The Landing of the Pilgrim Fathers*, 1869. 78 × 103 (30¾ × 40½). Sheffield City Art Galleries.
22 George Henry Boughton (1833–1905). *Deserted*, 1859. From *The Christmas Art Annual*, 1904.
23 John Everett Millais (1829–96). *Chill October*, 1870. 140.9 × 186.7 (55½ × 73½). Private Collection, currently on loan to Perth Museum and Art Gallery.
24 John Everett Millais (1829–96). *The Lost Piece of Silver (The Lost Mite)*. Watercolour 14 × 10.6 (5½ × 4½). Courtesy of the Fogg Art Museum, Harvard University, Bequest – Grenville L. Winthrop.
25 Mathijs (Thijs) Maris (1839–1917). *Souvenir of Amsterdam*, 1871. 46.5 × 35 (18¼ × 13¾). Rijksmuseum, Amsterdam.
26 Rembrandt van Rijn (1606–69). *The Men of Emmaus*, 1848. Oil on wood 68 × 65 (26¾ × 25½). Louvre, Paris. Photo Agraci.
27 Jacob van Ruisdael (1628/9–82). *The Copse*. 68 × 82 (26¾ × 32¼). Louvre, Paris. Photo Agraci.
28 Adriaen van Ostade (1610–85). *Family Portrait*, 1654. Oil on wood 70 × 88 (27½ × 34¾). Louvre, Paris. Photo Agraci.
29 Jules Breton (1827–1906). *Blessing of the Harvest in Artois*, 1857. 32 × 130 (12½ × 51¼). Musée National, Compiègne.
30 Gustave Doré (1832–83). *Yard at Newgate Gaol*, 1872. Engraving 24.5 × 19.1 (9⅝ × 7½). NMVG.
31 Anonymous. *The Mineshaft (Rescue Team Going Down after a Firedamp Explosion)*. Engraving 33.9 × 24 (13¼ × 9½). NMVG.
32 Auguste Lançon (1836–87). *Men Shovelling Snow*, 1881. Engraving 15.9 × 23.7 (6¼ × 9¼). NMVG.
33 Hubert von Herkomer (1849–1914). *Sunday at Chelsea Hospital*, 1871. Engraving 34 × 26.2 (13½ × 10¼). NMVG.
34 Edwin Buckman (1841–1930). *People Waiting for Ration Tickets in Paris*, 1870. Engraving 17 × 24.8 (6¾ × 9¾). NMVG.
35 Luke Fildes (1844–1927). *Homeless and Hungry*, 1877. Engraving 31.6 × 40.3 (12½ × 15¾). NMVG.
36 Luke Fildes (1844–1927). *The Empty Chair, Gad's Hill, June 9th, 1870*. Engraving 30 × 49.8 (11¾ × 19½). NMVG.
37 Matthew White Ridley (1836–88). *Heads of the People: The Miner*, 1876. Engraving 32.8 × 25.1 (13 × 9¾). NMVG.
38 Ary Scheffer (1795–1858). *Christ on the Mount of Olives*, 1839. 140 × 98 (55¼ × 38½). Dordrechts Museum, Dordrecht.

39 Ary Scheffer (1795–1858). *Christus Consolator (Christ the Comforter)*, 1837. 68 × 90 (26¾ × 35½). Dordrechts Museum, Dordrecht.
40 Attributed to Rembrandt (1606–69). *Christ with Mary and Martha (The House at Bethany)*, c. 1650. Pen and sepia wash 18.4 × 26.2 (7¼ × 10¼). British Museum, London.
41 Marinewerf (dockyard commandant's house), Amsterdam, 1890. Photo HistorischTopografische Atlas, Gemeentelijke Archiefdienst, Amsterdam.
42 Vice-Admiral Johannes van Gogh. NMVG.
43 The Rev. Johannes P. Stricker. NMVG.
44 Oosterbegraafplaats, Oosterpark, Amsterdam. Photo Historisch Topografische Atlas, Gemeentelijke Archiefdienst, Amsterdam.
45 Marcasse (Pit 7), Wasmes. NMVG.
46 *Coal-heaver*, July–Aug. 1879. Chalk and pencil 49.5 × 27.5 (19½ × 10¾). SMKM (F827).
47 Vincent's psalter. Photo Jean-Pierre Landenberg.
48 *The Potato Eaters*, 1885. 82 × 114 (32¼ × 45). NMVG (F82).
49 Kee Vos-Stricker, 1879. NMVG.
50 *Corner of a Garden with an Arbour*, June 1881. Watercolour 44.5 × 56.5 (17½ × 22¼). SMKM (F902).
51 *Shacks*, 1881. Pen and ink 45.5 × 61 (18 × 24). Museum Boymans-van Beuningen, Rotterdam (F842).
52 *Old Peasant by the Fire*, Nov. 1881. Charcoal 56 × 45 (22 × 17¾). SMKM (F868).
53 *Worn Out*, 1881. Watercolour 23.5 × 31 (9¼ × 12¼). Foundation P. and N. de Boer, Amsterdam (F863).
54 *The Great Lady*, 1882. Pen and pencil 19 × 10.5 (7½ × 4¼). Letter to Theo. NMVG.
55 *Girl (Sien's Daughter with Shawl: Left Profile)*, Jan. 1883. Chalk and wash 43.5 × 25 (17¼ × 9¾). SMKM (F1007).
56 *Weeping Woman (Woman with her Head in her Hands, Seated on a Basket)*, 1883. Chalk 50.1 × 31.7 (19¾ × 12½). The Art Institute of Chicago, given in memory of Tiffany Blake (F1069).
57 *Sien with a Cigar, Sitting on the Ground by a Stove*, Apr. 1882. Pencil and chalk 45.5 × 56 (18 × 22). SMKM (F898).
58 Jules Breton (1827–1906). *The Harvest*, before 1885. 23 × 38 (9 × 15). Rijksmuseum H.W. Mesdag, The Hague.
59 Anton Mauve (1838–88). *Digging Potatoes*. Watercolour 33 × 44.5 (13 × 17½). Rijksmuseum-Stichting, Amsterdam.
60 Jean-François Millet (1814–75). *Fisherman's Wife*, c. 1849. 47.5 × 38.5 (18¾ × 15¼). Rijksmuseum H.W. Mesdag, The Hague.
61 Jacob Maris (1837–99). *Evening on the Dunes (Fisherman's Wife, Seated)*.

235

Watercolour 42 × 30 (16½ × 11¾). Rijksmuseum H.W. Mesdag, The Hague.

62 Jules Dupré (1811–89). *Evening* (exh. Hague Academy of Fine Arts, 1882). 46.5 × 56.6 (18¼ × 22¼). Rijksmuseum H.W. Mesdag, The Hague.

63 Charles-François Daubigny (1817–78). *Sunset at Villerville*, 1866. 55 × 100 (21¾ × 39¼). Rijksmuseum H.W. Mesdag, The Hague.

64 Anton Mauve (1838–88). *Sale of Wood*, *c.* 1881. Watercolour 33.5 × 50.5 (13¼ × 20). Rijksmuseum H.W. Mesdag, The Hague.

65 *Roofs seen from the Artist's Attic Window*, July 1882. Watercolour 39 × 55 (15¼ × 21¾). Private Collection (F943).

66 *Road at Loosduinen*, 1882. Chalk and pen 24 × 34 (9½ × 13½). NMVG (F1089).

67 *Gas Holders (The Gas Tanks of the Hague)*, Mar. 1882. Chalk and pencil 24 × 33.5 (9½ × 13¼). NMVG (F924).

68 *Factory in The Hague (Sterkman's Factory)*, Mar. 1882. Pencil and wash 24 × 33 (9½ × 13). Private Collection (F925).

69 *Entrance to the Pawnshop, The Hague*, Mar. 1882. Pencil and pen 24 × 34 (9½ × 13½). NMVG.

70 *Bridge at Nieuw Amsterdam (Drenthe)*, Nov. 1883. Watercolour 38.5 × 81 (15¼ × 32). Groninger Museum, Groningen (F1098).

71 *Vicarage Garden with Figures*, Oct.– Nov. 1885. Watercolour 38 × 49 (15 × 19¼). Private Collection (F1234).

72 *Work in the Fields*, Oct. 1883. Pencil and pen 31 × 37.5 (12¼ × 14¾). Courtesy, Museum of Fine Arts, Boston, gift of John Goelet (F1095).

73 *Avenue of Willows with Shepherd and Peasant Woman*, spring 1884. Pencil and pen 39.5 × 54.5 (15½ × 21½). NMVG (F1240).

74 *The Vicarage at Nuenen*, autumn 1885. 33 × 45 (13 × 17). NMVG (F182).

75 *The vicarage at Nuenen*. NMVG.

76 *Lane of Poplars at Nuenen*, autumn 1885. 78 × 97.5 (30¾ × 38½). Museum Boymans-van Beuningen, Rotterdam (F45).

77 *Coming out of Church in Nuenen*, Jan. 1884. 41 × 32 (16¼ × 12½). NMVG (F25).

78 *Nuenen church*. NMVG.

79 *Weaver, Facing Front*, July 1884. 47.5 × 61 (19 × 24). Museum Boymans-van Beuningen, Rotterdam (F27).

80 *Woman Spinning*, 1885. 41 × 32.5 (16¼ × 12¾). NMVG (F36).

81 Anton van Rappard (1858–92). *The Brickworks*, 1885. 24 × 44 (9½ × 17¼). Centraal Museum, Utrecht.

82 Constantin Meunier (1831–1905). *The Brickmakers*. Oil on panel 46 × 70 (18 × 27½). Musée Constantin Meunier, Ixelles/Bruxelles.

83 *Peasant Woman Stooping*, Aug. 1885. Chalk 52.5 × 43.5 (20¾ × 17¼). SMKM (F1269).

84 *The Reaper with Cap, Moving to the Right*, Aug. 1885. Chalk 43 × 55 (17 × 21¾). NMVG (F1317).

85 Anton van Rappard (1858–92). *Girl Holding a Brick Mould*, 1885. Pencil and charcoal 75.8 × 50 (30 × 19¾). Rijksprentenkabinet, Rijksmuseum, Amsterdam.

86 Anton Mauve (1838–88). *The Potato-digger*. Chalk 19 × 26.3 (7½ × 10¼). Rijksprentenkabinet, Rijksmuseum, Amsterdam.

87 Georg Hendrik Breitner (1857–1923). *Couple Walking*. 98 × 73 (38½ × 28¾). Present whereabouts unknown.

88 Frans Hals (*c.* 1580–1666) and Pieter Codde (1599–1678). *The Company of Captain Reynier Reael . . .* , 1633–36. 209 × 429 (82¼ × 169). Rijksmuseum, Amsterdam.

89 Rembrandt van Rijn (1606–69). *The Jewish Bride*, *c.* 1666. 121.5 × 166.5 (47¾ × 65½). Rijksmuseum, Amsterdam.

90 Jozef Israëls (1824–1911). *Alone in the World*, 1878. 39 × 90 (15¼ × 35½). Rijksmuseum, Amsterdam.

91 The *Maris Stella* window, Andrieskerk, Antwerp, 16th century. Photo de Schutter.

92 The house where Vincent lodged, in Beeldekenstraat (Rue des Images). NMVG.

93 Académie Royale des Beaux-Arts, Antwerp. NMVG.

94 Henri Leys (1815–69). *Het Steen, Antwerp*. 41 × 114 (16 × 45). Musée Royal des Beaux-Arts, Antwerp. Photo ACL Brussels.

95 *The Marketplace, Antwerp*, 18 Dec. 1885. Chalk 22.5 × 30 (8¾ × 11¾). NMVG (F1352).

96 Charles de Groux (1825–70). *Benedicite*, 1861. 80 × 154 (31½ × 60¾). Musées Royaux de Belgique, Brussels. Photo ACL Brussels.

97 Henri de Braekeleer (1840–88). *Baron Leys' Dining-room*, 1869. 67 × 84 (26½ × 33). Musée Royal des Beaux-Arts, Antwerp. Photo ACL Brussels.

98 Peter Paul Rubens (1577–1640). *St Theresa Saving Bernardo de Mendoza from Purgatory* (detail), *c.* 1638. Oil on wood 194 × 139 (76¼ × 54¾). Musée Royal des Beaux-Arts, Antwerp.

99 *Head of a Woman*, Dec. 1885. 35 × 24 (13¾ × 9½). NMVG (F206).

100 *Portrait of a Woman*, early Dec. 1885. Charcoal and chalk 50.6 × 39.4 (20 × 15½). NMVG (F1357).

101 Eugène Delacroix (1798–1863). *Study for the Panel 'War' on the ceiling of the Salon du Roi, Palais Bourbon*, 1833–38. Pen 21.6 × 41.3 (8½ × 16¼). Cabinet des dessins, Louvre, Paris.

102 *Women Dancing*, early Dec. 1885. Chalk 9.3 × 16.4 (3¾ × 6½). NMVG (F1350B).

103 *Female Nude*, Jan. 1886. Chalk 19.5 × 11 (7¾ × 4¼). NMVG (F1353).

104 Oko Kunisada II (1823–80). *Two Girls Bathing*, 1868. Colour woodblock 37.4 × 25.1 (14¾ × 10). NMVG.

105 *Skull with Burning Cigarette*, Dec. 1885. 32.5 × 24 (12¾ × 9½). NMVG (F212).

106 Félicien Rops (1833–98). *The Husband's Train; The Death of the Sinner*. Etching, pencil drawing at right of plate, 12.8 × 19 (5 × 7½). Musée Félicien Rops, Namur.

107 *Hanging Skeleton and Black Cat*, Dec. 1885–Jan. 1886. Pencil 10.5 × 6 (4¼ × 2¼). NMVG (F1361).

108 Rue Lepic, Montmartre, late 19th c. Photo L.L. Roger-Viollet.

109 Salon of the painter Fernand Cormon, Paris. Photo H. Roger-Viollet.

110 Jean-François Raffaelli (1850–1924). *View of Montmartre*. Etching 20.7 × 28.1 (8 × 11). NMVG.

111 John P. Russell (1858–1931). *Vincent van Gogh*, Nov. 1886. 60 × 45 (23½ × 17¾). NMVG.

112 Meyer de Haan (1852–95). *Theo van Gogh*, *c.* 1889. Crayon 20.8 × 14.3 (8¼ × 5¾). NMVG.

113 *Old Boots (A Pair of Boots)*, late 1886. 37.5 × 45.5 (14¾ × 18). NMVG (F255).

114 Henri de Toulouse-Lautrec (1864–1901). *Vincent van Gogh*, 1886. Pastel 53 × 44 (21¼ × 17¾). NMVG.

115 *Self-portrait with Easel*, early 1888. 65 × 50.5 (25½ × 20). NMVG (F522).

116 *Self-portrait with Grey Felt Hat*, summer 1887. 41 × 32 (16 × 12½). Stedelijk Museum, Amsterdam (F295).

117 *Self-portrait*, autumn 1887. 47 × 35 (18½ × 13¾). Louvre, Paris (F320). Photo Lauros-Giraudon.

118 Claude Monet (1840–1926). *Four Boats in Winter Quarters, Etretat*, 1885. 26 × 32 (10¼ × 12½). Courtesy of The Art Institute of Chicago, Charles H. and Mary F.S. Worcester Collection.

119 Louis Anquetin (1861–1932). *Avenue de Clichy*, 1887. 69 × 53 (27 × 21). Courtesy Wadsworth Atheneum, Hartford, Ella Gallup Sumner and Mary Catlin Sumner Collection.

120 Adolphe Monticelli (1824–86). *Vase of Flowers*, 1875–80. 51 × 39 (20 × 15¼). NMVG.

121 Paul Signac (1863–1935). *Still-life with Maupassant's Book 'Au Soleil'*, dated 1883. 32.5 × 46.5 (12¾ × 18¼). Nationalgalerie, Staatliche Museen, Preussischer Kulturbesitz, Berlin (West).

122 *Plaster Statuette*, 1886–87. 40.5 × 27 (16 × 10½). NMVG (F216g).

123 *Nude Woman on a Bed*, 1887. 59.5 × 73 (23½ × 28¾). Copyright, The Barnes Foundation, Merion Station, Pa., USA (F330).

124 *The Italian Woman, with Carnations (La Segatori)*, winter 1887–88. 81 × 60 (32 × 23½). Louvre, Paris. (F381). Photo Giraudon.

125 *Asnières: Bernard and Van Gogh*, early 1887. NMVG.

126 *Riverside Walk near Asnières*, early summer 1887. 49 × 66 (19¼ × 26). NMVG (F299).

127 *Factory near the Pont de Clichy, Asnières*, summer 1887. 46.5 × 54 (18¼ × 21¼). Copyright, The Barnes Foundation, Merion Station, Pa., USA. (F318).

128 Bridge at Asnières, late 19th century. Photo C.A.P. Roger-Viollet.

129 Emile Bernard (1868–1941). *Bridge at Asnières*, autumn 1887. 45.9 × 54.2 (18½ × 21¼). Collection, The Museum of Modern Art, New York, Grace Rainey Rogers Fund.

130 *Restaurant de la Sirène, Asnières*, early summer 1887. 57 × 68 (22½ × 26¾). Louvre, Paris (F313). Photo Giraudon.

131 *Bathing Place on the Seine, Asnières*, summer 1887. 19 × 27 (7½ × 10½). From the collection of Mr and Mrs Paul Mellon, Upperville, Virginia (F311).

132 *Factories at Asnières Seen from the Quai de Clichy*, summer 1887. 54 × 72 (21¼ × 28½). The St Louis Art Museum, Gift of Mrs Mark C. Steinberg (F317).

133 Utagawa Kuniyoshi (1797–1861). *Portrait of a Woman Viewing Flowers, with an Inset of Local Industry, Bitchu Province*, 1852. Colour woodblock 37.5 × 25.5 (14¾ × 10). NMVG.

134 Utagawa Hiroshige (1797–1858). *Plum Trees in Flower*, 1857. Colour woodblock 35 × 22 (13¾ × 8¾). NMVG.

135 Utagawa Hiroshige (1797–1858). *Shower on the Ohashi Bridge near Ataka*, 1857. Colour woodblock 33.8 × 21.8 (13¼ × 8½). NMVG.

136 *Flowering Plum Tree*, first half 1887. 55 × 46 (21¾ × 18). NMVG (F371).

137 *The Bridge in the Rain*, summer 1887. 73 × 54 (28¾ × 21¼). NMVG (F372).

138 *Japonaiserie: Oiran*, summer 1887. 105 × 61 (41¼ × 24). NMVG (F373).

139 *Père Tanguy*, autumn 1887. 65 × 51 (25½ × 20). Stavros S. Niarchos Collection (F364). Photo A.C. Cooper.

140 *Self-portrait*, Sept. 1888. 62 × 52 (24½ × 20½). Courtesy of the Fogg Art Museum, Harvard University, Bequest. Collection of Maurice Wertheim, Class of 1906. (F476).

141 *Harvest, La Crau, with Montmajour in the Background*, June 1888. 72.5 × 92 (28½ × 36¼). NMVG (F412).

142 *Boats with Men Unloading Sand*, Aug. 1888. 55 × 66 (21¾ × 26). Folkwang Museum, Essen (F499).

143 *The Poet's Garden: Sunshine in the Park*, Sept. 1888. 73 × 92 (28¾ × 36¼). Courtesy of The Art Institute of Chicago, Mr and Mrs Lewis L. Coburn Memorial Collection (F468).

144 *The Stevedores*, end Aug. 1888. 53.5 × 64 (21 × 25¼). Thyssen-Bornemisza Collection, Lugano-Castagnola (F438).

145 Sunflowers on the road from Arles to Tarascon, 1981. Photo Harold Chapman.

146 *The Road to Tarascon: Sky with Sun*, Aug. 1888. Ink on paper 24.5 × 32 (9½ × 12½). The Justin K. Thannhauser Collection, The Solomon R. Guggenheim Museum, New York (F1502a).

147 Paul Gauguin (1848–1903). *Vincent Painting Sunflowers*, autumn 1888. 73 × 92 (28¾ × 36¼). NMVG.

148 *Fourteen Sunflowers*, summer 1888. 93 × 73 (36½ × 28¼). National Gallery, London (F454).

149 *A Garden*, July 1888. Pen 49 × 61 (19¼ × 24). Oskar Reinhart Collection, Winterthur (F1455).

150 *Sailing Boats Coming Ashore*, 2nd half June 1888. Sepia drawing 24 × 32 (9½ × 12½). Musées Royaux des Beaux-Arts de Belgique, Brussels (F1430b).

151 *Street at Saintes-Maries-de-la-Mer*, 2nd half June 1888. Pen and ink 24 × 31 (9½ × 12½). Collection, The Museum of Modern Art, New York, Bequest of Abby Aldrich Rockefeller (F1435).

152 *Patience Escalier*, Aug. 1888. 69 × 56 (27¼ × 22). Stavros S. Niarchos Collection (F444). Photo A.C. Cooper.

153 *La Berceuse: Mme Augustine Roulin*, Jan. 1889. 92 × 73 (36¼ × 28¾). SMKM (F504).

154 *Joseph Roulin Seated at a Table*, Aug. 1888. 81 × 65 (32 × 25½). Museum of Fine Arts, Boston, gift of Robert Treat Paine II (F432).

155 *L'Arlésienne: Madame Ginoux*, Nov. 1888. 90 × 72 (35½ × 28¼). The Metropolitan Museum of Art, Bequest of Samuel A. Lewisohn, 1951, New York (F488).

156 *The Poet: Eugène Boch*, Sept. 1888. 60 × 45 (23½ × 17¾). Louvre, Paris (F462). Photo Giraudon.

157 Paul Gauguin (1848–1903). *Vineyard at Arles with Breton Women*, 1888. 75.5 × 92.5 (29 × 36½). Ordrupgaardsamlingen, Copenhagen.

158 *Memory of the Garden at Etten*, Nov. 1888. 73.5 × 92 (29 × 36½). Hermitage, Leningrad (F496).

159 *Gauguin's Chair, Candle and Books (The Empty Chair)*, Dec. 1888. 90.5 × 72 (35¾ × 28¼). NMVG (F499).

160 *Vincent's Chair with his Pipe and Tobacco Pouch*, Dec. 1888–Jan. 1889. 93 × 73.5 (36¼ × 28¾). National Gallery, London (F498).

161 The Maison Jaune, Place Lamartine, Arles. NMVG.

162 *Vincent's House on the Place Lamartine, Arles (The Yellow House)*, Sept. 1888. 76 × 94 (30 × 37). NMVG (F464).

163 *Vincent's Bedroom in the Maison Jaune*, Oct. 1888. 79 × 90 (28¼ × 35½). NMVG (F482).

164 *The Night Café*, Sept. 1888. 70 × 89 (27½ × 35). Yale University Art Gallery, Bequest of Stephen Carlton Clark, B.A. 1903 (F463).

165 *Self-portrait with Bandaged Ear*, Jan. 1889. 60 × 49 (23½ × 19¼). Home House Society Trustees, Courtauld Institute Galleries, London (F527).

166 *Still-life on Table, with Book, Pipe, Candle, Letter and Onions*, Jan. 1889. 50 × 64 (19¾ × 25¼). SMKM (F604).

167 *The Hospital Ward, Arles*, Apr.–Oct. 1889. 74 × 92 (29¼ × 36¼). Oskar Reinhart Collection, Winterthur (F646).

168 Courtyard of the Arles hospital, 1981. Photo Harold Chapman.

169 *Courtyard of the Arles Hospital*, Apr.–May 1889. Pen and pencil 45.5 × 59 (18 × 23¼). NMVG (F1467).

170 *Two Poplars on a Road Through the Hills*, Oct. 1889. 61 × 45.5 (24 × 18). The Cleveland Museum of Art, Bequest of Leonard C. Hanna, Jr. (F638).

171 *Olive Trees*, Sept.–Nov. 1889. 72.5 × 92 (28½ × 36¼). Private Collection (F712).

172 *Undergrowth (Ivy)*, July 1889. 74 × 92 (29¼ × 36¼). NMVG (F746).

173 *Pine Woods at Dusk*, Oct.–Dec. 1889. 92 × 73 (36¼ × 28¾). Rijksmuseum Kröller-Müller, Otterlo (F652).

174 *Self-portrait*, Sept. 1889. 51 × 45 (20 × 17¾). Nationalgalerie, Oslo. (F528).

175 Fountain in the garden of the Hôpital van Gogh, Saint-Rémy, 1981. Photo Harold Chapman.

176 *Fountain in the Garden of the Hôpital Saint-Paul, Saint-Rémy*, May–June 1889. Ink 48 × 45 (19 × 18). NMVG (F1531).

177 *Poppies in a Field*, Apr. 1890. 71 × 91 (28 × 35¾). Kunsthalle, Bremen (F581).

178 *Wheatfield Behind Hôpital Saint-Paul*, June–Sept. 1889. 72 × 92 (28¼ × 36¼). SMKM (F617).

179 *Enclosure Behind Hôpital Saint-Paul with Rising Sun*, Nov. 1889. Chalk and pen 47 × 62 (18½ × 24½). Staatliche Graphische Sammlung, Munich (F1552).

180 *Wheatfield with Peasant Bearing a Sheaf*, Oct. 1889. 73 × 92 (29 × 36¼). Indianapolis Museum of Art, Gift in memory of Daniel W. and Elizabeth C. Marmon (F641).

181 *Study of Arum Lilies*, Apr.–May 1890. Pen 31 × 41 (12¼ × 16¼). NMVG (F1613).

182 *Sower in the Rain*, Jan.–Apr. 1890. Pencil and chalk 23.5 × 31.5 (9¼ × 12½). Folkwang Museum, Essen (F1550).

183 *The Road-menders*, Dec. 1889. 73.5 × 92.5 (28 × 36½). The Phillips Collection, Washington DC. (F658).

184 Boulevard Mirabeau, Saint-Rémy-de-Provence. NMVG.

185 *Self-portrait*, Sept. 1889. 65 × 54 (25½ × 21¼). Louvre, Paris (F627). Photo Agraci.

186 *Winter Landscape with Figures*, Jan.–Apr. 1890. Pencil 24 × 32 (9½ × 12½). NMVG (F1592r).

187 *Peasant Family by the Fireside*, May 1890. Chalk. 23.5 × 32 (9½ × 12½). NMVG (F1608r).

188 *Night: the Watch (after Millet)*, Oct. 1889. 72.5 × 92 (28½ × 36¼). NMVG (F647).

189 *Study of Nine Peasants, Two Diggers, Two Figures with Wheelbarrows*, early 1890. Pencil 24 × 31.5 (9½ × 12½). NMVG (F1599r).

190 *On the Road*, early 1890. Pencil 24.5 × 25 (9½ × 9¾). NMVG (F1596v).

191 *Hands; a Digger*, early 1890. Chalk 23.5 × 32 (9¼ × 12¾). NMVG (F1608v).

192 Rembrandt van Rijn (1606–69). *Raising of Lazarus*, c. 1632. Etching 36.8 × 25.7 (14½ × 10). British Museum, London.

193 Eugène Delacroix (1798–1863). *Christ on the Lake of Genesareth*, 1854. 50 × 60 (20 × 24). Private Collection.

194 *Raising of Lazarus (after Rembrandt)*, May 1890. 48.5 × 63 (19 × 24¾). NMVG (F677).

195 *Pietà (after Delacroix)*, Sept. 1889. 73 × 60.5 (28¾ × 23¾). NMVG (F630).

196 Pierre Puvis de Chavannes (1824–98). *Hope* (second version), 1872. 70.7 × 82 (27¾ × 32¼). Louvre, Paris. Photo Giraudon.

197 Pierre Puvis de Chavannes (1824–98). *Inter artes et naturam*, 1890. 295 × 830 (116¼ × 326¾). Musée de Rouen.

198 *Sketch from a Letter to Willemien* (W22), 4/5 June 1890. Pen 6.5 × 17 (2½ × 6¾). NMVG.

199 Pierre Puvis de Chavannes (1824–98). *Princess Maria Cantacuzène*, 1883. 78 × 45 (30¾ × 18). Musée des Beaux-Arts, Lyon.

200 *Young Girl in White Against a Background of Wheat*, 2nd half June 1890. 66 × 45 (26 × 17¾). National Gallery of Art, Washington, Chester Dale Collection 1962 (F788).

201 Dr Gachet's house at Auvers-sur-Oise, 1981. Photo Harold Chapman.
202 *Dr Gachet's Garden*, May 1890. 73 × 51.5 (28¾ × 20¼). Louvre, Paris (F755). Photo Giraudon.
203 The Town Hall, Auvers, 1981. Photo Harold Chapman.
204 *Town Hall, Auvers*, July 1890. Chalk 31 × 48 (12¼ × 19). NMVG (F1630r).
205 *Dr Paul Gachet*, June 1890. 68 × 57 (26¾ × 22½). Louvre, Paris (F754). Photo Agraci.
206 *The Plain of Auvers*, July 1890. 50 × 101 (19¾ × 39¾). Kunsthistorisches Museum, Vienna (F775).
207 *The Mower*, July 1890. Chalk 31 × 23.5 (12¼ × 9¼). NMVG (F1635v).
208 *The Plain of Auvers*, July 1890. 73 × 92 (28¾ × 36¼). Museum of Art, Carnegie Institute, Pittsburgh. Acquired through the Generosity of the Sarah Mellon Scaife Family (F781).
209 *Landscape at Auvers in the Rain*, July 1890. 50 × 100 (19½ × 39½). National Museum of Wales, Cardiff (F811).
210 *Thatched Sandstone Cottages at Chaponval*, July 1890. 65 × 81 (25½ × 32). Kunsthaus, Zürich (F780).
211 *Daubigny's Garden, with Black Cat*, June–July 1890. 56 × 101.5 (22 × 40). Rodolphe Staechelin Foundation, Basle (F777). Photo Hinz, Basle.
212 *Père Pilon's House*, June 1890. 49 × 70 (19¼ × 27½). Stavros S. Niarchos Collection (F791). Photo A.C. Cooper.
213 Emile Bernard (1868–1941). *The Funeral of Vincent van Gogh at Auvers*, 1893. Present whereabouts unknown.
214 Paul van Rijssel (Dr Paul Gachet, 1828–1909). *Vincent van Gogh on his Deathbed*, 29 July 1890. Charcoal. Louvre, Paris. Photo Lauros Giraudon.
215 Gravestones of Vincent and Theo, Auvers. NMVG.
216 *The Church at Auvers*, 3–8 June 1890. 94 × 74 (37 × 29¼). Louvre, Paris (F789). Photo Giraudon.

TEXT ILLUSTRATIONS

P.17 George Henry Boughton (1834–1905). *'On the hill by the sea lies buried Rose Standish'*. From H.W. Longfellow, *The Courtship of Miles Standish*, London 1888.
P.21 After Ernest Meissonier (1815–91). *The Reader*. Etching by Jules Jacquemart, 1856. 16.5 × 11.4 (6½ × 4½). Bibliothèque Nationale, Paris.
P.22 Anonymous. *Thomas à Kempis* (1379/80–1471). From a medieval manuscript of the *Imitation of Christ*. Österreichische Nationalbibliothek, Vienna, Cod. 1576, f.7.
P.26 Drawing from letter 67. *The square at Ramsgate*, Ramsgate 31 May 1876. Pen and pencil 5.5 × 5.5 (2¼ × 2¼). NMVG.
P.34 Thomas Couture (1815–79). *Jules Michelet* (detail), after 1843. 183 × 132 (72 × 52). Musée Carnavalet, Paris. Photo Giraudon.
P.40 Drawing from letter 126. *Café 'Au Charbonnage' at Laeken*, Laeken Nov. 1878. Pencil, pen 14 × 14 (5½ × 5½). NMVG.
P.70 Drawing from letter 166. Pencil 5.3 × 9.2 (2 × 3½). NMVG.
P.71 *Sorrow*, Apr. 1882. Inscribed 'How can it be that there is in the world one woman alone – deserted? MICHELET'. Black chalk on paper 44.5 × 27 (17½ × 10¾). From the Garman-Ryan Collection, Walsall Museum and Art Gallery.
P.91 Drawing from letter 399. *Two peasants Planting Potatoes*, Nuenen Apr. 1885. Pen 6.5 × 9 (2½ × 3¼). NMVG.
P.93 Drawing from letter 399. Pen, ink 5 × 8.6 (2 × 3½). NMVG.
P.94 Drawing from letter 409. Pen, brush, sepia 15.8 × 13.3 (6¼ × 5¼). NMVG.
P.127 *Self-portrait*, Paris summer 1887. Pencil (laid paper) 19.3 × 21 (7½ × 8¼). NMVG (F1379).
P.163 School of Giotto. *Death of the Virgin*, 14th c. Wood 20 × 15 (7¾ × 6). Musée Fabre, Montpellier.
P.170 Eugène Delacroix (1798–1863). *Alfred Bruyas*, 1853. 116 × 89 (45½ × 35). Musée Fabre, Montpellier.
P.200 A.M. Lauzet (d. 1898). *G.-Albert Aurier*. Etching 14.6 × 11.2 (5¾ × 4½). From *Oeuvres posthumes de G.-Albert Aurier*, Paris 1893.
P.207 Drawing from letter 651. Pen, ink 7.8 × 21.8 (3 × 8½). NMVG.

INDEX

Figures in *italic* are plate numbers.

Achenbach, Oswald 32
Aeschylus 44
Aliscamps, Les 172
Allebé, August 32, 34
Angrand, Charles 123
Anne of Brittany, Queen of France 10, 37–8
Anquetin, Louis 123, 158, 162, 195, 196; *119*
Aurier, Georges-Albert 7, 124, 170, 200–1, 202

Bakunin, Mikhail 12, 95
Barbizon School, 16
Bargue, A. 47; *19*
Barye, Antoine 74
Baudelaire, Charles 9
Begemann, Margo (Margot) 89–90
Bellini, Giovanni 27
Béranger, Pierre-Jean de 83
Berceuse, La 126, 172, 174, 198; *153*
Bernard, Emile 12, 123, 124, 157, 170, 208; *129, 213*; letter from Vincent to 126; Vincent on 158; Cloisonnism 195, 196, 197, 198; symbols of Christ 199
Beyle, Pierre 95
Bida, Alexandre 44
Bing, Samuel 127, 160
Bismarck, Otto von 167
Blanc, Charles 96
Blanchot, Maurice 207
Bloy, Léon 204
Blussé & Van Braam 30–1
Boccaccio, Giovanni 165–6, 167, 201
Boch, Anna 201
Boch, Eugène 162, 201; *156*
Bokma, 'Master' 39
Bonger, Andries (Dries) 123, 125, 171
Bonger, Johanna *see* Gogh-Bonger, Jo van
Borges, Jorge Luis 204
Bosboom, Johannes 16, 33, 34
Bossuet, J.-E.-B. 27
Botticelli, Sandro 165, 169
Boughton, George Henry 17, 29, 74, 84, 85; *20–22*
Bouguereau, William Adolphe 95
Boussod & Valadon, *see* Goupil
Bracquemond (Braquemond) Félix 96, 100, 118
Braekeleer, Henri de 17, 120; *97*
Breitner, Georg Hendrik 70; *87*
Breton, Emile 75
Breton, Jules 22, 33, 42–3, 75, 97, 176; *29, 58*
Brias, *see* Bruyas
Brion, Gustave 86
Brontë, Charlotte 10, 92
Brueghel, Pieter 40

Brusse, M.J. 31
Bruyas ('Brias'), Alfred 169, 170, 203
Buckman, Edwin *34*
Bunyan, John 10, 24, 29, 33, 162

Cabanel, Alexandre 169
Carbentus family 13
Carbentus, Catrina Gerardina 33
Carlyle, Thomas 10, 85
Cézanne, Paul 9, 158
Champaigne, Philippe de 18, 21, 29; *18*
Chardin, Jean-Baptiste-Siméon 68, 98
Charles I, King of England 27
Charles VIII, King of France 37
Christ 12, 162, 199, 208
Cloisonnism 120, 159–60, 195, 196, 198
clothing, Vincent's 8, 11–12, 34, 70, 80–1, 162
Codde, Pieter Jacobsz 97; *88*
Coleridge, Samuel Taylor 26
colour theories 90–1, 96–8, 120, 124, 162–5, 167, 176, 200–1
Conscience, Henri 28, 197
Constable, John 17
Cormon, Fernand 121, 122, 123, 124; *109*
Corot, Jean-Baptiste Camille 22, 83, 84, 85, 91, 124, 175
Courbet, Gustave 12, 75, 97, 169
Couture, Thomas 169
Cromwell, Oliver 36, 84–5
Cuyp, Aelbert 27

Dante Alighieri 165–6, 167
Daubigny, Charles-François 16, 17, 43, 75, 124, 206, 207; *63, 211*
Daudet, Alphonse 81; *Tartarin de Tarascon* 161
Daumier, Honoré 91, 166
David, Jacques-Louis 122
Degas, Edgar 123, 170, 173
Delacroix, Eugène 44, 123, 124, 159, 161, 162, 198; *101, 193*; Vincent's interest in 90, 91, 94, 175; use of colour 96, 97, 163–6, 176, 201; portrait of Bruyas (Brias) 169, 170
Delay, Jean 194–5
Denis, Maurice 208
Destaing, Fernand 13–14
Diaz, Narcisse-Virgile 16, 17, 201
Dickens, Charles 13, 16–17, 19–20, 31–2, 36, 37, 44; *36*
Doré, Gustave 32; *30*
Dostoievsky, Fyodor 164
Dupré, Jules 16, 38, 44, 82, 124, 173; *62*
Dürer, Albrecht 26, 40
Dyck, Anthony van 121

Eliot, George 10, 23–4

Erckmann-Chatrian 79
Escalier, Patience *152*
Eyck, Hubert and Jan van 154

Fabritius, Carel 44
Farasyn, Edgard 120, 121
Fildes, Luke 38; *35, 36*
Flaubert, Gustave 8, 174; *Madame Bovary* 89
Flowering Tree, Souvenir of Mauve 155
Fragonard, Jean-Honoré 156
Frère, Edouard 38, 68
Fromentin, Eugène 170
Fry, Roger 13

Gachet, Dr Paul 10, 198–9, 203, 204; *201, 202, 205, 214*
Gainsborough, Thomas 17
Gauguin, Paul 169, 174, 206, 208; *140, 147*; Vincent paints his empty chair 38, 201; *159*; collaboration with Vincent in Arles 126, 154, 157–8, 169; *157*; Vincent's letters to 157, 168; strained relations with Vincent 169–72; and Cloisonnism 195, 196, 197, 198; symbols of Christ 199
Gautier, Théophile 35
Geest 71
Gérôme, Jean-Léon 38, 162
Gigoux, Jean 91
Ginoux family 172, 201, 202; *155*
Giotto 163, 165–6, 169, 199, 200
Gladwell, Mr 27
Gleyre, Marc-Gabriel-Charles 21
Goes, Hugo van der 14, 17, 168; *17*
Gogh, Anna van (sister) 19, 25, 27, 93
Gogh-Carbentus, Anna Cornelia van (mother) 21, 121, 160, 196; Vincent goes to England 24–5; Vincent's relations with 32, 86–8, 204; and Vincent's appearance 34; and Vincent's decision to become lay evangelist 39; Vincent leaves paintings with 100; marriage 172; *7*
Gogh, C.M. van (Uncle Cor) 20, 24, 34, 38, 82, 200
Gogh, Cornelius van (Cor, brother) 124, 160, 196
Gogh, Hein van (uncle) *1*
Gogh, Johannes van (Uncle Jan) 32, 33
Gogh, Lies van (Elisabeth H. du Quesne-van Gogh, sister) 8, 33, 171
Gogh, Theo van (brother) correspondence with Van Gogh 7, 16, *et passim*; notices Vincent's neglect of clothing 11; introduction to art trade 16; and Vincent's love for Eugenia 18; Vincent advises

22; Vincent isolates himself from 41, 43–4; reconciliation with Vincent 42; encourages Vincent to paint 71; befriends a sick woman 78–9; buys clothes for Vincent 81; thinks of emigrating to America 82; Vincent tries to persuade to become painter 83–4; strained relations with Vincent 88–9; Vincent goes to stay with in Paris 48, 122–4; relations with Vincent in Paris 125, 128; and Gauguin 157, 168, 169; marriage 171, 172, 174, 196; and Vincent's madness 197, 198–9, 202–3, 204–5; death 208; *16, 215*
Gogh, Rev. Theodorus van (father) 21, 36, 164; Vincent goes to England 24–5; Vincent's relations with 30, 32–3, 44, 86–8, 204; and Vincent's appearance 34; visits Vincent in Amsterdam 38–9; and Vincent's decision to become lay evangelist 39; financial aid to Vincent 48; minister at Etten 67; argument with Vincent 69; tries to commit Vincent to asylum 73–4; death 93, 99, 172; *6*
Gogh, Vincent van (grandfather) *2*
Gogh, Vincent van (Theo's son) 199, 203, 204–5
Gogh, Vincent Willem van (uncle) 8, 16, 21, 24, 30, 32; death 161; *10*
Gogh, Willemien van (sister) 13, 16–17, 20, 68, 125, 156, 203
Gogh-Bonger, Jo van (Theo's wife) 18, 100, 125, 171, 195, 196, 202–3, 204–5, *208*
Goncourt, Jules and Edmond 118, 161
Goupil, Adolphe 16, 91, 123
Goupil & Cie (Boussod & Valadon) 8, 11, 16, 22, 28, 80, 81, 83, 84, 157; *9*
Gourmont, Rémy de 200
Goya, Francisco José 156
Graetz, H.R. 13
Graphic, The 40
Groux, Charles de 37, 74, 92, 120, 125; *96*
Gruby, Dr 157
Guillaumin, Armand 125, 157, 167, 168
Guizot, F.P.G. 12, 27, 91

Haanebeek family 16
Hague School 16, 75
Hals, Frans 96, 97, 119, 162, 196; *88*
Harvest, La Crau 159
Heine, Heinrich 20, 199
Henrietta Maria, Queen of England 27

239

Herkomer, Hubert von 74; *33*
Hermans, Charles 91–2
Hokusai 160, 164
Holbein, Hans 27
Holl, Frank 74
Hoornik, Christine Clasina
 Maria (Sien) 10, 24, 68–70,
 72–5, 79–82, 88; *55, 57*
Hugo, Victor 44, 92, 173
Huizinga, Jan 72
Hulsker, Jan 206
Huysmans, Joris-Karl 163

Impressionists 90, 154, 161,
 162, 208; Vincent becomes
 familiar with 95, 123, 125–6;
 Japanese influences 118;
 Vincent on 166, 196; use of
 colour 176
Isaäcson, J.J. 199
Israëls, Jozef 16, 34, 38, 75, 96,
 120, 125, 176; *90*

Jacque, Charles-Emile 33, 95
Jamin, Jules 34
Japanese art 118–19, 123, 127,
 158, 159–60, 167
Jones, Rev. T. Slade 28, 30, 39
Jordaens, Jacob 120

Karr, Alphonse 19
Kempis, Thomas à 21, 22–3,
 24, 33, 37, 38, 40
Kerssemakers, Anton 91, 98
Koekkoek, Barend Cornelius
 32, 95
Koning, A.H. 207
Kunisada, Oko II *104*
Kuniyoshi, Utagawa *134, 135*

La Boissière, Comtesse de 128
Lacan, Jacques 204
Lagye, Victor 17
Lamartine, A.M.L. de 35, 36
Lançon, Auguste *32*
Laski, Marghanita 9
Lauzet, M. 201
Lemonnier, Camille 173
Lemud, F.J.A. de 38, 91
Leonardo da Vinci 27
Leys, Henri 92, 99, 118, 120,
 121, 176, 201; *94, 97*
Lhermitte, L.A. 95, 96
Liebermann, Max *85*
Livens, H.M. 123–4
Lock, The 172
Longfellow, H.W. 10, 17
Loti, Pierre 127, 159–60
Louis XII, King of France 37
Louis-Philippe, King of France
 91
Loyer, Eugenia 10, 18
Loyer, Ursula 18
Luther, Martin 162

Maaten, Jacob Jan van der 34
madness 12–14, 73–4, 168–9,
 170–6, 194–9, 202–8
Mallarmé, Stéphane 92
Manet, Edouard 90, 95, 118,
 120, 125, 156–7
Mantegna, Andrea 27, 156
Mantz, Paul 164
Maris, Jacob 16, 20, 22, 34, 75;
 61

Maris, Thijs 16, 19, 20, 22, 37,
 40, 44, 84, 92, 121; *25*
Maris, Willem 75
Marx, Karl 12
Maupassant, Guy de 156, 159
Mauron, Charles 13
Maus, Octave 197
Mauve, Anton 16, 18, 34, 68–
 72, 75, 15, 155, 201; *59, 64, 86*
Mauve-Carbentus, Jet 18, 155
Meer, Jan van der, *see* Vermeer
Meissonier, Ernest 21–2, 23,
 38, 99, 200, 201
Mendes da Costa, M.B. 33–4,
 37, 38
Mertens, Charles 120
Mesdag, H.W. 16, 75
Meunier, Constantin 120
Meyer de Haan, Isaac *112*
Meyes families 38
Michel, Georges 36, 47
Michelangelo Buonarroti 96
Michelet, Jules 44, 91, 96;
 Vincent's admiration for 10,
 12, 19, 34; and the 'woman
 in black' 18, 22, 29, 37, 38
Mignard, Pierre 156
Millais, John Everett 17, 44,
 74; *23–24*
Millet, Jean-François 33, 43,
 44, 74, 75, 76, 84, 86, 91,
 124, 175; *61*; Vincent's
 interest in 38, 47, 71, 73, 90,
 96, 125, 176; *The Sower* 97
Milliet, P. 167
Monet, Claude 95, 123, 125–6,
 156, 175, 176; *118*
Monticelli, Adolphe 156, 159,
 165, 166, 175, 200–1; *120*
Mozart, W.A. 8
Murillo, Bartolomé Esteban
 120
Musset, Alfred de 21, 169

Napoleon I, Emperor 91
Naturalists 46–7
Neo-Impressionism 208
Neuhuys, Albert 75
Night Café 163–4, 172; *174*

Ostade, Adriaen van 22, 34; *28*

Paddemoes 71
Pascal, Blaise 8
Paul, St 204
Petrarch 165–6, 167
Peyron, Dr Théophile 197,
 199, 202
Picasso, Pablo 8
Pissarro, Camille 125, 158,
 168, 198
Pissarro, Lucien 168
Pointillism 162, 166
Portier, M. 94
portraits 126, 163, 203; *see also*
 self-portraits
Potato Eaters, The 93–4, 95, 96,
 98–9, 163; *48*
Potter, Paul 169
Poulet, Georges 9, 19
Pre-Raphaelites 199
Puritanism 29, 84–5
Puvis de Chavannes, Pierre 92,
 157, 163, 166, 199, 208; *196–99*

Quinet, Edgar 173

Raffaelli, Jean-François 95; *110*
Rappard, Anton, Ridder van
 47–8, 67, 78, 98–9; *85*
realism 47, 92
Reaper 197, 198
Reid, Alexander 27, 28, 126,
 200
Rembrandt van Rijn 27, 32–3,
 34, 44, 45, 119, 162, 170; *10,
 40, 192*; *The Men of Emmaus*
 22, 36, 196; *26*; *The Flight
 into Egypt* 37; *The House of
 the Carpenter* 39; Vincent's
 interest in 74, 96, 98, 196;
 The Jewish Bride 97, 196; *89*;
 Portrait of a Man 201
Renoir, Pierre Auguste 95,
 125, 126, 156
Rey, Félix 13, 173, 174, 195
Reynolds, Joshua 17
Ricard, L.G. 169
Richardson, John 28
Richepin, J. 127–8
Ridley, M.W. *37*
Rimbaud, Arthur 9
Rodin, Auguste 156
Roos family 16
Rooses, Max 121
Roosmalen, Mrs 124
Rops, Félicien 120; *106*
Rossetti, Christina 23, 29
Roulin, Augustine *153*
Roulin, Joseph 171, 172, 197;
 154
Rousseau, Théodore 16, 75,
 169
Rubens, Peter Paul 119–21;
 98
Rückert, Friedrich 21
Russell, John P. 155, 157; *111*
Russell, Lord and Lady 27
Ruyperez, Luis 23, 37
Ruysdael, Jacob van 22, 27, 74,
 96; *27*

Sainte-Beuve, Charles
 Augustin 21
Saintes-Maries 172; *151*
Salles, M. 174, 175
Schafrath (sacristan) 93
Scheffer, Ary 31–2, 163; *38, 39*
Schelfhout, Andreas 32, 95
Schuffenecker, Claude Emile
 171, 197
Segatori, Agostina 126, 163;
 124
self-portraits 11–12, 126, 163,
 164, 198; *115–17, 140, 165,
 174, 185*
Serret, Charles 95, 96
Seurat, Georges 123, 155, 156,
 158, 167; Vincent's
 admiration for 125, 162, 166;
 Vincent visits 128
Shakespeare, William 29, 44,
 45, 67, 196
Sien, *see* Hoornik
Signac, Paul 90, 123, 126, 167;
 works with Vincent 12, 125;
 Vincent's admiration for
 162, 166; visits Vincent in
 hospital 172–3; Vincent
 writes to 173; *121*

Sisley, Alfred 164
socialism 12
Sower 164
Starry Night 172
Steen, Jan 68
Stockum, Willem van 18
Stockum-Hannebeek, Carolien
 van 18
Stokes, Rev. William Port 24,
 25, 27, 28
Stowe, Harriet Beecher 44
Stricker, J.P. 32, 33–4, 38, 67–
 8; *43*
suicide 12–13, 16–17, 36, 73,
 89–90, 175, 197, 207–8
Swain 74
symbolism 47, 92, 208

Tanguy, Julien (Père) 126, 201;
 139
Tartarin, *see* Daudet
Tassaert, P.J. 169
Tasset, Emile 162, 207
Tersteeg, H.C. 16, 19, 20, 47,
 70–1, 74–5, 155, 164, 200
Tissot, James 121
Titian 27
Tolstoy, Leo 165, 167
Toulouse-Lautrec, Henri de
 12, 90, 158; *114*
Troyon, Constant 16, 201
Turner, James Mallord
 William 17

Unger, William 96

Velásquez, Diego Rodríguez
 de Silva y 156
Verdier, François 169
Verhaert, Piet 120
Verhas, Jan 120, 121
Verlat, Karel 121, 122
Vermeer (van der Meer), Jan
 97, 165, 196
Veth, Jan 72
Vleersteeg 71
Vos-Stricker, Cornelia
 Adriana (Kee) 33, 37, 67–9,
 73, 80, 81, 89, 90; *49*

Wagner, Richard 159, 165,
 166, 167
Wakker, Willem van de 91
Wallis, Messrs 28
Watteau, Jean-Antoine 201
Wauters, Emile 14, 17, 168; *17*
Weele, Herman Johannes van
 der 70
Weissenbruch, H.J. 16, 70–1,
 75
Welsh-Ovcharov, Bogomila
 195
Whistler, James Abbott
 McNeil 118, 176
Witkamp, Ernest Sigismund
 97
Wordsworth, William 26

Zen Buddhism 127
Ziem, F.F.G.P. 201
Zola, Emile 90, 93, 94–5, 158,
 163, 196